1989

PERPETUAL MOTIF
THE ART OF
MAN RAY

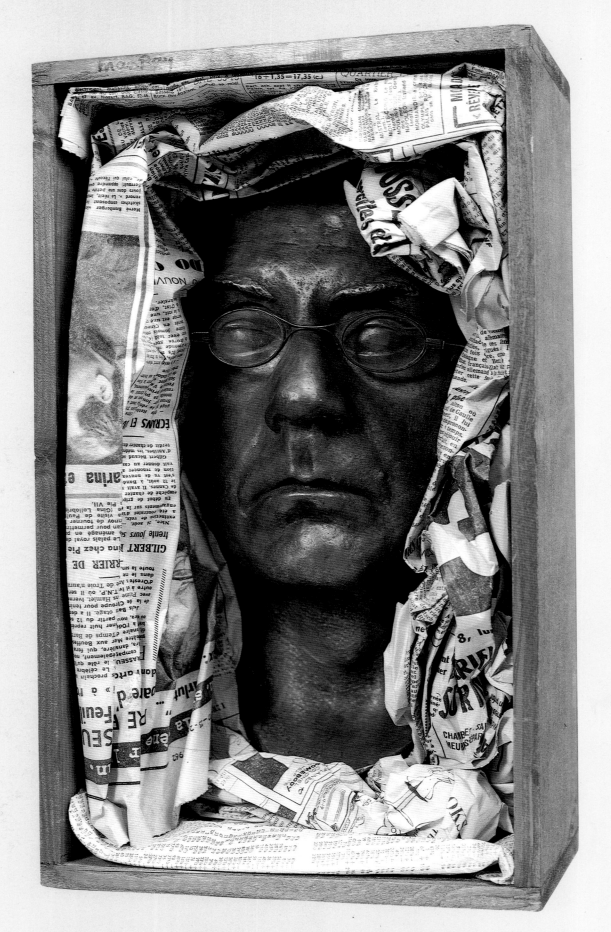

PERPETUAL MOTIF

THE ART OF

MAN RAY

Merry Foresta

Stephen C. Foster

Billy Klüver

Julie Martin

Francis Naumann

Sandra S. Phillips

Roger Shattuck

Elizabeth Hutton Turner

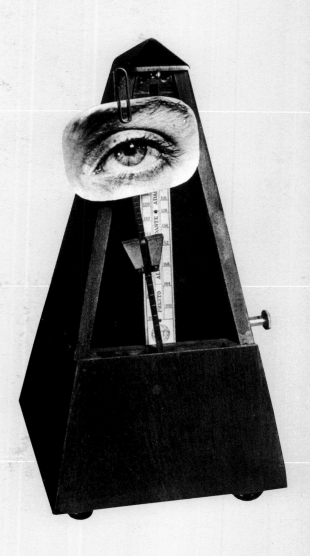

National Museum

of American Art

Smithsonian Institution

Washington, D.C.

Abbeville Press Publishers

New York

Front cover: *Larmes (Glass Tears)*. See fig. 179

Back cover: *Cadeau*. See fig. 204

Frontispiece: *Auto Portrait*. See fig. 30

Perpetual Motif: The Art of Man Ray has been made possible by a grant from the Smithsonian Institution's Special Exhibition Fund.

This book was published on the occasion of the exhibition *Perpetual Motif: The Art of Man Ray,* organized by Merry Foresta, National Museum of American Art, Smithsonian Institution.

National Museum of American Art, Smithsonian Institution, Washington, D.C., 2 December 1988–20 February 1989

The Museum of Contemporary Art, Los Angeles, California, 17 March–28 May 1989

The Menil Collection, Houston, Texas, 30 June–17 September 1989

Philadelphia Museum of Art, Philadelphia, 14 October 1989–7 January 1990

Unless otherwise indicated, all works illustrated in this book are by Man Ray.

Illustrations in this book represent Man Ray's work in a variety of media. In the case of his photographs, owners and locations have not been cited, for the images can be found in a number of collections. Copy prints of the majority of the photographs were obtained from the Man Ray Trust. When the work depicted is unique, however, owner and location are provided. Every effort has been made to use the title given to a work when it was first created or exhibited. References included in the Bibliography are abbreviated in the chapters' endnotes.

Editor, National Museum of American Art: **Gaye Brown**
Editor, Abbeville Press: **Alan Axelrod**
Designer: **Nai Y. Chang**
Production manager: **Dana Cole**

Published in the United States of America in 1988 by Abbeville Press, Inc., and National Museum of American Art, Smithsonian Institution, Washington, D.C.

Printed and bound in Italy.
First edition

Library of Congress Cataloging-in-Publication Data

Perpetual motif: the art of Man Ray / Merry Foresta . . . [et al.]
 p. cm.
 Bibliography: p.
 Includes index.
 Contents: Introduction: Perpetual motif: the art of Man Ray / Merry Foresta—Man Ray, 1908–1921 / Francis Naumann—Man Ray, Paris / Billy Klüver and Julie Martin—Transatlantic / Elizabeth Hutton Turner—Themes and variations: Man Ray's photography in the twenties and thirties / Sandra S. Phillips—Configurations of freedom / Stephen C. Foster—Exile in Paradise: Man Ray in Hollywood, 1940–1951 / Merry Foresta—Candor and perversion in no-man's land / Roger Shattuck.
 ISBN 0-89659-870-5.
 ISBN 0-89659-871-3 (pbk.)
 1. Ray, Man, 1890–1976—Criticism and interpretation.
I. Foresta, Merry A.
N6537.R3P47 1988
709'.2'4—dc19

CONTENTS

132,668

PREFACE

Five years ago when this study began, much was assumed about Man Ray (1890–1976), but little was in fact known. The search for Man Ray necessitated a new approach and new sources of information. Archives in both France and America, only recently made accessible, provided not only new information, but also a different context in which to view Man Ray's considerable influence. For example, Man Ray's voice rings much truer in his letters to contemporaries than it does in his own manuscripts for essays or lectures. Activities that he might have noted with cryptic literary cleverness in his autobiography, *Self Portrait,* years after their happening, lose such reflective self-consciousness when they come to us as his first-told accounts to distant friends, patrons, or family.

As an artist, however, the self-construction of personal history suited him perfectly. The desire to reenter his past, repossess it in words, and connect himself to the greater world was Man Ray's most committed historical act. Meaning in Man Ray's art is something that evolves, that is unimaginable independent of the unfolding of experience the works of art represent. What the works mean, then, requires an answer that pits our experience against our expectations for a work of art. The artist would surely agree that the answer to "Who is Man Ray?" is ultimately in the works themselves—but only revealed when they are set against the larger context of art and life, which we must provide ourselves.

The variety of Man Ray's work is complex. He was a painter, a photographer, a filmmaker, a maker of objects. The style in which he worked changed constantly, or he might work in two simultaneously. Given his indifference to matters of technical proficiency, in every phase of his career, Man Ray's work was erratic in quality. Like his colleague Picabia, he was labeled a joker.

Despite appearances to the contrary, Man Ray's art was a unified whole. Seeing him close-up, at all points of his career, is a necessity—which in turn required a division of this book into more or less chronological chapters. Having picked Man Ray apart, examining him and his life's work through the filter of historical documents, this study had the unparalleled task of then putting him back together in such a way as to convey both information and personality—in other words, that which is the art of Man Ray.

To my colleague, Merry Foresta, who has led the reevaluation

of Man Ray and ably coordinated all aspects of this publication and its related exhibition, go my sincere thanks for her inspired and faithful efforts. To her and her collaborators we are indebted for the richer understanding and appreciation of a remarkable American life, which emerges from this collective portrait. Yet, while extensive, this study in no way exhausts the subject. Man Ray's life and work offer us rich variety and pose challenging questions—as does the complex era in which he lived—and there are yet many possibilities for further investigation. The authors join me in keen anticipation of that continuing rediscovery of an American master.

Charles C. Eldredge
DIRECTOR (1982–88)
NATIONAL MUSEUM OF AMERICAN ART

INTRODUCTION

PERPETUAL MOTIF THE ART OF MAN RAY

Merry Foresta

To most Man Ray was a mystery. In part, this was the enigma posed by any expatriate who deliberately separates himself from home. In part, it was the confusion that resulted from the multifaceted activities of an artist who accomplished, with easy dexterity, so much. As a painter, a maker of objects, photographer, filmmaker, a participant in avant-garde circles on two continents, Man Ray was dazzling in the multiplicity of his talents. After almost a decade as a participant in New York's modernist movement, he left for Paris in 1921. There, he established his reputation on an ability to facilitate the ideas of the avant-garde. He endured where most expatriates did not, and for nearly twenty years he integrated himself into an art world of international proportions. In Europe Man Ray succeeded, an American artist of diverse talents. His art slid back and forth from dada revolt to surrealist iconography, from formal aesthetics to commercial design; his technique was whatever he chose, and he was dedicated to the creative idea rather than any particular style or medium. His themes reflected his innate curiosity and a sense of freedom. Yet it was not unusual for Man Ray to return repeatedly to a specific motif, as he did with the omniscient eye of the metronome object (fig. 1), reworking it in different media and producing multiple versions that each possessed their own beauty and mystery. Perpetuating his ideas for more than half a century, he produced a prodigious oeuvre that was as influential as it was inscrutable. Ever intriguing, he was always hard to explain.

In his review of Man Ray's 1936 exhibition of drawings at the Valentine Gallery in New York, critic Henry McBride searched for a way to describe the influence of the by-then notorious artist. Ordinarily, wrote McBride, the Man Ray drawings would "upset the town," except that the town was already upset by the current

1 *Perpetual Motif*, 1972, metronome and photograph. Originally titled *The Object to Be Destroyed* in 1923, it was remade and retitled *Object of Destruction* in 1932, *Lost Object* in 1945, *Indestructible Object* in 1958, *Last Object* in 1966, and *Perpetual Motif* in 1972.

sensational exhibition *Fantastic Art, Dada, Surrealism* at the Museum of Modern Art. The show, which McBride had earlier derided as a "Farewell to Art's Greatness," featured Man Ray's paintings, objects, and his own personal medium, rayographs; indeed, a 1923 rayograph had been chosen for the cover of the catalogue. The critic described Man Ray as "one of the original Dadaists, and the only one of eminence that America has produced." Although declaring him an American—Man Ray was born in Philadelphia in 1890—McBride added that Man Ray was "firmly adopted by France," and that "to all intents and purposes he was French." There, "an instant success," comparable in McBride's opinion to no less worldly a celebrity than the exotic dancer Josephine Baker, Man Ray had resided for sixteen years.[1]

Having thus described the artist, McBride, like many critics, found it more difficult to explain the art. In lieu of any formal critique, he resorted to a personal anecdote. "I shall never forget," he recounted of an experience in 1920s Paris, "my surprise when calling upon Erik Satie, the musician, at a time when Man Ray had only lived a couple of years in Paris, to have the composer say that a certain thing he was doing had 'a Man Ray effect.' "[2]

Appropriately, it was a Frenchman, Satie, creator of a new genre of music out of the energy of American jazz and the popular songs of the music halls, who captured with a phrase the phenomenon of Man Ray. Satie's own vagueness made it clear that even for a modern European sensibility, Man Ray was a phenomenon difficult—albeit delightful—to pin down. If Man Ray's art was suspect, it was because it defied easy categorization. The artist's elusive personality—American or European? artist or commercial photographer? loner or celebrity?—and his resistance to working in any one style or any one medium all contributed to the puzzle Man Ray presented to his critical audience. His integration of high art and popular and commercial art was, for the first half of the twentieth century, considered diabolic. Brilliant, skillful, provocative, Man Ray defied tradition and resisted definition while holding the imagination of his generation.

Man Ray's unusual approach to the arts manifested itself from the beginning. Early in his career, he thought of himself as a "Thoreau breaking free of all ties and duties to society."[3] Taking in the exhibitions at Alfred Stieglitz's Gallery 291 and witnessing the phenomenal 1913 New York Armory Show, Man Ray was quick to absorb the new lessons of modernism beginning to flood New York from Europe. He was impressed by paintings that suggested

new ways to depict space within the confines of a canvas, works that rearranged the structure of a figure or a landscape into a loose harmony of lines, planes, and colors, extending the impact of a painting beyond the bounds of mere representation. Nothing as provocative had been offered to young American painters, and Man Ray instinctively grasped the possibilities.

In a picture entitled *Man Ray 1914* (fig. 2), he simply, but emphatically, employed his own name and the date as a subject.

2 *Man Ray 1914*, 1914, oil on board, The Roland Penrose Foundation, Chiddingly, East Sussex

Painted when the artist was twenty-four, just months after he had seen the works of Picasso, Braque, Duchamp, Picabia, and others at the Armory Show, the work must have been for Man Ray a profoundly satisfying act of symbolically making his mark on cubism. The dismembered letters are bold, simple forms that fill the picture frame and assume colossal proportions. Only partly emerging from the shadow-filled gashes of paint by which they were formed, they suggest the mystery and magic of the great analytical cubist works. The painting's tiny dimensions—barely 7 by 5 inches—belie its role as a personal icon. More spontaneous than the studied blockiness he had earlier used to paint *The Village* (fig. 43) or the fractured, but stolid, activity of battling figures in *War (A.D.MCMXIV)* (fig. 3), his painted heraldry springs from deeper motives. It is not so much an attempt to practice cubism as an attempt to take possession of it. To speak of the picture's content, we must mention Man Ray; to refer to its style, again Man Ray.

Style and content were also inextricably linked in the "Ridgefield Gazook," a 1915 publication entirely handwritten and illustrated by Man Ray, who signed the texts and drawings with different pseudonyms. Perhaps sophomoric in comparison to the otherwise serious paintings he produced that year, such as *Black Widow* (fig. 4), *Dance* (fig. 49), and *Promenade* (fig. 50), the "Gazook" nonetheless sounded an important note in Man Ray's career. Anarchistic and more concerned with ideas than presentation, the pamphlet's four pages brim with wit and irreverence.

3 *War (A.D.MCMXIV)*, 1914, oil on canvas, Philadelphia Museum of Art, A. E. Gallatin Collection

4 *Black Widow*, 1915, oil
on canvas, Collection
Marion Meyer, Paris

Burlesque often served the young century's avant-garde, particularly in Europe. Picasso, for example, in ribald reaction to the Matissean dictum "Cézanne is the father of us all," mimicked the latter's famous subject and his colleague's patronizing statement. He turned Cézanne's bathers into prostitutes with primitive masks and scarred skin, creating a derisively different breed of painting with his 1907 *Les Demoiselles d'Avignon*.[4]

Other heroes were ragged. Guillaume Apollinaire celebrated April Fool's Day 1913 with a fictitious account of Walt Whitman's funeral in the *Mercure de France*. According to Apollinaire's "eyewitness" account, the event—which occurred spontaneously at the New Jersey fairgrounds, with catered barbecue, whiskey, and watermelon—included drunken orations and fist-pounding on the coffin. It was an absurd reversal of the sacred and the profane, a caricature that did not denigrate its subject but rather swept him into the ranks of the avant-garde.[5] But to American artists and literati who revered Whitman, such disrespect was an outrage. Courting tradition, serious about their artistic gods, Americans—painters and writers alike—could not embrace modern European wit and satire, with its distortions and ambiguities. Calls for apologies and retractions raged for months.

Man Ray was different. Encamped in the art colony of Ridgefield, New Jersey, across the river from New York, he enjoyed his role as outsider. Removed from his family and the demands of academic training, he was free to break the artificial routines—both personal and artistic—of city life. For him, even contemporary heroes were fair targets. With as much aplomb as when he borrowed from the style of French cubism, Man Ray dedicated the "Gazook's" cover drawing of two copulating insects "with apeologies" to a typographically suggestive "PicASSo" (fig. 5). More envious than contemptuous, Man Ray used the potent tools of mockery and absurdity to claim control, to appropriate the larger talent. Ridicule had, in this case, replaced imitation as the ultimate compliment.

As Man Ray practiced it, modernism meant nothing short of revolution. His attendance at the Modern School of New York's Ferrer Center, where conversation focused as easily on political change as art; his designing of covers for Emma Goldman's journal *Mother Earth* and the *International Socialist Review*; even his marriage to the exotic and intellectual Belgian writer Adon Lacroix, whose first husband was the sculptor and anarchist sympathizer Adolf Wolff—all were indications of an early romance with rebellion.[6] As a peripheral member of the group of young artists who gathered

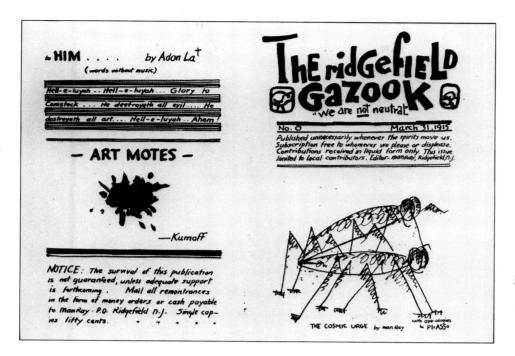

5 *The Ridgefield Gazook*, 31 March 1915, maquette for publication, Collection Arnold H. Crane, Chicago

around Stieglitz during the early and mid teens, Man Ray was entranced by more than the exhibitions of "daring" collages by Picasso, or watercolor sketches of nudes by Rodin, which read like "action pieces . . . and justified . . . abandon of academic principles." What most aroused Man Ray's interest was the gallery director: "Stieglitz was a secessionist from other photographers and the idea of seceding, or revolting always was appealing."[7]

Man Ray's conversion to modernism as a way of life originated at 291 Fifth Avenue. There, to anyone willing to listen, Stieglitz would talk at length about modern art. Yet to Man Ray, he also "worked incessantly at his photography," making portraits of anyone who happened to be in the gallery, even once Man Ray. Although he had no comment about his likeness, the younger artist did provide a vivid description of Stieglitz's procedure: "He produced a hoop stretched with cheesecloth, uncapped his lens, and began waving the hoop over my head, moving about like a dancer, watching me closely. It lasted about ten seconds. . . . With Stieglitz, it was simultaneous and synchronized."[8] Portending his own studio activities, Man Ray saw Stieglitz's greatness in his *performance* as an artist more than in his resulting imagery.

Among the Stieglitz circle, one of the central issues for modern art was photography. The medium provoked all the relevant questions of representation, abstraction, dimension, and method. Controversial and provocative, the use of the camera by artists encapsulated the aesthetic problems of the new-sprung century. The

gauntlet had been thrown by artist, critic, and, for the moment, devil's advocate Marius de Zayas in the January 1913 issue of *Camera Work*, Stieglitz's arena of public discourse. "Photography is Not Art. It is not even an art," De Zayas had insisted. In his search for an art appropriate to the modern age—as he called it, "the epoch of fact"—he portrayed photography as the "concrete representation of consummated facts." But although it was a powerful tool and though it introduced a measure of truth (in De Zayas's words, it "drew away the veil of mystery with which Art enveloped the represented Form"), he did not view it as a means of expression for the intellect of man.[9] Stieglitz added his own twist to the controversy by embracing the ambiguities inherent in creating art with a machine. Calling his own photographs "snapshots" to avoid the aesthetic pretensions of pictorialism and stressing clarity and focus, Stieglitz espoused photography that was "free of painting."

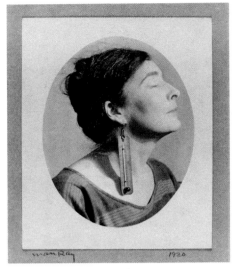

6 *Portrait* (Mina Loy), 1920, silver print, The Menil Collection, Houston

In machine-age America what art was and how it would look were continual questions. Interviewed in 1915 about the impact of French artists in America, De Zayas had theorized that the "American nation [was] still awaiting the magic of an artist's touch to spring forth in pristine, free expression."[10] Prompted perhaps by the aesthetics and debate going on around him in 1916, Man Ray produced his own treatise, "A Primer of the New Art of Two Dimensions." While the text was primarily concerned with defending his current painting style—specifically, his flat paper collages, *The Revolving Doors* (figs. 55–64)—it also hinted at his future goals. One of the Primer's "lessons" announced that the "new two-dimensional medium is not merely drawing or color. It is a most universal and concentrated form of expression. With it the artist can really begin to create."[11] In the future, he declared, decisions about creative methods would be "open-ended," free of traditional restraints. Neither in his pamphlet nor in later manuscripts did Man Ray specifically mention how the machinery of photography might have influenced his treatment of pictorial space, but the same year that he began to produce canvases "in a new flattened manner" he learned to use a camera. New art, new media, and a new kind of artist would be Man Ray's response to De Zayas's call to "magic."

Man Ray's initial photography, however, was practical. As he readied himself for his first exhibition in 1915 at the new Daniel Gallery in New York, he was dissatisfied with professional reproductions of his work. He began to photograph his paintings himself, delighting in the new technology and the use of panchromatic plates, which made it possible to photograph in black and white and preserve the values of colors. In his own words, he "studied

16

very thoroughly and after a few months . . . became the most expert photographer for reproducing things."[12] His ability to achieve the desired effects with a minimum of effort set him apart from other artists entrenched in laborious academic procedures. Photography might also have impressed Man Ray with its abilities to translate a painting's colors into tonalities and to so naturally produce the flatness that took him so long to effect in paint.

Although he readily mastered the skills of camera and darkroom, Man Ray's real talent lay in his grasp of photography's role as intermedium between art and life. Most interested, he said, in photographing "people, particularly their faces," he turned his downtown studio into a meeting place for other artists. He "didn't want to paint portraits anymore," or if he painted, he "wasn't interested in making a likeness, or even a dramatic thing."[13] He remembered being visited by two handsome young women, writers Mina Loy and Djuna Barnes, the one in "light tan clothes of her own design, the other all in black with a veil." Noting that they were "stunning subjects," Man Ray also realized the potential for a picture of strong graphic design.[14] Similarly, his 1920 portrait of Berenice Abbott, which won mention in a photography competition judged by Stieglitz and sponsored by Wanamaker's Department Store, isolated the white face of the young artist and floated it like a mask against a dark background for dramatic contrast. In another portrait of Loy, however, he parodied the work of commercial portrait photographers: set within a traditional oval format, Loy sports a darkroom thermometer as an earring (fig. 6).

A more dynamic subject was Duchamp cavorting with his hemispherical glass (fig. 7). The photograph—one of many Man

7 *Duchamp with His Glass,* 1917, silver print

8 *Eggbeater*, 1917, cliché-verre, Collection Lucien Treillard, Paris

9 *Man Ray in His Studio*, ca. 1920, silver print

Ray made of Duchamp and his works—provides a record not only of the work of art in progress, but of a performance by Duchamp that uses his painting on glass as a prop. Posing behind it, Duchamp seems to merge with his work physically and spiritually. Further, the ambiguity of the authorship of these collaborative images accentuated the artists' challenge to the inviolability of art objects. Later, as if to underscore the transmutation of his image from glass painting to photograph, Duchamp took his scissors to the print. Arch-shaped, though still "containing" the artist, the photograph became an even more precise simulation of his work.

Man Ray's drawings on glass were equally unusual but far more practical. As old as photography itself, the *cliché-verre* method of making direct photographic reproductions of drawings on glass was resurrected by Man Ray for a more modernistic cause. Produced the same year that he photographed Duchamp and his glass, the prints' wiry drawings depict machine-age automatons, a lively eggbeater in motion (fig. 8), or the humorous frenzy of music making, with animated instruments and music stands, rather than human musicians, for performers. Unlike the preciousness of Duchamp's *verre*, Man Ray's original glass drawings—transferable to photographic paper, multiplied as prints—were dispensable. Machinelike in their subjects as well as their method, they recall the sparse drawings of anthropomorphic assemblages by Francis Picabia that graced the covers of his journal *391* (fig. 117).

Most inventive of all Man Ray's subjects were his own studio self-portraits. One of the earliest shows him casually posed in his downtown atelier on Eighth Street, an "ideal" address he noted by the sign on the wall behind his head (fig. 9). The picture inventoried both art and art-making tools. On the dresser is his sculpture

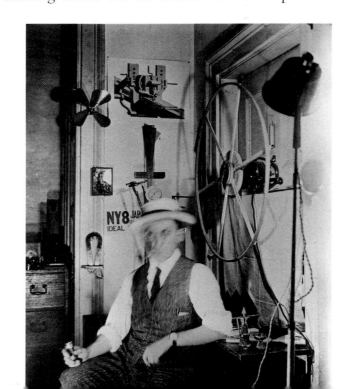

By Itself I; on the wall nearby hangs the gun-toting magnet-object (later to be photographed), *Compass*. Machines—both real and rendered—surround him. A motorized wheel, perhaps used for cinematic experiments with Duchamp, looms over his shoulder; a poster high on the wall illustrates the blocky power of a printing press. The most important, however, is almost hidden. Only the air-pressure gauge and the drawing wand that stick up like witty decorations to Man Ray's straw hat reveal the presence of the airbrush that allowed him to "paint like magic." Using the paraphernalia of his studio such as an electric fan (in combination with stenciled letters that spelled *dishabillé* ["exposed"], it became the aerograph *Anpor*) or a wooden T-square as stencils for the paint sprayed by the machine, Man Ray created works emblematic of the mechanized age. Significantly, as the picture was taken, it was Man Ray who moved—a blurred face the indication of a racing mind. The photograph is no simple self-portrait or document but an integrated image of a personal aesthetic.

Tutored by Duchamp and prompted by Picabia, Man Ray followed an aesthetic principle that esteemed the idea for a work of art more than the work itself. For him, the various artistic media had no hierarchy; they were all tools to be employed in the process of creating. In another studio photograph, an early sculpture, *By Itself II*, can be seen hanging on the wall (fig. 10). A later photograph of the sculpture's pencil-drawn outline captures an ephemeral version of the piece (fig. 11). Cropped to include only the drawing and the empty wall—which can be identified from the faint veins of cracked plaster—the image includes no reference to the studio or the sculpture that spawned the drawing. Save for his barely distinguishable signature on the left edge of the picture, the mechanical

10 *Man Ray Studio, 8th Street, New York*, ca. 1920, silver print

11 Untitled (outline of *By Itself II*), ca. 1917, silver print

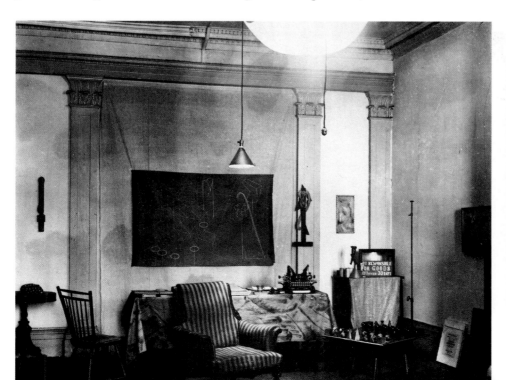

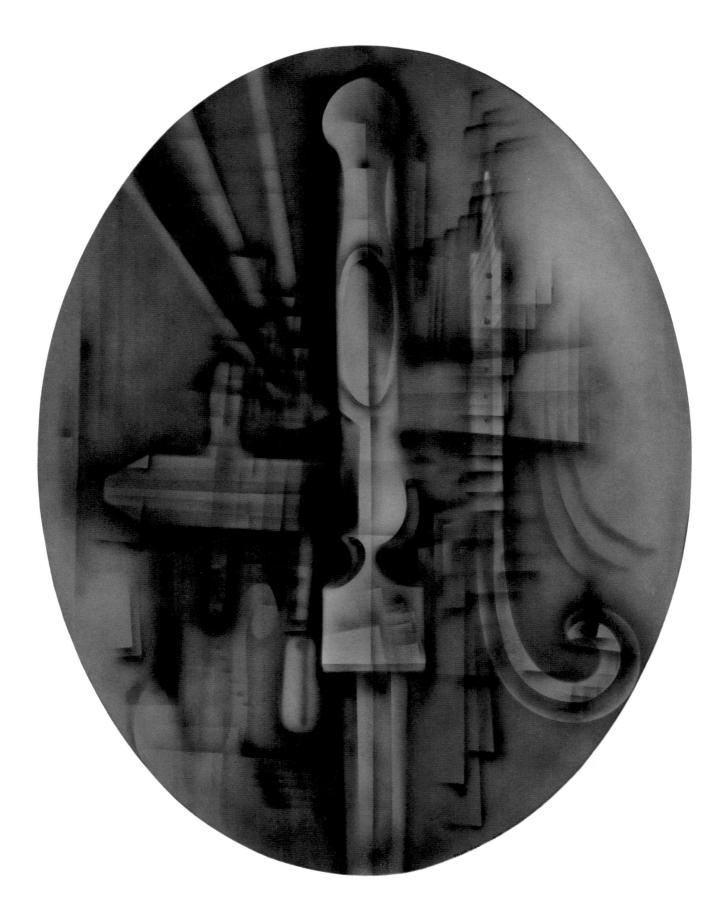

quality of the tracing seems to exclude even the artist. Pitting photographic illusion against artistic rendering, Man Ray converted the sculpture to two dimensions, then with deliberateness—no doubt mindful of the prevailing critical suspicion of the camera—converted the wall image to a "work of art" by framing it in a photograph. An exercise in designed flatness, the photograph in turn holds the key to the large airbrushed painting he executed the following year. For his aerograph of 1919 (fig. 12), an oval mimic of the great synthetic cubist works of Picasso and Braque, Man Ray used the same sculpture again as a stencil, painting its shadowed outline with his air-pressured spray gun.

While Man Ray moved through ideas and media quickly, there was a phenomenal interrelatedness to his work. His first photographs of objects coincided with his aerographs, and, not surprisingly, his first aerographs, painted in grays and tinted browns, looked very much like photographs, though, in his words, "their subjects were anything but figurative."[15]

Man Ray's virtuosity in photography became a key part of the modernist revolution. As a deliberate attack on traditional aesthetics, discarded and discardable objects like a crushed tin can (fig. 13) or an overturned ashtray, or threatening ones like the evil *Compass* (fig. 14), were made beautiful by the silvery tonalities of the photo-

12 Untitled, 1919, aerograph and watercolor on panel, Staatsgalerie, Stuttgart

13 *8th Street*, 1920, silver print

14 *Compass*, 1920, silver print

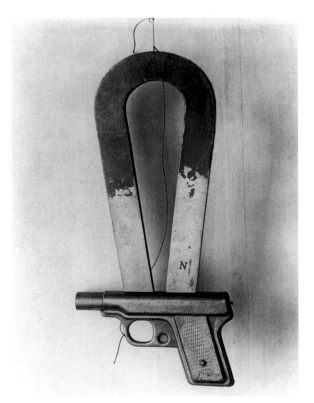

21

graphic print. Similarly, his paintings, converted to photographs for publicity or catalogues, took on a different life—perhaps also becoming dispensable once reproduced. Duchamp's anguish over the tediousness of making his large glass construction *The Bride Stripped Bare by Her Bachelors, Even* was tempered by Man Ray, who "suggested that there might be a photographic process that would expedite matters." According to Man Ray, Duchamp agreed, commenting, "Perhaps in the future photography would replace all art." Man Ray believed it would, not so much due to expediency as the need for artists to free themselves "totally from painting and its aesthetic implications."[16] Duchamp may have provided a point of view; Man Ray developed his own unique methods. If the feared prophecy first announced at photography's birth, "From today painting is dead," was still a threat, Man Ray was carrying it out.[17] Although a passion for painting remained throughout his life—and though he came to value its unique role among artistic media—at this early stage in his career he lost interest in brush and canvas. Having accepted the challenge of modernism, Man Ray needed a medium that could adapt to his ideas.

15 *Joseph Stella and Marcel Duchamp*, 1920, silver print

16 Untitled, 1920, silver print

17 *Joseph Stella and Marcel Duchamp*, 1920, silver print with collage, Yale University Art Gallery, New Haven, Bequest of Katherine S. Dreier

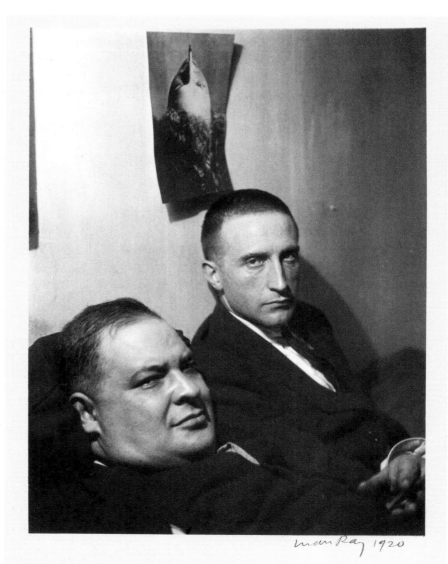

22

Much of Man Ray's art was deceptive in its casualness, like his portrait of Joseph Stella and Duchamp made at the latter's request as a present for patroness Katherine Dreier (fig. 15). The three artists—sitters and portraitist—were, if not close friends, certainly colleagues, having matched modernist sympathies first at the salon of Walter Arensberg, and then as members of Dreier's Société Anonyme. Man Ray's studio and his unofficial position as staff photographer for Dreier's organization would have made him the logical person to conduct the photo session.

Seemingly unposed, isolated in a shallow, almost empty space, Stella and Duchamp appear almost uncomfortable as they slouch on a sofa. Leaning against the wall, Duchamp rests his head at the edge of a picture. Unframed, edges curling, its presentation is as casual as the postures of the men. A photograph by Man Ray (fig. 16), the picture is of a woman with flowing hair, head tilted back, a cigarette in her mouth. It is a disturbing image; in fact, a sweet magazine cutout of a girl holding a basket of flowers was stuck over it in the portrait Dreier ultimately received (fig. 17). Man Ray's woman appears to have no body, no neck supporting her

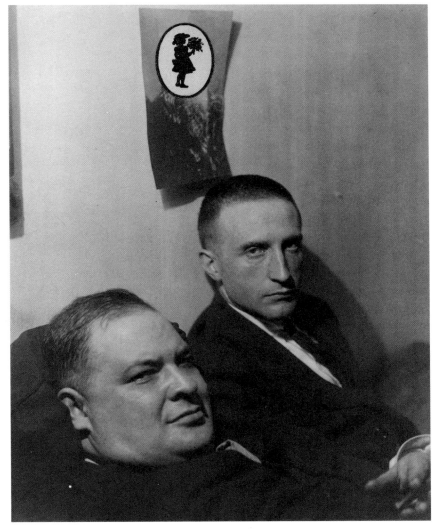

head; and the disembodied face is upside down, suspended by the pin of a cigarette, like a trapeze artist hanging on by her teeth in a death spiral. Sexually suggestive, equally sardonic, the image challenged a contemporary code that held use of tobacco to be very unladylike. In style and content, the photograph was a totally modern picture.[18]

Through the intruding presence of his photograph, Man Ray cleverly and provocatively added himself to the portrait. He had represented himself in his works before. Besides the photograph of the eggbeater, *Man*, he had used his handprint as a signature in his 1916 *Self-Portrait* (fig. 65). Later in Paris, he would represent himself in dada and surrealist group portraits in a variety of imaginative ways that made him more than just the photographer of record. His photograph within a photograph, however, functioned as more than a self-reference; it formed a creative triumvirate: between Stella, the painter, and Duchamp, the painter who no longer painted (he'd given up the medium in 1915), Man Ray, the painter who photographed or used machines to make his art, added a provocative alternative.

Man Ray was a star in France when he arrived in the summer of 1921. His reputation had preceded him. A photograph of his object *Lampshade* had been reproduced in Picabia's magazine *391* in July 1920. In November of that year, a portrait of Picabia attributed to Man Ray (though probably incorrectly) appeared in the same journal with an inscription by Picabia.[19] Man Ray's own publications, notably *New York Dada*, were also familiar to the group of young avant-garde artists and writers that welcomed him. Posted to Paris ahead of his arrival or carried by Duchamp, who preceded Man Ray there by several months, the four-page, single-issue journal was easily passed around.

Published in April 1921 in collaboration with Duchamp, *New York Dada* featured a letter from Tzara applauding the transatlantic extension of the movement.[20] Illustrating this "preface" was a graphic admonition to "Keep Smiling" and Man Ray's image of a human coatstand labeled *dadaphoto* (fig. 18). In lieu of a personal credit line, Man Ray chose a more universal, though distinctly American-sounding, tag for his work: *Trademark Reg.* Thus did he stake out his territory: the photomechanical reproduction of his photograph of an ephemeral object—a mix of nude and painted display manikin—simultaneously covered all media, while giving none precedence. Although later in Paris it would appropriately be titled *Portmanteau*, for this occasion it was most definitely a *dada*-photo, neither identifiable nor exact, linking the image, and Man

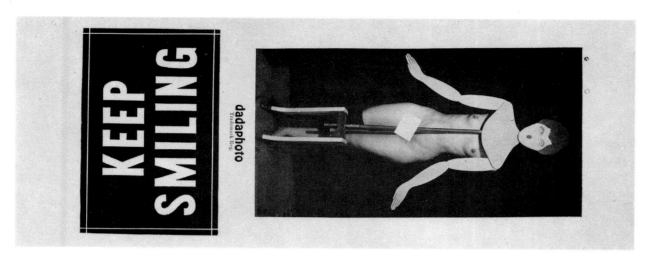

Ray, with a kind of art that could be many things for many
purposes.

To Tzara Man Ray had also sent photographs—the suggestive,
but faceless, *Man* and *Woman* (figs. 69, 70), which were included in
Salon Dada: Exposition Internationale in the spring before his arrival.
But what exactly was being exhibited, object constructions or pho-
tographs? Initially sent at Tzara's request for publication in *Dada-
globe*, the pictures efficiently represented and transported Man Ray's
work across the Atlantic for one purpose, and then to the lobby of
the exhibition space of Théâtre des Champs-Elysées for another.
The witty images were, in fact, many things in one, photographs
and objects, illustrations and works of art. And since the current
demand was for an art both immediate and available, they became
part of the modern solution.

It was simply "the American painter Man Ray," however,
whose exhibition at the Librairie Six gallery was announced in the
Paris papers on 3 December 1921, just four months after his arrival
in Paris. One work, the collage *Trans atlantique* (fig. 109), was
probably completed in Paris, and *Isadora Duncan Nue*, dated 1922—a
fictitious work—may have been simply wishful anticipation on the
part of the catalogue's author, Tzara. For the most part, however,
the works listed in the catalogue had traveled with the artist from
New York, spanning the range of his early career and including
almost all of his aerographs.

Attempting to infuse new life into their splintering movement,
the dadaists treated the exhibition as an event, welcoming their
American comrade with rhetoric and demonstration. In his brief
text for the catalogue, Tzara hoped that the messenger from New
York could with his "love fingers"—referring to a painting entitled
Doigts d'amour—"tickle" the French artists into action. But far more

than the early paintings, whose titillation derived from provocative titles rather than subject matter or style, it was the execution of the paintings made with machinery that most captivated the new audience.

In New York aerography had liberated Man Ray from the conventional manner of painting pictures and the aesthetic pretenses that went with it. When his aerographs were exhibited in 1919 at the Daniel Gallery, the critics had accused him of destroying art with mechanical tools. In Paris it was precisely this point that was celebrated. While the dadaists had determined that "art for art's sake" was no longer possible, the group could not agree on the

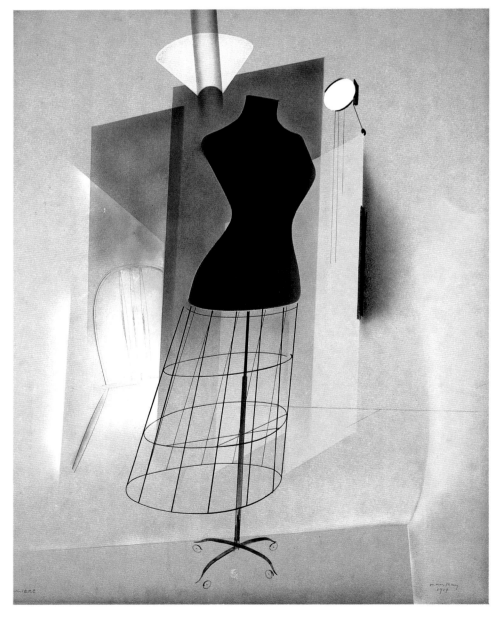

19 *La Volière* (*Aviary*), 1919, pencil and ink, air-brushed, The Roland Penrose Foundation, Chiddingly, East Sussex

alternatives. Man Ray's painting offered a solution: it was a visual translation of Breton's poetics as well as a vulgarization of traditional painting in keeping with Tzara's revolution. The only review of the Librairie Six exhibition to appear in the Paris papers succinctly, but energetically, forecast Man Ray's significance. "This," said the writer—who signed himself "Le Masque de verre"—"will be a real competition of dreams."[21]

In Paris Man Ray did, indeed, become a key player during a period of reconstruction. Breton, he later remembered, had once called him a "pre-surrealist," perhaps because his imagery had so anticipated the later movement.[22] Some works fitted the program exactly. First entitled *Aviary* in 1919 and *La Volière* in 1921, Man Ray's aerograph featured a drawing of a dressmaker's dummy in the middle of a spray-painted field (fig. 19). A picture of his New York studio—he had kept the manikin, he said, as a "companion"—the painting became in Paris a sign of the times. Slang for *brothel*, the French title expanded to include the larger definition of *le bordel*, which popularly referred to any confusing situation as well as a prostitute's place of employment. Equating painter and whore, studio and brothel, the aerograph implied artistic corruption, while its seductive technique—veils of paint seeming barely to touch the surface—revealed a tantalizing alternative to old methods.

"Abandon of the Safety Valve" was the message of another aerograph that used stenciled numbers and letters as well as the airbrush to suggest the superiority of mechanical means. Related in subject to earlier paintings and drawings that featured the dancing silhouette of the tightrope walker, *Admiration of the Orchestrelle for the Cinematograph* had an announcement that pointedly was more easily read from inside than outside the picture (fig. 20). In part mechanical drawing, in part an allusion to the sensation of a moving picture, the aerograph was above all else a manifesto. Conceived in New York, it was better appreciated, like Man Ray himself, in Paris.

Painting was not the only medium in which he faced the challenge. With no compressed-air machines available in France—and his own equipment left behind in New York—Man Ray resorted to the techniques of the darkroom to achieve his goals. His images would no longer be stenciled with paint but with light. Placing solid or translucent objects on sensitized paper, adjusting lights at various angles, moving objects and/or lights above and across the paper, and at times actually immersing objects in the developer during exposure, Man Ray achieved photographic images without using a camera.

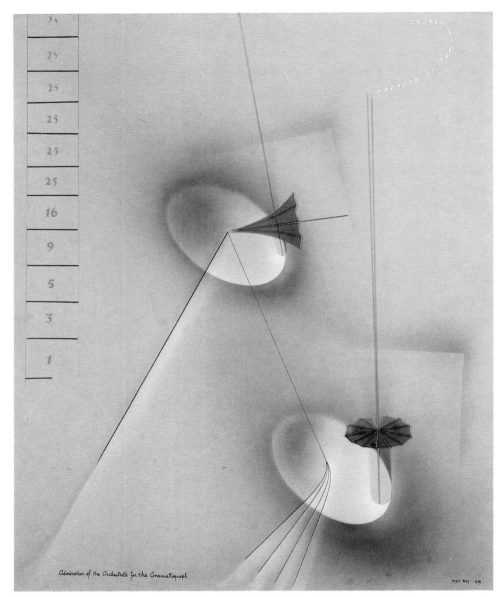

20 *Admiration of the Orchestrelle for the Cinematograph*, 1919, gouache, wash, and ink, airbrushed, The Museum of Modern Art, New York, Gift of A. Conger Goodyear

In fact, "photogenic drawing"—the nineteenth-century term for prints made by placing objects directly on light-sensitive paper—had been around since the invention of photography. In the context of twentieth-century visual experimentation and dada contradiction, however, photograms were heralded as a new art form.[23] In April 1922 Man Ray wrote to his skeptical and reluctant patron Ferdinand Howald, "In my new work I feel I have reached the climax of the things I have been searching the last ten years—I have never worked as I did this winter, I have freed myself from the sticky medium of paint, and am working directly with light itself. I have found a way of recording it. The subjects were never so near

to life itself as in my new work, and never so completely translated to the medium."[24] The idea, if not the solution, had been with him since New York. In his catalogue statement for the 1915 *Forum Exhibition of Modern American Painters*, he wrote: "The artist is concerned solely with linking . . . absolute qualities directly to wit, imagination and experience, without the go-between of a 'subject.' "[25] Rayography was photography liberated from the world of appearances, though not from the world of objects. While he had earlier simulated shapes and shadows with colored paper and paint, or appropriated found objects for constructions that served as photographic models, with rayographs his work was more literal. His choices were immediate and close at hand, personal items that, recalling his tiny 1914 painting, served as both subject and signature.

"Monsieur . . . , Inventeur, Constructeur, 6 Seconds" was the announcement that accompanied Man Ray's first published rayograph in the February–March 1923 issue of *Littérature* (fig. 21). Was it a portrait, the negative scratched to make two eyes, a long beak of nose, with a shadowy hand raised alongside as if in thoughtful contemplation of its viewer? Or a female figure, two breasts and an open bodice, the hand raised in salacious intent? The only thing certain is, it was meant to be ambiguous, amusing, and intriguing. Beneath the rayograph—created from a notched collar, folded paper, and the artist's own hand—was the caption, part title, part instruction manual for the manufacture of the strange image.

Man Ray's own account of his discovery of the rayograph process while developing fashion photographs for Paris designer Paul Poiret sounded like the common tale of an inventor: instinctive skill coupled with chance to produce something wholly new. After accidentally turning on the light in the darkroom, he "mechanically" placed objects directly on an extra piece of wetted paper in the developing tray: "I turned on the light: before my eyes an image began to form."[26] Like a machine himself, he had acted without thought. Impatient to make art quickly and without the interference of "glazing nature," he had happened upon a lucky and brilliant find.

Man Ray had experimented with photography while in New York with the same spontaneous approach. "I am trying to make my photography automatic," he had explained in a letter to Katherine Dreier, "to use my camera as I would a typewriter—in time I shall attain this."[27] "The man is a camera," was Tzara's ultimate conclusion. Writing in his preface "Photography in Reverse (Inside-Out)," for a collection of rayographs published in December 1922

21 *"Monsieur. . . , Inventeur, Constructeur, 6 Seconds,"* published in *Littérature*, 1 February–1 March 1923

29

under the title *Les Champs délicieux*, he claimed: "The photographer has invented a new method: he presents to space an image which surpasses it."[28] A reference to the collection of writings by Breton and Philippe Soupault, *Les Champs magnétiques* (1920), which attempted to bridge the distance between poetic thought and execution, Man Ray's photographic images of silhouettes and shadows were more concrete proof of the experiment's success.

"In six seconds," Man Ray had brought photography, and art, into the very realm that the poets were ardently exploring. In his 1924 *Manifesto of Surrealism*, Breton described the receptivity of a mind in a dreamlike state. As poet, he was more interested in the phrase that was "knocking on the window" of his consciousness. "[But] were I a painter," he continued,

> this visual depiction would doubtless have become more important for me than the other. . . . With a pencil and white sheet of paper to hand, I could easily trace their outlines. Here again it is not a matter of drawing, but simply of tracing. . . . Upon opening my eyes, I would get the very strong impression of something "never seen."[29]

In the somnolent red glow of his darkroom, not with pencil but with light, Man Ray achieved exactly that. Just as Breton and company would come to play surrealist games of automatic writing, or work the ouija board's planchette in search of subconscious messages, Man Ray moved his objects across the surface of the photographic paper for similar interpretations of reality.

Man Ray had done nothing less than rejuvenate visual art: "When all that one calls art was covered with rheumatism," said Tzara, "the photographer lit the millions of lights of his lamp, and the sensitive paper absorbed by degrees black cut up into some common objects . . . mechanical deformation, precise, unique, and correct, is set, softened, and filtered like a head of hair through a comb of light" (fig. 22).[30] Lacking the irreverent sarcasm of Picabia's art about machines, the rayographs were also unique in directing art away from the destructive egoism of dada. Although predominantly populated with equipment, springs, gears, or the hard natural shapes of crystals, the images frequently incorporated a face or a hand, even a familiar human activity (fig. 23). With American ingenuity, Man Ray had solved the modernist puzzle of how to create a machine-age art capable of sincerity.

It was Cocteau who dubbed the rayographs "paintings with

22 Untitled, 1923, rayo-
graph

23 Untitled, 1922, rayo-
graph

31

light."[31] To paint without using a brush was one thing, but to abandon paint and canvas entirely was a wholly modern program. It was a time when other artists were renouncing traditional methods and aesthetics. Satie and later the American George Antheil composed music that often resisted performance. "Everyone will tell you that I am not a musician," wrote Satie in his satirical *Memories of an Amnesic*. "It's true. Besides I get more pleasure from measuring a sound than I do from hearing it." The score of Satie's *Parade*, for example, included parts for whistles, ticker-tape machines, sirens, airplane propellers, and typewriters. Antheil's piano produced a hammered music that audiences would rather read than hear—or perhaps "see," as when he invited Man Ray to make a film to accompany one of his operas. Although none used paint or brush, Georges Ribemont-Dessaignes dubbed Man Ray, along with Hans Arp with his woodcuts and reliefs and Max Ernst with his collages, dada painters. "It was no longer," he said, "a question of preserving images in a box."[32] James Joyce abandoned traditional narrative and readability for the power of words themselves, creating in *Ulysses* and *Finnegan's Wake* a reverberation of language that more closely paralleled the process of thought.

Man Ray's contribution, thus, was painting with a machine, then making photographs without a camera, thereby transforming photographic objectivity into mystery. Much later, in answer to his critics, he quoted Satie almost verbatim: "Everyone will tell you I am not a photographer. . . . It's true. . . . My works are pure metrophotography."[33]

Despite their appreciation by the dadaists, however, the rayographs were hardly a "phenomenon" in America, where art for its own sake was too dearly won to be a target for demolition. Only the fashionable *Vanity Fair*, which had no stake in high art, enthusiastically featured "Experiments in Abstract Form, Made without a Camera Lens, by Man Ray, the American Painter," along with a quote from the stylish Cocteau, who claimed Man Ray had "come to set painting free again."[34] The explanation offered in a *New York Times* article of 1924 was much less than magical, even if it did bring Man Ray back to his roots as an architectural apprentice: "Popularly, perhaps [rayographs] seem to borrow from the commercial blue-printing process."[35] If Man Ray and the dadaists thought that he had found an innovative link between photography and painting, his American audience was less certain.

"Can a photograph have the significance of art?" was still the question in 1922, as it had been in 1915. Invited to respond in the December issue of *MSS* was a wide range of American experts,

including Thomas Hart Benton, Charles Chaplin, Carl Sandburg, and Charles Sheeler. Although others wrote from abroad, Man Ray was not invited. Almost all seemed to agree that it was or could be art—though Joseph Pennell adamantly declared that it was not, and Benton preferred to think of photography strictly allied to science. Even so, photography was generally considered inseparable from its mechanics. Many mentioned Stieglitz as the medium's major practitioner, and others cited Paul Strand and Edward Steichen. Only Georgia O'Keeffe seemed to point to the fact that the best photographers were those who did not separate photography from other media. And it was she who mentioned Man Ray as "a young painter of ultra modern tendencies and of varied experiments . . . [who] seems to be broadening the field of work." To De Zayas writing from Paris, however, Man Ray enjoyed a "false success" among the intellectuals. Although he claimed to be waiting for a photography that would "represent the object without the interference of man," De Zayas preferred to look for its appearance in young, industrial America. The rayographs, now part of a European program, did not interest him.[36]

Thus were the lines of Man Ray's dilemma drawn. An American in Paris, a painter without paint, he achieved recognition in Europe that was denied him at home. But in Paris Man Ray did not abandon the "sticky medium" of paint altogether. Following the lead of hundreds of other American artists, he had gone to Paris to paint, and his early scenes were rendered in a thick, palette-knife style. Although reflecting the more archaic style of impastoed impressionism, these works nonetheless concerned themselves with the effects of light (fig. 140). Other paintings had a strong pictorial connection to photography. In silver and black, paintings of Duchamp and Man Ray's lover, Kiki (fig. 24), are related to photographic portraits. Larger than any blowup he could have created with his darkroom enlarger, their scale makes them fitting tributes to two such important influences. "Neither a painting nor a photograph," was Man Ray's assessment of these works. Pleased with the confusion, he decided that "this should be the direction [his] future painting would take."[37] Late twenties paintings on gold and silver panels also suggested the tonalities of photographs. If their content related to such stylish subjects as Riviera patrons, their technique—drawing with paint applied directly from the tube to create outlines of people and things—derived from the spontaneous process of rayography.

In general, photography freed Man Ray to function on both sides of the barricade separating conventional expression from the

24 *Kiki*, 1923, oil on canvas, private collection, Princeton, New Jersey

imperatives of the avant-garde. Often reproduced in avant-garde journals such as *La Révolution surréaliste*, his images became provocative through the context of their reproduction rather than their style. Not by chance the first use of photographic illustration in the new series of Breton's *Littérature* coincided with Man Ray's arrival in France. Like his aerograph paintings, which had not achieved recognition before their debut in Paris, many of these photographs had been made in New York years before. Retitled and redated—

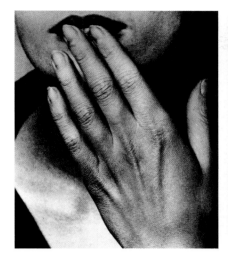
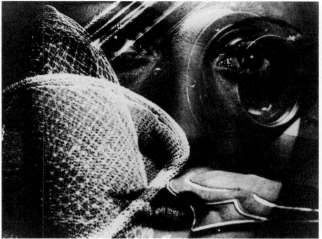
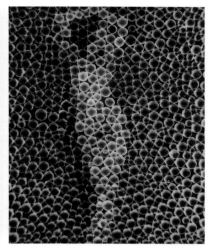

his 1918 photograph of dust on Duchamp's *Large Glass* became *Vue prise en aéroplane*, 1921, for example, when it was published in *Littérature* in October 1922—the images assumed new meaning as complements to the surrealist texts.

Beyond the making of art, the camera was also Man Ray's entrée into social as well as artistic circles. Unofficially, he was photographer-of-record for gatherings, parties, and informal meetings in the studio. In terms of commercial portraits and fashion photography, the camera was also his livelihood. As far as Man Ray was concerned, photography was capable of everything.

Part art, part illustration, *Photographs by Man Ray 1920 Paris 1934* was meant to be an inventory of his work, a kind of grand promotional catalogue. With 105 photographs, a cover in glossy color, a portrait of Man Ray by Picasso for the frontispiece, and short texts in English and French by Man Ray, Eluard, Breton, Tzara, and Duchamp, Man Ray's album was a virtuoso presentation of modern European-style photography. Close-up views, distorted angles, double exposures, night photography, negative prints, rayographs, still lifes, nudes, portraits, fashion photographs, and even a painting—the silvery *Gens du monde*—were reproduced. A variety of textures and surfaces were demonstrated by both the photographs and the rayographs, and there were numerous "solarized" prints, with faces and forms outlined in dark, ethereal elegance (figs. 25–27).

Calculated by Man Ray as a bridge between photography, art, and fashion, the album was greeted in the United States with questions. Less than congratulatory, Lewis Mumford reviewed the book for *The New Yorker* saying, "Man Ray has done almost everything with a camera except use it to take photographs. . . .

25 Untitled, ca. 1929, silver print

26 Untitled, ca. 1927, silver print

27 *Reflections*, 1932, silver print

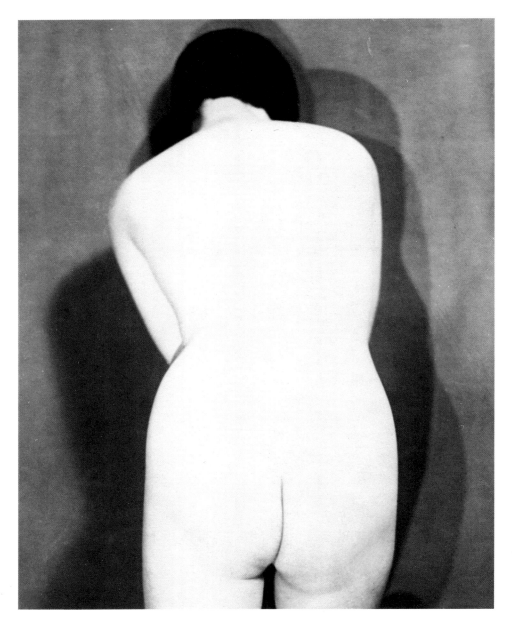

28 *Le Dos blanc*, 1927, silver
 print

29 *Nude*, ca. 1929, solarized
 silver print

[He] can make a photograph look like a water color [fig. 28] . . . or
a crayon drawing [fig. 29] . . . or a charcoal drawing; he can even
produce the brush effects of an oil painting." Instead of admiring
the artist's virtuosity, however, Mumford accused Man Ray of
trickery—a deceit all the more devious because "in some of his
male portraits he shows honest gifts as a photographer." "A pho-
tographer who can deal intelligently with the human face," he
declared, "should not waste his time photographing calla lilies so
that they will look like a drawing by a second-rate academician."[38]
 Mumford was angry: as an artist, Man Ray could not be

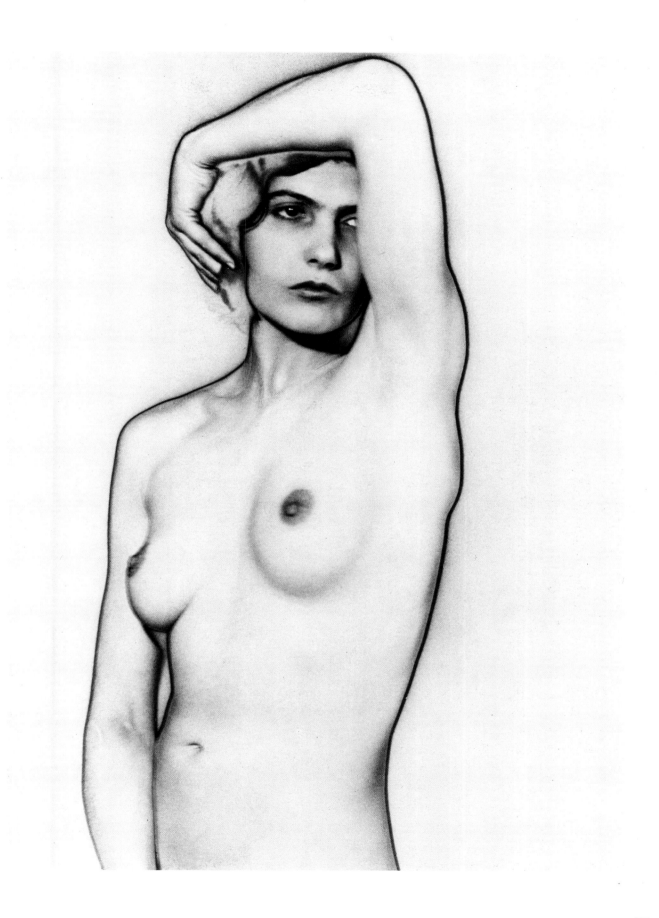

trusted. But Mumford, and perhaps all of America, had missed the point. For the better part of his career, Man Ray had dedicated himself to obscuring the boundaries between media, smudging the distinction between high and low art. In Paris, his first photographs of model Kiki had pleased him because "They really looked like studies for paintings, or might even be mistaken at a casual glance for reproductions of academic paintings." He had been satisfied, too, when his aerographs were mistaken for photographs, because "in the true Dada spirit" he had completed the cycle of confusion. To accusations that he had confounded pure photography with painting, as the pictorialists had done, he answered that it was "perfectly normal that one should influence the other."[39]

Man Ray, no doubt, had guessed that America would miss the point. In his aptly titled preface to the album, "The Age of Light," he stated,

> Each one of us, in his timidity, has a limit beyond which he is outraged. It is inevitable that he who by concentrated application has extended this limit for himself, should arouse the resentment of those who have accepted conventions which, since accepted by all, require no initiative of application. And this resentment generally takes the form of meaningless laughter or of criticism, if not of persecution. But this apparent violation is preferable to the monstrous habits condoned by etiquette and estheticism.[40]

Writing to Man Ray from her rue Bonaparte apartment, after he had undoubtedly called to complain about his bad review, Janet Flanner assured her old friend that Mumford

> doubtless cannot understand the deliberate sense of redistribution of life, objects, associations, emotions, arts . . . which some people *are* feeling now. Because there has been blague-ing and épater-ing the bourgeois in the past, many American citizens are suspicious now . . . of anything that doesn't look real, natural and if possible all right for little Mable, aged 8, to drink deep of. Because Americans . . . made money . . . out of the new world of mechanics that developed so passionately this century, they are still amazed to find that mechanics (as a mystic, almost) went somewhere else beside into their pocket, their factory or their superb new inventions for sterner steel. And that the other side of art—i.e. new perception,

of old materials which we secretly carry inside us, . . . that this other side of art, like the behind-side of the canvas is a state of consciousness (coming from unconsciousness) on the artists' part and not just the funnyness of Bohemianism visible on the front side of the canvas. THAT, my friend, they get mad as hops when they are told. And you told them and showed them in your Album, so they, he, Mr. M, is mad at YOU.[41]

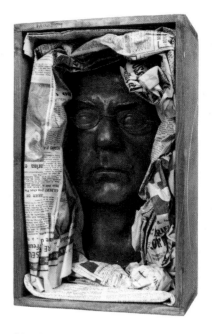

30 *Auto Portrait*, 1933, bronze, glass, and wood, National Museum of American Art, Smithsonian Institution, Washington, D.C., Gift of Juliet Man Ray

In a sense, Man Ray falls into a whole category of American tinkers who looked beyond practical applications and profits and instead found something visionary. Having accepted the challenge to discover a new art, Man Ray, "Monsieur Inventeur, Constructeur" had produced images that defied the categories that even modern critics struggled to define and maintain. Man Ray adopted a broader definition for his art. In another sense, though, Man Ray was part of a pragmatic, American tradition in that he used whatever was available—everyday materials from a hardware store or his studio workbench—to construct works that were both personal and independent.

Just such a picture graced the cover of his 1934 album. Assembled—like the pieces of a rayograph—from things and models near at hand, the image included the artist himself in the form of a plaster bust (fig. 186). Made in anticipation of the illustration, the bust had also been the inspiration for another object. His self-portrait of 1933 consisted of a bronze cast of the bust, which he fitted with a pair of his own spectacles and placed in a wooden box (fig. 30; also frontispiece). Just like any paper-stuffed shipping crate, the "package" of Man Ray was packed and ready for delivery. A reference to the death masks made of prominent figures, here surrounded by the ephemera of everyday news, the object is both a witty and profound statement on the artist's "entombment" in his work. As with the album, it was a passage home.

Intended for an American more than a European audience, the album was Man Ray's means of presenting his career to a homeland that had rarely seen his work. The history of modernism was being shaped, and, as the Museum of Modern Art opened its doors in 1929 and the Whitney Museum of American Art arranged its first biennial exhibition of contemporary art in 1932, it became clear that the records were being kept in New York, not Paris. Man Ray wanted to be counted. Aside from a showing of his work at the Daniel Gallery in 1927, and an oddly balanced one-man exhibition at the Chicago Arts Club in 1929, few American exhibitions had

included Man Ray's work during the twenties. Admittedly, he had sent little of it home from Paris. But the onset of the Depression had slackened the communication between the Old World and the New. Many of the small magazines, such as Jane Heap's and Margaret Anderson's *Little Review*, which had kept the dialogue going with illustrations, reviews, and opinions, were forced to disband. With only the fashion magazines to count on for publication, Man Ray was suddenly forced to represent himself. "Who is Man Ray?" became an increasingly difficult question to answer.

Larger by far than the 1935 surrealist exhibition in London, *Fantastic Art, Dada, Surrealism*, which opened the following year in New York, should have been Man Ray's most impressive homecoming. In an exhibition of almost 700 objects by more than 150 artists—including not only the dadaists and surrealists but also Leonardo da Vinci and Walt Disney—Man Ray's contribution was almost a small retrospective, from aerographs to objects, rayographs, and *A l'heure de l'observatoire—Les Amoureux* (fig. 221).

Besides his contribution as an artist, Man Ray lent a number of works by others to the exhibition, including Magritte's singular *Eye*, a painting that was highlighted in most of the newspaper cartoons spawned by the exhibit, as well as works by Duchamp and Jacqueline Breton. Although not the owner, he arranged the loan of Meret Oppenheim's controversial fur-covered bowl, plate, and spoon. And he acted as liaison between the museum and the European artists. When Breton and Eluard insisted that the exhibition be a surrealist manifestation of political proportions, the frustrated curator, Alfred Barr, wrote to Man Ray in Paris, suggesting he explain to his colleagues that America was different.[42]

Unfortunately, there was no going home again. While the exhibition received months of sensational press, most of it was negative. America was not prepared to accept an exhibition that broke every rule of stylistic categorization. Intriguing yes, serious no. Not surprisingly, the exhibit received its most positive coverage in the fashion magazines. *Harper's Bazaar*, in particular, scrutinized the new visual stimuli for fashion potential, while department stores offered their windows to "surrealist" displays.

Every issue *but* art seemed to have been addressed. When the exhibition was denounced by a committee of five artists—the so-called Defenders of Democracy—as further evidence of the "crafty, indirect methods of the international communists," Man Ray, as the American representative for the show, was called on to respond. "President Roosevelt and surrealism have much in common," he told the *New York Herald Tribune*,

both have been called communist for attempting something new . . . what's wrong with fur on cups . . . what difference is there between putting furs on inanimate objects or on women? They serve the same purpose, for women don't wear furs to keep warm but for display. . . . Putting fur on different kinds of objects may be new, but how was the first pair of wings received by contemporaries when they were painted on the backs of men?[43]

Even under attack, Man Ray was practical and matter-of-fact as always.

Something new. It was Man Ray's own credo. What then was his audience to think of the thirty-six drawings shown at the Valentine Gallery simultaneously with the Modern exhibition? On the one hand derided by McBride for their "artiness," the works were also chided for "abandoning the realms of pure folly" for a demonstration of old-fashioned draftsmanship, "a thing," said the critic, "that all those who can do it like to prove, from Matisse on down the line." Man Ray responded to McBride almost immediately:

> You say that you will not tell André Breton about the
> things of artisticness that got into them [the drawings],
> but Breton has already seen them and approves all the
> contradictions that occur in the drawings, because I could
> not and did not wish to help my self. They are the sum of
> all my experiences in photography as well as painting. Put
> to the service of my experiences of 1936.[44]

Man Ray had spent the summer of 1936 in the south of France, in Mougins above Antibes, with his lover Adrienne, Picasso, Dora Maar, Paul and Nusch Eluard, Roland Penrose, and Lee Miller. By the mid thirties Man Ray was frequently solicited by advertising agencies and fashion magazines for his photography. On assignment he traveled throughout Europe making portraits of eminent doctors and scientists that were used to advertise American products. "Drawing and painting . . . ," he said, "were a relief from my photography."[45] Probably he found himself inspired by the presence of Picasso, who in Man Ray's admiring words could "draw beautifully with a single line." However, it may have been an even trade, for Picasso spent the summer entranced in the darkroom making rayographic "shadow prints."[46] If the south of France offered him a respite from a hectic schedule of magazine

assignments, he could also share the stimulating association of a multitalented company:

> But we worked, too. In the evening Eluard read us his latest poem, Picasso showed us his starry-eyed portrait of Dora, while I was engaged in a series of literal and extravagant drawings, to appear later in a book illustrated with the poems of Paul Eluard—*Les Mains Libres*.[47]

In all, sixty-six drawings were published in Paris in 1937.

The linear drawings of figures, landscapes, and portraits were "literal" because they were photographic. For the most part, the works called on an imaginative iconography well established by earlier photographs. Some matched their photographic precursors exactly. Others were appropriations of fashion photographs or the poses of models. Describing the inspiration for *Le Château d'If* (fig. 31), Man Ray recalled that on returning to his hotel from a visit to a nearby castle, he found his laundry delivered, with "a picture of this man on the laundry wrapping."[48] Along with his photograph of turreted battlements, he used the wrapper image to concoct a picture of both antique and contemporary Riviera divertissement.

Likenesses of fellow Mougins sojourners—in *Mains libres* they are grouped under the title "Portraits"—with minor additions are very much after earlier photographs. The arresting stare of the eye,

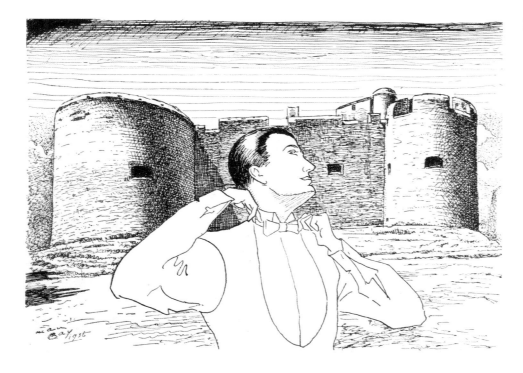

31 *Le Château d'If*, 1936, ink on paper, published in *Les Mains libres*, 1937

42

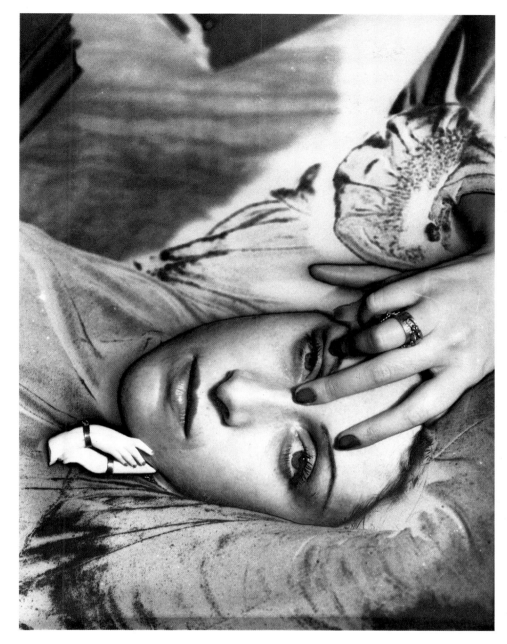

32 *Dora Maar*, 1936, solarized silver print

33 *L'Evidence*, 1936, ink on paper, present whereabouts unknown

sculptural arch of an eyebrow, and distinctive mouth in Man Ray's portrait of Dora Maar were all vertically aligned in the drawing *L'Evidence* for an equally "starry" likeness (figs. 32, 33). Even the title drawing, seemingly an abstract arrangement of haphazard lines and staccato dashes, was connected to an earlier photograph, *Space Writings*, an image Man Ray had framed by moving a light source in front of an open-shuttered camera (fig. 270).

Man Ray did not need to trace his photographs to draw. After all, he had begun his career as a draftsman. Certainly Picabia hadn't

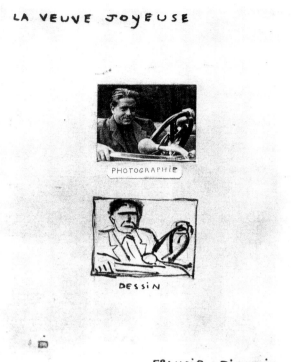

LA VEUVE JOYEUSE

PHOTOGRAPHIE

DESSIN

FRANCIS PICABIA

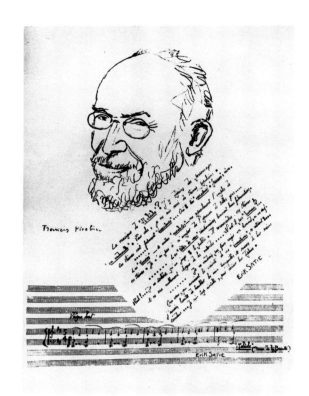

needed the photograph of himself by Man Ray to make his drawing for *La Veuve joyeuse* in 1921 (fig. 34). Although he attached the twin images to canvas—one labeled "photographie," the other "dessin" to make no mistake—Picabia's intention was far from painterly. Nor had he chosen to trace Man Ray's 1922 photograph of Erik Satie for the 1924 program of his ballet *Relâche* for reasons of technique (figs. 35, 86). Like the nonmusical ballet, whose title means "no performance," it was not the photograph, the drawing, or their creators that were important, but the subversion of a traditional system of rendering. It meant, too, that boundaries between media were blurred. Used for new purposes, or recombined, each tool and method of the artist was available to accomplish the ideas of a new age.[49]

Far from the "artiness" McBride had suggested, the 1930s drawings continued a unique technological genre that Man Ray had pursued throughout his career. Paintings that were not painted, photographs made without a camera, drawings that were traced from photographs, or drawn with "light"—Man Ray's subversion of traditional art making knew no bounds. Beyond the manipulation of media for its own sake, Man Ray had demonstrated a facility to express a whole new method of aesthetics for a century invested in art's inventiveness. If the once rebellious Man Ray now

34 Francis Picabia, *La Veuve joyeuse* (*The Merry Widow*), 1921, oil, paper, and photograph on canvas, Collection Michel Pèrinet, Paris

35 Page from the program of *Relâche* with Picabia's *Portrait of Satie* (after Man Ray photograph), 1924, The Dance Museum, Stockholm

drew, as Paul Eluard wrote in his preface to the Valentine Gallery exhibition catalogue, "to be loved," it was to prove the adaptability of his revolution.

The transatlantic nature of Man Ray's career continually demanded that he develop an art able to translate over distance and time. A chronic outsider—whether as American in Paris or returned expatriate in Hollywood—he survived the fluctuations of style and fashion by enforcing that role. His art, he vowed, could be appreciated only by those capable of enjoying its contradictory motive. Almost forty years after his opening at the Librairie Six, Man Ray was part of another dada exhibition in Paris. Outraged that a once revolutionary movement had become a gallery commodity, student artists and writers—called Les J'Arrivistes ("the pushers")—stormed the exhibit, singling out Man Ray's works in particular for attack. A replica of his 1923 *Object to Be Destroyed* was hammered into pieces, and the 1917 assemblage *Boardwalk* was carried out into the street and shot with a gun (fig. 36). In the ensuing trial, the

36 *Boardwalk*, 1917, shot with bullets, after the demonstration against dada at the Left Bank Gallery, Paris, 1958

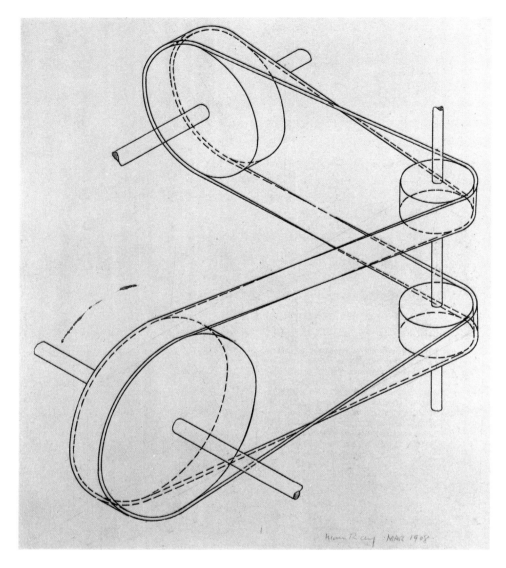

37 Untitled, 1908, pen and
ink, The Museum of
Modern Art, New York,
Gift of Mrs. Sylvia Pizitz

students were defended by no less a rhetorical champion than Albert Camus, and victim Man Ray acknowledged the suitability of their actions.

Thus, the avant-garde moved yet one generation further into the twentieth century. In fact, the J'Arrivistes' rebellious ancestor poet, Alfred Jarry—appreciated by both the dadaists for his anarchy and the surrealists for his visionary art—was a uniting thread, connected to a whole sequence of the century's events. Jarry, who made a career out of absurdist pretense, turned his temperamental oddities into characters such as Père Ubu, whose vulgarity and success mirrored, and at the same time mocked, the turbulent era at the turn of the century. Simultaneously confounding and stimulating, his science of "Pataphysics" linked opposites while it pro-

pounded "imaginary solutions." Like Man Ray's, Jarry's methods were systematic, his approach practical.

Distinctive, innovative, and often problematic, in the very mutability of his art Man Ray carried on the mission of the avant-garde. Beyond the technical switch between media, Man Ray was aiming not merely at the limit, but beyond the limit of an individual's conceptual powers, and this without abandoning reason. Like a time machine, his art carried his ideas forward. Having subverted artistic permanence by making his first metronome destructible, he made other versions as necessary, renaming the machine several times to suit different situations. *Last Object*, titled in 1966, was a premature conclusion. Announcing power rather than passivity, *Object of Destruction* marked the end of a love affair as it ushered in the difficult European thirties; *Lost Object*, made during his hiatus in Hollywood during the war, described the imperiled situation for most of his art left behind in Paris and his own isolation in a country that seemed not to know him. After the student uprising in 1958, he remade the object and entitled it *Indestructible Object*, with the thought that the assemblage was merely the casing for the idea—more could be made as necessary. It's first presentation in 1923 as *Object to Be Destroyed* was the dare of a brash, young American artist. Just as his early perspectival drawing of continuous motion had been an announcement of his career's intent (fig. 37), his 1970s title was more of a summation than a comment. Still the same object—metronome with ticking eye—*Perpetual Motif* (fig. 1) was now the final vehicle for an artist determined to be remembered for an art of discovery.

NOTES

1. McBride, "Farewell to Art's Greatness."

2. Ibid.

3. Man Ray, *Self Portrait*, p. 10.

4. Elizabeth Turner, "Who Is in the Brothel at Avignon? A Case for Context," *Artibus et Histoire*, n. 9 (1984): 139–57.

5. Guillaume Apollinaire, "Letter," *Mercure de France*, 1 April 1913, n.p.; English translation in *A Whitman Controversy*, introduction by Henry S. Saunders (Toronto: H. S. Saunders, 1921). For a full discussion of this event, see Turner, "The American Artistic Migration to Paris between the Great War and the Great Depression," pp. 72–73.

6. For a full discussion of Man Ray's anarchistic activities, see Naumann, "Man Ray and the Ferrer Center."

7. Quotations from Man Ray, *Self Portrait*, p. 18; and Paul Hill and Tom Cooper, "Man Ray Interview" (manuscript, Collection Juliet Man Ray), p. 3.

8. Quotations from Man Ray, *Self Portrait*, pp. 19–20. No portrait of Man Ray by Stieglitz has been found.

9. De Zayas, "Photography," *Camera Work*, no. 41 (1913): 17–20; reprinted in *Camera Work: A Critical Anthology*, edited with an introduction by Jonathan Green (New York: Aperture, 1973).

10. De Zayas quoted in "French Artists Spur on an American Art," *New York Tribune*, 24 October 1915, sec. 4, p. 2.

11. Man Ray, *A Primer of the New Art of Two Dimensions*, n.p.

12. Hill and Cooper, "Man Ray Interview," p. 1.

13. Ibid.

14. Man Ray, *Self Portrait*, p. 98.

15. Ibid., p. 73.

16. Ibid., p. 82.

17. The comment on photography's relationship to painting and sculpture was made by Paul Delaroche (1797–1856). Delaroche, a French painter of historical subjects, was chairman of a committee set up by the French Academy in 1839 to investigate the inventions of Louis Daguerre.

18. The photograph may also have been a pointed comment to Dreier, who had no compunction asking Man Ray to contribute his photographic services to the Société, while at the same time admonishing him to be more serious about his art. Her admiration for Stella and Duchamp, while relegating Man Ray to a "workhorse" status, would explain his subtle self-reference. The "flower-girl" print may have been yet another comment on her ability to appreciate modern art.

19. The inscription reads "Vive Papa/Francis/Le Raté" ("Long live Papa Francis, the washout"). While it is possible that Man Ray photographed Picabia in New York, no original print of this portrait has been found.

20. Tzara had originally sent Duchamp mock authorization for publication of a dada magazine in New York. Man Ray assisted, obtaining contributions, mostly unsigned, from Marsden Hartley, Stieglitz, and several others.

21. "Le Masque de Verre" [pseud.], "Les Echos."

22. Man Ray, *Self Portrait*, p. 264.

23. Besides Man Ray, other artists were experimenting with making images using light-sensitive paper. Schadographs—so christened by Tristan Tzara—were produced by German artist Christian Schad as early as 1918. Also active in Germany were Lucia Moholy and László Moholy-Nagy, both of whose works Tzara was well acquainted with.

24. Man Ray to Ferdinand Howald, 5 April 1922, Ferdinand Howald Collection.

25. *The Forum Exhibition of Modern American Painters* (New York: Anderson Galleries, 1916), n.p.

26. Man Ray, *Self Portrait*, p. 129.

27. Man Ray to Katherine Dreier, 20 February 1921, Katherine Dreier·Archives, Beinecke Rare Book and Manuscript Library, Yale University Library.

28. Tzara, "Photographie en revers," in Man Ray, *Les Champs délicieux*, n.p.

29. Breton, "First Surrealist Manifesto," p. 21.

30. Tzara, "Photographie en revers," in Man Ray, *Les Champs délicieux*, n.p.

31. Cocteau, "Lettre ouverte à Man Ray, photographe américain," n.p.

32. Ribemont-Dessaignes, "Dada Painting or the Oil-Eye," p. 11.

33. Man Ray, "What I Am." The text is the same as Satie's; only the words "mu-

sic" and "musician" have been changed to "photography" and "photographer." See Satie, "Memories of an Amnesic"; reprinted in *The Dada Painters and Poets: An Anthology*, ed. Robert Motherwell (Boston: G. K. Hall, 1981), pp. 17–19.

34. Cocteau quoted in "A New Method of Realizing the Artistic Possibilities of Photography," *Vanity Fair*, November 1922, p. 50.

35. "New Photography Employs No Lens." Curiously, this article announces the work of "Man Ray, Rumanian (modern) and traveler in fantasia" and his arrival the next month. Man Ray did not return to New York until 1927, and the writer may have been confusing him with the other major practitioner of cameraless photography, Moholy-Nagy.

36. De Zayas quoted in "Can a Photograph Have the Significance of Art?" pp. 17–18.

37. Man Ray, *Self Portrait*, p. 233.

38. Mumford, "The Art Gallery: Critics and Cameras," pp. 34–35.

39. Man Ray, *Self Portrait*, p. 145.

40. Man Ray, *Photographs by Man Ray 1920 Paris 1934*, n.p. Coincidentally, that same year *America and Alfred Stieglitz: A Collective Portrait* appeared (Lewis Mumford, Dorothy Norman, Waldo Frank, Paul Rosenfeld, and Harold Rugg, eds. [Garden City, N.Y.: Doubleday, Doran, 1934]). It was a large illustrated book with essays by friends and colleagues of Stieglitz, who lauded his work. Curiously, reviewers found the book out of step, one writing that "what we took for wisdom in 1905 sounded flat in 1935" (E. M. Benson, "Alfred Stieglitz: The Man and the Book," *American Magazine of Art* 28, no. 1 [January 1935]: 36–42).

41. Janet Flanner to Man Ray, 29 September 1934, Collection Juliet Man Ray.

42. Barr to Man Ray, 6 August 1936, Collection Juliet Man Ray.

43. "Man Ray Finds Surrealism in Roosevelt Boat."

44. McBride, "Farewell to Art's Greatness"; Man Ray's response in his letter to McBride, 30 January 1937, Henry McBride Papers.

45. Man Ray, *Self Portrait*, p. 227.

46. William Rubin, ed., *Pablo Picasso, A Retrospective* (New York: Museum of Modern Art, 1980), p. 308.

47. Man Ray, *Self Portrait*, p. 227.

48. Quoted in Padgett, "Artist Accompanies Himself with His Rays," pp. 79–80.

49. With Picabia and Jean Borlin of the Swedish Ballet, Satie composed a ballet that opened with a prelude based on a scandalous old student song, "The Turnip Vendor." A film by René Clair was included, and the finale consisted of Satie taking to the stage in a midget, five-horsepower Citroen. "It amounts," said Picabia, "to a lot of kicks in a lot of rears, sacred and otherwise." For a full critique of this composition and Satie's career, see Roger Shattuck, "Scandal, Boredom, and Closet Music," *The Banquet Years* (New York: Vintage Books, 1968), pp. 145–85.

CHAPTER ONE

MAN RAY, 1908–1921: FROM AN ART IN TWO DIMENSIONS TO THE HIGHER DIMENSION OF IDEAS

Francis Naumann

Man Ray made his first picture at the age of seven. With a box of crayons given to him by a cousin as a birthday gift, the young artist freely colored a drawing he had made of the *Maine*, the famous American battleship that was sunk in Havana Harbor in February of 1898. The drawing was based on a black-and-white reproduction of the vessel that appeared in one of the local newspapers. When the picture was completed, Man Ray's family and friends quickly praised the drawing for its accuracy and detail, but criticism was immediately directed at the young artist's arbitrary application of color, which he had selected at random from the full spectral range available in his box of crayons. Whereas the seven-year-old Man Ray may have lacked the facility to defend himself properly, the mature artist, when composing the text of his autobiography some sixty-five years later, was able to provide this logical explanation: "I felt that since the original pictures were in black, I was perfectly free to use my imagination."[1]

In retrospect, much can be made of the precociousness of this event. Man Ray's lifelong dedication to art and his penchant for

Painting, 1918 (reworked 1924). See fig. 68.

bright colors are clearly suggested by the incident; but more important, it provides an early indication of the artist's innate sense of defiance, directed—as it was—at both parental authority and artistic convention. Throughout his life, Man Ray would instinctively question the traditional notions of art, continuously seeking alternatives to accepted practices, and he would rarely allow the criticism of others to interfere with his creative efforts. At a very early age, he adopted a guiding principle that was to serve him well during the course of a long and unconventional artistic career. "I shall from now on," he declared, "do the things I am not supposed to do."[2]

Man Ray was born to Russian-Jewish parents in Philadelphia on 27 August 1890. On his birth certificate the artist's first name is given as 'Michael,' but his name was actually "Emmanuel," and close friends and relatives called him "Manny." There is also some mystery concerning his original last name; the family did not adopt "Ray" until 1911 or 1912. Man Ray made a concerted effort to keep the original name secret to avoid classification as an artist with an ethnic identity—the type of pigeonholing he abhorred.[3]

He was the first-born in a family of four, sharing a relatively strict upbringing with a brother and two sisters. His father worked at home as a tailor, while his mother usually occupied herself with domestic chores around the house. Dorothy, the youngest sister, recalled that their home was continuously cluttered with remnants from their father's profession: cloth samples and scraps of material, which their mother often stitched together to make carriage blankets and quilts. The children were also involved in the making of these items; while very young, they were taught to piece together material, sew, and embroider.[4] This domestic experience appears to have had a lasting effect on young Emmanuel, for he later employed a number of these same techniques in his paintings and collages.

In 1897 Man Ray's family moved to Brooklyn, where Emmanuel was forced to pursue his artistic inclinations in secrecy, as the life of an artist was not exactly the ideal career envisioned by his parents. In high school, however, he was able to take courses in art and mechanical drawing, acquiring at an early age the skills that would serve him well in years to come. He excelled in the mechanical drawing class, in particular, and remembered having admired the teacher for his ability to combine "everything that was practical with a wonderful sense of the graphic."[5] The early work that perhaps most harbors the essential characteristics of Man Ray's mature artistic creations is a group of drawings entitled *Triangles*

38 *Triangles*, 1908, pencil and watercolor on paper, Collection Juliet Man Ray, Paris

(fig. 38), six mechanical images of draftsman's triangles, each of which is rendered as if in suspension and casting a shadow against either curved or angular surfaces. The artist kept this series of small drawings in his possession throughout his life and, as we shall see, relied heavily on their imagery and procedural method for a number of subsequent works.

Upon graduation from high school, Emmanuel was awarded a scholarship in architecture. Against his parents' better wishes, though, he declined the opportunity for advanced formal education and decided instead to become an artist. He tried his hand at painting portraits and landscapes, but he admitted years later that these early works failed to communicate what he wanted to express. It was not entirely the intention of improving the technical quality of his work, however, that led him to enroll in life-drawing classes at the National Academy of Design and the Art Students League in New York. "I wanted to see a nude woman," he later confessed. If he was able to satisfy certain sexual curiosities, however, the young artist was quickly disillusioned by the regimen at these academic institutions. He found the time-consuming, laborious methods they demanded simply exhausting. Eventually, his teachers noticed their student's lack of patience and advised him to consider dropping their courses and begin working independently.[6]

It was at this point that the young artist—who by now had shortened his name to Man Ray—enrolled at the Ferrer Center, a progressive educational institution, located on East 107th Street in Harlem, which also happened to be the leading anarchist center in New York City.[7] It was here that Man Ray's disdain for conventional artistic practice was first allowed to express itself without restraint. In life-drawing classes at the Ferrer Center—which were taught by the American painters Robert Henri and George Bellows—students were not required to follow the slow and methodical techniques stipulated by the academies, but rather were encouraged to work quickly and spontaneously. Instead of modeling a figure for hours or even days, students were often required to complete their sketches within the twenty-minute period of a pose. As a result, their work exhibited a greater freedom and expressiveness (fig. 39), reflecting—in visual terms—the radical convictions of their teachers. Although Man Ray made relatively few works during these years that could be said to have been directly inspired by the tenets of anarchism, there can be little doubt that his early exposure to libertarian ideals prepared him for a more radical, unconventional approach to the art-making process.

Man Ray's enrollment at the Ferrer Center coincided with his

39 Untitled, 1912, ink wash on paper (inscribed on verso: "twenty minute sketch, Ferrer Center, 1912"), Collection Juliet Man Ray, Paris

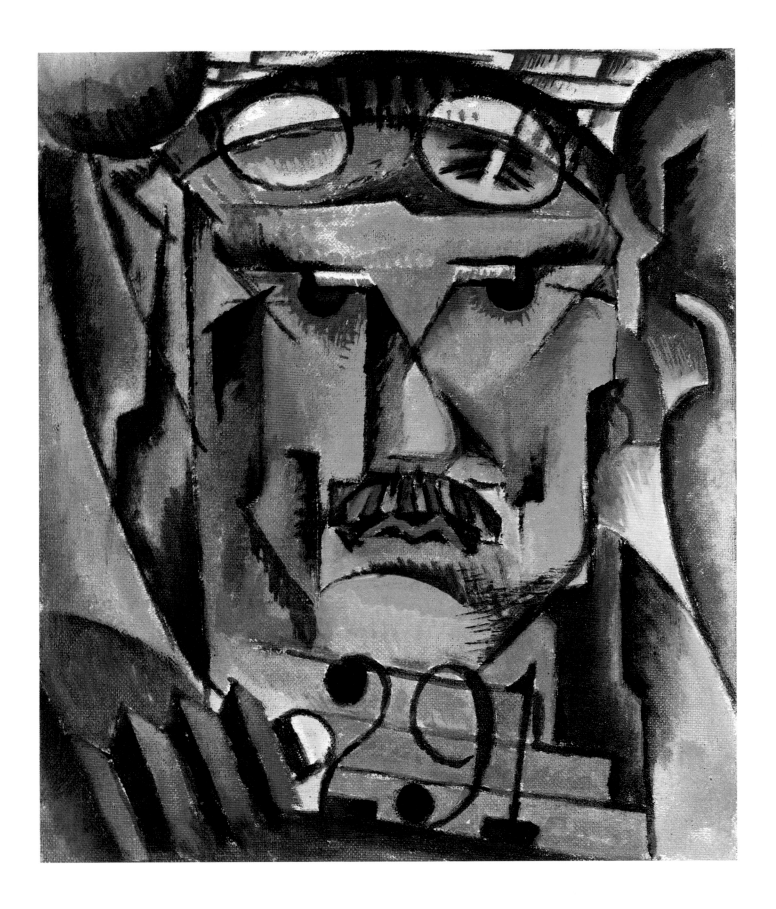

54

earliest exposure to modern art. At that time he worked as a calligrapher and layout artist for a large publishing company in Manhattan, and on his lunch hours he frequently rushed over to Alfred Stieglitz's Gallery 291, where he saw drawings and watercolors by Rodin (1910), watercolors by Cézanne (1911), sculpture by Brancusi (1914), and drawings and collages by Picasso (1911 and 1914). Although impressed by the work of various American painters exhibited at 291—particularly John Marin, Arthur Dove, Marsden Hartley, and Max Weber—he claimed to have felt an even greater attraction to the canvases of the European artists, whose works he found more mysterious. The mystery resided in their unfinished quality, their tendency to present imagery in an unresolved state; later he would even profess "an aversion to paintings in which nothing was left to speculation." In this respect, Man Ray was particularly impressed by the exhibiton of Cézanne watercolors. "I admired the economical touches of color and the white spaces which made the landscapes look unfinished but quite abstract," he remarked, "so different from any watercolors I had seen before."[8]

What Man Ray learned at Stieglitz's gallery helped prepare him—as it did many other American painters and sculptors—to view the most influential, grand-scale art exhibition held in this country, the 1913 Armory Show. The sheer size of the paintings by the French artists—particularly those by Francis Picabia, Henri Matisse, and Marcel Duchamp—prompted Man Ray to begin work on a larger scale, while their abrupt departure from conventional subjects and techniques affirmed his own modernist inclinations. The show's impact was so great, however, that it overwhelmed him to the point of inactivity. "I did nothing for six months," he later told a reporter. "It took me that time to digest what I had seen."[9] For the next two years, Man Ray would experiment with the most current European movements, fusing the bright colors of fauvism with the broken planes of analytic cubism. His *Portrait of Alfred Stieglitz* (fig. 40), for example, thought to be the first painting he made after seeing the Armory Show, clearly reveals the influence of cubism, particularly in its similarity to works by Picasso and Braque that were featured in the exhibition.

In the spring of 1913, just a few months after the Armory Show closed, Man Ray left his parents' home and moved to an artists' colony in Ridgefield, New Jersey, a village located across the Hudson River from Manhattan. He shared the rent on a small shack with the American painter Samuel Halpert, an older man whom he had befriended in classes at the Ferrer Center. Halpert,

40 *Portrait of Alfred Stieglitz,* 1913, oil on canvas, The Beinecke Rare Book and Manuscript Library, Alfred Stieglitz Collection, Yale University Library, New Haven

who had recently returned from a trip to Paris, occasionally joined the young artist on painting excursions in the open air. Although Halpert had studied briefly with Matisse, he was more deeply impressed by the work of another fauve painter, Albert Marquet, whose style was characterized by a reduction of detail, an accentuation of form through outline, and a restrained, though tonally atmospheric, palette. When he returned to New York, Halpert adopted a similar technique in his rendering of landscapes, as well as in his depiction of bridges and skyscrapers.

It was from Halpert that Man Ray drew his first serious inspiration as a painter. Although passages in Man Ray's landscapes from this period bear an obvious resemblance to the paintings of several cubists, the bold black outline that he adopted to clarify the contours of form reveals the influence of Halpert himself (fig. 41). Whereas a number of Man Ray's works continued to exhibit a bright, colorful fauve palette (fig. 42), others relied on the structural simplifications of cubism (fig. 43). It was the severe, geometric qualities of cubism—the "cubified" look that gave the movement its name—that attracted Man Ray and led to his discovery of a new figurative style. During the winter of 1913–14, the artist pursued this style in a series of large canvases, several of which present

41 *Ridgefield Landscape*, 1913, oil on canvas, private collection, Princeton, New Jersey

42 Untitled, 1913, watercolor on paper, private collection, New York

58

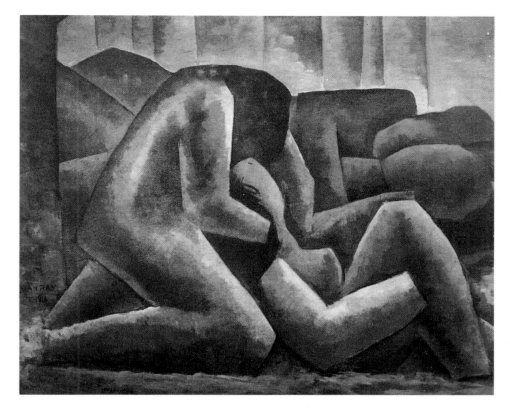

43 *The Village*, 1913, oil on
canvas, Collection
Arturo Schwarz, Milan

44 *The Lovers*, 1914, oil on
canvas, private collection

figures in such a reduced and blocklike fashion that they appear to
have been inspired more by examples of cubist sculpture than by
any paintings he might have seen at the Armory Show or in New
York galleries (fig. 44).

No matter what style Man Ray chose to emulate, and no
matter what subject matter he addressed—portraits, landscapes, or
still lifes—the paintings of this period share one important charac-
teristic: with few exceptions, they were all based on a relatively
straightforward figurative adaptation of their subject. Within a
year's time, however, the artist's approach would change dramati-
cally. In the autumn of 1914—on the final afternoon of a three-day
camping trip in Harriman State Park with his new wife, the Belgian
poet Adon Lacroix, and two other couples—Man Ray declared that
he would no longer seek inspiration directly from nature. "In fact,"
he told one of his friends, "I had decided that sitting in front of the
subject might be a hindrance to really creative work."[10] Instead, he
announced that upon his return to Ridgefield, he would paint a
series of "imaginary landscapes" based on his recollection of scenes
and events that had occurred during the course of the excursion.

One of the first of these "imaginary landscapes" may have
been a small untitled watercolor depicting a panoramic view of the

Ramapo Hills (fig. 45), a tree-covered mountainous terrain where the artist and his friends had hiked their first afternoon. The colors in the sketch appear to have been applied with a freedom and spontaneity that confirm the artist's decision to abandon the direct observation of nature. In the isolation of his studio, these visual recollections of his trip subsequently served as the basis for a series of larger, more highly finished pictures. Two details of the Ramapo Hills watercolor, for example—the large isolated tree and hills on the left and the cluster of trees and house in the lower right—formed the basis for two canvases, equal in size and both entitled *Ramapo Hills* (figs. 46, 47). The colors in these paintings are so saturated and applied with such intensity that the individual landscape elements appear to glow from some inner source of radiance. While the bright palette accurately captures the colors of an autumnal landscape, the pronounced artificiality of form simultaneously reveals the degree to which Man Ray had liberated himself from the motif.

Naturally, the more Man Ray removed himself from a direct

45 Untitled, ca. 1914, watercolor on paper, private collection, Princeton, New Jersey

60

46 *Ramapo Hills*, 1914, oil
on canvas, private collec-
tion

47 *Ramapo Hills*, 1914, oil
on canvas, private collec-
tion

48 *Arrangement of Forms,
No. 1*, 1915, oil on can-
vas, Collection Juliet
Man Ray, Paris

observation of his subjects, the more abstracted and artificial his imagery became. "I changed my style completely," he recalled, "reducing human figures to flat-patterned disarticulated forms." In the beginning of 1915, he painted a series of still lifes and figure

studies whose forms were thoroughly reduced and dematerialized, an effect he achieved, in part, by systematically eliminating nearly all cues to illusory depth (fig. 48). In some paintings, the background and foreground are so completely interfused that the viewer is forced to concede their existence on the same plane. "In my painting . . . ," he claimed, "I never forgot that I was working on a two-dimensional surface which for the sake of a new reality I would not violate."[11]

In order to enhance this "new reality," Man Ray employed a variety of techniques, some of which were derived from the experiences of his youth. In *Dance* of 1915 (fig. 49), for example, he so

49 *Dance*, 1915, oil on canvas, Collection Andrew Crispo, New York

thoroughly flattened the figure that when the work was first exhibited, one critic described the painting as "some tailor's patterns . . . having a gay time."[12] Although doubtlessly intending this as a derogatory comment, the critic was unwittingly perceptive, for the work clearly draws on Man Ray's childhood images of a household cluttered with suit and dress patterns and irregularly cut pieces of cloth. Man Ray arranged his patterns so as to form multiple visions of the same figure, the foremost of which is rendered as a translucent entity, overlapping its counterparts in a fashion suggesting the repetitive movements of dance. He could also hardly have failed to notice how the sense of translucency enhanced the spatial compression he desired. During the next two years, Man Ray systematically explored the full potential of this technique, reducing the internal components of each picture to a series of flat, overlapping geometric forms (fig. 50).

It was during this period, when Man Ray first began to develop his unique formalist program, that he met Marcel Duchamp, the French artist who was renowned in America due to the scandalous reception of his *Nude Descending a Staircase* in the 1913 Armory Show. When they were introduced by the wealthy poet and collector Walter Arensberg during the summer of 1915, Man Ray could not possibly have envisioned the revolutionary effect that Duchamp's ideas about art would have on his work. He had seen a number of Duchamp's cubist compositions in the Armory Show, and he may even have been familiar with examples of the artist's more recent, mechanically inspired work.[13] But no doubt it was Duchamp's iconoclastic spirit that most appealed to Man Ray, who by then was eager to liberate himself totally from the aesthetic conventions of the past.

It may have been Duchamp's depiction of simple mechanical devices that first drew Man Ray's attention to an increasing tendency among young European painters to acknowledge the revolutionary implications of the machine age. But it was Francis Picabia's vociferous exaltation of the machine and his newly developed mechanomorphic style that provided the most cogent example of this new aesthetic. "The machine has become more than a mere adjunct of life," Picabia told an American reporter in October of 1915. "It is really a part of human life—perhaps its very soul."[14] Having moved from the rural environment of Ridgefield to a studio in midtown Manhattan, Man Ray was literally surrounded by the most recent advancements of the mechanical age. "They were building the Lexington Avenue subway," he recalled, "and the racket of concrete mixers and steam drills was constant." But the

50 *Promenade*, 1915, gouache on paper, Collection Juliet Man Ray, Paris

PROMENADE

51 Untitled, 1915, ink on paper, Morton G. Neumann Family Collection, Chicago

incessant noise did not bother him. "It was music to me and even a source of inspiration," he said, "I who had been thinking of turning away from nature to man-made productions." With these new and exciting urban surroundings, he later explained, it was inevitable that he change his influences and technique.[15]

An untitled drawing that can be dated to late 1915 shows that Man Ray had at least experimented with the new style before the end of the year (fig. 51). In a discussion about the themes of his work during this period, the artist provided a virtual description of the nonfunctional, mechanical imagery of this drawing: "The new subjects were of pseudo-mechanistic forms, more or less invented, but suggesting geometric contraptions that were neither logical nor scientific."[16] Indeed, neither logic nor science figure into the intertwining shapes of the essentially abstract image. A thin, vertical corkscrew bisects the center of the composition and is surrounded by a number of sharply delineated forms, connected to one another at points of coincident alignment. It was only when the design was reworked for a series of collages the following year that it became clear that the seemingly unrelated shapes were actually produced by a logical system of overlapping, irregularly cut transparent sheets.

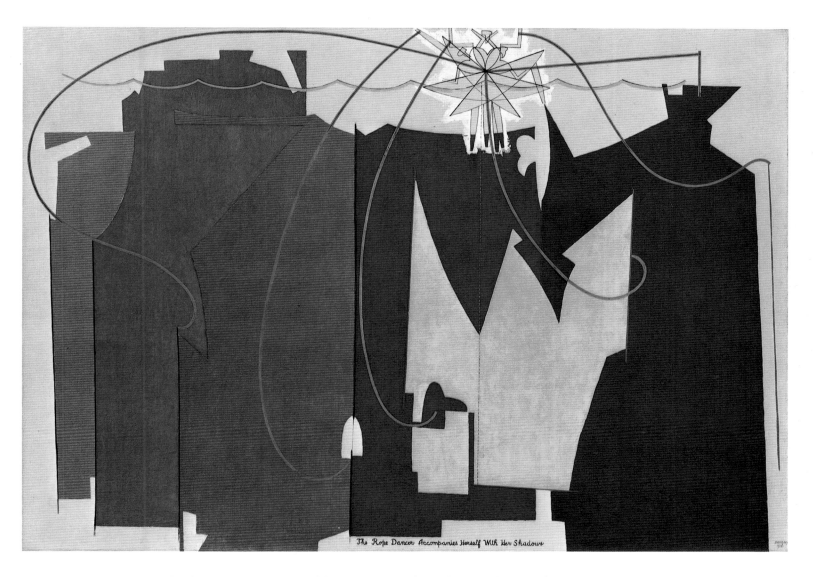

The Rope Dancer Accompanies Herself With Her Shadows

A year before, Man Ray had been exposed to the medium of collage through the Picasso/Braque exhibition at 291. The two-dimensionality of the works and their sparcity of detail appealed to his formalist interests. Whether or not Man Ray fully understood the implications of collage, he soon experimented with it.[17]

During the closing months of 1915, just after he moved into his Lexington Avenue studio, he began the most important work of his early career, a painting whose title succinctly describes its subject: *The Rope Dancer Accompanies Herself with Her Shadows* (fig. 52). While the theme of a tightrope walker, or rope dancer, was well established in both art and literature—the precariously balanced figure symbolizing the human struggle for existence—Man Ray claimed that his inspiration for the subject came from a vaudeville performance.[18] Apparently, upon returning home after the show, he

52 *The Rope Dancer Accompanies Herself with Her Shadows*, 1916, oil on canvas, The Museum of Modern Art, New York, Gift of G. David Thompson

53 *Study for the Rope Dancer*, 1916, ink on paper, private collection, Milan

made a number of quick sketches recalling the movements of a ballerina (fig. 53). He then rendered the dancer in a more mechanical fashion, showing her in a sequence of animated positions silhouetted against three dark ovoid shapes, meant to represent the projected beams of a spotlight (fig. 54).

According to several subsequent accounts, Man Ray would have us believe that the basic design of the painting was not predetermined, but rather the result of a chance discovery. Supposedly, he began enlarging the shapes of the dancers on different-colored sheets of construction paper, which he in turn cut out and attempted to position in a satisfying arrangement. While so doing, he noticed the scraps of paper that had fallen to the floor. These irregularly cut pieces were of such compelling visual interest that he based his final composition on them instead. He selected six scraps and arranged them in an overlapping format for maximum color contrast. These abstract shapes were then faithfully transcribed to canvas, where they were rendered in an almost trompe l'oeil fashion. Apparently, it was only at the very end of this process that Man Ray decided to recall the original dancer. At the top of the composition, he painted a sharp, almost crystalline form representing three superimposed figures joined in a single point at the waist,

implying that the translucent beings were multiple readings of the same figure. From this connecting point, he painted three lines that link the dancers to their "shadows" below (the ends of three more lines, or ropes, are held in the dancers' hands). Thus, the dancer accompanies her shadows—as someone accompanies a dog on a leash—a visual image that suggested the lengthy, narrative title boldly inscribed across the base of the painting. As Man Ray later explained, "I gave the picture an almost literal if not literary title!"[19]

Man Ray's experimentation with spectrum-colored papers provided not only the inspiration but also the modus operandi for an entire series of collages from this period, each of which was supposed to serve as a preparatory study for a larger work in oil.[20] The series consisted of ten separate collages, the individual panels of which were prepared from carefully cut pieces of construction paper pasted onto white cardboard. For their first installation at the Daniel Gallery in 1919, each collage was separately framed and hinged onto a rotating support, so that the entire ensemble could be spun

54 *Ballet-Silhouette*, 1916, ink on paper, Peggy Guggenheim Collection, Venice

around like a revolving door, hence Man Ray's title *The Revolving Doors* (figs. 55–64).

Each panel was also assigned a somewhat unusual, though generally descriptive, title and was accompanied by what Man Ray described as a "long" and "rambling" text. On occasion insightful, most of the statements are rather abstruse analyses of the individual images. Both the titles and the texts were likely inspired by the finished images—not the other way around—a method the artist frequently employed.[21] The title for the first work, *Mime*, for example, was probably suggested by its anthropomorphic shape, which, with its vertical, colored striations and outstretched, armlike forms, recalls the quiet movements of a mute clown.

When Man Ray later prepared a *pochoir* edition of these works in facsimile, he numbered them from one to ten, probably to reflect the order of their making. If the sequence is indeed chronological—and there is some indication that it is—then it becomes apparent that distinctly different aesthetic sensibilities were in operation during the making of the series. The first five images reflect the formalist principles Man Ray had established for an art of two dimensions.[22] They are inherently more pictorial; that is, their forms more completely reflect the surface of their rectangular support, and thus reinforce our awareness of their planar expanse. The latter five, on the other hand, are far more iconic. In spite of their basically abstract designs, they exhibit obvious figurative associations (with the possible exception of *Shadows*). This does not imply that their designs were generated by specific, recognizable imagery, but that these works intentionally direct the viewer's attention to something else, that is to something other than what they are. In other words, while the earlier designs emphasize the physicality of the works themselves, the latter five collages emphasize the physicality of the objects alluded to in their titles.

As this progression seems to indicate, Man Ray was becoming less concerned with his earlier preoccupation that a picture reflect the integrity of its surface. By combining elements in one image that simultaneously referred to two and three dimensions, he was faced with either reconciling the contradictions that inevitably resulted, or simply accepting them for what they were. During the closing months of 1916, there can be little doubt that he chose the latter option. The ambiguities, he must have reasoned, were not inconsistent with his general disapproval of art objects that were so highly finished and rationally developed that they lacked the essential ingredient of mystery. For this reason, he often created works that intentionally defied the possibility of a logical reading. "What

The Revolving Doors,
1916–17, serigraph on
paper, National Museum
of American Art, Smith-
sonian Institution, Wash-
ington, D.C.

is logic?" he once asked with characteristic irony. "To me 2 and 2 equals 22; not 4."[23]

65 *Self-Portrait*, 1916, oil on canvas, bells, and push button (original destroyed; photograph by the artist)

In the closing months of 1916, as he prepared for his second one-man show at the Daniel Gallery, Man Ray's earlier formalist concern—to draw attention to a painting's inherent two-dimensionality—gradually gave way to an alternative approach, one that more thoroughly explored a painting's physical properties. Man Ray attained the desired effects through a variety of essentially of texture, the creation of an illusion of shallow relief, and, in certain instances, the attachment of actual two- and three-dimensional objects to the canvas. The painting in the Daniel exhibition that drew the most attention from the press was a mixed-media assemblage that consisted of a vertical panel painted in black and aluminum, apparently meant to represent the shape of a doorway (fig. 65). Upon the panel were affixed two doorbells and a push button, as if to suggest that if one pushed the button, the bells would ring. This was not the case, however, and it caused considerable disappointment among visitors to the exhibition. "They were furious," Man Ray later recalled, "they thought I was a bad electrician." He had never intended, though, to set up a simplistic stimulus-and-response demonstration, as in a psychological experiment. As he himself explained, "I simply wished the spectator to take an active part in the creation."[24]

The controversy generated by this picture alone underscored the seemingly unbridgeable gulf that existed between the idea for a picture and the expression of that idea in physical terms. Nevertheless, Man Ray continued to emphasize the precedence of an artistic concept over any technical considerations involved in its realization. Such an approach presented certain obstacles. "I didn't realize it at that time," the artist later recalled, "that the public, the people, even those who are intelligent, above all things, hate ideas." As a consequence, none of the paintings in his exhibition sold, and even his dealer attempted to discourage him from further experimentation by offering to purchase examples of his earlier work. "But I couldn't go back," Man Ray later explained. "I was finding myself, I was filled with enthusiasm at every new turn my fancy took, and, my contrary spirit aiding, I planned new excursions into the unknown."[25] During the next four years, Man Ray did indeed make his way through what was then aesthetically uncharted territory, exploring and defining even more adventurous and experimental avenues of artistic expression.

Throughout 1917, in addition to manipulating the physical properties of his art, Man Ray simultaneously experimented with

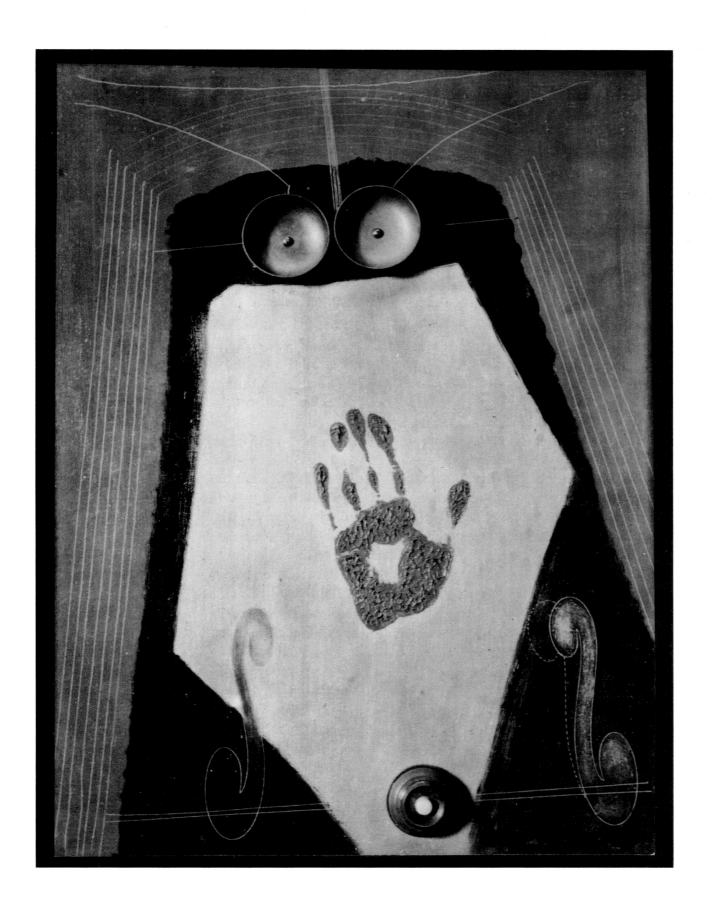

an opposing approach: virtually eliminating all cues to tactility. In his exploration of the latter of these two directives, the artist's pursuit of painting for exclusively formalist concerns was dramatically curtailed. "My efforts [during] the last couple years," he later said of this period, "had been in the direction of freeing myself totally from painting and its aesthetic implications." The freedom he sought was fueled by an obsession to be different. "I wanted to find something new," he later recalled, "something where I would no longer need an easel, paint, and all the other paraphernalia of the traditional painter." The solution presented itself in the form of a mechanical device that he had learned to use in his commercial work: the airbrush, an instrument used by illustrators to produce a light, even spray of ink or paint. The airbrush was usually employed to produce large areas of color or to create the convincing impression of reflective surfaces and shadow. "When I discovered the airbrush," he later wrote, "it was a revelation—it was wonderful to paint a picture without touching the canvas; this was a pure cerebral activity. It was also like painting in 3-D; to obtain the desired effects you had to move the airbrush nearer or farther from the canvas."[26]

66 *Suicide*, 1917, ink airbrushed on cardboard, The Menil Collection, Houston

One of the first of Man Ray's aerographs—as his works in this medium are called—was *Suicide* (fig. 66). Originally the work was entitled *Theatre of the Soul*, after a play by the Russian director and playwright Nikolai Evreinof, best known for his theatrical parodies, satires, and monodramas. Man Ray knew the play well and a few years later published an English translation of the text.[27] It is unlikely that the work was ever intended for production, although performances were later staged in England and America. "The action," Evreinof wrote, "passes in the soul in the period of half a second." The principal character is identified only as a professor, who, before the curtain rises, appears before the audience to introduce the other characters and the play itself. On a blackboard, the professor then begins to illustrate the plot. He draws a diagram representing a "large heart, with the beginning of its main artery . . . [which] lies between two lungs," as well as a "little system of nerves, threads of nerves, pale in color, and constantly agitated by vibration." According to Man Ray, *Suicide* was meant to represent the "dramatic situation on the professor's blackboard."[28] Although the various abstract elements in the aerograph are not a literal visualization of the professor's words, the ovoid forms suspended in the foreground of the composition probably refer to the two lungs, while the triangular configuration of lines in the upper center illustrates the system of nerves.

There is a similarity between the airbrush technique and the process of printing photographs, a skill Man Ray had taught himself a few years earlier in order to make pictures of his paintings. Just as light is filtered through a translucent plane (the negative) in photography to create an image on photosensitive paper, the ink or pigment forced through the nozzle of an airbrush must first pass through various obstructing devices (used like templates) before it creates an image on the surface of the canvas or paper. Indeed, since Man Ray's airbrush pictures tended to be monochromatic, it has frequently been noted that they have the appearance of photographic prints. Ironically, the artist would later be accused of trying to make his photographs look like paintings.[29]

It is unlikely, however, that the similarities in these media would have been of much concern to Man Ray. "To express what I feel," he later explained, "I use the medium that is best suited to express that idea." In this respect, Man Ray owed a considerable debt to Duchamp, who maintained that art should avoid a purely "retinal" approach, and that the art-making process should be a "cerebral" act. The precedence of idea over form had one inevitable result: painting as a pure exercise in the exploration of formal properties would cease. Duchamp painted his last picture in 1918, and except for occasional experiments, after 1917 Man Ray painted only when some other medium was not appropriate for the expression of a specific concept. As he clearly explained, "Perhaps I wasn't as interested in painting itself as in the development of ideas."[30]

From 1917 through 1921, Man Ray discovered that most of his ideas were best expressed through the use of objects. Even though he often appropriated the elements that comprise these works from his immediate environment, they differed from Duchamp's "readymades," which were usually chosen at random and given titles that had nothing to do with the objects themselves. Rather than select a commonplace, utilitarian item, with what Duchamp described as "aesthetic indifference," Man Ray preferred to alter or manipulate the design of the manufactured piece, sometimes by combining it with other objects and/or by adding provocative titles to create a sense of poetic expression. "Whatever elements that may come to hand or that are selected from the profusion of materials," he explained, "are combined with words to create a simple poetic image."[31] Thus, when an assembly of wood strips held together by a C-clamp is entitled *New York* (fig. 67), we immediately see more than the simple elements with which the object was constructed; the sleek verticality and ascending angular profile recall a New

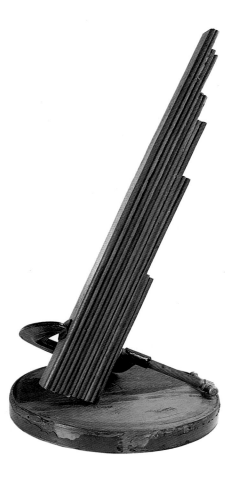

67 *New York*, 1917, wood strips and carpenter's C-clamp, Collection Phillip Rein, Paris

York skyscraper, in the sharp geometric style of numerous high-rise buildings then under construction in Manhattan.

Once Man Ray discovered the expressive potential of objects—particularly when they were given titles that provided new literary contexts—he no longer considered himself exclusively a painter, at least not a painter in the more traditional fashion to which he had earlier aspired. This is not to say that he stopped painting altogether; there are isolated examples even from these years, such as the abstract composition of 1918 simply and appropriately entitled *Painting* (fig. 68).[32] Working on a relatively small surface with a palette knife, Man Ray defined a series of angular color planes, their surfaces so emphatically textural that the image is more readily comprehended for its material presence than for any illusionistic properties one might associate with the art of painting. Indeed, as if to underscore this very point, in certain passages the artist applied unmodulated areas of black pigment, which at first glance can be interpreted as areas of shadow. But these same dark passages hover conspicuously in a cruciform format in the lower left portion of the composition, defying our spatial comprehension of the image by visually fusing foreground and background. Finally, with the edge of his palette knife, Man Ray applied thin lines of black paint to the surface of three angular shapes in the lower center of the painting. These lines resemble primitive calligraphic markings, the center-most of which takes on the shape of the artist's own monogram. Combined with the textural build-up of pigment and the work's self-referential title, the lines reinforce our reading of the painting as an object, which the artist certainly strove to attain. "I'd already done away with brushes and was painting almost exclusively with knives," he told Arturo Schwarz, "but I was still not satisfied."[33]

No matter how thickly he applied the paint, Man Ray wanted his creative efforts to go even further beyond the five-hundred-year tradition established by the representational arts. For Man Ray, it no longer made sense for an artist to carve some material into a predetermined shape, or to manipulate pigment on a flat canvas in order to represent something other than what it was—even if that something were nothing more than abstract planes of color arranged in a certain order. The airbrush offered one solution to freeing himself from traditional methods and aesthetics, but objects were an even more alluring alternative. Once the idea for a given object took hold, Man Ray only had to select the medium that best expressed his intentions. In some cases, a photograph of an object better conveyed his thoughts than the object itself.

The photographic record of an eggbeater and its shadows, for

68 *Painting*, 1918 (reworked 1924), oil on canvas, Collection Stephan Lion, New York

example, allowed the artist to more succinctly link the subject to its suggestive title—*Man*—(fig. 69) than would have been possible through the casual display of the actual object. To put it another way, rather than allow the commonplace, utilitarian item to become the work of art—as Duchamp might with one of his readymades—after the photograph was taken, Man Ray likely discarded the object or returned it to its original functional context. In presenting only a photograph of the eggbeater, the artist was able not only to exercise complete control over the spectator's point of view, but also carefully to adjust lighting and shadows so as to make the anthropomorphic reading possible. Through Man Ray's manipulation, for example, the lower portion of the eggbeater is duplicated, suggesting appendages, while the assembly of gears can be seen to represent a torso, and the ovoid handle at the top, the head of a figure. Given this reading, the tapering, cylindrical handle attached to the large central gear and carefully positioned between the two floating "appendages" has obvious phallic implications, a detail that provides the object with its novel male identity.[34]

Appropriately, after having created the image of *Man*, the artist arranged certain objects from his darkroom to create the likeness of *Woman* (fig. 70). Two metal light reflectors and six clothespins attached to the edge of a plate of glass are illuminated in such a way that they are duplicated in sharp shadow. Just as the eggbeater can be read for its uniquely male characteristics, the paired circular reflectors in *Woman* can be seen as breasts, while the angular pattern created by the glass and the evenly spaced rows of clothespins create a highly provocative channel of entrapment, suggesting that the slightest touch could snap the panels shut like the leaves of a Venus flytrap. In this context, the circular opening at the upper convergence of the glass plates alludes, perhaps, to a singular orifice, an anatomical metaphor for woman.

This reading would not have been possible, of course, if the construction were not duplicated in shadow. As discussed earlier, reflected images were of increasing concern to Man Ray in his paintings and drawings of this period (particularly in *The Rope Dancer* and the *Revolving Doors* collages). Indeed, when disassociated from the image of *Man*, the print of *Woman* has been frequently exhibited under the title *Shadows*.[35] "The shadow is as important as the real thing," the artist once remarked when describing these images. He may have been referring to Plato's famous parable of the cave, but one need not look to such a remote influence to trace the source of this motif in Man Ray's work. Duchamp and cubist painters before him had used the shadow to allude to the fourth

dimension, and Duchamp had even photographed the shadows cast by his readymades—precisely the procedure Man Ray adopted in his realization of *Man* and *Woman*.[36]

One could argue that these photographs of a simple eggbeater and darkroom equipment are still an extension of the representa-

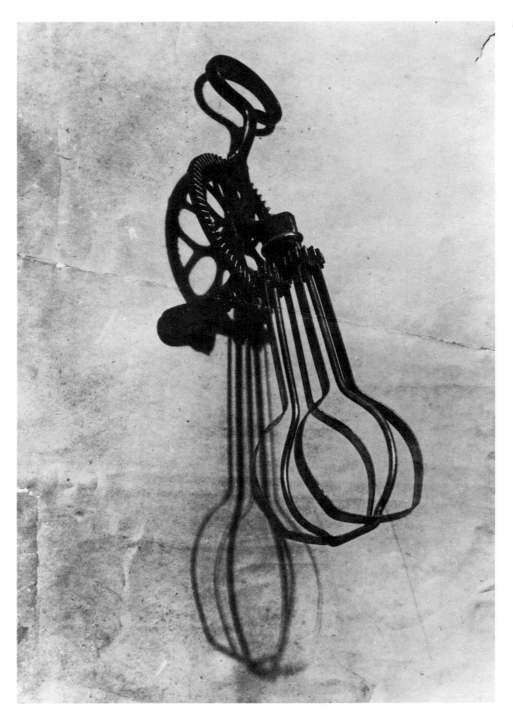

69 *Man*, 1918, silver print

tional arts, since their imagery alludes to known elements. But the photographs differ sharply from any previous figurative tradition by allowing the objects to be read first and foremost for what they are, with further associations supplied only through the addition of evocative titles. In effect, then, the objects take on a life of their own, which Man Ray acknowledged when he later united them under the warm and intentionally emotive appellation *Objects of My Affection*.[37] Unbeknownst to the artist at the time of their conception, these two object-photographs would come to be regarded as

among the most significant and exemplary works of the dada and surrealist movements.

Exactly to what degree Man Ray was aware of dadaism in Europe before 1920 is uncertain. In January of that year Duchamp had returned to New York after a five-month sojourn in Paris. Although he did not actively partake in the gatherings of the dadaists, he had frequented the local cafés and learned more about the group's nihilistic activities. Recent scholarship has revealed that word of dada had reached a select number of individuals in New York shortly after its founding, but the movement was to attract few adherents in America until its principal spokesman and founder, Tristan Tzara, moved to Paris after World War I and extended his proselytizing efforts to a more international audience.[38] Duchamp may have been in correspondence with Tzara as early as 1916 or 1917, and Man Ray could have learned about the movement then; upon Duchamp's return to New York, he no doubt learned a great deal more. One thing is certain, however: with few exceptions, from 1920 to 1921 Man Ray completely—though only momentarily—abandoned his commitment to the traditional materials and techniques of painting. Instead, he developed an almost obsessive affection for the object, which he manipulated, adapted, or incorporated into his work with what can best be explained as an innate dada sensitivity.

Except for Duchamp's introduction of the readymade, few aesthetic principles beyond the iconoclasm of dada provide sufficient precedent for Man Ray's highly imaginative, sudden, and virtually unrestrained treatment of the object. Little else, for instance, helps to explain his submission of an unwound lampshade to an art exhibition (fig. 71), or his creation of a sculpture entirely out of coathangers (fig. 72). Perhaps even closer to the aesthetics of dada was his elevation of a crushed tin can to the status of an art object and his treatment of discarded materials as valued artifacts, as in the object he made from nothing more than a jar and some ball bearings (fig. 73).[39]

At this time, Man Ray was developing an interest in vanguard French literature. The work that perhaps best exemplifies this new influence—and reveals his reliance on the very sources that had been an important literary precedent to dada—is *The Riddle*, or *The Enigma of Isidore Ducasse*, a photograph of an unidentified object, or objects, wrapped in the folds of a thick carpet, which in turn is tied with rope (fig. 74). Although the entire assemblage was discarded after the photograph was taken, Man Ray wanted the viewer to believe that two rather commonplace objects were hidden under the

71 *Lampshade*, 1919 (1921 replica illustrated), painted white tin, Yale University Art Gallery, New Haven, Collection of the Société Anonyme. The original object, which was destroyed, was a paper lampshade hung from a metal stand.

72 *Obstruction*, 1920, coathangers (original lost or destroyed; photograph by the artist)

73 *New York*, 1920, jar of steel balls (original object lost; photograph by the artist)

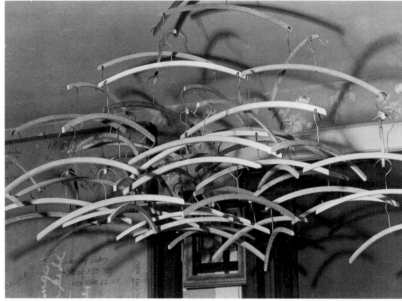

carpet. The only way a viewer could know what they were, though—and thus solve the riddle—was to have been familiar with the writings of the obscure, though extremely influential, French author Isidore Ducasse, whose pseudonym was the Comte de Lautréamont. During the near half-century that had passed since his death, Ducasse's writings were largely forgotten—until they were rediscovered by André Breton, who saw the author's outrageous and flamboyant style as a forerunner of dadaism and immediately published excerpts of his writings in *Littérature*, the avant-garde French magazine that he helped to edit.[40]

Word of Ducasse had reached America shortly after his discovery in Europe. Duchamp, while in Paris during the latter half of 1921, wrote to the Arensbergs, asking if they had seen the book by Lautréamont. "In it," he told his American friends, "you will see the very seed of dada."[41] By 1920, at least two statements by the French author had attained near legendary status: his observation

that "Poetry must be made by all, not by one" and his oft-quoted "Lovely as the fortuitous encounter on a dissecting table of a sewing machine and an umbrella." It was, of course, this bizarre, though visually provocative, exemplar of beauty that Man Ray illustrated in *The Riddle*. "When I read Lautréamont," he later

explained, "I was fascinated by the juxtaposition of unusual objects and works." Even more important, he was drawn to the count's "world of complete freedom."[42]

Man Ray's fascination with the work of other French authors—Baudelaire, Rimbaud, Mallarmé, and Apollinaire—fueled his desire one day to live in the land of Lautréamont. During these years, he worked hard to bring Tzara's message of dada to his American friends. With Duchamp's help, he edited and published the first and only issue of an American periodical devoted exclusively to dadaism in New York, appropriately entitled *New York Dada*. The magazine, however, attracted little attention, and the movement gained no new adherents. "The effort," Man Ray later recalled, "was as futile as trying to grow lilies in a desert." A few months after the appearance of this review, Man Ray wrote to Tzara, reporting that his efforts were in vain: "Dada cannot live in New York," he wrote. "All New York is dada, and will not tolerate a rival,—will not notice dada." Years later Man Ray would claim to have been the principal exponent of the movement in New York: "With the permission and with the approval of other Dadaists I legalized Dada in New York. Just once. That was enough. The times did not deserve more."[43]

Although the times may not have deserved more, Man Ray was convinced that he did. The American public's staunch resistance to any form of aesthetic experimentation created an atmosphere he found repressive. When Duchamp announced his plans to return to Paris in the spring of 1921, Man Ray promised that he would soon follow. The necessary funds to finance the trip were eventually raised. In the summer of 1921, Man Ray set sail for the country and people who would better appreciate the abilities of a young, rebellious artist who had not only mastered a variety of unusual techniques, but who had also embraced the ideological tenets through which to exercise his extraordinary inventiveness.

74 *The Riddle*, or *The Enigma of Isidore Ducasse*, 1920 (original object intentionally dismantled; photograph by the artist)

NOTES

This essay is derived from the author's doctoral dissertation, "Man Ray: The Early Years in New York and Ridgefield, 1907–1921" (Graduate Center of the City University of New York, 1987).

1. Man Ray, *Self Portrait*, p. 4.
2. From an interview with Arturo Schwarz, "This Is Not for America," *Arts* 51, no. 9 (May 1977): 117; first published in Schwarz, *New York Dada: Duchamp, Man Ray, Picabia*, pp. 79–100.
3. The discrepancy in his first name may be due to the fact that his original birth certificate was destroyed by a fire in the Philadelphia Hall of Records. The replacement was made from informal records stored at another location. Those records may have been incorrect or the clerk may have made a mistake in transcribing the information. Or Man Ray's father, Max, may have considered "Michael" a more common, and hence more acceptable, name for a legal document.
4. Information provided in an interview with Man Ray's sister, Dorothy Ray Goodbread, 9 October 1983, Rydal, Pa.
5. Man Ray, *Self Portrait*, p. 9. Man Ray attended Boys High School in Brooklyn (information provided by Dorothy Ray Goodbread through Naomi Savage, November 1986).
6. On Man Ray's desire to see nude women in this period, see "This Is Not for America," in Schwarz, *New York Dada: Duchamp, Man Ray, Picabia*, p. 119. In his autobiography, Man Ray describes his academic experiences but leaves the institutions unnamed (pp. 12–16). In a questionnaire circulated by the Museum of Modern Art, New York (artist's files, Department of Painting and Sculpture), however, Man Ray gave the names of the schools and his dates of attendance: National Academy of Design, 1908, and the Art Students League, 1910. The National Academy of Design, though, lists him as having applied for admission for the first time on 28 October 1910 (information provided by the academy's archivist, Abigail Gerdts). He also studied at the Art Students League from 2 October 1911 through 25 May 1912, enrolling in the classes of George B. Bridgman, who taught anatomy and was a student of Gérôme; Edward Dufner, who offered classes in illustration and composition; and Sidney E. Dickinson, a well-known portrait painter (information provided by Lawrence Campbell, editor of publications, the Art Students League).
7. On Man Ray's activities at the Ferrer Center, see Naumann, "Man Ray and the Ferrer Center."
8. In his autobiography (p. 18), Man Ray reported having attended these exhibitions, without providing dates. Although he identified the Cézanne watercolor exhibit as the first show he had seen at 291, he also mentioned having viewed the exhibition of Rodin watercolors, which was held a year earlier, from 21 March through 18 April 1910 (though Rodin drawings were periodically exhibited in group shows at the gallery). Quotations from Man Ray, *Self Portrait*, pp. 181, 18.
9. Quoted in C. Lewis Hind, "Wanted, A Name," *Christian Science Monitor*, ca. November–December 1919 (exact date of publication unknown; clipping preserved in the scrapbooks of Katherine Dreier, Société Anonyme Collection); reprinted in Hind, *Art and I* (New York: John Lane, 1920), pp. 180–85.
10. Man Ray, *Self Portrait*, p. 54.
11. Ibid., pp. 55, 49. He would later describe this phase of his work as "my Romantic-Expressionist-Cubist period" (ibid., p. 65).
12. A. v. C., "Man Ray's Paint Problems."
13. Both versions of Duchamp's *Chocolate Grinder* (Arensberg Collection, Philadelphia Museum of Art) were shown in New York three months before Duchamp arrived in this country, in an exhibition of modern French art held at the Carroll Galleries in March 1915.
14. "French Artists Spur on an American Art," *New York Tribune*, 24 October 1915, sec. 4, p. 2. On Picabia's works of this period, see William A. Camfield, "The Machinist Style of Francis Picabia," *Art Bulletin* 47 (September–December 1966): 309–22; and Camfield, "New

York and the Mechanomorphic Style," in *Francis Picabia: His Art, Life and Times* (Princeton, N. J.: Princeton University Press, 1979), pp. 71–90.

15. Man Ray, *Self Portrait*, pp. 65, 66.

16. Ibid., p. 65. It has been assumed that Man Ray's mechanical style did not begin until late 1916 or early 1917, the date previously assigned to this drawing. My dating of late 1915 is based on Man Ray's own record in his card file (preserved in the artist's estate, Paris).

17. Naumann, "Theory and Practice in the Art of Two Dimensions," p. 38. The Picasso/Braque exhibition was held 9 December 1914 through 11 January 1915.

18. Man Ray, *Self Portrait*, p. 66. For historical precedents to this theme in German painting of the early twentieth century, see Janice McCullagh, "The Tightrope Walker: An Expressionist Image," *Art Bulletin* 66, no. 4 (December 1984): 633–44.

19. The most extensive account of the creation of *The Rope Dancer* was provided by the artist in his autobiography (pp. 66–67), but he also described the process in his response to a questionnaire sent to him by the Museum of Modern Art shortly after they acquired the picture (preserved in the artist's files, Department of Painting and Sculpture). The questionnaire is undated, but it was sent to Man Ray with a letter from Alfred H. Barr, Jr., on 26 August 1954. It was in his

response that Man Ray commented on titling the painting.

Originally I had assumed *Ballet-Silhouette* served as a preliminary study for the painting (see Naumann, "Theory and Practice in the Art of Two Dimensions," p. 38). The same assumption guides the analysis of the drawing by Angelica Zander Rudenstine, "Silhouette," in *Peggy Guggenheim Collection, Venice* (New York: Harry N. Abrams, 1985), pp. 481–85. We now know, however, that this work was actually made *after* the final painting was completed. "After finishing the painting," Man Ray wrote, "the idea still obsessed me, and I made a fine-line drawing called 'Ballet-Silhouette'" (Museum of Modern Art questionnaire). Nevertheless, it is likely that a similar drawing—or at least one containing many of the same details—was cut up, and its fragments utilized in the construction of the final picture.

20. Only one collage, *Legend*, was actually used as the model for a painting (Collection Baron and Baroness J. B. Urvater, Brussels).

21. Man Ray, *Self Portrait*, p. 68. The texts for five of these collages were published by Man Ray in 1919 in the magazine *TNT*, which he edited. The commentaries were presented without illustrations or explanations. Only in 1935 were all of the images published with their accompanying texts (in French); see Man Ray, "Les

Portes tournants," *Minotaure*, no. 7 (1935): 66.

A number of authors have suggested that all ten panels were based on recognizable imagery. See, for example, Lesley Baier and Anna Chave, "Revolving Doors," in Herbert, *The Société Anonyme and the Dreier Bequest*, p. 567.

22. For Man Ray's formalist theories and their effect on his work of this period, see Naumann, "Theory and Practice in the Art of Two Dimensions."

23. Quoted in Watt, "Dadadate with Man Ray."

24. Quotations from Schwarz, *Rigour of Imagination*, p. 136; and Man Ray, *Self Portrait*, p. 71.

25. Quotations from "This Is Not for America," in Schwarz, *New York Dada: Duchamp, Man Ray, Picabia*, p. 119; and Man Ray, *Self Portrait*, p. 71.

26. Quotations from Man Ray, *Self Portrait*, p. 82; and Schwarz, *Rigour of Imagination*, p. 39.

27. The text was published in *TNT* (1919). Evreinof (1879–1935) was well known for his monodramas, which were written for a single performer but relied on the participation of spectators (see *Columbia Dictionary of Modern European Literature*, s.v. "Yevreinov, Nikolai Nikolayevich," and *McGraw-Hill Encyclopedia of Russia and the Soviet Union*, s.v. "Evreinof, Nikolai"). An inventory Man Ray kept of works from this period (preserved in the artist's estate, Paris)

indicates the original title of the work. He later inscribed the word *Suicide* at the base of the picture, and in 1924 allowed a photograph of it to be published as his sole response to a question directed to the surrealists by André Breton: "Is Suicide a Solution?" (see Breton, "Le Suicide est-il une solution?" *La Révolution surréaliste*, no. 2 [15 January 1925]: 12).

28. Man Ray to Dominique de Menil, 20 October 1973 (excerpts quoted in *Gray Is the Color: An Exhibition of Grisaille Painting, Twelfth to Twentieth Centuries* [Houston: Rice Museum, 1973], p. 130).

29. See, for example, Man Ray, *Self Portrait*, p. 145; and Man Ray, "Photography Can Be Art," in J. H. Martin, *Man Ray Photographs*, p. 34.

30. Quotations from Schwarz, *Rigour of Imagination*, p. 12; and Man Ray, *Self Portrait*, p. 340.

31. Man Ray, "Objects of My Affection," in *Oggetti d'affezione*. For Man Ray's explanation of his titles, see his interview with Bourgeade in *Bon Soir, Man Ray*, pp. 64–65, 68.

32. During this period, Man Ray painted sporadically, and only when some other medium did not readily suit the task at hand. Later, however, particularly during his years in Hollywood, the artist preferred to be recognized primarily as a painter, and he repeatedly identified the art of painting as his "first passion" (*Self Portrait*, p. 254). Although signed and dated in Paris in 1924, *Painting* was actually produced during the artist's years in New York.

In Man Ray's card file, the work is reproduced (without the white dots, which were probably added later) and dated 1918.

33. Quoted in Schwarz, *Rigour of Imagination*, p. 39.

34. It is tempting to speculate why Man Ray chose this particular kitchen utensil to represent man. Could it be, as Arturo Schwarz has suggested, that the artist read the word *eggbeater* as a beater of eggs, or to put it another way, as a wife beater (*Rigour of Imagination*, p. 158)? Although unusually literal for Man Ray, this is a tempting interpretation, particularly in light of the fact that it was precisely at this time that the artist began to experience acute marital difficulties.

35. The photographic image of the eggbeater was first made by Man Ray in 1917. At that time, he titled the picture *Man*. It was the companion piece to his subsequent photograph of lights and clothespins, *Woman*. However, the eggbeater photograph later reappears, retitled and redated *La Femme*, 1920 (Collection Centre National d'Art et de Culture Georges Pompidou). Since the handwriting at the bottom of the photograph does not appear to be Man Ray's, it is tempting to imagine that Tzara, having received *Man* and *Woman* for his magazine *Dadaglobe*, switched their titles when he entered them in the 1921 exhibition at the Théâtre des Champs-Elysées. No copy of *Woman* retitled *L'Homme* exists, however.

36. Man Ray's comment on shadows is quoted in Schwarz, *Rigour of Imagina-*

tion, p. 234. A photograph taken in Duchamp's studio in 1918 was entitled *Shadows of Readymades* (reproduced in Anne d'Harnoncourt and Kynaston McShine, eds., *Marcel Duchamp* [New York: Museum of Modern Art, 1973], p. 285); it is not known whether or not Duchamp took the photograph or if it was taken by a friend (probably either Man Ray or Henri-Pierre Roché). Duchamp traced the shadows cast by several readymades on the surface of his painting *Tu'm* (1918; Yale University Art Gallery, New Haven), and nearly fifty years later, he held an exhibition in Paris that featured shadows cast by the readymades recorded on the gallery walls (*Readymades et editions de et sur Marcel Duchamp*, Galerie Givaudan, 8 June–30 September 1967). On the importance of shadows in the work of Duchamp, see Linda Dalrymple Henderson, *The Fourth Dimension and Non-Euclidian Geometry in Modern Art* (Princeton, N.J.: Princeton University Press, 1983), pp. 30, 120, 139, 155, 157–58.

37. Exactly when Man Ray chose to categorize these works as *Objects of My Affection* is uncertain. Their earliest appearance in book form was in 1971 in *Oggetti d'affezione*.

38. The date when American artists first became aware of the dada movement in Europe, and the degree to which they were affected by it, is treated at greater length in Naumann, "The New York Dada Movement."

39. Although this object dates from 1926, it is based on a

work the artist made in 1920 (Martin, Krauss, and Hermann, *Man Ray: Objets de mon affection*, cat. no. 19, p. 141), and which he cleared through French customs at the time of his trip to Paris in 1921 (Man Ray, *Self Portrait*, p. 110).

40. Ducasse, "Poésies," Parts 1, 2, *Littérature*, nos. 2, 3 (April, May 1919): 2–13, 8–24 (see also Breton's introductory note, no. 2, p. 1 [incorrectly numbered p. 2]). Man Ray's attention would have been drawn to these publications, for they were advertised in Tzara's magazine, *Dada* (nos. 4–5, May 1919), on the same page as an announcement of the upcoming New York review *TNT*.

41. Marcel Duchamp to Walter and Louise Arensberg, formerly in the collection of the Francis Bacon Library, Claremont, Calif. (original now lost). The letter was probably written during the fall of 1921, at which time Duchamp was staying in Paris with his sister, Suzanne, and brother-in-law, Jean Crotti (see Francis Naumann, ed., "Marcel Duchamp to Walter and Louise Arensberg: 1917–1921," *Dada/Surrealism*, no. 15, forthcoming).

42. Translation of Lautréamont by Roger Shattuck; Man Ray quoted in Man Ray, "Tous les films que j'ai réalisés," *Etudes cinématographiques*, nos. 38–39 (Spring 1965): 43–46; reprinted in Schwarz, *Rigour of Imagination*, p. 161.

43. Quotations from Man Ray, *Self Portrait*, p. 101; Man Ray to Tzara, postmarked 8 June 1921, Archives of Tristan Tzara, Bibliothèque Littéraire Jacques Doucet; and Man Ray, "Dadamade," 8 July 1958, reprinted in *Dada: Dokumente einer Bewegung* (Düsseldorf: Kunsthalle, 1958), n.p., and quoted in Man Ray, *Self Portrait*, p. 389.

CHAPTER TWO
MAN RAY, PARIS

Billy Klüver and Julie Martin

Man Ray sailed from New York on 14 July 1921 aboard the *S.S. Savoie*. Shortly before leaving, he had received a letter from Marcel Duchamp.

> I will try to be at the train in Paris when you arrive . . . if you do not see me at the station, take a taxi to 22 rue La Condamine and ask for me, downstairs. I will be in or leave the key (6th floor, *top floor*, right hand door when you get off the elevator). . . . I have arranged a room for you in a little hotel where Tzara lives. He may be gone when you arrive. I suppose you will land about the 22nd. Marcel[1]

The *Savoie* did dock at Le Havre on 22 July; Duchamp met Man Ray at St. Lazare station and brought him to Hôtel Boulainvilliers. Located at 12 rue Boulainvilliers, it was a small, triangular, four-story residence hotel in the sixteenth arrondissement just behind what is now the headquarters of Radio France. Tristan Tzara had moved there in December 1920, after occupying the sofa in the living room of Francis Picabia's mistress, Germaine Everling, for almost a year. Hôtel Boulainvilliers was less than a mile from Everling's apartment at 14 rue Emile Augier, where Picabia had gradually taken up residence since his return to Paris in 1919. Both Man Ray and Duchamp had known Picabia in New York and had corresponded with Tzara on their dada activities. This connection, coupled with Duchamp's recent return to Paris on 16 June, after an absence of a year and a half, and his very short notice of Man Ray's arrival, probably accounts for his putting Man Ray at the unlikely hotel, far from the areas in Paris where most artists lived and worked.

Man Ray described how late in the afternoon on the day of his arrival Duchamp took him to Certà (fig. 75), "a café in the boulevards where the young writers of the Dada movement met regularly before dinner." There he encountered Jacques Rigaut, André

75 Inside Galerie du Barometre, looking north. Café Certà was located at number 11 on the left side of the passage.

Breton, Louis Aragon, Paul Eluard and his wife, Gala, Philippe Soupault, and the medical student Theodore Fraenkel. The group did not hesitate in accepting Man Ray, who was the most active American dada artist and main promoter of dada in New York. Man Ray joined them for dinner and then "went to the fair"—most likely the permanent street fair on boulevard de Clichy—where he was "bewildered by the playfulness and the abandon of all dignity by these people who otherwise took themselves so seriously."[2]

Dada had arrived in Paris January 1920 in the person of Tristan Tzara, one of the original group of dadaists at the café Voltaire in Zurich. He had finally responded to the separate urgings of both Picabia and Breton to join them in Paris and showed up at the doorstep of Picabia's mistress's apartment two weeks after she had given birth to their son.[3]

Breton had met Picabia for the first time only two weeks earlier. Breton and Louis Aragon had founded their own literary magazine, *Littérature*, in March 1919, and late that year had chosen to make their headquarters at the café Certà, in the Passages de l'Opéra—two parallel glass-covered arcades running off boulevard des Italiens, opened in 1822 behind the opera house. The stage entrance of the opera house had been in galerie du Baromètre, which, on Saturdays, the evenings of the *bal masqué*, would fill with elegant costumed opera-goers. But by the time Breton discovered the Passages, the opera had long since moved, and the arcades were filled with small shops selling canes, handkerchiefs, stamps, lace, and books, as well as two hairdressing salons, several small restaurants, and a rooming house with a brothel on the first floor.[4] The dadaists chose a café here because of their "hatred of Montparnasse and Montmartre," the traditional centers of literary activity in Paris. They were also attracted by the Certà's unconventional decor: empty barrels for tables, cane-bottomed stools, and wicker armchairs of various shapes and heights. The specialty of the café was port wine, but cocktails like "Kiss me quick" or "Pick me hup" were also available.

Breton and his group at the café Certà greeted Tzara enthusiastically, and he immediately turned their plans for an evening of sedate literary readings and musical performances on 23 January into a dada manifestation that infuriated the audience and delighted the press. Led by Tzara and Picabia, Breton and the Parisian dadaists launched a year and a half of dada manifestations, poetry readings, theater pieces, exhibitions, magazines, broadsides, and newspaper articles that continued to provoke violent reactions, cre-

ate scandals, and generate notoriety. Although their activities were reported extensively in the press, the dadaists made little headway against the literary and artistic establishment in Paris, whose prevailing temperament favored a *retour à l'ordre* and a reassertion of French classical rationality in art and literature.

By the time the group dispersed for the summer of 1920, the differences in goals and personalities among Picabia, Tzara, and Breton were beginning to surface. Breton had grown tired of Tzara's insistence that dada be spontaneous, unorganized protest and confrontation, with no programmatic aims. Uncomfortable with such nihilism, he wrote, "Exception to the artistic or moral rule gives us only an ephemeral satisfaction . . . over and above this an irrepressible personal imagination . . . will have free reign."[5] He wanted to go beyond dada and launch a new direction in literature; he was already writing about "systematic exploration of the unconscious" and invoking Apollinaire's use of the word *surréalisme*.

Picabia, like Tzara, rejected all efforts to codify dada or inject it with social goals. For him, dada was permanent iconoclasm, continual freedom to create new "conventions," which were to be discarded as soon as they were used. These differences strained relations among the three leaders of the group, and no official dada events were planned for the fall of 1920.

Picabia, however, continued his many-sided dada activities. He published his magazine *391*, wrote articles in the daily arts newspaper *Comoedia*, and submitted his dada paintings to each Salon. He was, in the eyes of the art public, the chief dadaist in Paris, and his fame as an artist rivaled Picasso's. He outraged the other dadaists with his radical and unpredictable actions. Breton, for example, refused to write a preface to his outrageous "philosophical treatise" *Jesus Christ Rastaquouère (Jesus Christ Flashy Foreigner)*. Picabia also made the French dadaists extremely uncomfortable by moving with ease in high society. At the opening of his exhibition at Jacques Povolozky's gallery La Cible on 10 December 1920, the party lasted until two in the morning and newspapers were filled with accounts of Mistinguett dancing to "The Vamp"; the jazz band, comprised of Jean Cocteau, Georges Auric, and Francis Poulenc, performing "New York Fox-trott" and "Tango du Boeuf sur le Toit"; and Tzara delivering a dada discourse on "Weak and Bitter Love."[6]

Increasingly, Picabia found the planning meetings at café Certà to be unbearable, as Breton took authoritarian command of the group, posed serious questions, and probed for answers. He finally stopped going, and the "Grand Season Dada" in the spring of 1921 reflected the ideas and concerns of Tzara and, even more, Breton.

Breton, for example, took over the organization and promotion of the one-man exhibition of the work of the Cologne dadaist Max Ernst. He announced it in the May issue of *Littérature*, wrote the preface to the catalogue, and framed Ernst's collages in his room at Hôtel des Ecoles, rue Delambre, when Ernst, a German citizen, could not get permission to enter France. The opening on 2 May at the bookstore Au Sans Pareil attracted more than one hundred guests, including such luminaries of the Parisian cultural world as critic Louis Vauxcelles, Isadora Duncan, André Gide, Kees van Dongen, Prince Joachim Murat, and Baronne Frachon. The extensive press reports paid more attention to the antics of the dadaists than to the works on the wall: Rigaut loudly counting the cars and the pearls of the visitors; Soupault playing hide-and-seek with Tzara; Benjamin Péret and Serge Charchoune shaking hands constantly.[7]

The last event of the spring 1921 season was *Salon Dada: Exposition Internationale*, an exhibition and series of readings and theater performances organized almost entirely by Tzara at Théâtre des Champs-Elysées (fig. 76).[8] The exhibition included the Germans, Max Ernst, Johannes Baargeld, and W. Mehring; the Swiss, Hans Arp; three Italians, J. Evola, Gino Cantarelli, and A. Fiozzi; and two Americans, Joseph Stella and Man Ray. Man Ray was represented by two photographs of dada constructions, *Man* and *Woman* (figs. 69, 70), which he had earlier sent to Tzara, probably in response to Tzara's request for material for his planned publica-

76 Installation photograph of *Salon Dada*, June 1921. The banner hanging above the ties reads: "Here you see ties and not violins. Here you see bonbons and not marriages."

tion *Dadaglobe*.[9] The bulk of the show was made up of objects, collages, placards, and other works made expressly for the exhibition by Tzara and the French dadaists.

Salon Dada opened the sixth of June and was to run until the thirtieth; however, when the dadaists disrupted one of the performances—a concert of futurist music by Luigi Russolo—the theater manager closed the exhibition and canceled their events. They retaliated by appearing en masse at the première of Cocteau's *Mariées de la Tour Eiffel*, produced by the Swedish Ballet with music by composers from the group Les Six. They ruined the performance by continually changing their seats and shouting "Vive dada!" With his characteristic disregard for dada squabbling, Picabia hosted a reception after the première to which everyone was invited: aristocrats and socialites, the futurists Marinetti and Russolo, Cocteau and Les Six, Ralph de Maré and the members of the Swedish Ballet, and, to their own great discomfort, the dadaists.

By the summer of 1921 the cohesion of the dada group had completely broken down. In May Picabia had publicly withdrawn from the movement in protest against Breton's performance event "Trial by Dada of Maurice Barrès." Breton presided over an attack on the aging French writer, who had abandoned the liberal anarchistic ideas of his youth to become a reactionary superpatriot; other dadaists served as lawyers and witnesses. Georges Ribemont-Dessaignes expressed the feelings of Tzara, Picabia, and himself when he later wrote: "Dada was not present here—Dada could be a thief, a coward, a plunderer . . . but never a judge." Picabia sat in the audience and dramatically walked out on the proceedings. Breton continued to lead his group toward surrealism, while Tzara struggled to keep the international dada movement alive. But dada in Paris had outlived the energy of its first impulses—the confrontation and conflict in the public manifestations had become repetitious and boring to both the public and the participants. Most of the energy that did exist was turned to squabbles among themselves. Picabia turned away from Tzara after members of the Berlin dada movement visited Paris and complained to him that Tzara had not acknowledged their contributions to dada. Picabia also attacked Breton's group in a July issue of *391*, ridiculing the "little Dadas of the café Certà . . . [who] looked as if they had come out of a pickling jar."[10] He then left for several weeks by the sea at Deauville. Tzara left Paris on 20 July to meet Arp and Ernst in the Tyrol, to be joined later by Eluard and Breton. There they composed a rebuttal, "Dada au grand air," which was published when Tzara returned to Paris in October.

It was into this environment of personal animosity, shifting alliances, and arcane public denunciations that Man Ray, American dadaist, was thrown when he arrived in Paris in July 1921. Man Ray was greatly encouraged, though, by his enthusiastic reception at the café Certà. He managed to get his dada objects through customs quickly by the clever stratagem of calling some of them scientific experiments (*Catherine Barometer*, he told customs, was a color guide for his paintings) and others, primitive fetish objects, souvenirs of America to prevent homesickness. He invited "his new French friends" to his hotel room to see his work. Breton, Aragon, and Eluard responded wholeheartedly; and Man Ray reported in a letter to his patron Ferdinand Howald that they were arranging an exhibition for the fall. They then dispersed for summer vacations and Breton became preoccupied with his coming marriage to Simone Kahn. Planning for his show, however, did not begin in earnest until Tzara returned to Paris in the beginning of October.[11]

About a month after he arrived, Man Ray wrote to Howald, "The hospitality and interest of friends has made it possible for me to stay here." Since Man Ray had very little money in his first months in Paris, he had accepted Duchamp's invitation and moved to a room in the apartment of Yvonne Chastel at 22 rue La Condamine, where Duchamp was living. Chastel had been in New York during the war and had traveled with Duchamp to South America in 1918, the summer after her divorce from Jean Crotti, who married Duchamp's sister Suzanne in 1919. Man Ray had also known Chastel in New York and had given her a photograph of his Eighth Street studio with the dedication "in remembrance of our follies for life." Chastel was now designer Paul Poiret's agent in London and was setting up a shop for his Martine designs there. Although rue La Condamine was close to Montmartre, a traditional artists' quarter, Man Ray was still living in a bourgeois neighborhood. His principal artistic activity was his collaboration with Duchamp, who was "working on a series of black-and-white spirals of which he wished to make a film embellished with anagrammatic phrases." On Sundays, Duchamp and Man Ray would go to lunch with Duchamp's brother Jacques Villon in Puteaux. After, they would "set up the old movie camera in the garden and [film] the spirals on an upright bicycle wheel, as it revolved slowly."[12]

Left on his own to wander around the city, Man Ray soon gravitated to Montparnasse, the center of artistic activity in Paris. The history of the artists' community there began in 1810, when Napoleon evicted artists from their studios in the Louvre and they settled in two areas: Montmartre and Montparnasse. In the nine-

teenth century the impressionists made Montmartre the primary center attracting new artists, but by 1910 Montparnasse had taken over this role and the foreign artists who came to Paris settled there. The heart of the quarter was the intersection of boulevard du Montparnasse and boulevard Raspail, where the two great artists' cafés were located: the Dôme, which opened in 1898, and the Rotonde, which opened in 1905. An incredible café life developed that mixed nationalities and personalities as never before. Modigliani, Matisse, Picasso, Soutine, Lipchitz, Brancusi, Diego Rivera, Mondrian, and countless others gathered in a truly international art community. After the war, artists from all over the world began to stream into Montparnasse again. Man Ray remembered: "I . . . found myself indeed in the midst of a cosmopolitan world. . . . I wandered from one café to another, noticed that the groups were quite well segregated—one café was patronized almost exclusively by the French, another by a mixture of various nationalities, a third by Americans and English who stood up at the bar and were the most boisterous." The three cafés he described were the Parnasse, the Rotonde, and the Dôme. The Parnasse (fig. 77), a small establishment next to the older Rotonde, had, in April 1921, been the first café to hang regular group exhibitions of Montparnasse artists on its walls. The legendary proprietor of the Rotonde (fig. 78), Victor Libion, encouraged artists of all nationalities to mix freely. Although in 1921 Libion was selling the café, it remained the favorite of the Montparnasse artists and retained its international atmosphere. The Dôme (fig. 79), with its long wooden bar, marble-topped tables, and billiard table in the back room, had always been the favorite of generations of American artists. "The animation pleased me," Man Ray explained of his attraction to Montparnasse. "I acquired the habit of sitting around in the cafés and made new acquaintances easily."[13]

Despite his complaints about having difficulty with French, all evidence suggests that Man Ray learned quickly and without embarrassment. By the fall he was writing letters to Tzara in a headlong, liberated French, which combined direct translation of conversational English with an overlay of French grammar. And he felt at home in Montparnasse: during Tzara's first days back in Paris in the beginning of October, Man Ray made a date to meet him at the Rotonde at nine o'clock in the evening, despite the fact that both of them were living far away from the Left Bank.[14]

In early December, Man Ray moved into the most famous of the artists' hotels in Montparnasse, taking room thirty-seven at the Hôtel des Ecoles, 15 rue Delambre.[15]

77 Café du Parnasse was absorbed in 1924 by the Rotonde.

78 The tables cover the entire sidewalk outside the Rotonde for the Bastille Day celebration, 14 July 1920.

79 Several rows of tables are set up on the *terrasse* of the Dôme, anticipating a large crowd.

Picabia and Germaine Everling had spent several weeks at Marthe Chenal's summer house at Villers-sur-Mer, near Deauville. Chenal, a popular and highly successful singer, was then being courted by the Baron Henri de Rothschild, who invited all of them to elegant dinners on his yacht in Honfleur harbor and served contraband wild game, shipped to him in a special car from the Pyrenees.[16]

Picabia and Everling returned to Paris in early September; soon after, Man Ray went to lunch at their apartment, where "in his salon stood a large canvas covered with phrases and signatures of visitors. Pots of paint stood on the floor, and I was invited to sign." He wrote on the painting, "Man Ray Directeur du mauvais movies," the same dada tag he had used in a letter to Tzara from New York. In the general enthusiasm of the meeting, Man Ray offered to photograph *L'Oeil cacodylate*.[17] He continued to photograph Picabia's paintings during the next year and also shot pictures of Picabia in his Mercer automobile. Picabia also cut out and added some Man Ray photographs to *L'Oeil cacodylate* sometime after Man Ray had photographed it (fig. 80).

Picabia suggested that Man Ray show his work to Léonce Rosenberg at his Galerie de l'Effort Moderne. After the war, Rosenberg had become the leading dealer for the second-generation cubists and showed Severini, Metzinger, Gleizes, Dunoyer de Segonzac, and Ozenfant. Man Ray left his *Revolving Door* collages with him (figs. 55–64), but Rosenberg, who had very definite ideas about what cubism should be, saw nothing to champion in the American. He did not take him on, nor did he include him in the exhibition *Quelques aspects nouveaux de la tradition*, held in November at the gallery.

Man Ray was given an introduction to Paul Poiret by Gabrielle Buffet, Picabia's first wife, whom he had photographed in New York in 1920 when she was there promoting the French fashion industry.[18] Poiret, France's leading designer before the war, had closed his shop and joined the French war effort in 1914. While in the military, he had been active in promoting French art and design; but in 1919 he had to start his fashion house virtually all over again. Poiret's collections were still eagerly awaited, especially by actresses and performers; but his luxurious, exotic designs did not correspond to the new life-styles of postwar Parisian women, and his business declined.

In late August or early September, Man Ray brought a portfolio of photographs he had taken in New York to Poiret's complex of buildings in a triangular garden at the intersection of avenue d'Antin and rue du Faubourg Saint Honoré. Crossing the garden to

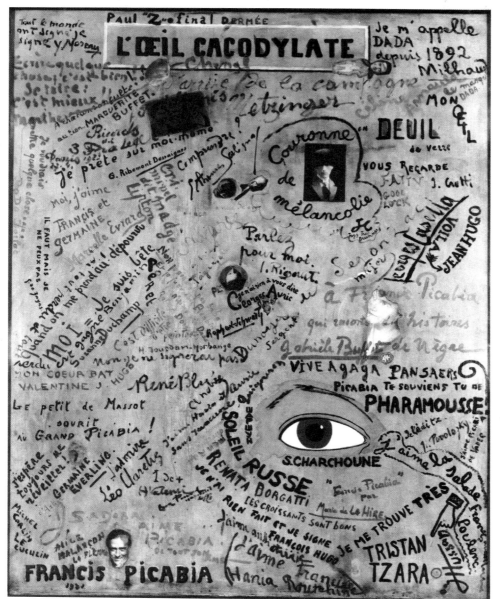

80 Francis Picabia, *L'Oeil cacodylate*, including Man Ray's photographs *Woman with Cigarette* and two versions of *Duchamp Tonsured* (1919), ink and gouache on canvas, Musée National d'Art Moderne, Centre National d'Art et de Culture Georges Pompidou, Paris

Poiret's mansion, the artist was struck by the "brightly painted chairs and little tables scattered about, with a raised platform at the farther end. Over the whole floated an inflated canopy in bright yellow, like a blimp held down by ropes." This was the special inflatable ceiling designed by the auto maker Voisin for Poiret's outdoor night club and theater, L'Oasis, a venture he started after the war to make money to reestablish his design house. In the summer of 1921, Poiret gave elaborate balls and theater performances, which reconstructed the days of Moulin Rouge and the Montmartre café concerts, with all the performers wearing Poiret creations.[19]

Poiret had always had an eye for good fashion photography. In 1911 he had engaged Steichen to photograph his models.[20] When he saw Man Ray's portfolio, he told him "he would like to get some original pictures of his mannequins and gowns, something different." Duchamp remembered that Man Ray "started off brilliantly by meeting Poiret, who took a liking to him. Poiret had him photograph his fashion models, and Man Ray could thus immediately make some sous with his photographs."[21] Although Man Ray did take some photographs of Poiret's models and did sell some to a fashion magazine, there is no evidence that he did a lot of work for the designer, and only a few Poiret prints survive (fig. 81).

Picabia introduced Man Ray to Jean Cocteau "as somebody who knew everybody in Paris." From an early age, Cocteau had been the darling of Right Bank aristocratic literary and artistic salons. During the war, he discovered the artists of Montparnasse and persuaded Picasso to work with him and Erik Satie on *Parade* for Serge Diaghilev's Ballet Russe, a collaboration that launched Picasso in the fashionable circles of Parisian collectors and patrons. Cocteau's involvement with the music and poetry performances at Lyre et Palette in Montparnasse in 1916 brought aristocratic patrons of art and music to the Left Bank and established Cocteau as the spokesman and champion of Georges Auric, Francis Poulenc, Arthur Honegger, Germaine Tailleferre, Darius Milhaud, and Louis Durey, the group of young French composers known as Les Six. The dadaists, of course, violently disapproved of Cocteau, who was the epitome of the social and stylish establishment writer. Picabia maintained good relations with him and his gang, but in true Picabia style, he published Cocteau in *391* even as he attacked him in the pages of that journal.

Cocteau returned to Paris in October 1921, having spent the summer at the seaside resort of Le Piquey, on the Atlantic east of Bordeaux, with his protégé and obsession, the young writer Raymond Radiguet. For many years, Cocteau had been fascinated by things American. His poem "Cape of Good Hope" had been translated and published in the *Little Review*, an American literary magazine, in the fall of 1921; and, as he wrote Valentine Hugo on 1 December, "Americans come to see me and I speak with them in sign-and-grimace language." He could have been referring to Man Ray in this letter, as with his unerring nose for talent, Cocteau had invited the artist to come to his apartment at 10 rue d'Anjou, where he lived with his mother. His drawing room, cluttered with furniture and decorative objects, caught Man Ray's eye, and he made at least two photographs there: Cocteau looking through an empty

81 *Poiret Coatdress with Train*, ca. 1922, photograph. The model stands with Brancusi's sculpture *Maïastra*, which Poiret acquired in 1912.

picture frame, and Cocteau in profile looking at a model ship with complicated rigging (fig. 82). Delighted with these portraits, Cocteau soon brought Radiguet to Man Ray for a sitting.[22] Later, Man Ray photographed three of Les Six, Milhaud, Tailleferre, and Poulenc.

When Tzara returned to Paris at the end of September, he immediately began his efforts to launch the dada artist from America—not only in Paris but also internationally. Man Ray had already received an offer to go to Brussels, possibly through Clément Pansaers, a Belgian dadaist in Paris who was closely allied with Picabia.[23] It was probably Tzara who suggested to Max Ernst that a Man Ray exhibition be organized in Cologne, to which Ernst responded enthusiastically. Letters in early October indicate that Man Ray was planning to go to Cologne, with Ernst offering all his help. Man Ray did not leave Paris, however, and in a letter of 21 October, Ernst offered to arrange an exhibition of his works in Cologne in January or February of 1922 and later a group show—Arp, Ernst, Duchamp, and Man Ray—at Alfred Flechtheim's gallery in Berlin. In the meantime, Ernst wrote, "Please ask Man Ray to send some photographs (about 10) for a photograph exhibition in Köln."[24]

In response to this request, Man Ray took a photograph of Tzara with an ax and clock overhead (fig. 83). On it he superim-

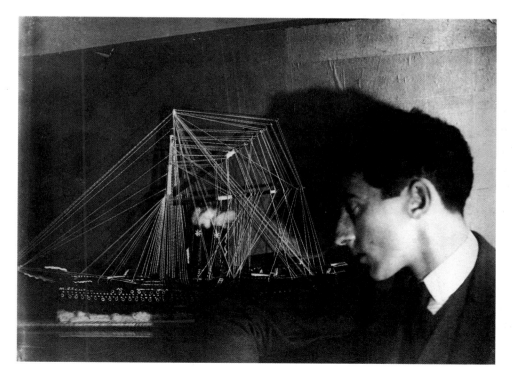

82 *Bateau ivre*, 1921, silver print

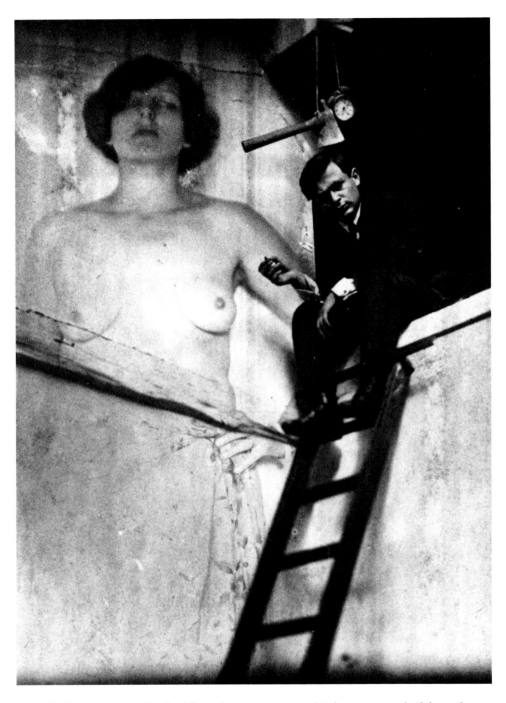

83 *Tzara with Ax*, October 1921, silver print

posed the image of a half-nude woman, which was probably taken at rue La Condamine. Who was she? Of the women in Duchamp's and Picabia's circle, her face most closely resembles that of Madeleine Turban, from Rouen, who went to New York in 1917 to raise money for the French Red Cross. When she told Duchamp that she was estranged from her husband, he offered to share his studio with her. After suffering the displeasure of Yvonne Chastel and an inva-

sion by Isadora Duncan, Turban fled to her own apartment, but remained close friends with Duchamp.[25]

Man Ray sent this composite image and a group of New York photographs to Ernst in Cologne. The exhibition took place in the beginning of November, and Ernst wrote Tzara, "I like Man Ray's photographs very much. I would like to have the pessimistic photograph of you with the Mona Lisa nude lady and the nude lady New York." The other proposed exhibitions in Germany, however, never took place.[26]

Man Ray's first priority was an exhibition in Paris. As he wrote Howald on 12 October, "I want to make my first show in Paris so that I do not appear provincial. . . . I am still dickering with several galleries about a one-man show. Two places have offered me their walls, but it [sic] is too small for a good show."[27] Allowing for a deliberately optimistic account to his patron—in a letter requesting further subsidy—Man Ray was probably referring to two dada bookstores that hosted exhibitions. One of them was René Hilsum's Au Sans Pareil. Hilsum had published and distributed dadaist books and held one-man shows of dada works since 1920. The other was the newly opened bookstore Librairie Six, run by Mick Verneuil, Philippe Soupault's wife. Soupault, a fan of American movies, had adopted what he regarded as "the American tempo," and was described as "forever on the run, like a man of great affairs, arriving breathlessly, doffing his hat, departing as swiftly, for he had many irons in the fire." He was a poet, an editor of the literary magazine *La Revue européene*, and had a government job in the Bureau de Pétrole. Soupault also "led a frantic social life, for according to legend he had admiring lady friends in all the different quarters of Paris."[28] Although it was closer to Montparnasse than Au Sans Pareil, Librairie Six, located at 5 avenue Lowendal, was still far out of the usual art circuit and a small map of its location was included in the catalogue (fig. 84).

Tzara's hand can be seen throughout the organization and publicity for the exhibition: from the wording of the invitation—"cher ami, vous êtes invités au vernissage de l'exposition Man Ray (charmant garçon)"—to the catalogue, which contained a dada biography of Man Ray and statements by Aragon, Arp, Eluard, Ernst, Ribemont-Dessaignes, Soupault, Tzara, and Man Ray himself. The text by Ernst was adapted from a letter he had written to Tzara in October that did not refer to Man Ray at all, since Ernst had not yet seen any of Man Ray's works.[29] Tzara also "enhanced" the humorous, but more subdued, biography Man Ray had written for him in October:

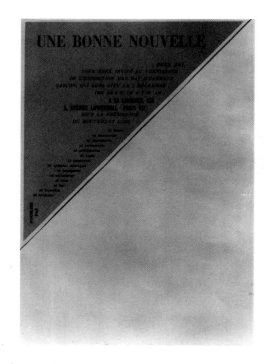

84 The invitation to Man Ray's Librairie Six exhibition, December 1921: "GOOD NEWS Dear friend you are invited to the opening of an exhibition by Man Ray (delightful boy) which will take place the 3rd of December 1921 from 2:30 to 7:30 at Librairie Six, 5 Avenue Lowendall [sic] Paris Vie, under the sponsorship of the Dada Movement. neither flowers, nor crowns, nor umbrellas, nor sacraments, nor cathedrals, nor carpets, nor folding screens, nor metric system, nor spaniards, nor calendar, nor rose, nor bar, nor conflagration, nor candies. Don't forget."

Born in Philadelphia United States 1890, but I always stay in New York, which for me is the United States. I made my first exhibition in New York in 1912. After, I showed in Los Angeles and San Francisco, California, Buffalo, Cincinnati, Philadelphia, Detroit, Worcester, and other cities in America. I am married, but now I don't have a wife and children. I like white wine the best.

Tzara's version read:

Monsieur Ray was born one no longer knows where. After having been successively a coal merchant, several times a millionaire and chairman of the chewing gum trust, he decided to respond to the invitation of the dadaists and show his latest canvases in Paris.[30]

Sometime in November, Man Ray took an "official photograph" of the dadaists, the first of a series of group portraits that he made throughout the twenties (fig. 85). The image is subtle dada: each person carries a version of a cane, and the image of Man Ray appears as if reflected in a mirror held by Paul Eluard.[31] The absence of Breton testifies to his lack of involvement in the exhibition. Aragon, who usually followed Breton's lead in the group's endless disputes, is also missing—although he did contribute to Man Ray's catalogue.

The dada group, splintered and warring by this time, did not

85 *The Dada Group*, November 1921, photograph. Back row (l. to r.): Paul Chadourne, Tristan Tzara, Philippe Soupault, Serge Charchoune; front row (l. to r.): Man Ray, Paul Eluard, Jacques Rigaut, Mick Soupault, Georges Ribemont-Dessaignes.

give Man Ray its full support. The announcement of the exhibition as the first dada event of the winter season, which was sent to the Paris papers on the first of December, was hardly a call to arms: "One reads everywhere in all the journals that dada has been dead for a long time. . . . One has to see if dada is really and truly dead, or if it simply has changed tactics." The article boasted that 118 dada exhibitions were being organized in eight countries and declared that the "dada movement is spreading all over the world with an intensity never seen before." The announcement ended: "The first dada manifestation this winter will be the exhibition of American painter Man Ray, in a bookstore, 5, avenue Lowendal, close to l'Ecole Militaire. The vernissage of this exhibition, Saturday the 3rd of December, will be a sensation."[32]

In late November, the American writer Matthew Josephson, who had arrived in Paris a few months before Man Ray, was introduced to him and Tzara at the Rotonde by Gorham Munson, another young American writer who was to publish a short-lived magazine with Josephson called *Secession*. At this meeting Tzara "explained" dada, and Man Ray invited Josephson to the opening of his exhibition. Although Josephson inaccurately described some of the artworks shown, his is the only account of the mood and activities of the afternoon event:

> For this occasion the ceiling of Librairie Six was festooned with brightly colored toy balloons, which were hung together so closely that one had to brush them aside to see the pictures. The place was filled with young people in their twenties, very bourgeois in appearance and dress, but full of laughter at one another's sallies and capers. Without alcohol they nevertheless seemed intoxicated. Evidently they did not make the mistake of taking Art seriously— with a capital A. At a given signal, several of the young men in the crowd applied their lighted cigarettes to the ends of strings attached to the balloons overhead and all of them went popping off, while the crowd of about fifty persons became as merry as if it were Bastille Day.[33]

There is no description of what further dada "capers" were pulled at the opening. From Josephson's estimate that the guests numbered only fifty young people, it is clear that the ability of dada to draw a large and fashionable crowd had diminished. Picabia arrived alone and toured the show with Man Ray, pointedly ignoring the other dadaists.

During the opening, Man Ray was inspired by meeting Erik Satie (fig. 86) and made the object *Cadeau*, which he added to the exhibition. It disappeared right away, and Man Ray speculated that Soupault took it, as the dadaists collected each other's work.[34]

The ability of the dadaists to attract press coverage had also vanished. Except for an announcement of the opening in the "Les Echoes" column of *Comoedia* on 3 December promising "This will be a real competition of dreams," no further articles or reviews appeared in the press. Equally distressing for Man Ray was the lack of sales. At the end of December he had to decline Tzara's invitation to join him in Cologne for a visit to Max Ernst, explaining, "I haven't sold one thing from my exhibition."[35]

During December Man Ray took part in a curious and abortive attempt by Russian artists and writers to feed into the dada movement in Paris. Serge Charchoune, a Russian painter briefly allied with the dadaists, organized an evening of lectures and readings on 21 December 1921. "Palata Poetov" ("Chamber of Poets") was held at a dingy little restaurant, Le Caméléon, on boulevard du Montparnasse, where since March of 1921 a group of conservative French poets and writers had been meeting in the tradition of the *café littéraire* of the Latin Quarter and Paul Fort's Tuesday evening poetry readings at Closerie des Lilas. Number seven on the program, which was in Russian, was "Amerikanski dadaist: Man Rey." While there is no record of what Man Ray did that evening, Marguerite Buffet, Gabrielle Buffet's cousin, played a piano work by Ribemont-Dessaignes; Breton, Aragon, Eluard, and Soupault read from their works; Charchoune and other Russian poets, including Ilya Zdanevich, just arrived from Tiflis, read from theirs. But the Russians' effort was too late and too foreign to have any lasting effect on the Paris dada scene. Eluard's nasty comment in a letter to Tzara—"I have to tell you about Charchoune's evening. Totally idiotic Russians had tears of boredom in their eyes"—is an indication of the French group's lack of interest in support from this quarter.[36]

Man Ray also participated in the final dissolution of the dada movement in Paris: the controversy over Breton's idea to organize the Congrès de Paris. Breton wanted to hold an international conference of artists and writers to define the new direction of "the modern spirit." He chose an organizing committee representing a wide spectrum of artists and intellectuals: Fernand Léger, Robert Delaunay, Amédée Ozenfant, Georges Auric, Jean Paulhan, secretary general of *La Nouvelle Revue française* (*NRF*), the most prestigious establishment literary journal, and Roger Vitrac, director of

86 *Erik Satie*, 15 February 1922, photograph

104

Aventure, an avant-garde literary journal. The situation deteriorated when Breton viciously attacked Tzara for refusing to join the organizing committee. Tzara, Satie, Ribemont-Dessaignes, and Éluard called a protest meeting for 17 February 1922 at Closerie des Lilas, inviting Breton to explain himself. Matthew Josephson recalled that more than one hundred people filed into the banquet room on the second floor of the restaurant, including Picasso, Matisse, Brancusi, Cocteau, and Radiguet, the group around *NRF*, and several journalists. After "the most tempestuous verbal brawl I have ever seen," recounted Josephson, the group voted to censure Breton. Josephson joined Satie, Tzara, Éluard, Delaunay, and others at another café, where Satie, who had acted as "judge," led the group in composing the resolution of censure.[37] Man Ray and about forty others signed the document, which was released to the press. This was the first and last time Man Ray took sides in the byzantine, internecine quarrels among the dadaists and surrealists. And it was not such a serious side-taking at that, since his top-hat design was used for the covers of the first three issues of the new series of *Littérature* when Breton resumed publication in March 1922 (fig. 87).

87 Cover of *Littérature*, 1 March 1922

By the winter season of 1921–22, the war had been forgotten and the elegant parties were in full swing. The new year started with Réveillon Cacodylate, the New Year's Eve party that Marthe Chenal asked Picabia to organize at her mansion on rue de Courcelles. They each invited their own friends, creating a strange amalgam of politicians, artists, and socialites: Erik Satie and Ezra Pound, Picasso and Ambroise Vollard, Cocteau and Georges Auric, Deputy Henry Pathé and Prince Rospigliosi, all mixed under the watchful eye of the guest of honor, Picabia's painting *L'Oeil cacodylate*.[38]

Some of the guests hopped over to the party given by Comte and Comtesse Etienne de Beaumont at their mansion on the corner of rue Duroc and boulevard des Invalides. Their first postwar costume ball, "Bal de Jeux," was held later that winter, on 27 February.

What Man Ray was doing that New Year's Eve besides taking down his paintings (his exhibition closed on 31 December) may never be known, but on 2 January, Beatrice Hastings ended a passionate, convoluted love letter to Raymond Radiguet with "There is Léger and Man Ray to take me to Mme. Frachon." Baroness Renée Frachon, who had known Brancusi since 1907 and posed for him repeatedly, was one of the aristocratic patrons around dada who had been a prominent guest at Max Ernst's

exhibition the spring before. Her family was from Lyons, as was the young dadaist poet Pierre de Massot. During the fall of 1921 there were plans for a dada exhibition in Lyons, perhaps inspired by her patronage.[39]

Beatrice Hastings, an English writer who had been Modigliani's lover during the war, had fallen violently in love with Radiguet, whom she had met at a dinner party in Brancusi's studio in November. Their stormy affair—which Radiguet encouraged partly to escape the smothering attentions of Cocteau—was becoming more and more one-sided, but Hastings continued to pursue him ferociously. It was probably for this reason that Radiguet and Brancusi, after a preopening party at Le Boeuf sur le Toit, took off precipitously for a two-week stay in Corsica and thus missed the sensation of the winter season, the official opening of the new night club.

The history of Le Boeuf actually began one year earlier in 1921, when pianist Jean Wiéner suggested to Darius Milhaud that a small café selling port wine, Le Gaya on rue Duphot, would be a congenial headquarters for Cocteau and his gang. Milhaud called Cocteau, who "didn't hesitate a minute." Wiéner agreed to play the piano, an American jazz musician, Vance Lowry, played trombone, and a set of drums was borrowed from Stravinsky. The opening was set and "Cocteau with four or five telephone calls alerted all of Paris."[40] The Gaya was an immediate success; from the first day, the place was jammed with people, the tiny street jammed with cars. Soon the bar was too small, and when it closed on 27 June for the summer, the manager, Louis Moyses, began to look for a larger place in the same area around the Madeleine.

It was widely rumored that Cocteau was one of the owners of the new place, but he contributed only the publicity and the name. On 10 January 1922, Le Boeuf sur le Toit opened at 28 rue Boissy d'Anglas, and according to Cocteau, "became not a bar at all, but a kind of club, the meeting place of all the best people in Paris, from all spheres of life. . . . The prettiest women, poets, musicians, business men, publishers—everybody met everybody at the Boeuf."[41]

Man Ray and his photographs were associated with Le Boeuf from the beginning. Swedish journalist Thora Dardel recalled that "portraits by Man Ray of members of the Cocteau gang decorated the wall."[42] When two of Picabia's paintings were rejected from the Salon des Indépendants in January 1922, he handed out flyers on the steps of the Grand Palais with the rejection letter from Paul Signac, president of the Salon, on one side and on the other a Picabian

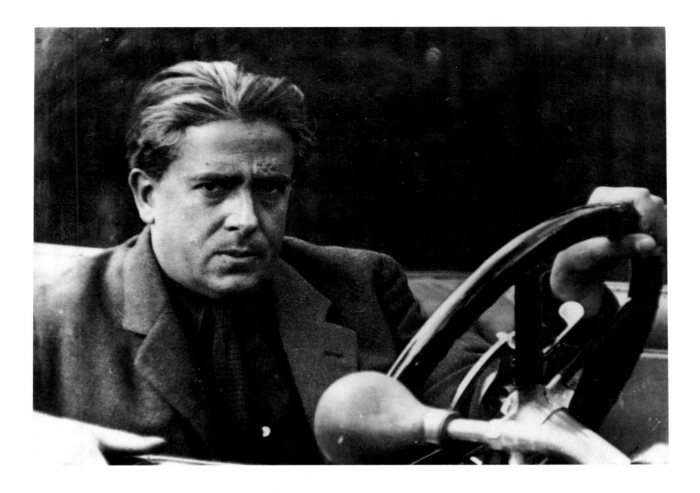

attack on the Salon and the announcement that the "two rejected paintings are on display at bar Moyses, 28 rue Boissy-d'Anglas."[43] One of the paintings, *La Veuve joyeuse*—rejected on the flimsy grounds that the Salon barred photography—prominently featured Man Ray's photograph of Picabia in his Mercer (fig. 88). Picabia's other painting, which also incorporated Man Ray's photos, *L'Oeil cacodylate*, was acquired by Moyses and hung at Le Boeuf for many years. Man Ray went regularly to Le Boeuf, and his connection with this phenomenally successful place helped to establish his reputation in fashionable Paris.

Picabia had encouraged Man Ray to submit work to the Salon des Indépendants, which in 1922 ran from 28 January to 28 February. Man Ray sent three pieces—described in a letter to Howald as "a 1913, 1917 and 1921," and listed in the catalogue as *Le Fond*, *Boardwalk* (fig. 36), and *Catherine Barometer* (fig. 112). Although Man Ray wrote that he received "some amusing notices and compliments," his works were, like those of the other dadaists in the

88 *Picabia in His Mercer*, 1922, photograph. Picabia used an uncropped version of this Man Ray photograph of himself in the painting *La Veuve joyeuse*, submitted to the Salon des Indépendants in January 1922.

Salon, Jean Crotti and Suzanne Duchamp, virtually ignored in the scandal surrounding the rejection of Picabia's pictures. Man Ray essentially felt that he had made no headway with critics, dealers, or collectors in his attempts to "do something with my painting." He ended his letter: "If I could make an income and have a couple of friends to enthuse with me over ideas and things, I should never enter the art market, and never exhibit. I may do so in the near future."[44] Man Ray must have informed his friends of his decision, as all plans for his exhibitions in Germany appear to have ended, and Duchamp wrote him from New York in the spring of 1922, "I am delighted to know that you are having fun and above all that you have given up painting."[45]

Man Ray quickly established a new priority: "[I] now turned all my attention to getting myself organized as a professional photographer, getting a studio and installing it to do my work more efficiently. I was going to make money—not wait for recognition that might or might not come." While he had been doing portrait photography seriously since his first days in Paris—his portraits of Picabia, Tzara, Cocteau, and Radiguet were definitely taken before his exhibition in December—it was not until January or February of 1922 that he decided to make portrait photography his source of livelihood and began in earnest to pursue clients. There was also a sense of excitement in his decision. It took him out of what he called the "fierce competition among painters here" and gave him universal entrée in Paris: "My new role as photographer has made it possible to go everywhere and be much talked of."[46]

Man Ray's first portrait work was done in the art community. He wrote in his memoirs that he took many photos of artists' works during his first year; in particular, he recalled: "My first meeting with [Picasso] was for the purpose of photographing his recent works, in the early Twenties. As usual, when I had an extra plate, I made a portrait of the artist." No photographs of Picasso's paintings, however, have surfaced.[47] Furthermore, Man Ray's letters to Howald and Tzara during the spring and summer of 1922 indicate that Braque, Gris, and Matisse came to him specifically for portraits. Man Ray was greatly amused by the discussion between Matisse and Breton that took place at his studio when Matisse came to be photographed (fig. 89): "Breton was at my place this morning at the same time as Matisse, they argued for one hour. It was funny like two men who speak different languages. It was astonishing. A man like Matisse who talks of the necessity of drawing a hand like a hand and not like a box of cigars." At the time, Breton was advisor to the couturier-turned-collector Jacques Doucet and en-

89 *Matisse*, August 1922,
photograph

couraged him to buy work by Man Ray. Doucet purchased a
painting and three photographs: the upside–down woman smoking
a cigarette, for 200 francs, and two portraits of Picabia, at 25 francs
each.[48]

One important source of clients was the British and American
community in Paris. Man Ray made contact with the American
expatriates very quickly, since he met Gertrude Stein not at one of
her salons but at the hotel suite of an affluent American couple, the
Willie Dunbar Jewetts, who owned a tenth-century château near
Perpignan, where Gertrude and Alice had met them during the
war.[49] Stein, as good a sniffer of talent as Cocteau, made an ap-
pointment with Man Ray to take a photograph of their friend
Jeanne Cook, the French wife of the American painter William
Cook, who had been in Paris during the war. Stein described his
studio at Hôtel des Ecoles:

It was one of the little, tiny hotels on rue Delambre and
Man Ray had one of the small rooms. But I have never
seen any space, not even a ship's cabin, with so many
things in it and the things so admirably disposed. He had a
bed, he had three large cameras, he had several kinds of
lighting, he had a window screen and in a little closet he
did all of his developing. . . . He showed us pictures of

90 *Gertrude Stein and Alice Toklas in 27 rue Fleurus*, ca. 1922, photograph

Marcel Duchamp and a lot of other people and he asked if he might come and take photographs of the studio and of Gertrude Stein.

91 *James Joyce*, January 1922, photograph

Man Ray went to rue Fleurus to photograph her and Toklas (fig. 90), later recalling that his "portraits of Gertrude Stein were the first to appear in print."[50] He also photographed Stein as she sat for a portrait bust by the American sculptor Jo Davidson, published in *Vanity Fair* in February 1923. Man Ray's connection with the American art community in Paris was minimal, however: there are no early portraits, for example, of Charles Demuth, Morgan Russell, Patrick Henry Bruce, Gerald Murphy, or long-time residents of Montparnasse like Janet Scudder and Jo Davidson.[51]

Man Ray's association with the English-speaking writers in Paris was not close; but Sylvia Beach, proprietor of the bookstore and expatriate literary gathering place Shakespeare and Company, referred many of the prestigious British and American novelists and poets to him for photographs. It is not clear when Man Ray met her, but she sent James Joyce to him in January 1922 for publicity photographs for the forthcoming publication of *Ulysses* (fig. 91), which came off the press 12 February. Beach continued to send

writers to him; although Man Ray photographed them with little enthusiasm and less profit, there was a "growing collection of English writers on the walls of Sylvia Beach's book shop," and his files ultimately contained portraits of most of the well-known writers who came through Paris in the twenties (figs. 127, 129, 130, 158).[52]

Sylvia Beach had close ties to the Parisian literary establishment through her friend and fellow bookstore owner Adrienne Monnier, but Man Ray photographed none of the leading French writers, such as Colette, André Gide, or Paul Valery. The exceptions were Proust, photographed on his deathbed in November 1922 at the request of Cocteau (fig. 92), and St. Pol Roux, an older poet who had been "rediscovered" by Breton and the surrealists.

During these early days in Paris, Man Ray was also involved in making erotic photographs, though little of this work has shown up. In his memoirs he described one occasion when a young model asked him to take nude photos of her so that she would not have to undress when being interviewed by a painter. He agreed, as long as she brought another model with her so he could make some compositions for himself. On the day of the sitting, "the two nudes were more at ease than if they had been alone; at my suggestion, they even took some intimate poses with arms around each other, making for rather complicated anatomical designs." From this ses-

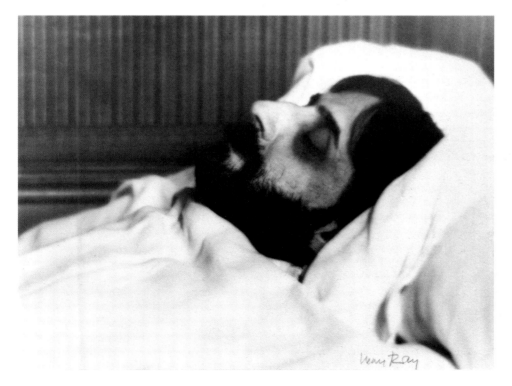

92 Man Ray got up from his sickbed to take this *Deathbed Portrait of Marcel Proust*, November 1922, silver print

sion Man Ray produced a series of very delicate prints, "which were much admired."[53] Among the people he showed them to was Henri-Pierre Roché, who noted his first visit to Man Ray in his diary on 8 May. "Man Ray," he wrote, "makes 99 photos of me with his large electric lamp. . . . A beautiful portrait of Marcel Duchamp hangs on the wall. . . . Man Ray shows me very moving pictures of lesbians, in the eight most lavish poses. I know one of these beautiful girls. Then two photos of love making between a man and a woman." Roché was pleased with his portrait, which he thought made him look like a movie director, and continued to see Man Ray for the next several years. He would bring photos he had taken of one of his many lovers for the artist to develop and enlarge.[54]

The Marquise Casati (fig. 93), a former lover of the Italian poet Gabriele d'Annunzio and a ubiquitous, though eccentric, member of Parisian aristocratic circles, appeared in Man Ray's hotel room on rue Delambre in the winter of 1922 and invited him to come to her home to make her portrait. As he described in his memoirs, he blew the fuses with his lights, just as he had done at Poiret's. The result was his famous photograph with three pairs of eyes (fig. 94), which the marquise adored, claiming it "portrayed her soul." She ordered dozens of prints and sent them to her friends

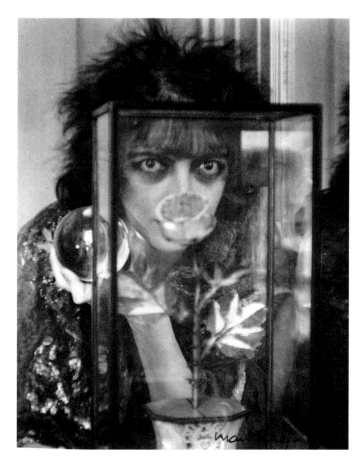

93 *The Marquise Casati with Plant and Ball*, ca. 1922, silver print

94 *Marquise Casati*, 1922, silver print

112

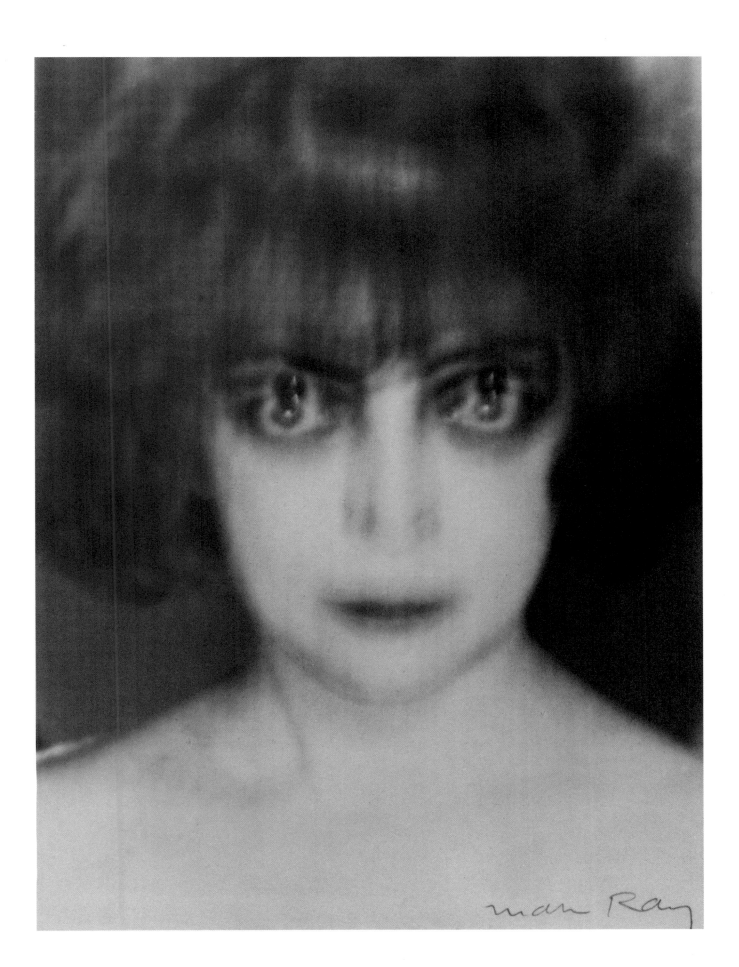

all over Paris. Other aristocratic clients followed later in the twenties.[55]

It was probably through Cocteau that Man Ray met and photographed Comte Etienne de Beaumont, who invited him to take pictures of guests at his balls (fig. 95). Some of his most famous images are from the ball the Beaumonts hosted in honor of "Les Soirées de Paris," a series of theater and ballet performances that Beaumont sponsored in June 1924, which included the ballet *Mercure* with sets and costumes by Picasso, a version of *Romeo and Juliet* by Cocteau, and a performance of Tzara's play *Mouchoir des nuages*. The photographs include Tzara kissing the hand of Nancy Cunard, Picasso in toreador costume with Olga Picasso and Mme. Eugénia Errazuriz (fig. 96), and the sweeping image of Comte de Beaumont and his cousin the Marquise de Jaucourt, taken from the back as they were going through the doorway.

One of Man Ray's most amusing encounters was with the elderly Countess Elisabeth de Greffulhe—who had provided Proust with the model for his Duchesse (and Princesse) de Guermantes.

95 *Comte de Beaumont,* ca. 1924, photograph

96 *Picasso as Toreador at the Comte de Beaumont Costume Ball,* spring 1924, photograph

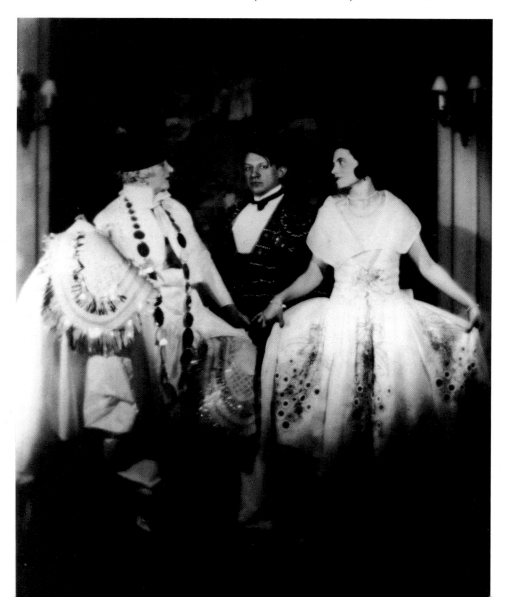

She sent Man Ray a special invitation—complete with map and chauffeur—to come to her country home and teach her photography. After a staid lunch, she took him to her makeshift studio, where a sheet hung at one end of the room and one bare light bulb was attached to the back of a chair, and insisted on making his portrait. As the countess fiddled with her old plate camera, Man Ray prepared for a long exposure time: "I put my hand back against the sheet, but it met empty space. I lost my balance, fell backward . . . and landed in a bathtub." Later Man Ray developed and printed the plates; and although the countess was enthusiastic, he turned down her offer to collaborate with H. G. Wells on a spiritualist film. "It always irritated me when someone looking at my work immediately conceived the idea of applying it to his particular interests," he complained. Man Ray was willing to accommodate editors and advertisers with what he called his "less esoteric work," but his "more creative productions" would be done "according to [his] own ideas."[56]

Man Ray rarely took on students or gave lessons to friends. One exception was Bryher, a rich Englishwoman who married the American writer Robert McAlmon to gain independence from her parents. She was in Paris in the summer of 1923 and took lessons in photography with Man Ray.[57]

Although Man Ray started by photographing Poiret's models, he did not pursue run-of-the-mill work photographing collections for designers. Instead, he specialized in magazine assignments, making fashion photographs of fashionable women. By the mid twenties, he was extremely well known, with commissions from journals throughout Europe and America. Some of his earliest work was done for the woman's magazine *Charm*, published by Bamberger's, a New Jersey department store. In the November 1924 issue, a photograph of Kiki accompanied an article on models in Paris by Djuna Barnes. Man Ray's first fashion spread was published in December of that year: photographs of models' heads to accompany an interview by Barnes of the fashionable hairdresser Antoine.[58] For the March 1925 issue of *Charm*, he assembled a remarkable portfolio of photos of international socialites living in Paris: "Princess Eristiva, Countess Schoenborn, Mme Robert Pignet, Mrs. Hasting-Barbour, and Madame Bagénov, all of whom the author of the accompanying article assures his readers are *'dames de qualité'* who are the synthesis of elegance."[59] In the same issue, Man Ray contributed photographs of Suzanne Duchamp (fig. 97), Hélène Perdriat, Marie Laurencin, and Hermine David for an article by Florence Gilliam, "Paris Women in the Arts," and his photo of Jeanne

97 *Suzanne Duchamp*, published in *Charm*, March 1925

Lanvin at her desk accompanied an interview with the eminent couturière.

Thora Dardel, wife of a Swedish painter living in Paris and journalist for the Swedish weekly *Bonniers Veckotidning*, regarded Man Ray highly and frequently bought and commissioned photos by him to illustrate her reports from Paris. The first Man Ray photograph published in the magazine was of Kiki, in the summer of 1924. In 1925, Dardel also did "Three Parisian Women Artists," a picture story using two photographs Man Ray took for *Charm*, of Marie Laurencin and Hélène Perdriat, as well as a picture of Irène Lagut. A double spread featured his photographs from the June 1924 Beaumont ball; and his picture of Peggy Guggenheim wearing a dress by Poiret was reproduced full page (fig. 98). Dardel vigorously defended Man Ray when her editor, Ake Bonnier, complained that 500 SKr (1,500 francs, or $125) was an outrageous fee to photograph the Russian duchess Maria Pavlovna, former wife of Prince Wilhelm of Sweden.[60]

The French, too, commissioned Man Ray's talent. In 1925 he photographed the exhibition of stylized manikins wearing fashions by various designers in the Pavillon de l'Elégance at the Grand Palais, part of the International Exposition of Decorative Arts.

Man Ray found more in photography than just a means of making a living. In the spring of 1922 he was writing Howald excitedly about "my new work," in which "I have reached the climax of the things I have been searching the last ten years—I have never worked as I did this winter. . . . I have freed myself from the sticky medium of paint and am working directly with light itself." In his next letter to Howald, at the end of May, he was completely confident of his new work that "uses photographic materials without the camera: objects found or forms constructed by myself intercepting arranged lights that are thrown on sensitive paper. Each work is an original." During the previous winter, Man Ray had been able to set up his darkroom properly after he moved into Hôtel des Ecoles in early December, and it was at that time that he accidentally discovered the rayograph process (fig. 99).[61]

These "dada photographs," as Tzara enthusiastically called them, elicited an immediate response not only among the dadaists, but also in other quarters, where they were seen as an artistic breakthrough. Poiret bought two "because he liked new experiments"; and Henri-Pierre Roché commented, "The photos of Man Ray, objects put directly on sensitive paper, each one unique like a painting: remarkable."[62] Cocteau published one in the April–May

98 *Margueret (Peggy) Guggenheim*, 1925, silver print, published in *Bonniers Veckotidning*

99 Untitled, 1922, rayograph. In this rayograph, Man Ray incorporated a previous object, *Compass*, and his room key at Hôtel des Ecoles.

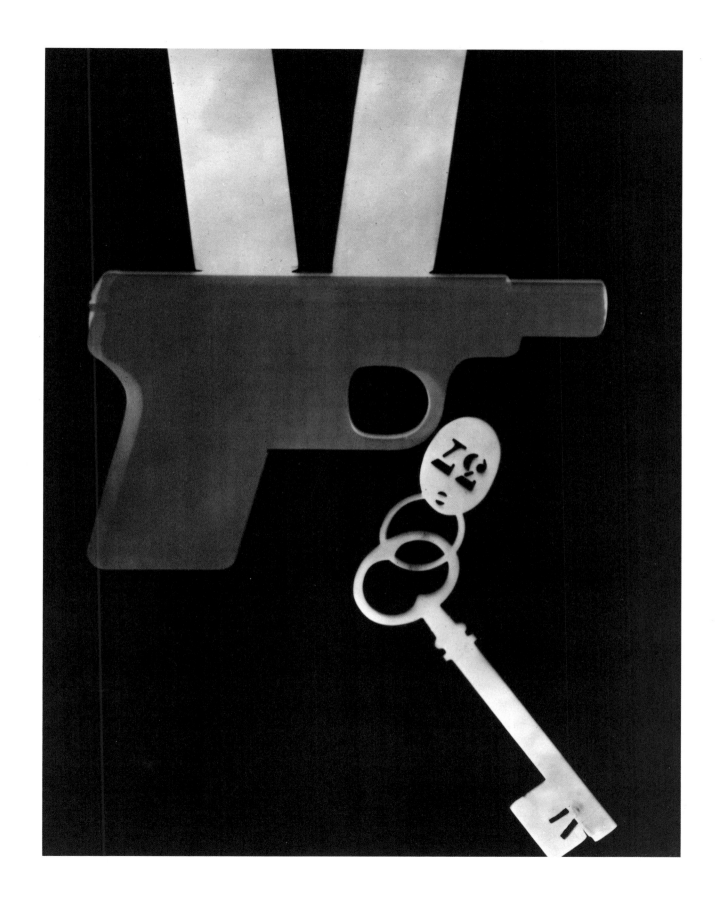

1922 issue of the art and literary magazine *Les Feuilles libres*, with an adulatory "Lettre ouverte à Man Ray, photographe américain," in which he enthused, "Man Ray has delivered painting anew." By the end of May, Man Ray had sold twelve of the pieces; and Frank Crowninshield, editor of *Vanity Fair*, had taken four for the November 1922 issue of that influential magazine. The full-page spread, entitled "A New Method of Realizing the Artistic Possibilities of Photography," included a photograph of Man Ray and the four works (fig. 100). It was the only time he gave them long, descriptive dada titles, indicating his involvement with the movement at this period. The article stated that Man Ray called the

100 "A New Method of Realizing the Artistic Possibilities of Photography," *Vanity Fair*, November 1922

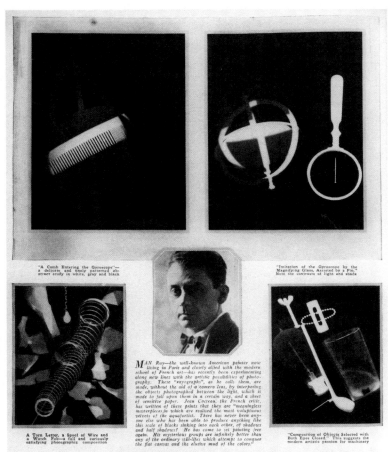

A New Method of Realizing the Artistic Possibilities of Photography

Experiments in Abstract Form, Made without a Camera Lens, by Man Ray, the American Painter

works "rayographs"; in European journals, however, they continued for several years to be referred to as "photographs." In the fall Man Ray published a limited-edition album of twelve new images, *Les Champs délicieux*, with a preface by Tzara.

Man Ray's paintings and photographs appeared frequently in the avant-garde magazines of the early twenties; Picabia published his photographs in *391* even before Man Ray arrived in Paris. In January 1922, a reproduction of a *cliché-verre* (an image developed from a drawing done directly on a photographic plate) that he had made in New York was published in the short-lived Paris journal *Aventure*, headed by Roger Vitrac. *Der Sturm* in Berlin also published reproductions of two of his *cliché-verre* drawings in its special March 1922 "Paris Dada" issue. *Broom*, published by Harold Loeb and Matthew Josephson in Italy and Berlin, reproduced the painting *Sequidilla* in November 1921 (fig. 111); the March 1923 issue featured a cover by Man Ray and four rayographs. In the fall–winter 1923–24 issue of the *Little Review*, Man Ray published four rayographs, after having published another in the autumn 1922 issue. And in 1925, Thora Dardel published an article on his work in *Bonniers Veckotidning*, "The Most Modern Photo Art," and reproduced three images.

One of the reasons for Man Ray's burst of creative energy during the winter and spring of 1922 may have been his love affair with Kiki. Soon after he had moved to Hôtel des Ecoles in Montparnasse at the beginning of December, he spotted her.

> I was sitting in a café one day chatting with Marie Vassi-
> lieff. . . . Across the room sat two young women, girls
> under twenty, I thought, but trying to look older with
> heavy make-up and the hairdo then in fashion among the
> smart women, short cut with bangs low on the forehead.
> The prettier one had curls coming down on her cheeks in
> the manner one associated with the girlfriends of Parisian
> apaches. She waved a greeting to Marie, who told me it
> was Kiki, favorite model of the painters.[63]

Kiki was born Alice Prin in Chatillon-sur-Seine in Burgundy in 1901. Her unmarried mother soon went to Paris, leaving her to be raised by her grandmother, who made a precarious living doing laundry for well-to-do families. When Alice was twelve, her mother brought her to Paris. One year later, Kiki left school and went to work as a knitter's apprentice at 50 centimes a week—the first in a series of menial jobs she had over the next few years

before she found her way to the artists' community in Montparnasse. When she was seventeen, she fell in love with a Polish painter, Maurice Mendjiszky, whom she probably met through Chaim Soutine, and moved in with him. Her name as a model was made when Moishe Kisling, a Polish painter who had lived in Montparnasse since 1910, noticed her at the Rotonde in 1918. He shouted, "Who's the new whore?" and after a friendly exchange of insults, asked her to pose for him. Although Kiki insisted "most of the time I was a mess as a model," Kisling painted her again and again during the twenties.[64]

101 One of Man Ray's first photographs of Kiki, taken in front of a make-shift screen in his hotel room, 1922

At their first meeting, Man Ray invited Kiki to dinner and the movies, where they held hands in the dark. At the end of the evening, he asked her to pose for him. She hesitated, saying that photographs were too realistic and factual. Man Ray promised her that he "photographed as [he] painted, transforming the subject as a painter would." Encouraged by Marie Vassilieff, Kiki agreed and went to Hôtel des Ecoles. Man Ray wrote that at the first session, "I got her to take a few poses, concentrating mostly on her head; then gave up . . . my mind wandered, other ideas surged in." They went out to dinner. The next morning he "made some prints on proof paper exposed in printing frames to daylight. . . . [T]hey really looked like studies for paintings or might even be mistaken at a casual glance for reproductions of academic paintings." Thus, he produced images beautiful enough for Kiki to agree to pose again (fig. 101). At the second session, they fell into each others' arms, and Man Ray's love affair with the most celebrated woman in Montparnasse began. It would last nine years. Kiki moved in with him: "[H]e photographs folks in the hotel room where we live, and at night, I lie stretched out on the bed while he works in the dark."[65]

By the end of his first year in Paris, Man Ray was fully part of Montparnasse. The poster announcing a benefit costume ball, "Fête de nuit à Montparnasse," listed him as one of the forty sponsoring artists, along with Gris, Léger, Picasso, and Picabia, and nine writers including Cocteau, Tzara, and Huidobro. It was to be held at Bal Bullier, the large dance hall across boulevard de L'Observatoire from Closerie des Lilas, on 30 June 1922, and it promised such attractions as clowns, dances, miracles, jazz, sports, and Kisling as bartender. Man Ray was the only American artist involved.

All that remained was to settle into a permanent studio. This was very much on Man Ray's mind when he wrote Howald at the end of May 1922: "I am still living and working in a hotel room which is very cramped and expensive. But studios here are impossi-

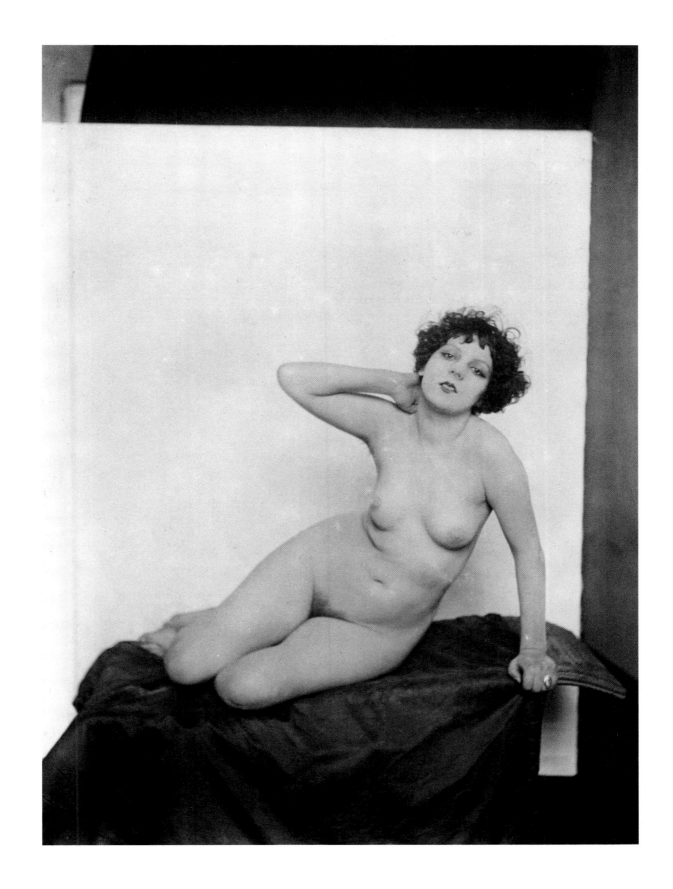

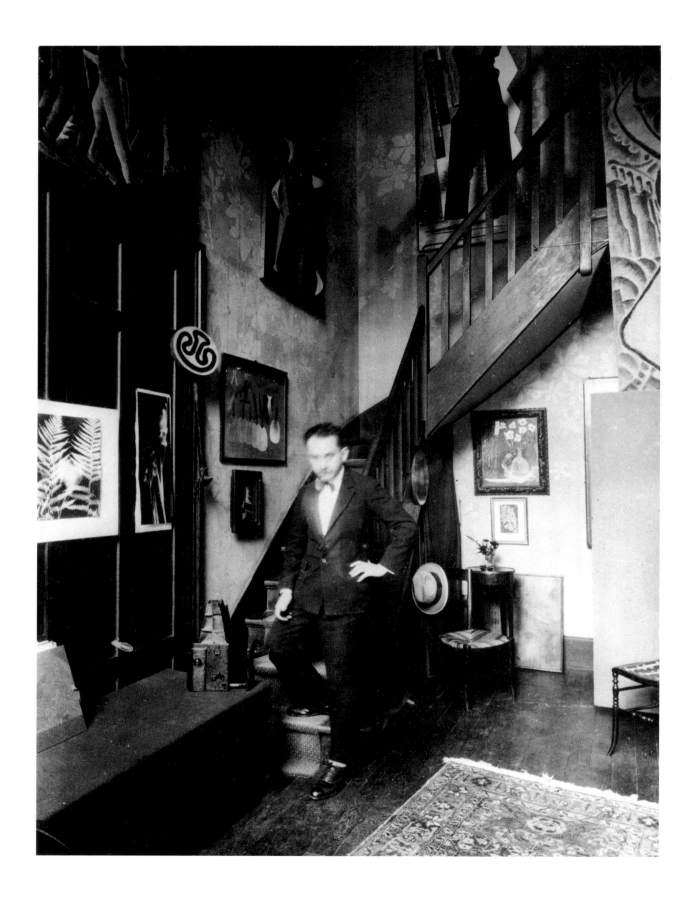

ble—without water or light for the night unless you can pay a huge price, and then you first must find it."[66]

Man Ray did find what he was looking for. On the first of July (the beginning of the third quarter in the Parisian rental year), he moved into a studio building at 31 bis rue Campagne Première. Built by the architect Arfvidsson in 1911, the building departed from conventional studio design by combining the work space with an apartment. A glowing review of the building in an architecture magazine described the concept:

> On the level of the studio is the entrance, diningroom, kitchen, etc. On the floor above is the living room (with a loggia facing the studio), bedrooms, bathrooms, etc. An internal staircase connects the two floors. . . . The size of the living arrangements vary from the studio of a *célibataire*, which has only one room with a *cabinet de toilette*, up to the studio of the head of a family, which has an apartment with four bedrooms.[67]

Comfort was emphasized: the building had an elevator, central heating, gas, and electricity. Tenants could, for 50 francs a year, have their own telephone, or they could use the phone in the concierge's apartment for free. The price of the smallest studio was 1,600 francs per year when the building opened—at a time when an artist, if careful, could live for 100 francs per month.[68] Man Ray chose a *célibataire* apartment located on the ground floor, to the left of the 31 bis entrance (fig. 102). The studio was 15 by 25 feet, with a large window facing the street. At the opposite side of the studio, a staircase led to a fair-sized landing with toilet and sink and a *soupente*, or balcony, 10 by 29 feet. At the end of it, facing the street, was a round window located above the entrance. It was here that Man Ray set up his darkroom. When he wrote Duchamp about his new apartment, Duchamp—who had friends living in a sculptor's studio in the courtyard—replied, "A studio in that building is a remarkable thing."[69]

The block between rue Campagne Première and rue Boissonade contained hundreds of artists' studios, where American artists had lived since the 1870s. Man Ray may also have been attracted to the building because, standing outside his door, he could see the sign "Photographie" on the top of the building at the end of the street, at 151 boulevard du Montparnasse (fig. 103). And Atget had lived for many years at number seventeen. Man Ray settled here until 1933.

102 Man Ray in his studio at 31 bis rue Campagne Première, 1922

103 *Boulevard du Montparnasse*, ca. 1930, photograph. The sign was over the photography studio of Georges Allié.

Soon after he moved in, the artist gave a housewarming party, "inviting all the people I knew in the Quarter as well as more distinguished people from other parts of town. Most of the Dadaists came too, and each guest brought a bottle." The party was a huge success. Tzara found a pail and mixed all the bottles of liquor together; Rigaut, impeccably and formally dressed, chased all of the unattached girls. Kiki suddenly gave Man Ray a "resounding whack on the side of [the] head," followed by a "torrent of invectives" for being "particularly attentive to two young girls, daughters of a famous general, whom [he] anticipated as future models or clients." But all in all, everyone went home drunk and happy, leaving Man Ray to make up with Kiki and apologize to the neighbors for all the noise.[70]

By the end of his first year in Paris, Man Ray was firmly established in Montparnasse and was living there the way he wanted. He had a studio, a mistress, a means of making a living, a circle of friends who supported and encouraged him, and he was pursuing his own work in a medium that stimulated and excited him. Thirty years old when he arrived in Paris, Man Ray had already created a considerable body of work and painted a number of extraordinary paintings in New York. He was a dadaist in New York, and he remained so in Paris. It was his own energy, initiative, and talent that propelled him to acceptance in the Parisian avant-garde art community—not the introductions, contacts, and connections of others. He quickly chose the things and people he wanted to be associated with and made his own way. He found Montparnasse on his own, for example, and decided to live there, though the dadaists disdained it. It was also typical of Man Ray that both Picabia and Cocteau—the most dada and least dada of all Parisian artists— appreciated his talent, gave him work, and brought him clients during his first year; and that both Breton and Tzara, who at the time would not even speak to each other, promoted his work.

When Man Ray decided to support himself with his camera, he pursued "straight" photography with all the directness and energy he had shown in his art. He took photos of artists and writers, which were distributed among their friends, attracting an ever-wider circle of clients. He diligently developed a standing among the "carriage trade," which brought him clients for portrait work and had French socialites begging him to come to them. Increasingly lucrative commissions from American and European fashion magazines followed.[71]

In his private life, too, Man Ray set up his own structure. He

did not become a "regular" in any group: he did not attend Gertrude Stein's Saturday receptions, join Pascin's weekly dinners and rounds of night clubs, or sit with Breton's group at the café Certà. He had his private life with Kiki, but he would not accompany her every night when she went to the Rotonde or later sang at the Jockey, nor would he take her to the fancy places he went in connection with his commercial work. He went to the elegant costume balls not for the sake of being there, but to take photos. The life he established related strictly to his work.

In addition to his highly paid commercial activities, Man Ray continued to photograph artists and writers in Paris during the twenties. By far his greatest involvement was with the dadaists-surrealists. He took innumerable portrait photos of them, individually and as a group. He created surrealist photo images—*Violon d'Ingres* (fig. 262), *Noire et blanche* (fig. 164)—which were published in their magazines. He took part in group exhibitions arranged by them—in fact, his was the inaugural exhibition at the Galerie Surréaliste in March of 1926.

Man Ray continued a close relationship with Duchamp and Picabia and collaborated on projects with them. During the fall of 1924, Picabia was working with Erik Satie on the ballet *Relâche*. At the time, Picabia, Duchamp, Satie, and Man Ray all had rooms at the Hôtel Istria, on rue Campagne Première, next door to Man Ray's studio. All four performed—Man Ray and Duchamp playing a game of chess on the roof of the Théâtre des Champs-Elysées—in *Entr'acte*, the film by René Clair for which Picabia wrote the scenario. When *Relâche* premiered on 4 December of that year, *Entr'acte* was shown at the intermission. Encouraged by their success, Picabia created and Clair directed a new spectacle, `Ciné-sketch,` presented on New Year's Eve at the theater. Man Ray performed as "talker." His photo of Duchamp and Bronia Perlmutter as Adam and Eve is the only documentation of the performance (fig. 104).

Later in the twenties, the artist also developed a close relationship with the younger surrealists at 54 rue du Château—Yves Tanguy, Georges Duhamel, Georges Sadoul, and André Thirion—and he documented some of the goings-on at this lively establishment.

Kiki was his favorite model; he photographed her over and over again throughout the twenties (figs. 105, 106). He made portraits of his friends, but he did not spontaneously photograph everyone in his immediate environment, as Kertész did, for example. Right away he photographed the well-known artists he admired: Picabia, Cocteau, Picasso, Braque (fig. 107), Gris, Matisse,

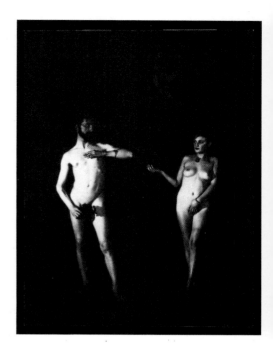

104 *Ciné-sketch: Adam and Eve* (Marcel Duchamp and Bronia Perlmutter), 1924, silver print. René Clair fell in love with Perlmutter during the performance, and they married soon after.

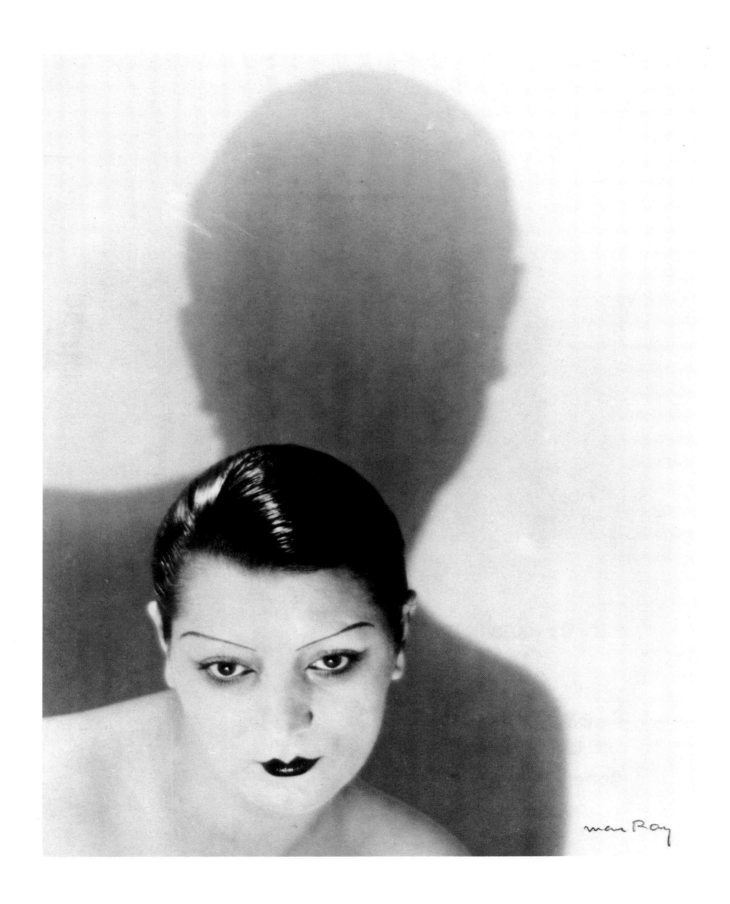

126

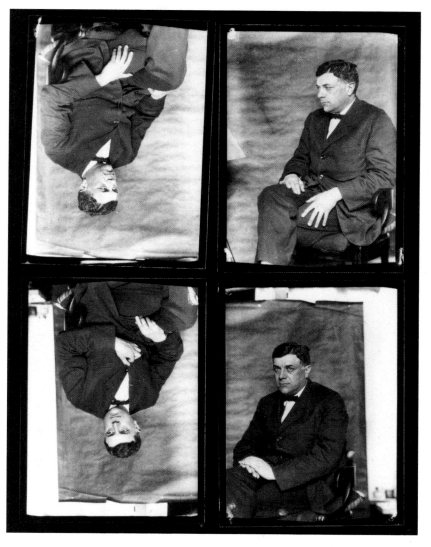

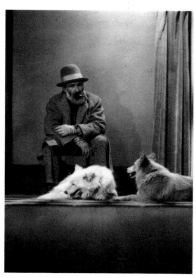

Léger, and Brancusi (fig. 108). However, he did not photograph many of the artists who became wealthy and popular in the twenties: Van Dongen, Kisling, Soutine, Dufy. Some, like Derain, Delaunay, Vlaminck, Pascin, and Foujita, sat for him later in the twenties. He never photographed the Montparnasse cubists: Metzinger, Severini, Gleizes, Dunoyer de Segonzac, Ozenfant—the group around Léonce Rosenberg's gallery; nor did he ever photograph critics, gallery owners, and collectors, though he did make a portrait of Jacques Doucet, who had bought some work from him.

Although it is surprising that an artist as talented as Man Ray was unable to become successful as a painter, it is not surprising that the dadaists were unable to launch his career in Paris. The Parisian art public had grown bored with dada antics by the fall of 1921, so the announcement of a new dada season could not generate

excitement for Man Ray—or anyone. The movement itself was crippled by internal dissension and family squabbles. Neither Breton nor Picabia showed any interest in publicly putting their prestige behind Man Ray's exhibition. His vernissage was a far cry from Ernst's crowded opening the previous May, and the exhibition was virtually ignored by the press. Man Ray's show was not only the first dada event of fall 1921, it was also the last dada event of that season. Strictly speaking, it was the last dada event ever.

But more important, dada in Paris was, as Duchamp had pointed out, a movement "relating rather to literature than to painting."[72] Most of the leading dadaists—Tzara, Breton, Aragon, Soupault, Eluard—were writers who were not interested in promoting painters but in promoting dada. Along with literary and theater events, they did organize exhibitions of "dadaist painters," but they did nothing to develop the support structure of critics and dealers necessary for an artist to survive by his work. The exhibitions at the bookstores, Au Sans Pareil and Librairie Six, or at Galerie Montaigne in the Théâtre des Champs-Elysées were not tied in with the Parisian gallery network. No galleries, collectors, or dealers were committed to dada artists at this time, as they would be four years later with the surrealist painters.

On the other hand, the art market in Paris was booming after the war, and the number of galleries and shows devoted to modern art grew rapidly during the twenties. There were people willing to sell art and buyers looking for new art. It is inconceivable that Man Ray would not have been able to support himself as a painter, given the strength and expansion of the Parisian art market in the twenties. But there is no evidence that he recognized or understood the economic vitality of this postwar market, or that he made a concerted effort to find a proper dealer and gallery.[73]

It is interesting to speculate why Man Ray gave up so easily on trying to sell his paintings and objects when others persisted. It was partly a question of survival. He had arrived in Paris with a $200 advance from Howald and a little money from his family; later, Howald agreed to send him $50 a month for six months. He had to make his own living in Paris. To pursue painting exclusively would have required economic hardship and sacrifices, and Man Ray probably had no desire to relive the immigrant experience of his youth. All around him, he could see the plight of struggling artists from abroad trying to make it in Paris. He had already endured that phase of his life in New York; he did not want to go back to it again in Paris at the age of thirty. Man Ray did not want merely to survive, but to live well. He was not willing to freeze in a cheap,

unheated glass box of a studio in Montparnasse. Instead, he chose one of the more expensive studios in Paris, in an elegant building, with electricity, heat, and soon even a telephone.

But a more important explanation of the artist's decision is to be found in his abhorrence of what he called "the great mass of daubers." In 1922, when he showed at Salon des Indépendants, there were more than fourteen hundred artists represented, of whom about three hundred fifty lived in Montparnasse. Among the painters in Paris, he found a codification of cubism together with a resurgence of more conservative styles. The spirit of *retour à l'ordre* was in full swing. As a dadaist, Man Ray felt a sense of revulsion at the glorification of the master artist, which he believed had produced a fake and degraded art. Like the dadaists, he wanted to remove the artist's hand and the artist's overbearing authority from the creation of a work. Of the two artists Man Ray knew best who most actively addressed these issues, Duchamp found the most radical solution. His intellectual reasoning led him from painting to readymades and then to chess. Picabia's restless pursuit of freedom led him from his mechanomorphic, proto-dada paintings through a wild plunge into dada writing and painting, and finally into an idiosyncratic painting style as individualistic as the artist himself. Man Ray fell between these two: he moved from mechanical means of making paintings—his aerographs—to mechanical means of making pure images. Man Ray's choice of photography was deliberate. He found in photography, particularly in his manipulations of photographic mechanisms and images, a medium that satisfied him as an artist and served as a revolutionary gesture that kept him at the forefront of the avant-garde. Man Ray did not so much give up painting as take up photography.

By entering photography with a dada perspective, Man Ray changed the medium. Until then, those who had approached photography as art had used it to create romantic images that looked like nineteenth-century academic paintings. In general, though, photography was not seen as an art medium at all, or afforded any of the reverence paid to art. This was part of its appeal to the dadaists. Photography was not tainted by its own tradition; it was a virgin medium that freed the artist to do anything he wanted. It was a modern medium, achieved by mechanical means. The inviolability of the image disappeared: it could be multiplied, distorted, endlessly manipulated.[74] By putting his energies and talents into photography, Man Ray, to paraphrase Cocteau, "delivered photography," fulfilling its revolutionary potential and creating some of the most beautiful photographic images of the twentieth century.

There had never been a problem of acceptance for artists of any nationality in Paris. Throughout the nineteenth century, Paris had attracted and accommodated generations of foreign artists. The Salon system made the road to success clear: study at the Ecole des Beaux Arts or with a master painter, serve an apprenticeship, and be accepted to show at the annual Salons, after which commissions and sales would naturally follow. By the 1920s, this system was essentially defunct, and the artists who arrived in the city were free agents who could do whatever they pleased. The modern infrastructure for selling work—critics, dealers, collectors—was well established by the early twenties, and there were ambitious, successful artists who were making money, who had ample studio spaces, lived well, entertained, bought cars, traveled, and took vacations. Montparnasse, uniquely, was an open community where one artist could meet another without elaborate, formal introductions. Everyone gathered at the cafés, and everyone was accepted. Any artist appearing in Montparnasse after the war had the opportunity to realize his artistic desires and goals. It was no doubt this openness and sense of limitless possibilities that drew Man Ray to Montparnasse, just as the sense of opportunity drew him to Paris in the first place. And as it had for generations of artists before him, Paris fulfilled this promise, so that after less than a year there, he was to sign his work: Man Ray, Paris.

NOTES

1. Duchamp to Man Ray, ca. early July 1921 (based on internal evidence), The Carlton Lake Collection. The Duchamp–Man Ray correspondence of 1921–22 was brought to the authors' attention by Francis Naumann. Man Ray's statement that he arrived on 14 July has been widely quoted. However, Tzara left Paris on 20 July (Sanouillet, *Dada à Paris*, p. 287), and Man Ray noted his absence (*Self Portrait*, p. 107); there is also no evidence that the two met in July 1921.

 The name of the ship, *S.S. Savoie*, was written on the notecards Man Ray made when writing *Self Portrait*. The departure of the *Savoie* on 14 July was announced in the *New York Times*, as was its arrival in Le Havre, 22 July. In a letter to Ferdinand Howald dated 18 August 1921, Man Ray wrote, "It is nearly four weeks since I arrived," which corresponds to an arrival date of 22 July (Ferdinand Howald Collection).

2. Quotations from Man Ray, *Self Portrait*, pp. 108–9. The group did not always welcome newcomers. A few months earlier, the young poet Robert Desnos, on leave from the army on his way to North Africa, had received a very cool reception when he went to Certà (Desnos, *Nouvelles Hébrides et autres textes, 1922–1930* [Paris: Gallimard, 1978], pp. 303–5). Duchamp, on the other hand, had been welcome at Certà when he was in Paris in 1919 but essen-

tially stayed aloof from dada activities (Duchamp, *Ingénieur du temps perdu: Entretiens avec Pierre Cabanne* [Paris: Pierre Belfond, 1967], p. 106).

3. Germaine Everling, *L'Anneau de Saturne* (Paris: Fayard, 1970), pp. 98–99.

4. See Hillairet, *Dictionnaire historique des rues de Paris*, vol. 2, p. 37. Aragon described life in the passages in great detail in *Night Walker (Le Paysan de Paris)*, trans. Frederick Brown (Englewood Cliffs, N.J.: Prentice-Hall, 1970), pp. 59–85. Certà was located on what is now the open space where the boulevards des Italiens, Montmartre, and Haussmann meet.

5. Breton, "For Dada," in Robert Motherwell, ed., *The Dada Painters and Poets* (New York: Wittenborn, Schultz, 1951), p. 202.

6. William A. Camfield, *Francis Picabia: His Art, Life and Times* (Princeton, N.J.: Princeton University Press, 1979), p. 158.

7. Sanouillet, *Dada à Paris*, pp. 249–53.

8. Théâtre des Champs-Elysées, at 13 avenue Montaigne, was directed by Jacques Hébertot. It was the home of the Swedish Ballet, organized by Rolf de Maré, which first performed in Paris in 1920. The theater was the scene of many other avant-garde performances. In April 1921, Jean Crotti and Suzanne Duchamp exhibited at Galerie Montaigne, a space in the lobby of a studio-theater on the top floor of the building.

In 1928 Man Ray was included in a photographic exhibition there, the *Salon Indépendant de la Photographie* (Georges Charensol, interview with author, Paris, 10 December 1980).

9. Man Ray to Tzara, 1 December 1920, Tzara Archives, Bibliothèque Littéraire Jacques Doucet. Despite a last-minute plea from Crotti, Duchamp refused to participate. Breton also abstained (Sanouillet, *Dada à Paris*, p. 277).

10. See "Picabia Separates Himself from Dada," *Comoedia*, 11 May 1921; Ribemont-Dessaignes, *Déjà jadis: Du mouvement dada à l'espace abstrait* (Paris: René Julliard, 1958), p. 141; and Picabia, "Le Pilhaou-Thibaou," illustrated supplement to *391*, 10 July 1921, p. 13.

11. Man Ray to Howald, 18 August 1921, Ferdinand Howald Collection.

12. Ibid. The photograph of Man Ray's studio is in the collection of Lucien Treillard, Paris. Man Ray's activities with Duchamp are related in *Self Portrait*, p. 117. Henri-Pierre Roché described how at a dinner at Mme. Conran's on 21 January 1922, Marcel Duchamp used a small projector to show "film experiments. fragments, geometric dances, on a screen of bathroom glass. . . . The result is impressive and rather fantastic, certainly exploitable" (Diaries of Henri-Pierre Roché, The Carlton Lake Collection). The film, *Anemic Cinema*, was completed in 1926

with the assistance of Marc Allagret.

13. Quotations from Man Ray, *Self Portrait*, pp. 117–18.

14. Man Ray to Tzara, 9 October 1921, Tzara Archives, Bibliothèque Littéraire Jacques Doucet.

15. Built around 1900, Hôtel des Ecoles had housed generations of American artists. Breton lived there in 1921, until his marriage in mid September; Tzara moved in in January 1922 and stayed at least until 1924. The key for room thirty-seven appears in one of Man Ray's early rayographs.

16. Everling, *L'Anneau de Saturne*, p. 144.

17. Man Ray, *Self Portrait*, p. 112. The photograph of *L'oeil cacodylate* appeared in the Picabia issue of the *Little Review*, Spring 1922, along with other photographs of Picabia's works, presumably also taken by Man Ray. That he continued to work with Picabia is clear from Breton's letter to Picabia, 20 December 1922: "Man Ray was ready to photograph 'Feuille de Vigne' but the Salon is closed and I don't know the destination of the painting" (quoted in Sanouillet, *Dada à Paris*, p. 526).

18. Man Ray's photo of Gabrielle Buffet Picabia appeared in her undated article "A Frenchwoman's Impression of New York and Certain American Traits" in the *New York Tribune* (clipping in Picabia Archives, Bibliothèque Littéraire Jacques Doucet). Borràs attributed the photograph to Man Ray. Picabia affixed a copy of the picture to *L'Oeil cacodylate* and Gabrielle wrote over it

before Man Ray photographed the painting. Picabia also had close contacts with Poiret and was very good friends with Nicole Groult, Poiret's sister and a fashion designer as well.

19. Man Ray, *Self Portrait*, pp. 120–21. The dating of Man Ray's first contact with Poiret is based on the fact that he saw the setup for this summer theater.

20. François Chapon, *Mystère et splendeurs de Jacques Doucet, 1853–1929* (Paris: J. C. Lattès, 1984), p. 361, n. 119. Reproductions of the Steichen photographs, which were taken at Poiret's mansion, appear in the catalogue *Paul Poiret et Nicole Groult: Maîtres de la mode art deco* (Paris: Musée de la Mode et du Costume, 1986), pp. 66–69.

21. Quotations from Man Ray, *Self Portrait*, p. 122; and Duchamp, *Ingénieur du temps perdu*, p. 114.

22. Cocteau quoted in Francis Steegmuller, *Cocteau: A Biography* (Boston: Little, Brown and Company, 1970), p. 279. The photograph of Radiguet is signed and dated 1921.

23. Pansaers was a poet who had met frequently with Picabia during 1920. He wanted to establish a publishing house for dada in Brussels and an organization for buying art, as well as hold a festival with major dadaists from Paris. He became disgusted with the Paris dadaists over an incident involving the theft of a waiter's wallet at the café Certà on 25 April, and he attacked them in Picabia's "Le Pilhaou-Thibaou." He was also one of the signers of the censure of Breton in February 1922 (Camfield, *Pi-

cabia*, pp. 150–51, 161). Man Ray had written Tzara on 12 September: "When you return, maybe I will go to Brussels next month and want to talk dada to you before I leave" (12 September 1921, Tzara Archives, Bibliothèque Littéraire Jacques Doucet). He mentions Brussels for the last time in a letter to Howald on 12 October.

24. Ernst to Tzara, 8 and 21 October 1921, quoted in Werner Spies, *Max Ernst Collagen: Inventar und Widerspruch* (Cologne: Verlag M. DuMont Schauberg, 1974), p. 238.

25. Jennifer Gough-Cooper and Jacques Caumont, *Plan pour écrire une vie de Marcel Duchamp* (Paris: Collection Centre National d'Art et de Culture Georges Pompidou, 1976), pp. 88–89, illus. p. 92. It is unlikely that the photograph of Tzara was taken at 22 rue La Condamine; Anie Tolleter has searched the building and not found any space similar to that of the photo.

26. Ernst to Tzara, 13 November 1921, quoted in Spies, *Max Ernst Collagen*, p. 238. The "nude lady New York" could refer to the photograph *Coat Rack*. The date of the show is established by this letter, in which Ernst remarked that Paul Eluard had just been in Cologne and had seen Man Ray's photographs in the exhibition. No further information about the exhibit has been found.

27. Ferdinand Howald Collection.

28. Quotations from Josephson, *Life among the Surrealists*, pp. 121–22.

29. Tzara's use of Ernst's letter

was pointed out by Spies in *Max Ernst Collagen*, p. 238. The catalogue is reproduced in Y. Poupard-Lieussou and Michel Sanouillet, *Documents Dada* (Paris: Librairie Weber, 1974), pp. 73–75.

30. Man Ray's biography was included in his letter to Tzara, 6 October 1921, Tzara Archives, Bibliothèque Littéraire Jacques Doucet.

31. Kate Keller, photographer at the Museum of Modern Art, New York, pointed out that the image is reversed, as in a mirror, and Eluard is holding something vertical and rigid; but the horizontal black area across Man Ray's chest made her suspect that the photograph of Man Ray was taken separately and affixed to a negative or a print. A print of this photo without the Man Ray image has been found, which supports this conclusion. It must have been taken at rue La Condamine in mid to late November, since Eluard was out of Paris until 12 November.

32. Quoted in Sanouillet, *Dada à Paris*, p. 298 (translation by authors).

33. Josephson, *Life among the Surrealists*, pp. 108–9.

34. Man Ray's story of *Cadeau* is in *Self Portrait*, p. 115. This incident may not have taken place at the opening, however. There is a photograph of *Cadeau* dated 1921, which indicates that Man Ray either had time to photograph the object before it disappeared, or that he replicated it soon thereafter.

35. Man Ray to Tzara, 27 December 1921, Tzara Archives, Bibliothèque Littéraire Jacques Doucet. Papers consulted for reviews appear-

ing during the month of December 1921 were *Le Figaro*, *Le Journal de Paris*, *Paris-Journal*, *L'Evénement*, *Petit Parisien*, *Croix*, *Paris Midi*, and *Comoedia*.

36. Eluard's letter to Tzara, dated 4 January 1922, quoted in Sanouillet, *Dada à Paris*, p. 303. In November 1923, Le Caméléon became the Jockey, the first nightclub in Montparnasse.

 Charchoune, in Paris since 1912, had studied with Le Fauconnier; his paintings were primarily cubist and abstract in style. He had met Tzara in 1920. He was active in the dada activities of the spring of 1921 and prominently signed *L'Oeil cacodylate*. He and Tzara even initiated plans for a dada event to "bury Cubism" at Povolozky's gallery, renamed Eglise de la Sainte-Cible.

 More futurist than dadaist, Zdanevich was head of a group of Russian writers that had created a new poetic language, "*zaoum*," and started a publishing house, "41 Degrees," which the group judged to be the proper body temperature of a poet and his friends when creating. Program for "Palata Poetov" reproduced in Poupard-Lieussou and Sanouillet, *Documents Dada*, p. 71.

37. Josephson, *Life among the Surrealists*, pp. 149–50. See also Sanouillet, *Dada à Paris*, pp. 333–35.

38. Everling described the unprecedented mixture of guests in *L'Anneau de Saturne*, pp. 139–40.

39. Hastings to Radiguet, 2 January 1922, quoted in Nadia Oudouard, *Les Années folles*

de Raymond Radiguet (Paris: Editions Seghers, 1973), p. 276.

40. Jean Wiéner, *Allegro appassionato* (Paris: Pierre Belfond, 1978), pp. 42–45.

41. Cocteau, *Entretiens avec Roger Stéphane* (Paris: Edition Tallendier, 1964), p. 91. See description of *Le Boeuf sur le Toit* in Darius Milhaud, *Notes without Music: An Autobiography*, trans. Donald Evans (New York: Alfred A. Knopf, 1953), pp. 101–4. *Le Boeuf sur le toit* was a pantomime set to a Brazilian-inspired score by Milhaud. The Fratellini brothers and other clown performers from Cirque Medrano performed a script by Cocteau, burlesquing the adventures of a policeman who wanders into a bar in America during Prohibition. The production was sponsored by Comte de Beaumont and was presented on 12 February 1920 at the Comédie des Champs-Elysées, the small hall on the upper floor of the Théâtre des Champs-Elysées.

42. Dardel, *Jag for Till Paris* (Stockholm: Albert Bonniers Forlag, 1941), p. 90.

43. Quoted in Poupard-Lieussou and Sanouillet, *Documents Dada*, pp. 76–77.

44. Man Ray to Howald, 5 April 1922, Ferdinand Howald Collection. For discussion of the Picabia scandal, see Camfield, *Picabia*, pp. 171ff.

45. Duchamp to Man Ray, Spring 1922, The Carlton Lake Collection. Man Ray did submit a painting to another Salon, the Salon d'Automne in 1923. Duchamp sat on the jury that year. The catalogue listed Man Ray's painting as "Portrait," price

4,000 francs. The portrait may have been of Duchamp or Kiki, both of whom he painted in 1923.

46. Quotations from Man Ray, *Self Portrait*, p. 119; and Man Ray to Howald, 28 May 1922, Ferdinand Howald Collection.

47. Man Ray, *Self Portrait*, p. 223. In the next few years, the archives of the Picasso Museum may yield Man Ray photos of works from 1922. He did continue to photograph Picabia's works until the end of 1922. It is important to note that there is no inventory of all the photos Man Ray took; no complete catalogue has been made of the negatives that exist in his rue Férou studio. Further, Man Ray related in his memoirs that on a trip to France after World War II, he found "negatives and prints . . . scattered on the floor and trampled upon" in the attic of his country house and he "spent days in the attic, classifying, destroying prints and negatives" (*Self Portrait*, p. 363).

48. Man Ray quotation from his letter to Tzara, 7 August 1922, Tzara Archives, Bibliothèque Littéraire Jacques Doucet. For information on Doucet's purchases see Chapon, *Mystère et splendeurs de Jacques Doucet*, pp. 72, 282, 289.

49. So far the authors have not been able to trace the source of Man Ray's early connections with the fashionable American expatriate community. One possibility is through Robert Chanler, a conservative painter who was part of a large, wealthy family connected to the As-

tors. He had lived in Paris before the war, and many members of the family were longtime residents of Paris. In his memoirs, Man Ray wrote of meeting Chanler during a visit to Provincetown shortly before he left for Paris (*Self Portrait*, p. 103).

50. Quotations from Stein, *The Autobiography of Alice B. Toklas* (New York: Random House, 1933), p. 197; and Man Ray, *Self Portrait*, pp. 181–82. A question of chronology is raised by Man Ray's account of going to rue Fleurus: "Miss Stein introduced me to her friend Alice Toklas, whom I had taken for her maid, although, in her print dress trimmed with white lace, she was too carefully groomed" (*Self Portrait*, p. 181). This is a mistake he would hardly have made if, as Stein wrote, "We all three went to his hotel." In any case, the two photo sessions took place before July 1922, when Man Ray moved to rue Campagne Première.

51. He did make a portrait of Yvonne Davidson, Jo Davidson's wife, for *Charm*, January 1926; and he made family portraits of Gerald and Sara Murphy and their children in the summer of 1926. Man Ray also mentioned that two American artists, Curtiss Moffit, a photographer, and Edward MacKnight Kauffer, had been in Paris and continued to send him clients from London. Except for his presence in a group photograph outside the Jockey in 1923, there is no portrait of Moffit by Man Ray.

52. Man Ray, *Self Portrait*, pp.

185–86.

53. Ibid., p. 132.

54. May 8, Diaries of Henri-Pierre Roché, The Carlton Lake Collection. Roché, a writer and an active, though mysterious and independent member of the Parisian art community, was at this time the agent for John Quinn in Paris, helping him acquire his great collection of contemporary art. He was good friends with Duchamp and Brancusi.

55. Man Ray, *Self Portrait*, pp. 160–61.

56. Ibid., pp. 163–67.

57. Bryher to H. D., 14 and 22 June 1923, H. D. Collection.

58. Barnes, "The Models Have Come to Town," *Charm* 3, no. 4 (November 1924): 16; and "The Coiffure à la Grecque," *Charm* 3, no. 5 (December 1924): 25–27. Other contributors to the magazine were Malcolm Cowley, Walter Pach, and Mina Loy.

59. Andrée de Fouquières, "La Femme élégante," *Charm* 4, no. 2 (March 1925): 14–20.

60. Interview with Dardel, Stockholm, January 1987. Man Ray's letters to Gertrude Stein and Sylvia Beach indicate that he charged friends and acquaintances at a lower rate. In 1922 he charged Jeanne Cook 100 francs for a print of her portrait. Later in the twenties, he charged Sylvia Beach 15 francs for small prints and 50 francs for larger ones. He apologized: "I am forced to make this price as I have never gotten either credit or money for photos of Joyce that were reproduced, and must charge for them as I would for an order from any client" (Man Ray to Beach,

undated, Sylvia Beach Collection).

61. Man Ray quotations from his letters to Howald, 5 April and 28 May 1922, Ferdinand Howald Collection. Man Ray's account of the discovery of the rayograph process is in *Self Portrait*, pp. 128–29. That Man Ray was working on the process during January 1922 is established by a rayograph published in the autumn 1922 issue of the *Little Review*. Entitled *озоwose sel à vie* (fig. 125), and, according to Francis Naumann's analysis, a collaboration with Duchamp, it therefore must have been done before Duchamp left for New York on 28 January 1922, as Duchamp did not return to Paris until after the rayograph was published.

62. Poiret's comment in Man Ray, *Self Portrait*, p. 131; Roché's comment in 8 May 1922 entry, Diaries of Henri-Pierre Roché, The Carlton Lake Collection.

63. Man Ray, *Self Portrait*, pp. 140–41. Russian artist Marie Vassilieff had settled in Montparnasse in 1907 and started a drawing academy in her studio, which she turned into a canteen for artists during the war. Paul Poiret was one of her first collectors, when she turned from painting to making portrait puppets of her friends.

64. Kiki, *Kiki's Memoirs*, pp. 129–30.

65. Quotations from Man Ray, *Self Portrait*, pp. 140–45; and Kiki, *Kiki's Memoirs*, p. 138.

66. Man Ray to Howald, 28 May 1922, Ferdinand Howald Collection.

67. Ch.-Al Gautier, "Causerie: Immeuble pour ateliers d'artistes," *L'Architecture*, January 1912.

68. See Gunnar Cederschiöld, *Efter levander modell* (Stockholm: Natur Och Kultur, 1949), p. 75.

69. Duchamp to Man Ray, July 1922 (based on internal evidence), Collection of Timothy Baum.

70. Quotations from Man Ray, *Self Portrait*, p. 146.

71. It could be argued that Man Ray was a role model for Andy Warhol. Numerous parallels between them exist: involvement with film, commercial art, and mechanical means of making images, as well as their concentration on portrait commissions as a source of funds. Both had poor immigrant backgrounds, mixed with high society, and were essentially private people. Warhol, who owned *Peinture féminine* and had it prominently displayed at the Factory, made a portrait of Man Ray in 1975.

72. Duchamp interview in Margery Rex, "Dada Will Get You If You Don't Watch Out: It Is on the Way Here," *New York Evening Journal*, 29 January 1921; reprinted in Rudolf E. Kuenzli, ed., *New York Dada* (New York: Willis Locker & Owens, 1986), p. 140.

73. Malcolm Gee points out that surrealism emerged "by the end of the decade as the dominant avant-garde tendency, at least in terms of public response. . . . The rapidity with which surrealism conquered a market was frequently commented on at the time and afterwards." Gee lists four galleries—Galerie Pierre, Galerie Jeanne Bucher, Galerie Van Leer, and the Galerie Surréaliste—that bought and exhibited work by surrealist artists. It should be noted that Man Ray had exhibitions at three of these. Man Ray also attracted wealthy patrons; the Vicomte and Vicomtesse de Noailles, for example, who bought surrealist paintings by Miró, Masson, and Ernst, commissioned Man Ray to make a film. See Gee, *Dealers, Critics and Collectors of Modern Painting: Aspects of the Parisian Art Market between 1920 and 1930* (New York: Garland Publishing, 1981), pp. 279–81.

74. Barbara Rose, "Kinetic Solutions to Pictorial Problems: The Films of Man Ray and Moholy-Nagy," *Artforum* 10 (September 1971): 68–73. An indication of the lack of regard for photos is that Man Ray's associates in the twenties cut up his photos and made their own collages from them. Picabia put them to the service of his art in *L'Oeil cacodylate* and *La Veuve joyeuse*. The Comte de Beaumont constructed elaborate collages using photos of his ball guests by Man Ray and other photographers. Jean Wiéner made a collage of his musical and artistic heroes from Mozart to Stravinsky and included Man Ray's portraits of Satie and Cocteau (the latter carefully cut out around the picture frame that Cocteau was holding). And of course Sylvia Beach's wall collage of writers contained Man Ray's portraits along with snapshots by her and others.

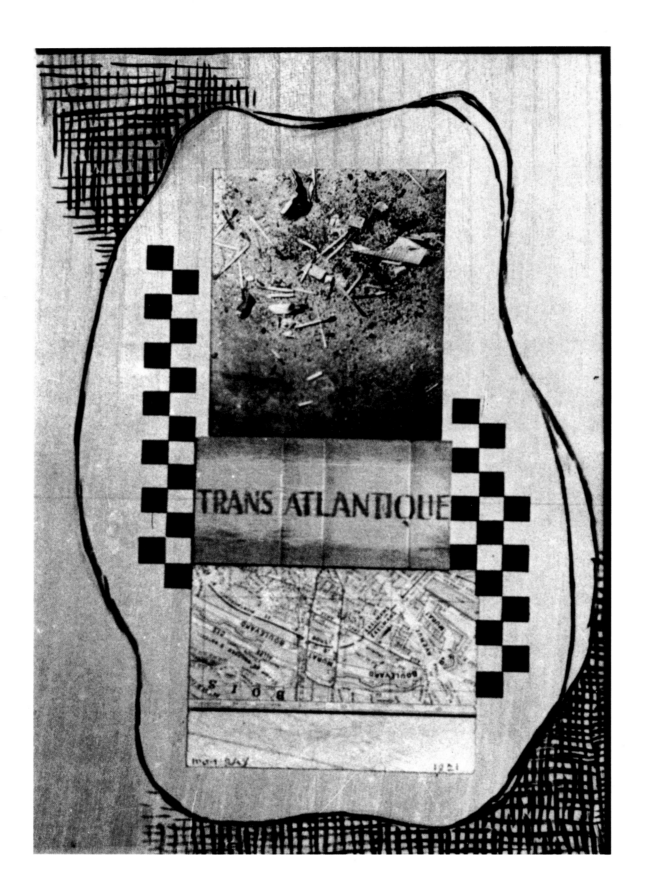

TRANS ATLANTIQUE

man Ray 1921

CHAPTER THREE
TRANSATLANTIC

Elizabeth Hutton Turner

Writing from Paris in August 1922, Marius de Zayas told Alfred Stieglitz, "America is too young and Europe is too old to produce art and there you are and here I am."[1] In a time of transition after the Great War, youth from both America and France acknowledged that Paris represented the past and that New York represented the future. They were, however, less certain about the present. Gambling on what he believed to be the future direction of American art, Man Ray was among those who tied their fortunes to the ephemeral and often shifting perspectives provided by the Atlantic crossings of the artistic and literary avant-garde. To symbolize this melding of the Old and New Worlds, he created a collage framed by crosshatching and checkered shapes—playful referents to canvas and perspective—comprising a dada photo entitled *New York 1920* and a map of Paris, between which he inscribed "Trans atlantique" (fig. 109).

Transatlantique was the popular term for *ocean liner*—the people's choice during the 1920s. Fueled by the strong dollar, these great floating cities of steel brought record numbers to Europe. Like gypsies, the new travelers did not intend to set down roots.

Man Ray's "New York 1920" (fig. 110)—represented by a scattered configuration of used matchsticks, a cigar butt and ash, a scrap of newsprint, and mashed metal strips seemingly awash on a gray shore—had been the scene of artistic innovation encouraged by the presence of Duchamp and Picabia during the war. From 1914 to 1919, Man Ray's art rapidly evolved from cubism to abstraction, from easel painting to airbrush stencils, from natural to mechanomorphic form. After the war, however, it seemed clear that America could not yet sustain the climate of radical invention that had launched his career. Sadly deflated, in June 1921 the artist wrote to Tristan Tzara in Paris, "Dada cannot live in New York."[2] On the heels of this pronouncement, he booked passage to France, bringing his more experimental work with him and leaving the rest behind with his dealer, Charles Daniel.

The map of Paris on Man Ray's collage was like that used by

109 *Trans atlantique*, 1921, collage, present whereabouts unknown

110 *New York 1920*, 1920,
silver print

any first-time tourist arriving at his destination. In 1921, postwar
Paris had been open to civilian travel from America for only one
year and was still uncharted territory for the American artist
abroad: no one knew what to expect from the revived art scene.
Changes were evident as early as 1919, when just after the armistice
the Luxembourg Museum hosted an exhibition of contemporary art
celebrating the coming-of-age of American painting.[3] Yet out of
this mélange, from impressionist Frederick Frieseke to synchronist
Patrick Henry Bruce, no style or technique and no one American
artist had yet been singled out by the French when Man Ray
arrived in July 1921. Six months later, his one-man show at the

Librairie Six changed all that. The first of the New York avant-garde abroad to receive such recognition, Man Ray became a new milestone on the map of Paris for aspiring young Americans riding the transatlantic in the twenties.

Surprisingly little about Man Ray's early career in New York foretold his success or distinguished him from others of his generation in the American wave to Europe. Charles Demuth and Marsden Hartley, who shared his concerns about artistic growth and freedom, also undertook their sojourns that same summer. As Demuth explained to Alfred Stieglitz, "I wanted to do something to stop the 'wheels' going around backwards,—so chanced this."[4] Like Man Ray, their previous involvement with Duchamp and other refugee artists in New York during the war led them to believe there would be receptive audiences abroad. All three carried the hope that Paris would somehow sustain them—no one anticipated that the Parisian avant-garde would be looking for the same from them.

As Man Ray described it to his patron Ferdinand Howald, "They crave America. So we are making a fair exchange, for I love the mellowness and finish of things here." Similarly Demuth's initial message to Stieglitz read, "It is all very amazing, to me, to find this enthusiasm, here,—after knowing what we have always felt for the French, not, thinking much of our own; and, the great Frenchmen telling us that we are very good." As they saw it, the fall exhibition season seemed ripe with promise. Man Ray, encouraged by Duchamp and the dadaists, assured Howald that an exhibition was being arranged for him. Demuth, on the basis of his contact with French painters such as Albert Gleizes, wrote Stieglitz, "I am told either of the Rosenbergs [two Parisian dealers] will have our things."[5]

Beyond this window of opportunity, however, Demuth and Hartley saw the need for a knowledgeable spokesman. Both agreed that Stieglitz should come at once. In October Demuth wrote him, "There is a great need at the moment for you here." He explained that while the French painters were eager to have the best Americans with them, their understanding of American modernism was limited to publications such as the *Dial*, an American literary journal that flourished in the twenties. As Demuth observed, "Pound [author of the *Dial*'s 'Paris Letter'] has done a lot but he really doesn't know much about painting." Invoking the days when Stieglitz's gallery on 291 Fifth Avenue had been the first to show the Parisian avant-garde in New York, Demuth spoke of "sympathetic order" and of "the dream coming true" for American artists in

Paris.[6] Four days later, Hartley sent another petition to Stieglitz via a personal messenger: "Tell him [Stieglitz] now is the time to start the American idea in Europe. They want American representation here and will provide the gallery. . . . It would be truly great and important if Stieglitz could only come over with good things. Now is the great time and the French painters believe in what Americans are doing."[7]

The artistic tide of events in reconstruction France was not strong enough to carry Stieglitz away from New York in the fall of 1921. At the very moment Demuth and Hartley were hailing him from Paris, Stieglitz was beckoning editors of *Broom*, a new avant-garde periodical published by Americans in Italy, to look to New York. "Much is crystalyzing—much is being set agoing—a real livingness—'291' was never more alive—Each the same direction."[8] Without an advocate like Stieglitz, there would ultimately be no center, no "American Place" for painters in Paris, as Stieglitz called his New York gallery in the twenties. The American contribution abroad swiftly veered on a course away from art as Stieglitz and his followers understood it when the dadaists took up Man Ray's mantle at the Librairie Six that December.

Matthew Josephson had only recently been selected as author of *Broom*'s Paris letter when Man Ray asked him to attend his opening. Since *Broom*'s first issue had featured his aerograph *Sequidilla* (fig. 111), Man Ray probably saw a prospect for a favorable review. For his part, Josephson welcomed the invitation as an opportunity for a closer look at the new and very radical French writers, for the Librairie Six was not an art gallery but a bookstore owned by the wife of writer and publisher Philippe Soupault.

Soupault's presentation of Man Ray did, indeed, turn out to be no ordinary exhibition but rather a dada event decorated with brightly colored balloons and filled with young peoples' laughter at one another's sallies and capers. Josephson was impressed that no one made the usual mistake of taking art too seriously and compared the mood of the occasion to Bastille Day.[9] The dadaists celebrated Man Ray's work—his dazzling technical feats of aerography, his portraits of perculators, and his improvisations of jazz instruments—as liberating innovations drawn from the wellspring of New York. Taking his cue from a painting entitled *Love Fingers*, Tzara wrote in the exhibition catalogue, "New York sends us one of its love fingers, which will not be long in taking the susceptibilities of the French painters." Indeed, there was a new and exciting mechanized verve—unlike anything Paris had ever seen before—in the streamlined airbrushed surfaces, shadowy reserved shapes, and

animated linear configurations of *Sequidilla*'s fan dancers and *Admiration of the Orchestrelle for the Cinematograph*'s high-tension wires and rotating reels (fig. 20). The inscription on the latter, "Abandon of the Safety Valve," captured perfectly the adventure of the moment.

In introducing the artist himself, the dadaists made caricature of biography. The Man Ray welcomed in the Librairie Six catalogue was a millionaire coal merchant and chairman of a chewing-gum trust with an artistic avocation. The description ironically bore some resemblance to the artist's patron, Ferdinand Howald, a retired coal merchant from Ohio, and underscored the dadaists' desire for the new artist in their midst to embody the American spirit found not in art but in industry and invention. Here was the brilliant naïve, unshackled by tradition, whose innovative genius promised revitalization.[10]

Amidst the laughter and buffoonery at the Librairie Six, the avant-garde made it clear that the measure for the American artist

111 *Sequidilla*, 1919, aerograph, Hirshhorn Museum and Sculpture Garden, Smithsonian Institution, Washington, D.C., Joseph H. Hirshhorn Purchase Fund

in postwar Paris had little to do with French mastery or precedent. Quite the opposite: the French were relying on the forward gaze of the Americans for their entrée to the twentieth century. There was an underlying expectation that the American artist would draw on the authority of his mechanized civilization to supplant Europe's outmoded and outworn artistic expressions. Josephson was among the first to explain this principle to an American audience still quite ambivalent about the machine age:

> The fundamental attitude of aggression, humor, unequivocal affirmation which they pose, comes most naturally from America. . . . Reacting to purely American sources, . . . we may yet amass a new folklore out of the domesticated miracles of our time.[11]

Man Ray himself was only beginning to understand. He later recalled in his autobiography that his presence that evening had seemed superfluous. At one point he left the celebration with a mysterious stranger, possibly a banker by the look of his bowler hat, who had expressed admiration for his work. Over drinks at a nearby café, Man Ray learned that the man was in fact composer and fan of things American Erik Satie. They returned to Librairie Six with a new readymade, a flatiron bristling with tacks, fabricated as a totem of the occasion. Man Ray titled the piece *Cadeau* (fig. 204), in homage to the older Frenchman who had sought him out.[12] At the same time, the playful, but ominous, object may also have been a pun on the well-known Flatiron Building, and a warning that the New York being touted that evening was also barbed and threatening.

After the Librairie Six experience, Man Ray felt that he had attained special status as a modern American artist, but his direction remained unclear. He next sought recognition at the Salon des Indépendants, where he saw himself as America's representative. As he explained to Howald:

> I am satisfied with the results of my exhibition [Librairie Six] which has placed me sort of apart from the huge mass of daubing that goes on here. Even the few recognized or "arrived" painters regard me either in a spirit of conciliation or quiet fury. . . . I am exposing now at the Salon des Indépendants,—permit me to say that America is represented at the Grand Palais! (What a responsibility I have assumed!)[13]

The Salon des Indépendants had launched the cubist revolution in 1909 and was considered the forum for the latest advances in art. Yet as with so many prewar traditions, it was suffocating under the weight of its success. The reviewer for the Paris edition of the *New York Herald* observed that the enormous number of entries in the 1922 Salon had led to a premium being placed on violent effects, which defeated the Salon's original purpose of simply providing younger artists an opportunity to show their work to critics. Man Ray's barometer case with coil and color chart, a humorous object-portrait of his Société Anonyme patron Katherine Dreier as "fair and rising" (fig. 112), was lost among the literally thousands of alphabetically arranged exhibits. Later, Man Ray correctly surmised that he had been either overlooked or dismissed: "The critics ignored these works; some visitors lumped them with the usual bid for publicity by Dadaists."[14]

Given his choice, Man Ray would no doubt have preferred recognition in the circles of the more established modernists. On occasion in the fall of 1921, he placed his work on consignment among them at the Léonce Rosenberg Gallery without success.[15] The times were over when one could casually join the band of Picasso or Matisse, as the Stieglitz circle had done in 1910 at Gertrude Stein's soirées. In the 1920s Stein made it clear to any of the newcomers who would listen that the once close-knit circle of prewar modernists was gone. Her Saturday evenings were, in her words, "casualties of the war." "Painting," she said, "now after the great moment must come back to a minor art."[16]

Using his camera as entrée, Man Ray engineered an alternate route to the artistic elite. Employed to photograph their works for publications and catalogues, he often reserved a frame of film for a personal portrait. We see, as Man Ray did then, Picasso's public persona—proud, successful, out of reach—and a reclusive Matisse by an open studio window (figs. 113, 114). Man Ray's first photographs of Stein placed the "Sybil of Montparnasse" with her collection of early works by Picasso and Matisse—within her "sacred wood," as it was known (fig. 115). As he saw it, "Nothing that came after her first attachment would equal them."[17]

By the spring of 1922, in the wake of his celebration at the Librairie Six, his disappointment at the Salon des Indépendants, and his pilgrimages to the modern masters, Man Ray suddenly found the direction he was seeking. He was ready to embrace a new medium, one that would take him out of the fierce competition of painters struggling in the shadows of Picasso and Matisse and at the same time permit him to continue his art. His April letter to

112 *Catherine Barometer*, 1920, washboard, tube, and color chart, Alain Terika, Paris

143

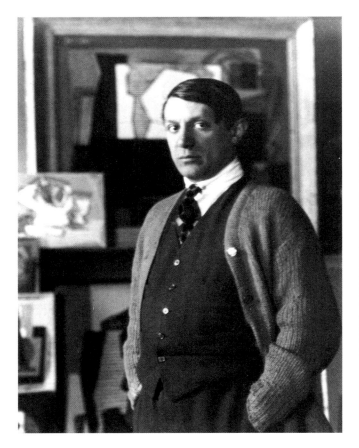

113 *Picasso*, ca. 1922, silver print

114 *Matisse*, ca. 1922, silver print

115 *Gertrude Stein and Picasso's Portrait*, 1922, silver print

144

Howald contained news of the change: "You may regret to hear it, but I have finally freed myself from the sticky medium of paint, and am working directly with light itself. I have found a way of recording it. The subjects were never so near to life itself as in my new work, and never so completely translated to the medium."[18] With such a dramatic pronouncement, one might have supposed Man Ray had invented a radically new form of painting, using something like a laser, perhaps. In fact, he was referring to a rather primitive cameraless photography effected by placing objects directly on or in front of light-sensitive paper. Ironically, out of a medium commonly used by schoolchildren, Man Ray fashioned his futuristic alternative to painting.

Man Ray's glowing silhouettes of pipes, keys, funnels, and combs seemed to begin where his mechanomorphic abstractions of 1915 and streamlined airbrush stencils of 1919 left off. With the new process, objects and their shadows could not only be posed or set off against one another on a tonal field, as in an ordinary still life, but also moved like actors on a stage or drawn away from the surface, creating veils of gray fading into deep shadow. By the same token, light, the great animator of the composition, could be manipulated in its intensity, direction, and duration to highlight the contours and textural variations of each object. A silhouette registered as black or white depending on the opacity of an object's substance and its angle in relation to the paper. Man Ray combined both effects in his first compositions of darkroom objects (fig. 116). The reserved white silhouette of a clay pipe against the lower black area of exposed paper initiates a diagonal continued by the black silhouettes of the glass bottle and funnel. Such exquisite variations left Man Ray with the impression that he no longer simply described the effects of light as most painters did, but had in fact harnessed it. As Man Ray told Howald, "In my new work I feel I have reached the climax of the things I have been searching for the last ten years."[19]

That spring when the dadaists ventured into Man Ray's darkroom, they hailed the discovery of a new art form. Man Ray, the photographer, then fully assumed the role of a *jeune fille américaine*, the avant-garde's phrase for a character whose innovative spirit had the power to break free from convention. In Alfred Jarry's novel *Le Surmale*, she was the willing participant in André Manviel's experiment to mechanize the sex act. In Francis Picabia's 1915 object-portrait, she assumed the form of an inspirational and suggestive spark plug (fig. 117). In Jean Cocteau's libretto for the 1917 ballet *Parade*, the *jeune fille américaine* appeared on stage "cranking up and

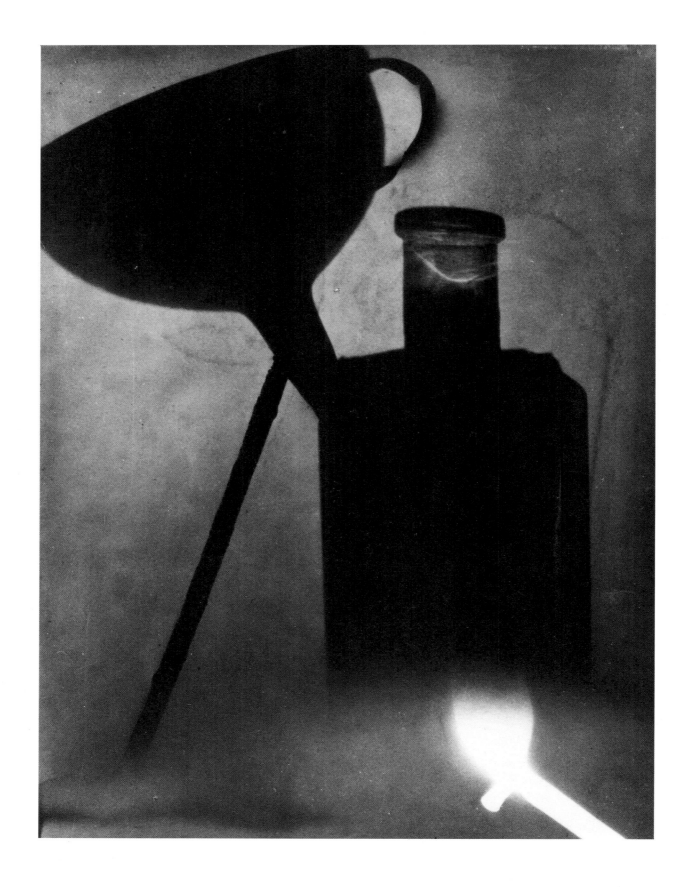

146

driving a Model T Ford," "snapping the new shutter of her new Kodak," and "doing a Charlie Chaplin." (Not surprisingly, her "Steamboat Ragtime" in *Parade*, complete with horns, whistles, and jazz effects, was written by Satie.)

Like the *jeune fille*, Man Ray provided the spark of new life the Europeans so wanted. One of his first photograms, a white silhouetted manikin with walking stick, was published in the April 1922 issue of *Les Feuilles libres* accompanied by Cocteau's "Lettre ouverte à Man Ray, photographe américain." The article proclaimed Man Ray "the master of light." Moreover, Cocteau prophesied that Man Ray would "deliver painting": "He has come to set painting free again. His mysterious groups are infinitely better than any of the ordinary still-lifes which attempt to conquer the flat canvas and the elusive mud of the colors."[20] Later that year, Tzara prefaced Man Ray's photo album entitled *Les Champs délicieux* with a similar refrain. Man Ray was bringing new methods, new materials, and above all a new spirit of invention to art:

> When all that one calls art was covered with rheumatism, the photographer lit the millions of lights of his lamp, and the sensitive paper absorbed by degrees black cut up into some common objects. He had invented the force of tender and fresh lightning, which surpassed in importance all the constellations destined for our visual pleasure.[21]

While Man Ray was out in front with his photograms in Paris, his old New York audience wondered whether he had gone too far afield. His new work defied traditional artistic boundaries. Was it painting or photography? Was Man Ray a photographer or an artist? Cameraless photography that circumvented the science of the lens did not sit well with the Stieglitz circle. (Indeed, Man Ray placed a premium on naïveté. Berenice Abbott recalled that in 1923 he picked her to be his assistant in Paris because she knew nothing about photography.)[22] Writing in the summer of 1922 from Paris, Marius de Zayas felt compelled to respond to Stieglitz's survey "Can Photography Have the Significance of Art?" because of what he termed the "false success" of Man Ray as photographer-artist. "And I must also say that outside of what you and Sheeler have done in Photography I find the rest quite stupid."[23]

Likewise, it was important for Howald, a painting collector whose taste in Man Ray's art had been limited to semiabstract works like *Madonna* (fig. 118), to determine whether the new works were created by a painting or a photographic process. In response

116 Untitled, 1922, rayograph

117 Francis Picabia, *Portrait d'une jeune fille américaine dans l'Etat de Nudité*, 1915, San Francisco Museum of Modern Art

118 *Madonna*, 1914, oil on canvas, Columbus Museum of Art, Gift of Ferdinand Howald

to the news that Man Ray had "given up the sticky medium of paint" and was now "painting with light," Howald wrote in the spring of 1922, "I am interested in what you say about your new process and you arouse my curiosity. If you use light it must be a photographic process it seems to me."[24]

Aside from Howald's collecting preferences, there was increasing tension between patron and artist over when Man Ray would return home to exhibit his new work. Howald advised Man Ray that to protect his interests he must bolster New York contacts, but the artist kept his patron at bay: "I should like to show in New York this fall if I can make some arrangement. But it must be well arranged and I must have money." The central issue was Man Ray's eroding confidence in Charles Daniel, his New York dealer. "Daniel in New York seems to have deserted me. Not a word nor a cent from him since I am here. I felt before I left that he had not the imagination nor the enterprise to really back me." Beyond the question of Daniel's abilities, however, was Man Ray's ambivalence about New York. On the one hand, New York provided his American "identity" in Paris. On the other hand, it held him back from pursuing his art among the dadaists. In April he quarreled with Howald about whether or not it was necessary for an artist to stand with his work on exhibition. By May he insisted that he must secure a studio in Paris and "spend six months on each side of the ocean every year." Finally the artist confessed, "New York is sweet, but cold, Paris is bitter, but warm—there is real life here, real feeling, I seem to breathe and communicate with people more easily in spite of the lack of vocabulary."[25]

After May the chain of correspondence broke between Man Ray and his patron. That summer the artist rented a studio at 31 bis rue Campagne Première. He set up housekeeping with Kiki, born Alice Prin, the most seductive model in the School of Paris, and began a commercial photography enterprise in earnest. Lights were installed on the balcony for photo sessions, while the area below became a gallery displaying his photographs, cubist paintings, and dada inventions.

When Howald arrived in the fall of 1922, he found Man Ray "definitely installed" in Paris; none of the new paintings interested him. At the time, Man Ray was painting on brown paper and cork cutouts, producing collages like *6,396,78*, which depicts the whimsical disjunction of a propeller and a gear with their shadows (fig. 119). Howald's idea of new American painting from Paris, however, was more in line with the faceted planes of oil on canvas and subtle coloration of the monumental transatlantic liner found in

Demuth's *Paquebot Paris*, which he acquired (fig. 120). Although Howald did purchase a subscription for Man Ray's upcoming photo album, *Les Champs délicieux*, the artist later believed his commitment to photography actually disappointed Howald. "I thought to please him by doing his portrait; but he told me a painter should stick to his painting." In a final attempt to keep his patron's interest, Man Ray wrote him about completing a cubist full-length portrait, begun in 1913, and submitting it to the Salon des Indépendants at the first of the year.[26] As it turned out, it was Man Ray's last letter to Howald, and the artist took an altogether different route.

The new year led Man Ray even further away from painting. Along with other members of the Parisian avant-garde, he abandoned the rather perfunctory Salon des Indépendants in 1923. With this gesture, Man Ray began to sever his remaining ties with prewar modernism and increasingly to associate his art with dada alternatives. In his 1923 *Little Review* article "Dada Painting or the Oil Eye," Georges Ribemont-Dessaignes wrote: "The Dadaists are not the sons of the cubists. . . . They are neither sons nor fathers of anyone. No prophets announced them." The critic described Man Ray, together with Jean Arp and Max Ernst, as new painters who had "broken with sight" and like blind poets aspired to the sublime.[27]

119 *6,396,78*, 1922, cork, gouache, graphite, and silver paint on brown paper, New Orleans Museum of Art, Muriel Bultman Francis Collection

120 Charles Demuth, *Paquebot Paris*, ca. 1921, oil on canvas, Columbus Museum of Art, Gift of Ferdinand Howald

MER DE LA MER DE LA MER DE LA MER DE LA MER DE LA MER

de l'a merique !

Cher Tzara – dada cannot live in New York.
All New York is dada, and will not tolerate a
rival, – will not notice dada. It is true
that no efforts to make it public have been
made, beyond the placing of your and our
dadas in the bookshops, but there is no
one here to work for it, and no money
to be taken in for it, or donated to it. So
dada in New York must remain a secret.

No additional sales have been made of
the consignment you sent to "Société Anonyme.
The "anonyme" itself does not sell anything.

The appearance of New York dada was made
possible through the generosity of a few poor
friends, but it cannot go on so. Perhaps in
the future we may do something again.
I have not come across any corpuses,
but will watch for them.

What has happened between you and
Picabia? I saw a little article from some
French paper. It is unfortunate.

Thanks very much for the photos of yourself
and friends.

I shall send you some more New York
dadas.

Duchamp is returning this week to France
you will meet him, no doubt, and have
a talk with him.

Merci pour Mlle Berïne's sentiments!
I am doing nothing of interest now to
anyone or to myself.

Most cordially
man Ray
directeur du mauvais movies

In July 1923 at a dada event called "Soirée du coeur à barbe," Tzara introduced Man Ray as a prominent filmmaker. The occasion marked the debut of Man Ray's first feature-length film, *Retour à la raison*, which had been commissioned earlier that year by Tzara. The epithet "filmmaker" was not a new one, though. Tzara had known of Man Ray's New York film ventures with Duchamp—the most notorious depicted the shaving of the Baroness Elsa von Freytag Loringhoven's pubic hairs—and in a letter to Tzara prior to his departure for Paris, Man Ray had identified himself with the medium: using a film clip of the nude baroness to illustrate the "A" of the letterhead, he had closed the letter with a clip of himself and the caption "le directeur du mauvais movies" (fig. 121).[28]

In many ways Man Ray approached film as a kindred spirit of the younger generation of French writers who had discovered a new pictorial poetry in silent cinema during the war years. As early as 1916, Man Ray conveyed the avant-garde's initial enthusiasm for the medium in the newspaper assemblage *Theatr*, the headline of which read, "Cinema Ideas Have a Chance" (fig. 122). By 1923 he was more demonstrative. In *Retour à la raison*, with its initial rapid-fire sequences—shimmering salt crystals, dancing pins, rotating gyroscopes, floating dots, flickering merry-go-round lights, and a lone

121 Letter from Man Ray to Tristan Tzara, ca. June 1921, Bibliothèque Littéraire Jacques Doucet, in the Bibliothèque Sainte-Geneviève, Paris

122 *Theatr*, 1916, collage, Moderna Museet, The National Swedish Art Museums, Stockholm

thumbtack jumping across the screen—Man Ray emphasized what the French called an "American tempo," first discovered in the early Edison films, which were made with a slow-timed motion-picture camera that produced staccato images. He realized that it was not the narrative of the cinema that they found compelling but the often delightfully incongruous dramas emerging from unexpected juxtapositions—as in Hollywood films where, in the offices of the cigar-chewing tycoon, "the telephone rang with the sound of a horn in the forest" (or as Man Ray later joked, "when the lion chirps 'Peep, Peep' ").[29] Similarly, the close-up, when disembodied from the narrative, opened up imaginative associations. To complete his three-minute piece, Man Ray exploited the dramatic, but enigmatic, qualities of a series of close-ups: a roll of paper much like his 1919 *Lampshade* (fig. 71) unravels; an egg crate revolves faster and faster and eventually multiplies, disengaging from its shadows on the wall; and finally a female torso, clothed in striped shadows, turns twice before a window (fig. 123).

123 *Light Striped Torso*, 1923, silver print

The soirée's program boasted an all-star cast, including first auditions of compositions by Darius Milhaud, Erik Satie, and Igor Stravinsky and poems by Jean Cocteau, Guillaume Apollinaire, Philippe Soupault, Tristan Tzara, and Jacques Baron. In addition to *Retour à la raison*, two other films were shown: "The Smoke of New York" by Charles Sheeler and Paul Strand and an abstract film of geometric shapes by Hans Richter. According to *Little Review* editor Jane Heap, who was in attendance, "All the celebrities of Paris: painters, sculptors, musicians, poets; foreigners of every title, and rich excitement-hunting Americans turned out for this ultra-modern show." Most prominent in her account, as in Man Ray's own recollections of the event, was the impression of riotous protests erupting in the audience, of the arrival of the police and subsequent expulsions from the theater. The poetry reading by Jacques Baron, which amounted to a monotonous listing of the Parisian avant-garde, including Man Ray "*mort au champ d'honneur*," met with shouts of "Shut up baby! . . . We know all that? . . . Come out and we'll blow your nose! . . . Silly! . . . The door! The police! We want to hear! . . . The door! . . . The door!" Whereas the French took this to be genuine dadaist warfare, Heap interpreted it as dadaist performance with perhaps contrived disruptions. When the film broke during the screening, forcing Man Ray to run onstage to mend it, *Retour à la raison* itself seemed to add to the chaos of the evening.[30]

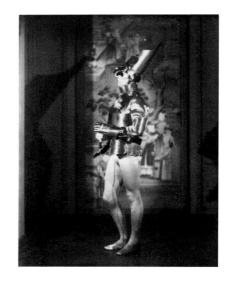

124 *Gerald Murphy*, 1924, photograph

Man Ray's participation in "Soirée du coeur à barbe" added to his notoriety. He was, in the words of the *Herald*, "the only American to be taken up by the French Dadaists on their own ground."[31] After attending the event, New York critic Henry McBride remarked to his readers in the *Dial* that

> beyond the admittance of our own Man Ray to the ranks
> of the magicians there seems to be no new name to be
> learned. The Parisians are just dying to have an affair with
> some new artist, but the boldness of the blandishments
> they offer seems to frighten rather than attract, and young
> geniuses, if they exist, are incredibly coy.[32]

It mystified McBride to find Man Ray, once the struggling modernist who made photo postcards for Katherine Dreier's Société Anonyme in New York, ahead of the rest of the Americans in Paris. To be sure, up to this time, no other artist had so embodied American vigor and spirit of invention in France. Such accolades had been reserved for heroes of American theater or industry:

Charlie Chaplin, George Gershwin, or Henry Ford. Yet to Mc-Bride, Man Ray was only one among "the ranks of the magicians" casting a spellbinding suggestion that film had supplanted painting.

With the establishment of his photography studio in Paris, Man Ray bought himself time and distance from an America that was still grappling with Cézanne and a community of dealers, patrons, and critics that had not changed since the Armory Show. He eliminated the need for both a sponsor and a dealer by exhibiting and selling his own work, and he reveled in the freedom. His highly original photographs well suited the modern aspirations and fantasies of an affluent American and European clientele frequenting Montparnasse—like the guests at the Comte de Beaumont's 1924 costume ball (fig. 124).

American publishers in Paris who used Man Ray's portraiture aligned his name with the most advanced trends in modern art—indeed, they were the first to use the interchangeable terms *rayogram* and *rayograph* in print. As early as May 1922, soon after Cocteau's article appeared in *Les Feuilles libres*, Frank Crowninshield visited Man Ray and bought four photograms for a full-page story in *Vanity Fair*.[33] The November issue featured rayograms with captions such as " 'A Comb Entering the Gyroscope'—a delicate and finely patterned abstract study in white, gray and black." That same fall the *Little Review* published what it termed a "rayograph," a dadaist object-portrait of Duchamp as *Rrose sel à vie* (fig. 125). Although the contributions of others were acknowledged, Man Ray's profile dominated the field. In March of 1923, when *Broom* published László Moholy-Nagy's photograms as well as his discussion of the plastic qualities of light, four of Man Ray's rayographs were also published, and his design commanded the cover of the issue. As in a rayograph, the letters *B R O O M* appeared as white silhouettes, and an intricate tracery of light and shadow played upon what was becoming Man Ray's insignia of lampshade and chess pieces (fig. 126).

Among the American intelligentsia in Montparnasse, Man Ray's expertise with a camera was respected and much sought after. He was, after all, successfully using "new tools" to make art at a time when, as Ezra Pound complained, "The 'big wave'!!! so much of it, looks to me merely like a lot of people using a set of tools made in 1912; and using 'em no better than their daldies [*sic*] used the set made in 1650 or 1880."[34] According to American writer-publisher Robert McAlmon, Man Ray's studio became a landmark in Montparnasse before the establishment of American bars such as the Jockey. When McAlmon's wife, Bryher (Winifred Ellerman),

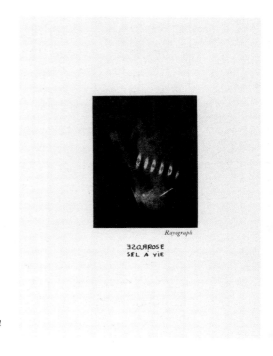

125 *Rrose sel à vie*, 1922, rayograph, published in *The Little Review*, autumn 1922

126 Cover for *Broom*, March 1923

came to Paris in June 1923, she made the Man Ray studio her first stop on a celebrity circuit that included the atelier Brancusi and Gertrude Stein's salon.[35] As official photographer for Shakespeare and Company (ca. 1922–26), a bookstore and lending library owned and operated by Sylvia Beach, Man Ray met with a steady stream of aspiring and arrived literary lights seeking portraits in a modern idiom. Gertrude Stein let it be known that he was the only photographer in Paris allowed to make her portrait.[36] In 1924 when Man Ray was interceding for her with the publishers of London *Vogue*, she created her own prose portrait of him, as she had done for Picasso before the war. As Sylvia Beach put it, "To be done by Man Ray meant that you rated as somebody."[37]

127 *James Joyce*, 1922, silver print

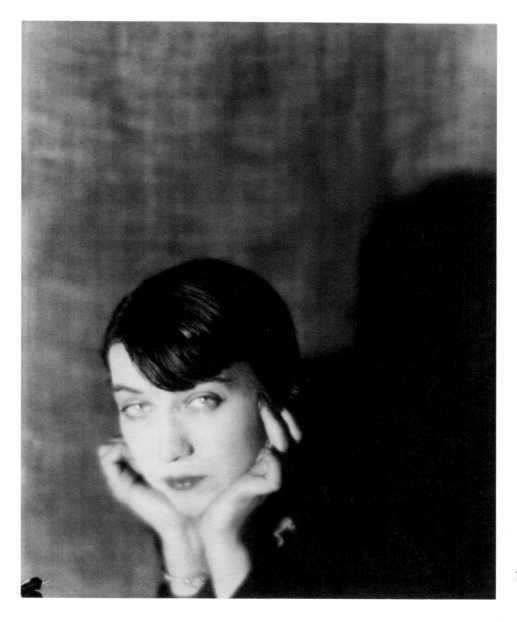

128 *Berenice Abbott*, 1922,
silver print

For the most part, Man Ray portraits took the form of close-ups, like movie stills. He captured James Joyce in profile the moment he turned away from the camera to shield his eyes from the studio lights (fig. 127). Berenice Abbott, then an impoverished sculpture student, appeared only as a face floating in a sea of shadow (fig. 128). Man Ray also meshed prop and sitter serendipitously, as the occasion required. Sinclair Lewis, slightly inebriated after the cafés on the boulevard Montparnasse, was seated before a large wooden screw from a wine press—a readymade Brancusi found in an antique shop—Lewis's head and shoulders forming the base for the wooden column that towered behind him (fig. 129).

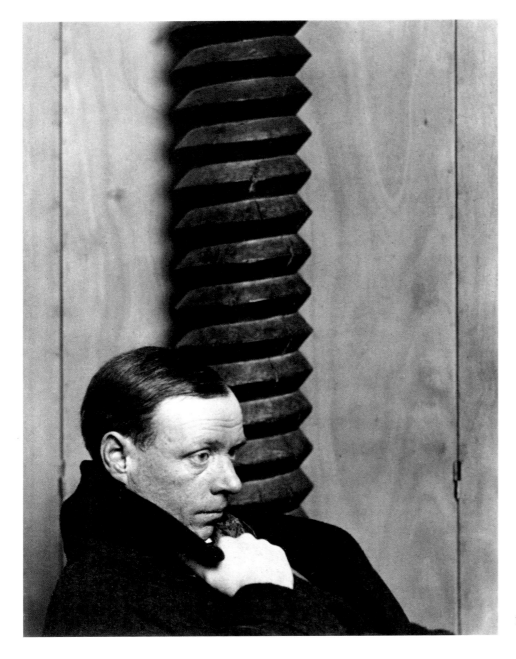

The drum of a banjo formed a halo around the face of a young Hemingway newly arrived in Paris (fig. 158); a year later, in 1924, after a window casement fell on Hemingway's head at a studio party, Man Ray captured the bandaged author as the reincarnate Apollinaire (fig. 130).

The anecdotal history of the period is replete with stories of artists who visited Man Ray's studio to see or buy his portraits and ended staying to discuss methods and techniques. It is said that Brancusi at one point decided to learn how to photograph his

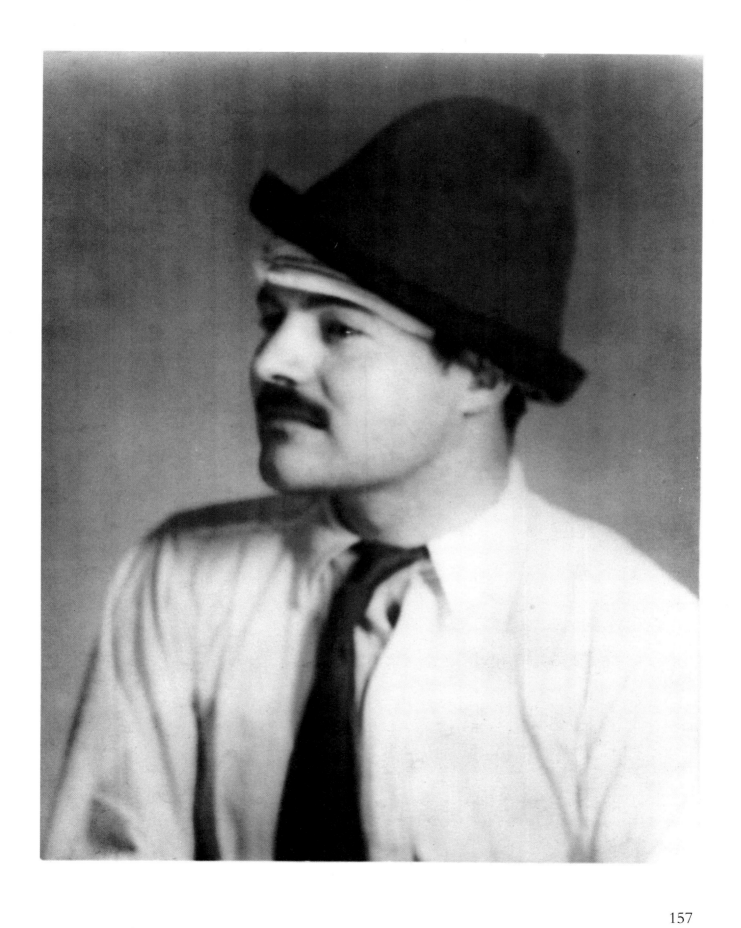

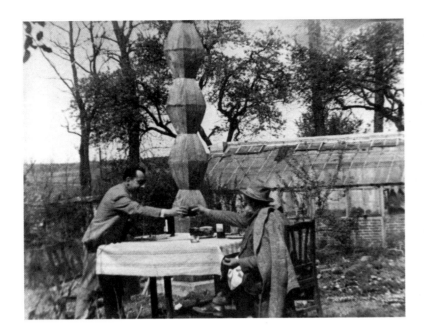

sculptures and so for a time in the twenties became Man Ray's pupil. A series of photographs—Man Ray and Brancusi toasting before the Endless Column and Man Ray wielding light sticks (figs. 131, 132)—made with Brancusi's camera, record their ensuing friendship. To be sure, the master of highly polished wood, stone, and bronze, and the master of luminous photochemical fields had much to learn from one another about the effects of light and abstraction.

Others in the twenties used 31 bis rue Campagne Première as a jumping-off place for their interest in film. More often than not, Man Ray found himself in the position of advisor to a patron turned film enthusiast. Bryher, who later founded the film journal *Close-up*, brought her baby Pathé, a popular camera of the period, to Man Ray to "get some hints." Interested in the reportage aspect of film, Hemingway borrowed Man Ray's camera to record a bullfight in Pamplona, Spain. Movie cameraman Dudley Murphy first brought special split-view lenses to Man Ray and had several sessions with him before collaborating with Léger on *Ballet mécanique* (1924)—an ambitious production aimed at capturing "percussion in pictures." Man Ray said later he was relieved to have resisted Murphy's offer of collaboration—indeed within two years of Murphy's visit, he made what he called an "antithesis" of *Ballet mécanique*. Although he lent his name and inventions to various causes and was willing to give others a start, Man Ray was adamant about maintaining his independence in an ever-widening field of ideas and reactions to film.[38]

131 Man Ray and Brancusi in Edward Steichen's garden (photographer unknown)

132 Man Ray wielding light sticks in Brancusi's studio (photograph by Brancusi)

In 1926 a patron unexpectedly appeared with an open-ended contract for another film. Arthur S. Wheeler was, as Man Ray saw him, an *homme d'affaires*, a dealer in high finance riding a transatlantic circuit between his seat on the New York Stock Exchange and his home in Paris. Wheeler first came to Man Ray's studio to commission his wife's portrait, but after several photo sessions the couple took an interest in Man Ray's other artistic activities. At the time, Wheeler was contemplating his retirement from the stock exchange and wanted to do something related to art. Film, he told Man Ray, held "the future for all art and money making."[39] Wheeler believed that his compatriot had the ideas to influence the direction of filmmaking, and he was willing to risk a considerable amount of capital to back him.

The commission was the financial break Man Ray had been waiting for since Howald's departure four years earlier. To him it represented the freedom to continue his artistic explorations in Paris and to visit New York on his own terms. Like many expatriates of his generation, the question of *when* to return to America was often tied to *how*. As Ezra Pound wrote when offered an American lecture tour: "Of course I wont to [*sic*] come to N.Y. unless I can come 'first' i.e. class. . . . Merely I dont refuse to come to the U.S. (on principle), I merely must have honorable terms."[40] With what was, at that point, the biggest commission of his career, Man Ray could indeed return to America "first class."

The sum negotiated with Wheeler was $10,000, with no strings attached except that the film be completed within the year. Other than the $5,000 he spent on a deluxe camera, Man Ray invested very little capital in the project. The remainder he sent to his bank account in New York. On 18 March 1926 Man Ray wrote his sister Elsie:

> Enclosed find cheque for $1,000 which please credit to my account BNU I have found a patron who is putting up money for me to do some moving pictures and this is a reserve fund. I just want to have some money put away for when I come back to New York or if an emergency happens here.

In April he sent another $2,000 and informed Elsie, "Am starting in earnest on my movie which I expect to finish in the fall. That may be a good excuse to come to New York to put it on."[41]

For a time in the summer of 1926, Man Ray suspended commercial work (or rather left his assistant Berenice Abbott in charge)

133 Gerald Murphy and his
sons, Patrick and Boath

134 Picasso and his son Paolo

and enjoyed the luxury of being a full-time artist. He vacationed
with the Wheelers in Biarritz; while traveling he filmed motoring
sequences and scenic vistas. Snapshots from this golden summer
also reflect his presence in Antibes with the Gerald Murphys and
Picasso (figs. 133, 134). Although there would be other vacations in
the south of France, other times with Picasso, this would be the
only summer when he kindled such high hopes for an American
success. He wrote his sister in July, "Just got back this week from
the south [of France] where I had been resting awhile and working
a little. . . . Thinking seriously of New York for the fall—really
want to go home for awhile." Within the month he was telling his
sister, "Am leaving in a day or so for the south again to stay with
some friends a couple of weeks. Have been working tremendously,
hope to have the film ready this fall and show it in New York."[42]

A fifteen-minute film entitled *Emak Bakia* premièred in New
York in the spring of 1927, after a Paris preview the preceding fall.
Man Ray's program notes for the New York showing described the
film as "a pause for reflection upon the present state of the cin-
ema." *Emak Bakia* was meant to be different. It was neither an
"objective" film, as Léger called his *Ballet mécanique*, which ana-
lyzed speed and motion in anecdotal fragments of people and ma-

chinery, nor was it a narrative with popular dances, songs, and cars like Hollywood productions—although its improvisations employed aspects of both approaches. *Emak Bakia* instead was an ironic play on the medium itself, complete with satirical pranks and distortions that presented light as the underlying visual and emotive power of film. As Man Ray explained:

> "Emak Bakia" is a film composed of improvisations within a few square feet of space snatched from images in passing. If the screen on which it is projected could suddenly be snatched away, its projection through space itself would have no less meaning.[43]

Two years later Man Ray further dramatized his point by projecting a movie literally on dancing couples dressed in white at the costume ball of Count and Countess Pecci-Blunt.[44]

Set to the jazz accompaniment of Django Reinhardt, *Emak Bakia* begins with a shot of Man Ray behind the camera, followed by an abstract sequence of revolving crystals and mirrors in and out of focus. The first narrative segment opens with eyes reflected in the headlights of a car (fig. 135). Man Ray is then shown touring Biarritz in an automobile with a female companion (possibly Rose Wheeler). The sensation of travel on the open road, in the perspec-

135 *Headlights* (film still from *Emak Bakia*), 1926, The Museum of Modern Art Film Stills Archive, New York

tive of a highway bordered by a parade of trees, continues until the
view rotates as the car seemingly collides with a herd of sheep.
Pairs of legs move backward and forward, on and off the running-
board of the car (fig. 136), establishing the tempo for a series of
close-ups: legs dancing the Charleston (the latest jazz craze from
America) and a hand playing the banjo (fig. 137). In the next
episode, the same "woman" (possibly the female impersonator Bar-
bette) steps into her boudoir, primps in front of a mirror, and
approaches the open doors of a balcony. Contrary to the viewer's
expectations, she never emerges from the room. Instead, the view
of the beach below becomes the subject, with another series of
close-ups—legs moving in the sand, waves crashing; then the cam-
era submerges to find fish swimming with their shadows.

The focus and tempo of the film shift to the rather staccato
movements of animated objects, but these vignettes always return
to the ongoing theme of axial motion and light. Man Ray's cork
figure entitled *Fisherman's Idol* rotates and multiplies. The male
manikin in his collage *Homme d'affaires* springs from a standing
position up into the air and down again, lines tracing its course (fig.
138). Next the infamous sphere, cylinder, and cone (Cézanne's
abiding abstractions from nature) parade before Man Ray's 1915
cubist painting *Dance* (fig. 49). This is followed by improvisations
on a still life with dice and an electric logo spelling out "Every
Night at Magic City." The slow removal of a fan reveals the
waking face of a woman, fading to a merry-go-round and rotating
crystals. The awakening shot is repeated with two variations: either
she smiles and the image fades to a coral flower or she begins to

136 *Legs on and off Car Run-
ningboard* (film still from
Emak Bakia), 1926

137 *Hand Playing Banjo* (film
still from *Emak Bakia*),
1926

162

speak and dissolves into light, rotating like the movie reel from which the imagery unwinds.

Before the final narrative sequence, Man Ray broke the momentum of the film by stopping the music and displaying the subtitle "The Reason for This Extravagance" on the screen. At last it seemed all would be explained. In the vivid drama that follows, a car pulls up to a door and the notorious dandy Rigaut, with briefcase in hand, gets out. He goes inside and opens the briefcase. When he empties out collars, which dance and twirl to the tune of the "Merry Widow Waltz," the viewer realizes he has fallen victim to Man Ray's ruse. There is no further explanation, just the echo of Man Ray's contention that his film would have no less meaning "if the screen on which it is projected could suddenly be snatched away." The film ends with a good-humored close-up of Kiki's face. She shuts her eyes only to reveal another pair painted on her lids. As if in response to the joke, Kiki smiles. Her parted lips expose the word *Finis,* written in black dissolving letters on her teeth.

Emak Bakia was pure visual poetry and showed Man Ray in full command of the medium of film: slowing it down, speeding it up; touching down in the objective world then pulling away to abstraction; creating suspense and exploding it with laughter. Insisting on the primacy of the performance itself, Man Ray offered the following disclaimer in the program: "In reply to critics who would

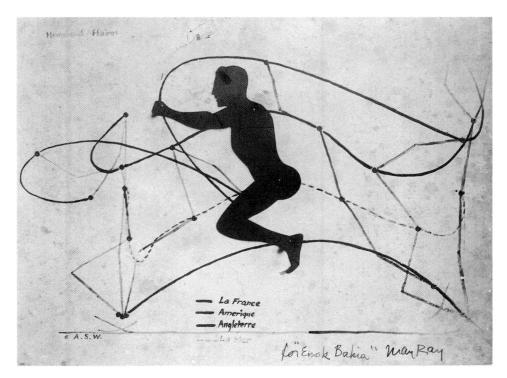

138 *Homme d'affaires*, 1926,
 silver print

like to linger on the merits or defects of the film, one can reply simply by translating the title 'Emak Bakia,' an old Basque expression, which was chosen because it sounds prettily and means: 'Give us a rest.' "[45] He had good reason to speak with such confidence about his new medium. He had the backing and approval of wealthy American patrons, Arthur and Rose Wheeler. He had the attention of those responsible for bringing the most advanced trends in modern art to New York, including Katherine Dreier, director of the Société Anonyme and organizer of the International Exposition of Modern Art, and Frederick Kiesler, De Stijl architect-filmmaker who, together with Jane Heap, organized the 1926 International Theatre Exposition. Something, however, was missing. Art critics were not in evidence at *Emak Bakia*'s New York showing, for none were prepared to promote film as art. Four years later Julien Levy would try, but at the moment of Man Ray's New York première, Levy ironically was sailing for Paris with Duchamp in hopes of working with Man Ray there. *Emak Bakia* remained unnoticed outside the boundaries of the New York avant-garde community. By contrast, that same month a rather hastily conceived exhibit of Man Ray's recent photographs and paintings at the Daniel Gallery merited a review in the *New York Times*.

The fact that Man Ray had gone to Paris and become a photographer was well known in New York. In 1924 when the Little Review Gallery exhibited his portfolio of rayographs—"chemical paintings," as Jane Heap called them—the *Times* had carried a story describing Man Ray's inventive use of electric lights and photosensitive papers.[46] Three years later, at the Daniel Gallery, it was newsworthy that Man Ray had been painting. His new canvases were a notable departure from the highly cerebral abstractions he had exhibited at the gallery in 1919. In works such as *Arc de Triomphe*, *Le Grand Palais* (fig. 139), and *Regatta* (fig. 140), Man Ray returned to the picturesque, but with a rather deliberate clumsiness. Treating paint as a sculptor would clay, he laid out the planes of his composition in broad sheets of pigment, playing upon the opaque and reflective qualities of color. Lines etched through the paint revealed the white of the underlying canvas and supplied detail. The reviewer from the *Times* compared the works to the "abstract musical scores" of Braque and Juan Gris. Ultimately, however, the paintings did not withstand the inevitable comparison with the inventiveness of Man Ray's photographs. As the reviewer concluded: "Otherwise, Man Ray's paintings do not seem to be especially significant. His gift really is in the province of photography. One may say briefly, of this photography that it results from

the ultilization of all the possibilities of the camera, in relation to paper which he has discovered. He has found a good deal that is interesting, especially in his arrangement of a pin and a candle."[47]

The review itself was a small item, but it signified larger realities about New York for Man Ray. The fact that the reviewer felt it necessary to choose between media meant that he had missed Man Ray's commentary about light and its translation from one medium to another—the very reason for exhibiting both paintings and photographs together. And was it enough for the reviewer to express interest in the arrangement of the candle and pin rayograph without seeing a whimsical portrait or a landscape in it as well? Something indeed had been lost in the transatlantic exchange of audiences. While the Parisian avant-garde easily moved from one medium to the other—imaginatively exploring aspects of light, form, and texture in each—the aesthetic barriers seemed insurmountable in the New York art world. If Man Ray had any doubts about this, his suspicions were soon confirmed by the resounding failure of Georges Antheil's program of alternative mechanical music at Carnegie Hall.[48] Perhaps the artist considered himself lucky to slip away quietly.

Within a month of both his film debut and Daniel Gallery

139 *Le Grand Palais*, ca. 1924, oil on canvas, Columbus Museum of Art, Gift of Ferdinand Howald

140 *Regatta*, 1924, oil on canvas, Columbus Museum of Art, Gift of Ferdinand Howald

exhibition, Man Ray returned to Paris without his hoped-for American triumph. He never premiered another film in New York, nor did he return Stateside simply to stand with his works on exhibit. The 1927 New York trip confirmed his dependence on a Parisian context. Back in Paris the following year, Man Ray was in his element. He wrote to Dreier and Duchamp in New York: "Are you coming over soon? I've been in Paris all summer working. Am showing a new film this week. What with abstract and portrait photography, movies and now and then a painting. I have plenty to do. But it's all one thing in the end. Giving restlessness a material form!"[49] Ironically, *Emak Bakia*'s New York premiere had carried weight with his Paris audience. *Close-up*, a magazine devoted to "making film ready for art" edited by Kenneth Macpherson and Bryher, republished Man Ray's New York program notes for *Emak Bakia*'s Paris showing, and the film enjoyed an extended run at Studio des Urselines during the fall.[50] His next two movies, *L'Etoile de mer* (1928), an improvisation based on a poem by Robert Desnos, and *Le Mystère du château de dés* (*The Mystery of the Castle of Dice*, 1929), commissioned by the Vicomte de Noailles and enacted by weekend guests at his château, were very much tied to a particular genre of surrealist filmmaking and not made with the same New York aspirations as the Wheeler commission.

Similarly, his 1929 paintings showed the influence of surrealist automatism with characters such as Gens du monde, whose squiggled shapes (complete with hat and cane) are literally squeezed from tubes of paint onto silver- and gold-leaf panels. Man Ray's irreverence toward the precious panels, historically reserved for religious icons, represented the latest volley in an ongoing battle waged by the European avant-garde against *la belle peinture*. If Picasso committed violent sacrilege in *Guitar* (1926) by taking a dirty shirt (a painter's rag), sewing it to a canvas, and violating its surface by punching nail holes through it, then Man Ray employed the antithetical tactic of glorifying the surface with inviolate gold-leaf and trivializing the painter's action upon it. As the title of Man Ray's *Tableau ton gout I* wryly suggested, the issue had really become "a matter of taste" (fig. 141).

A magazine begun in Paris in 1927 by Eugene Jolas entitled *transition* served as Man Ray's primary intermediary between the continents during this period. *Transition* continued to maintain literary exchanges and address inquiries concerning the mechanized, accelerated rhythms of the postwar era after the *Little Review* ceased regular publication. Like the latter, *transition* acknowledged signs of America's artistic awakening by publishing new or experimental art

141 *Tableau ton gout I*, 1929, oil on silvered panel, Collection Marion Meyer, Paris

forms by American artists abroad. In the summer 1928 issue, Man Ray's photos shared its pages with wire improvisations by Alexander Calder. In fact, the resurgence of interest in Man Ray's alternative media—his "painting with light"—may actually have been revived by Calder's newly acclaimed "drawing with wire," his *fils de fer* (fig. 142). (In 1927, all of Montparnasse clamored to see Calder's wire-circus performances.)[51] In February 1929, *transition* reproduced a series of rayographs and reprinted a 1923 commentary by Robert Desnos: "It would be, in my opinion, denaturing the significance of the Universe that Man Ray suggests to me, were I to dwell on the figuration of dazzling elements in his work; for he reveals a land that is as tangible and, for the same reasons, as indisputably material as light, heat or electricity."[52] Writings like the Desnos article, however, had become less and less readable in America. The Man Ray presented to the American public—*when* he was presented to the American public—remained a curious amalgam of old New York work and newer items from Paris. With no offers for a one-man show forthcoming in New York, he sent a group of rayographs, an aerograph, and a chess set to the Arts Club in Chicago for a one-man show. That same year, Albert Gallatin's Gallery of Living Art in New York included his 1914 painting *War* in its exhibition of "contemporary" art. In his 1929 *Telegram*, a work in which paint inexplicably dribbles up and across a scribbled note, Man Ray seemed to acknowledge the increasingly cursory and perplexing communication between him and his American public (fig. 143).

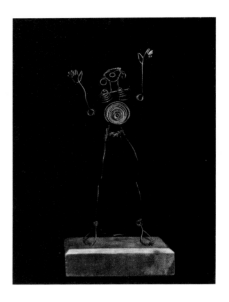

142 Alexander Calder, *Josephine Baker*, ca. 1926–27, wire, Musée National d'Art Moderne, Centre National d'Art et de Culture Georges Pompidou, Paris

143 *Telegram*, 1929, oil on canvas, Collection Paride Accetti, Milan

The vision of a new art and a new order for the twentieth century that first spawned the transatlantic collaborations at Stieglitz's 291 and sustained the postwar migration of artists to Paris seemed to have dissipated, along with the political and economic stability achieved by the fragile peace of 1919. There would be no melding of Old and New Worlds. When the decade ended, each who had once aspired to a European venture had his own explanation. Believing that it would "take years to get into" what was happening in postwar Paris, Demuth resolved to return to Lancaster, Pennsylvania. After his self-described tenure in the south of France as the "American Cézanne," Hartley settled in Maine, the New York critics panning his works for their very similarities to those of the modern master. Stieglitz felt tired and defeated by his prior associations with France. He wrote bitterly to Demuth in 1930: "And none of the artists I have [worked] for have become rich like the French artists so lovingly supported by art loving America! Why aren't you & Marin & O'Keeffe & Dove Frenchmen?—& I at least a Man Ray in Paris?"[53]

Perhaps the most pessimistic note was sounded by one of the greatest proponents of the machine age, Jane Heap, who wrote at the passing of the *Little Review*:

> The revolution in the arts, begun before the war, heralded a renaissance. The Little Review became an organ of this renaissance. . . . For years we offered . . . a trial-track for racers. We hoped to find artists who could run with the great artists of the past or men who could make new records. But you can't get race horses from mules. I do not believe that the conditions of our life can produce men who can give us master-pieces.[54]

Matthew Josephson, however, while weary of the game-playing of dada and surrealism, was unwilling to give up the quest for a new art. He simply eschewed the transatlantic as a means of arriving at it. Long-distance relationships were no longer enough when the face of modern America was changing daily. In 1928, his "Open Letter to Ezra Pound and the Other 'Exiles' " put Pound on notice that attendance was being taken at home:

> What of you, then Mr. Pound, at this juncture—while the Faubourg Saint-Germain and all such genteel milieux are being swept away? Keeping in mind your "old world views," perhaps you had best return to your Cantos, with

their odd mixture of classical and modern tags? Was this not the best of you? But no, I am told that you have gone back to them already. . . . Then return, to America, whom you long for, no doubt in the jealous way of lovers! Return! . . . We may become centurions of soap for a time, pro-consuls of hydro-electricity; we may sing before the microphone; dance before the television box. A period of mind will leaven this society which has known only material preoccupations. The dispersed and scattered beauty of automobiles and spotless kitchens and geometrical office buildings will have been organized and given direction through our understanding of the ensemble. A spiritual equilibrium will have been reached, in which we shall have been factors.[55]

As the gulf between Man Ray's two worlds deepened, it became clear that he was praised or criticized for his celebrity in France—not for his art. In the eyes of critic Henry McBride, the American artist in Paris was part of a herd participating in an "On to Paris Movement" that threatened the identity of an independant American art. McBride no longer claimed "our own Man Ray." Since Man Ray had been "adopted by the French," he should look to them, and them alone, for patronage: "If an American artist must live in Paris for his soul's good, that is his affair; but in doing so he automatically becomes French and must gain French support rather than live, parasitically, upon funds from home." Moreover, from McBride's point of view, it was questionable whether works directly translated from objects such as the rayographs were even "art." In the wake of the 1932 surrealist exhibitions at the Julien Levy Gallery, McBride reminisced,

When Marcel was here we almost got to the point of thinking that art consisted of things rather than the painted reflection of them, but he went away and all of us but Walter Arensberg of Los Angeles and Katherine Dreier of Connecticut backslided. Now, it seems, we shall have to begin all over again.[56]

With the onslaught of the Great Depression, it was indeed like starting all over again. Long after his compatriots had gone home, Man Ray remained abroad awaiting vindication of his art in America. The optimism of the previous decade seemed remote. In the heady celebrations of postwar France his work had stretched the

boundaries of the imagination even as American industry had expanded the pace and possibilities of modern life itself. With the advent of talking pictures, however, the direction and nature of film gave itself completely to narrative, and Man Ray, the painter with a camera, lost interest. In 1932 he sold his car and his movie camera, later explaining: "I felt ready for new adventures. I also had to get rid of the things that had taken up too much of my time and energy especially mechanical things." In 1933 while making his album *Photographs by Man Ray 1920 Paris 1934*—comprising portraits of Lewis, Hemingway, Pound, and Kiki; rayographs and surrealist photos with accompanying essays by Tzara, Breton, and Eluard; and a portrait of himself by Picasso—Man Ray closed a chapter of his career. If Gertrude Stein had not kept her portrait of him, he would have included it as well.[57] Indeed, her incantation captures the futuristic aspirations of one who had cast his fate on the transatlantic of the twenties: "Sometime Man Ray sometime. Sometime Man Ray sometime. Sometime Man Ray sometime. Sometime sometime."

NOTES

1. De Zayas to Stieglitz, 3 August 1922, Stieglitz Collection; reprinted in "Can a Photograph Have the Significance of Art?" p. 18.
2. Man Ray to Tzara, ca. June 1921, Tristan Tzara Archives, Bibliothèque Littéraire Jacques Doucet.
3. The exhibition originally planned for 1914 was a homage to Whistler, but as a result of the war it was postponed and then changed to celebrate the spirit of Pershing and his soldiers. See Léonce Benedite, *Exposition d'artistes de l'école américaine* (Paris: Musée Nationale de Luxembourg, 1919), p. 3.
4. Demuth to Stieglitz, 13 August 1921, Stieglitz Collection.
5. Quotations from Man Ray's letter to Howald, 18 August 1921, Ferdinand Howald Collection; and Demuth's letter to Stieglitz, 10 October 1921, Stieglitz Collection.
6. Ibid.
7. Hartley to L. Baer, 14 October 1921, Stieglitz Collection.
8. Stieglitz to Alfred Kreymbourg and Harold Loeb, 25 November 1921, Stieglitz Collection.
9. Josephson, *Life among the Surrealists*, p. 109.
10. The catalogue was a three-page pamphlet comprising a checklist, fictitious biography, and statements by Aragon, Arp, Eluard, Ernst, Man Ray, Ribemont-Dessaignes, Soupault, and Tzara. A copy is in the collection of Lucien Treillard.
11. Josephson, "Made in America," *Broom* 2, no. 3 (June 1922): 266.
12. Man Ray, *Self Portrait*, p. 115.
13. Man Ray to Howald, 3 February 1922, Ferdinand Howald Collection.
14. Man Ray, *Self Portrait*, p. 119. For the *New York Herald* review, see "With the Artists."
15. Man Ray to Howald, 21 October 1921, Ferdinand Howald Collection.
16. Stein, *The Autobiography of Alice B. Toklas* (New York: Harcourt Brace and Company, 1933), p. 237; Stein, *Everybody's Biography* (1936), quoted in Janet Hobhouse, *Everybody Who Was Anybody* (New York: G. P. Putnam's Sons, 1975), p. 138.
17. Man Ray, *Self Portrait*, p.174.
18. Man Ray to Howald, 5 April 1922, Ferdinand Howald Collection.
19. Ibid.
20. Cocteau, "Lettre ouverte à Man Ray, photographe américain," pp. 134–35.
21. Tzara, Preface to *Les Champs délicieux*, n.p., taken from an unpublished translation by Man Ray entitled "Photography in Reverse," Collection Lucien Treillard.
22. Avis Berman, "The Unflinching Eye of Berenice Abbott," *Art News* 80, no. 1 (January 1981): 89.
23. De Zayas to Stieglitz, 3 August 1922, Stieglitz Collection; reprinted in "Can a Photograph Have the Significance of Art?" p. 18.
24. Howald to Man Ray, 16 May 1922, Ferdinand Howald Collection.
25. Man Ray quotations from his letter to Howald, 5 April and 28 May 1922, Ferdinand Howald Collection.
26. Quotations from Man Ray, *Self Portrait*, p. 104; and Man Ray to Howald, 28 November 1922, Ferdinand Howald Collection.
27. Ribemont-Dessaignes, "Dada Painting or the Oil Eye," pp. 10–11. Man Ray's decision not to exhibit in the Salon was reported in "Studio Gossip."
28. Man Ray to Tzara, ca. June 1921, Tristan Tzara Archives, Bibliothèque Littéraire Jacques Doucet.
29. Josephson, *Life among the Surrealists*, p. 123. In an interview with the Paris *Herald* entitled "The Lion Will Chirp 'Peep, Peep,'" Man Ray said that despite the advent of the talkies, his films would always maintain an incongruous and often ironic conjunction of sound and image. "I don't think that I will ever be interested in the talkies in any general way of using them to reproduce the words spoken by actors" (19 May 1929, sec. 1, p. 2).
30. Heap, "Comments," *Little Review* 9, no. 3 (Spring 1923): 27–28.
31. This evaluation appeared in February 1923 in "Studio Gossip." The *Herald* had earlier alluded to Man Ray's far-reaching influence in its 18 July 1922 report that "our American Man Ray" was among the influences cited by an unnamed Frenchman who had just created an Art Machine ("Dadaism Yields

to Art Machine," p. 2).

32. McBride, "The Banquet by Pascin," *Dial*, November 1923, as quoted in Daniel Catton Rich, ed., *The Flow of Art: Essays and Criticism of Henry McBride* (New York: Atheneum Publishers, 1975), p. 176.

33. "I've begun to show my things to people who come to see me, and have sold about 12, not including 4 which *Vanity Fair* has taken for last week and was very enthusiastic" (Man Ray to Howald, 28 May 1922, Ferdinand Howald Collection).

34. Pound to William Carlos Williams, 23 July 1922, William Carlos Williams Collection.

35. McAlmon and Boyle, *Being Geniuses Together*, p. 34: "The American bars had not yet come into being, and there was a great deal more entertaining in the home than was later to occur. Man Ray was settled into his studio with Kiki, spoke French fluently and was getting a French public, in a measure due to the help of Marcel Duchamp and Tristan Tzara and other Dadaists"; Bryher to H. D. (Hilda Doolittle), 19 June 1923, H. D. Collection.

36. In response to Man Ray's request for payment, Stein wrote, "Kindly remember that I have always refused to sit for anyone who wishes to photograph me in order to give you the exclusive rights. Kindly remember that you have never been asked to give me any return for your sale of my photograph" (12 February 1930, Gertrude Stein Collection).

37. Beach, *Shakespeare and Company*, p. 120.

38. Bryher quoted from her letter to H. D., 19 June 1923, H. D. Collection. For further discussion of *Ballet mécanique*, see Hugh Ford, *Four Lives in Paris* (San Francisco: North Point Press, 1987), pp. 30–31.

Man Ray recalled attending a boxing match with Hemingway in Paris and making exclusive footage, which he later turned over to the press. Sometime after that, Murphy, having heard of Man Ray's interest in movies, presented himself and his equipment at the studio (*Self Portrait*, pp. 184–85, 266–67).

39. Man Ray, *Self Portrait*, p. 268.

40. Pound to William Carlos Williams, 23 July 1922, William Carlos Williams Collection.

41. Man Ray quotations from his letters to Elsie Ray, 18 March and 9 May 1926, Collection of Naomi Savage, Princeton, N.J.

42. Ibid., 10 and 20 July 1926.

43. " 'Emak Bakia' by the Noted Modernist Artist Man Ray."

44. Man Ray, *Self Portrait*, p. 168.

45. " 'Emak Bakia' by the Noted Modernist Artist Man Ray."

46. "New Photography Employs No Lens." Heap's term appeared in *Little Review* 9, no. 4 (Autumn–Winter 1923–24): 39.

47. *New York Times*, 20 March 1927, p. 6.

48. For a discussion of Antheil's New York performance of *Ballet mécanique*, see Ford, *Four Lives in Paris*, pp. 59–60.

49. Man Ray to Dreier, 24 September 1928, Société Anonyme Collection.

50. "Emak Bakia," *Close-Up*, no. 2 (August 1927).

51. Calder paid his rent in Paris by giving performances of his wire-circus company. In the spring of 1927, word of it reached critic Jean Cocteau and the French press, which hailed it as art. For further discussion of Calder and American art in Paris, see Turner, "The American Artistic Migration to Paris between the Great War and the Great Depression."

52. Desnos, "The Art of Man Ray."

53. Stieglitz to Demuth, 28 January 1930, Stieglitz Collection.

54. Heap, "Lost: A Renaissance," *Little Review* 12, no. 2 (May 1929): 5.

55. Josephson, "Open Letter to Ezra Pound and Other 'Exiles,' " *transition*, no. 13 (Summer 1928): 101–2.

56. Quotations from McBride, "Motorized Calder," *New York Sun*, 21 May 1932; reprinted in Rich, *Essays and Criticism of Henry McBride*, p. 293. In the face of American backlash, the Valentine Gallery—which took Man Ray under its wing in 1936—defended French modernism in New York ("Here Is an Answer to the American Attack on French Modernism," *Art Digest*, 1 January 1932, p. 7).

57. Man Ray, *Self Portrait*, p. 291. The manuscript is in the Gertrude Stein Collection.

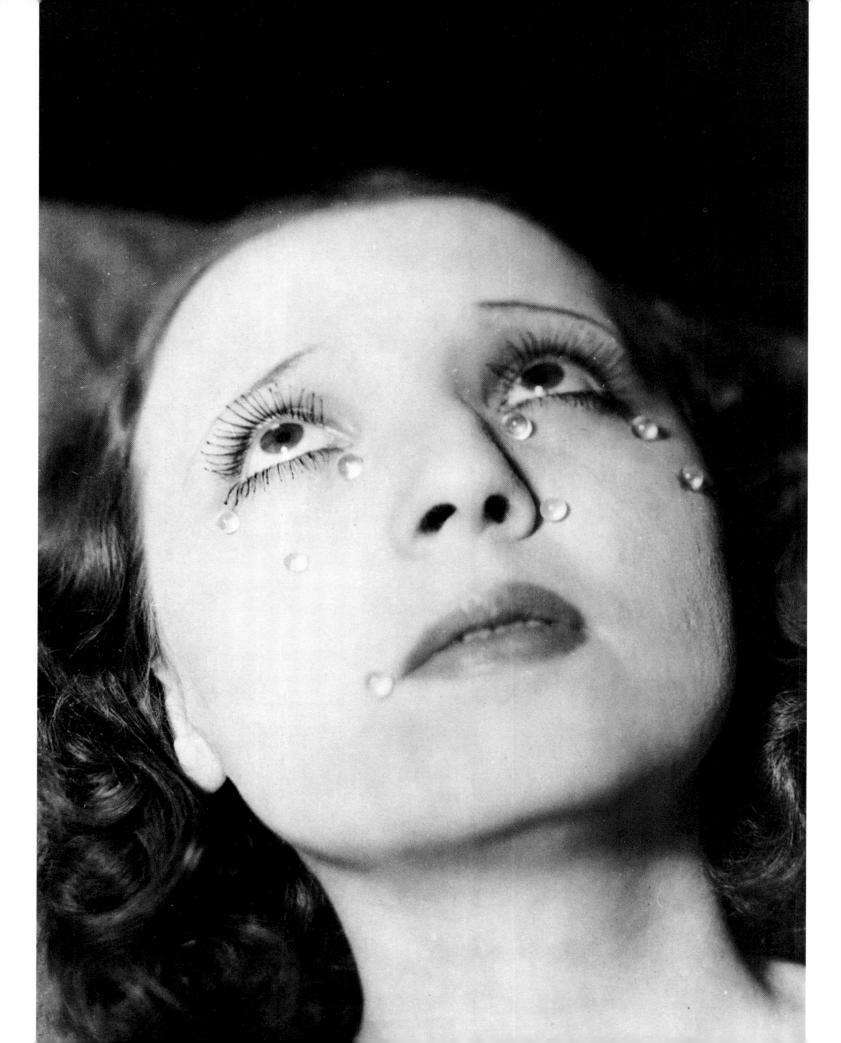

CHAPTER FOUR

THEMES AND VARIATIONS: MAN RAY'S PHOTOGRAPHY IN THE TWENTIES AND THIRTIES

Sandra S. Phillips

For the catalogue of Man Ray's exhibition at the Galerie aux Cahiers d'Art in 1936, Max Ernst designed a cover that aptly conveyed his friend's American brand of deadpan humor, witty outrageousness, and perhaps his aesthetic dilemma (fig. 144). A negroid Statue of Liberty hoists not a torch but a giant screw aloft, and a bold X is scratched on her tablet. She stands perilously close to a container of matches (in fact, the statuette may have originally been designed as a match holder). In front of her, a strange figure composed of assorted shoes and boots looms large, a palette hooked onto one protrusion—an arm? a breast?—and a strange ladle-shaped object sprouting from its top. A disembodied moon face shines benignly over the shoe-person, and a geometrical object sits on the ground before it.

Ernst's configuration contains some of the very elements depicted in Man Ray's photographs of the interwar period: screws, matches, mathematical constructions, and floating heads. While the painter's palette is a prominent feature of the anthropomorphic figure, the large riding boot forming its leg seems ready to kick the geometrical object, a subject frequently photographed by Man Ray at that time. Was Ernst, so close to Man Ray, alluding to an artistic situation he saw his friend confronting? One thing is sure: Ernst's selection of objects was not arbitrary. No doubt they had a personal

Larmes (Glass Tears). Variant of work in Fig. 179.

à man ray max ernst

significance to Man Ray—while effectively undermining reality through the use of real things, in keeping with the spirit of surrealism.

Most art historians who have faced Man Ray's career have had to come to terms with his marvelous discontinuity, his irreverent, effulgent contradictions. Did he, for instance, ever believe photography was "art"? Did he consider his painting and drawing as "serious" as that of the aesthetic innovators who were his contemporaries? Did he view the work he made to earn a living—the portraits and fashion photography—as a bore or a challenge? If there is anything consistent about Man Ray's art, it is that its inconsistency was deliberate and, indeed, typical of the "whole" man—painter, photographer, filmmaker, writer.

Before he left for France, he wrapped a sewing machine in an old army blanket and tied it up. *The Enigma of Isidore Ducasse* (fig. 74) is a realization of the later principles of surrealism, that the juxtaposition of concrete, disparate things can provoke the subconscious. The strange or surreal is not far from the real and ordinary, and the conjunction of unrelated, spontaneously chosen objects can lead to dreams, to unexpected poetic associations. Late in life, Man Ray told a reviewer, "I never do just one thing, but *two things* that are totally unrelated. I put these together in order to create, by contrast, a sort of plastic poetry."[1] Perhaps his work, as abundant in styles as it is in media, is best characterized by a spiral, always moving—one of his favorite configurations. Although he protested when he was an old man that "photography was simply a matter of calculation, obtaining what had been figured out beforehand, [while] painting was an adventure in which some unknown force might suddenly change the whole aspect of things," his early work as a photographer clearly contradicts this.[2]

When Man Ray arrived in Paris and discovered that he could not support himself as an artist, he easily turned to photography as a livelihood. In New York he had learned to use the camera to document his paintings, and he worked with Katherine Dreier's Société Anonyme as the museum's resident photographer, again documenting works of art. Thus it was natural to assume the same role in France, where Duchamp and Picabia helped by introducing him to artists such as Picasso who needed their paintings reproduced for use in catalogues or by galleries. Man Ray had always disliked this kind of work, however, and portrait photography soon became his principal and preferred source of income. Marie Vassilieff, the owner of an artist's canteen who also made caricature dolls

of fashionable figures, introduced him to a variety of socialites. He also became a friend of Jean Cocteau's. Possibly through Yvonne Chastel or more likely through Picabia's wife, Man Ray was introduced to the designer Paul Poiret and thereby assumed yet another role, that of fashion photographer, within the first months of his stay in France.[3] It was while he was printing fashion enlargements, in fact, that he discovered the rayograph.

In New York Man Ray had been friendly with Alfred Stieglitz, who had developed the aesthetic consciousness of Americans by exhibiting European modernists and who had a sense of mission about the artistic potential of photography. For Stieglitz, photography definitely—even defiantly—was art. Man Ray's dadaist images in New York, their earthy funniness, their acid wittiness, may have been an antidote to Stieglitz's aestheticism and idealism.[4] Man Ray's *Man*, for example, a photograph of an eggbeater hanging on the wall (fig. 69), debunks the purity and idealism of Paul Strand's machine aesthetic and is closer to Picabia's drawings of machines as funny and fallible personalities. Despite their divergent outlooks, however, Stieglitz may have inspired in his younger compatriot a belief in photography as a truly expressive medium and a desire to press it to the limits. Stieglitz's presence may also account for how Man Ray viewed his rayographs, which was as art.

As he was printing his fashion work for Poiret sometime late in 1921 or early 1922,

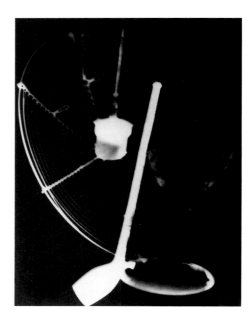

145 Untitled, 1922, rayograph, from the portfolio *Les Champs délicieux*

> one sheet of photo paper got into the developing tray—a sheet unexposed that had been mixed with those already exposed under the negatives—I made my several exposures first, developing them together later—and as I waited in vain a couple of minutes for an image to appear, regretting the waste of paper, I mechanically placed a small glass funnel, the graduate and the thermometer in the tray on the wetted paper. I turned on the light; before my eyes an image began to form, not quite a simple silhouette of the objects as in a straight photograph, but distorted and refracted by the glass more or less in contact with the paper and standing out against a black background, the part directly exposed to the light.[5]

Man Ray immediately christened the new works rayographs (fig. 145), and Tzara, who shared the same hotel at the time of the discovery and was the group's self-styled artistic "godfather," saw that they were accepted by his dadaist friends.[6] If Man Ray was

178

interested in becoming well known as an artist, he had succeeded as a photographer. Indeed, he would be the only innovative photographer of that period in France, and the rayographs played a large role in this achievement: they bestowed on him the same status in photography that Picasso had in painting.

To Man Ray, the rayographs were a kind of abstract art. Because his best friends, the dadaists, were mostly poets, the rayographs were usually described as poetic creations. In his introduction to Man Ray's first book, *Les Champs délicieux*, Tzara wrote a wonderfully evocative essay—funny, very responsive to the strange assortments of objects in the rayographs, and appreciative of their mysteriousness as well.[7] Some years later, when Man Ray was discussing rayographs with an interviewer, he explained:

> I began as a painter. In photographing my canvasses I discovered the value of reproduction in black and white. The day came when I destroyed the painting and kept the reproduction. From then on I never stopped believing that painting is an obsolete form of expression and that photography will dethrone it when the public is visually educated. . . . I know one thing for sure—I need to experiment in one form or another. Photography gives me the means, a simpler and faster means than painting.

Later in this same interview, he described the rayographs' impact on Picasso: "I saw Picasso here on his knees before a photogram. He allowed that in many years he had not experienced as great a sensation of art as from it. Painting is dead, finished." When the interviewer questioned, "But you still paint?" Man Ray replied, "Yes, sometimes, but only to completely persuade myself of the inanity of it."[8]

While in Man Ray's eyes, as in the eyes of his contemporaries, the rayographs were equal to painting in expressive power and invention, he would always feel compelled to be contrary. To purists such as Stieglitz, emerging from the fog of pictorialism, they were a confusion of art and photography—which must have delighted the dadaists enormously. However, the only works that really resembled Man Ray's rayographs, which he may very well have seen, were not the often-cited photograms by Christian Schad or László Moholy-Nagy, but the abstract images by a contemporary pictorialist named Ira Martin. Pretentiously titled and probably inspired by Thomas Wilfred's clavilux, a machine that produced abstract "light music," they were published in *Vanity Fair* a few

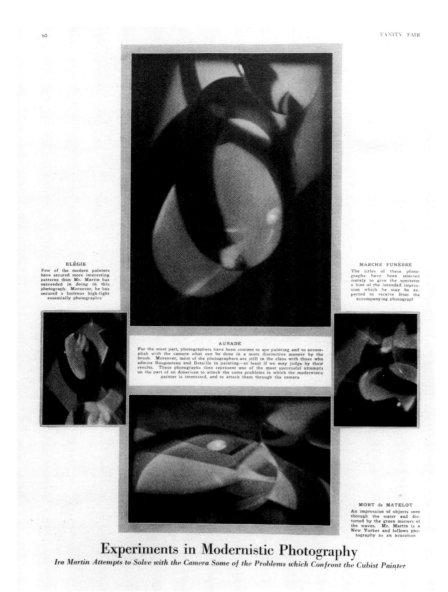

ELÉGIE
Few of the modern painters have secured more interesting patterns than Mr. Martin has succeeded in doing in this photograph. Moreover, he has secured a lustrous high-light essentially photographic

MARCHE FUNÈBRE
The titles of these photographs have been selected merely to give the spectator a hint of the intended impression which he may be expected to receive from the accompanying photograph?

AUBADE
For the most part, photographers have been content to ape painting and to accomplish with the camera what can be done in a more distinctive manner by the brush. Moreover, most of the photographers are still in the class with those who admire Bouguereau and Detaille in painting—at least if we may judge by their results. These photographs then represent one of the most successful attempts on the part of an American to attack the same problems in which the modernistic painter is interested, and to attack them through the camera

MORT de MATELOT
An impression of objects seen through the water and distorted by the green mirrors of the waves. Mr. Martin is a New Yorker and follows photography as an avocation

Experiments in Modernistic Photography
Ira Martin Attempts to Solve with the Camera Some of the Problems which Confront the Cubist Painter

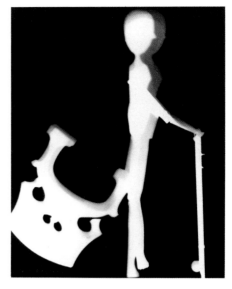

146 *The Manikin*, 1923, rayograph

147 "Experiments in Modernistic Photography," *Vanity Fair*, July 1921

months before Man Ray's rayographs were presented in the magazine (fig. 146). The text contended that Martin's images "represent one of the most successful attempts on the part of an American to attack the same problems in which the modernistic painter is interested, and to attack them through the camera."[9] Man Ray's rayographs were not so lofty. Instead of pompously cascading arcs of light and dark, he created mushroom shapes and fashioned little stick men with canes (fig. 147). Although he was experimenting with a new medium—light—thus making photography an appropriately modernist pursuit, his rayographs also had an offhand, deadpan element, a nagging, funny factuality—in other words, they were true dada emanations.

148 *Dust Raising*, 1920, silver print

Although the rayographs seemed radically new, they were related to Man Ray's past work, to his aerographs made with a spray gun designed for photographic retouching, as well as to his dropping of colored papers—again, accidentally—on the floor and using the throwaway pieces for a collage. He had always been interested in shadows, too—shadows cast by the *Rope Dancer* (fig. 52), the eggbeater *Man,* or its companion *Woman* (figs. 69, 70), moving from the material to the immaterial. And he liked working with oddball, ordinary things. The immense space—what Ribemont-Dessaignes called his universe—had also appeared before, in *Dust Raising* (fig. 148), for instance, in which a detail of Duchamp's tediously worked *Large Glass* (*The Bride Stripped Bare by Her Bachelors, Even*) appears as if in some astral landscape, or *New York 1920* (fig. 110), whose spilled ashes and matches move back and forth between a gritty, immediate space and some starry distance.[10]

Particularly prominent in these works is the theme of autobiography. Like leaves fallen from a nearby tree, these rayographs bear the strong imprint of the man from whom they were generated. In what is possibly the earliest rayograph of all (fig. 116), we see the actual objects that he set on his unexposed paper: a bottle for chemicals, a funnel, a stirring rod, and his own pipe. His early work in the medium is very concrete and tactile: combs, pins, kitchen utensils, his hotel keys, drafting instruments, the handgun that appeared in *Compass* before he left New York, light-bulb

181

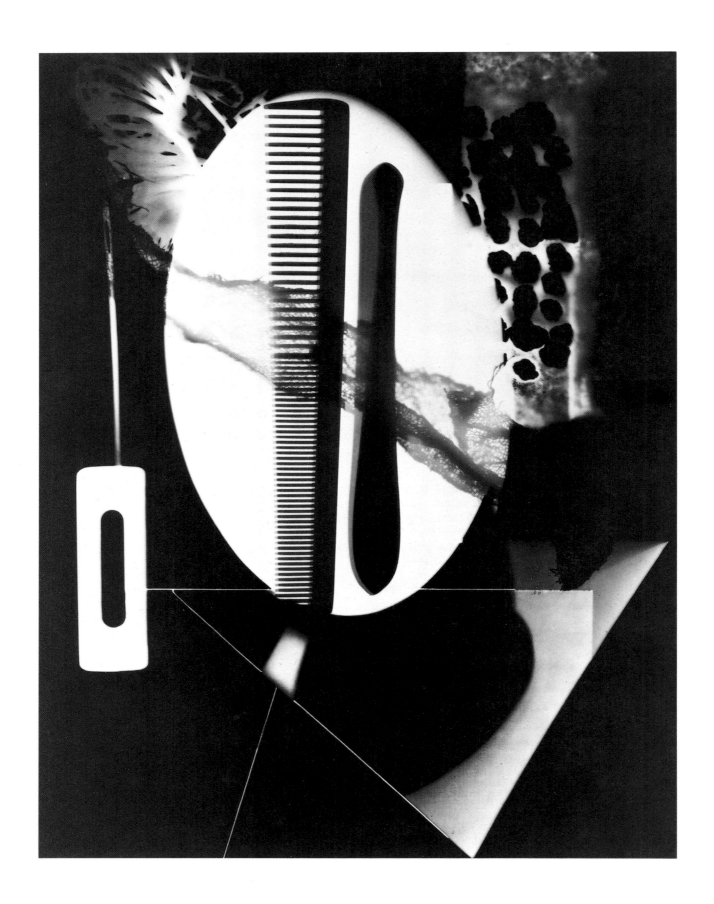

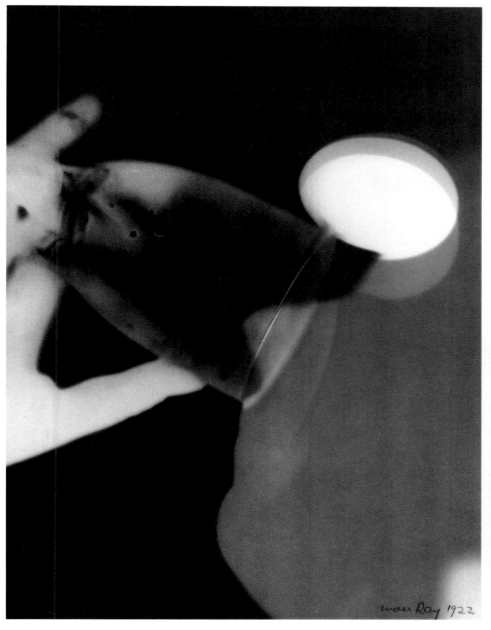

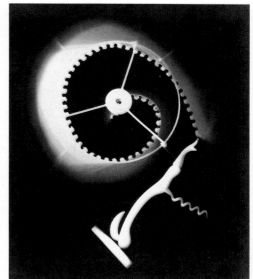

sockets, and corkscrews—all marks of himself as well as evidence of the improvisational nature of his rayographs (fig. 149). There are handprints (*main* = Man) and the shadow of Kiki drinking (fig. 150). And there are references to some of his other works: in one rayograph he joins a corkscrew with a spiraling lampshade, not only recalling an early New York object, but also introducing a humorous sexual pun (fig. 151).

A manikin—or little Man—is another rayograph subject that appears as early as 1922.[11] The theme of man as machine—usually a figure or face made of castoff things, not necessarily mechanical—

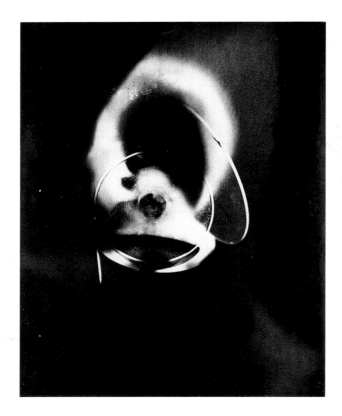

had surfaced before, in the funny, cryptic, and satiric eggbeater *Man*. More often women were represented, as dummies or composed of clothespins and mirror reflectors. While related to the imagery of Duchamp and Picabia, Man Ray's mechanical beings are usually more mordently humorous and more personal. His interest in developing this theme was perhaps stimulated by his fashion photography, which early on featured carefully draped manikins. But there was a darker aspect to some of them. Man Ray created strange primitive faces out of a violin bridge and two wine glasses, or a mask and a firecracker; in the shadows of a wine glass lurks the hissing face of a rodentlike creature (fig. 152). Man-made as well as handmade, the rayographs offered a realm of discovery usually associated with painting.

The "convulsive" beauty of love mentioned by Breton in the *First Manifesto of Surrealism* (1924) was a central theme in Man Ray's oeuvre. There is a strong erotic element in many of his objects: the hairy shank of *Emak Bakia* (fig. 213), the haunting eye of *The Object to Be Destroyed* (fig. 212), the vulvalike shape of *Saddle* (fig. 153). He called his accretions of things *Objects of My Affection*.[12] In a *cliché-verre* of 1922, objects from his own world—a pipe, bottles and jars, a fashionable belt buckle—cluster around a drawing after a photograph of the Marquise Casati with doubled eyes, a haunting

152 Untitled, 1923, rayograph

153 *Saddle*, 1934, silver print

184

apparition (fig. 154). The feminine presence is also manifest in the rayographs, although more indirectly—in Kiki's kiss, her beads, her shadow drinking from a glass. While Man Ray certainly glorified women, he made fun of them as well. A firecracker, a needle, some torn paper, and a doily form a woman's head in one rayograph, making perhaps a comment on Kiki's explosive personality (fig. 155).

One of his objects, *De quoi écrire un poème*, has some of the configurations found in rayographs—the feather, for instance, and the crimped, fanlike paper. Tangible, earthly things, they allude to another, grander dimension, a sublime alliteration of real and imagined, a fitting conceit for a visual poet among poets. Other objects also express a stolid tactility while hinting at a vaster space—his frequent use of paper funnels, for instance, wire springs, and spirals. By 1922 he had introduced crystals, and later prisms, some of which look like dice, a meaningful motif for the dadaists who were so interested in the revelations of chance (fig. 156). One example of this duality, of examining the specific and intimating the universal, is the conjunction of magnifying glass and gyroscope, or of the shadows of his hand and a gyroscope. When he adds a straight pin, he juxtaposes not only the mysterious and the concrete, but the grand and the mundane (fig. 157).

154 *Marquise Casati*, 1922, cliché-verre, present whereabouts unknown

155 Untitled, 1923, rayograph

156 Untitled, 1922, rayograph

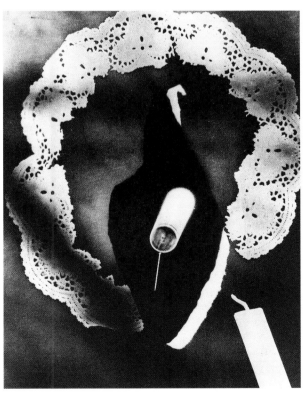

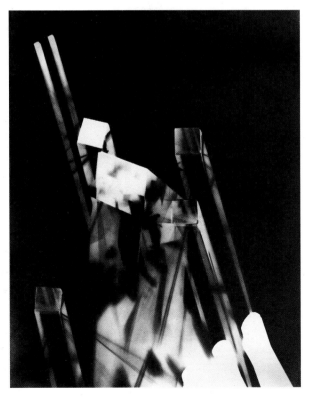

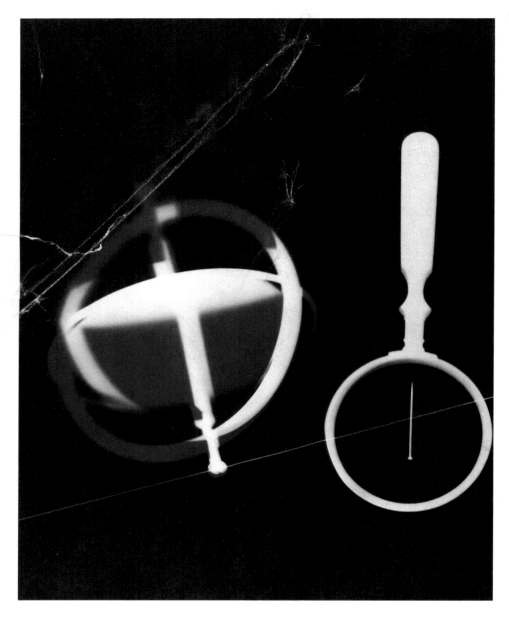

157 Untitled, 1922, rayo-
graph, from the portfolio
Les Champs délicieux

Against this body of abstract, personal, "artistic" work, in
1921 Man Ray began a long career of portraiture. His first subjects
were dada artists and poets. The American newcomer was valued as
their recorder, their personal photographer, and the portraits have a
consistency that defines the group as Man Ray's own. His camera
granted him immunity from their political strife, though, and
broadened his circle of friends in both the French and American
artistic communities. Portraiture thus gave him entrée, while also
almost disguising and distancing him—he could not really be a
member of a group if he was photographing it. A sense of slight
withdrawal, of documentary objectivity informs this work; indeed,

these qualities typify his relationship with the dadaists-surrealists in general. Although they were strong supporters of his art and he was closely involved in their activities, the only surrealist manifestos he signed were *Hands Off Love*, supporting Charlie Chaplin's divorce in particular and sexual freedom in general, and *When the Surrealists Were Right*, an anti-Stalinist statement. This noncommittal attitude was perhaps best appreciated by Picabia, who had suffered the group's brutal cliquishness. In an introduction to a brochure for an exhibition of Man Ray's portrait photographs, he wrote: "You listen with your eyes, which all painters should do; your paintings, your photographs neither laugh nor cry, I compare them to the philosopher lying in the sun, they are a far cry from the cannibalism of Paris!"[13]

The portraits made in the early twenties are often romantic, with a sense of wonder. Most were photographed some distance from the subject and then enlarged, a technique that enabled him to achieve a softness and idealization without retouching or manipulating the print. The slightly romantic glow of pictorialism is still evident in his portrait of young Ernest Hemingway, who is haloed by a banjo, symbol of their shared Americanism, hanging on the studio wall (fig. 158). Picasso, shown at the age of forty-one, has less the arrogance or worldliness usually associated with him and more a manly sureness, even a gentleness. Many of Man Ray's portraits were of his literary compatriots, such as Gertrude Stein and Sinclair Lewis. Some were commissioned by Sylvia Beach—James Joyce, for instance, sat for Man Ray at her request—and a great many were published by *Vanity Fair*, which probably provided his principal source of income in the twenties (fig. 159). Amid the magazine's pages, his portraits of celebrities, the creative up-and-coming, were reproduced alongside images by Arnold Genthe, Edward Steichen, Nickolas Muray, and others—photographers both notable and forgettable.

There are other, more spontaneous documents, however, often funny or even sweet, that are more truly dadaist and closer to the photographer's personal life and spirit. They tend to be more inventive as well. Images of the young Cocteau are plentiful. Man Ray was extremely sensitive to the beauty and poignancy of his face, its sexual ambiguity. There is a certain humor as well as a sense of melancholic entrapment in the image of Cocteau framing himself as a work of art, silently observed by a portrait bust behind him—an appropriate comment on Cocteau's personality (fig. 160). The photograph is a close relative of earlier portraits of Duchamp behind his glass paintings. Soupault, in a series on men undressed

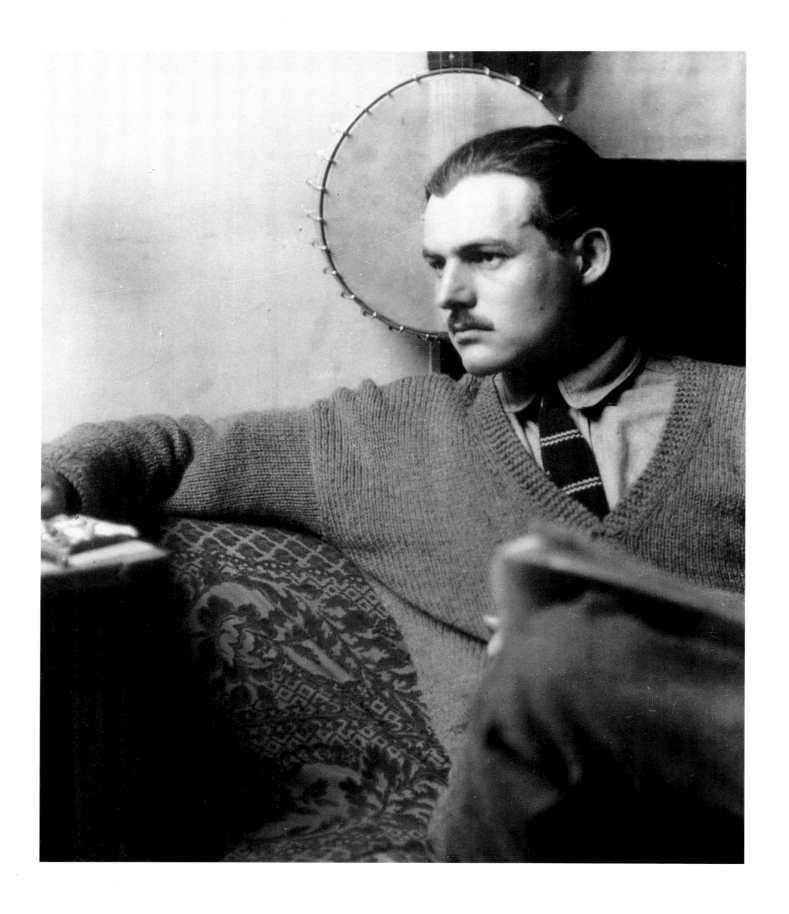

158 *Ernest Hemingway*, 1923, silver print

159 Man Ray's portraits of Pablo Picasso and James Joyce, published in *Vanity Fair*, July 1922

160 *Jean Cocteau*, 1922, silver print

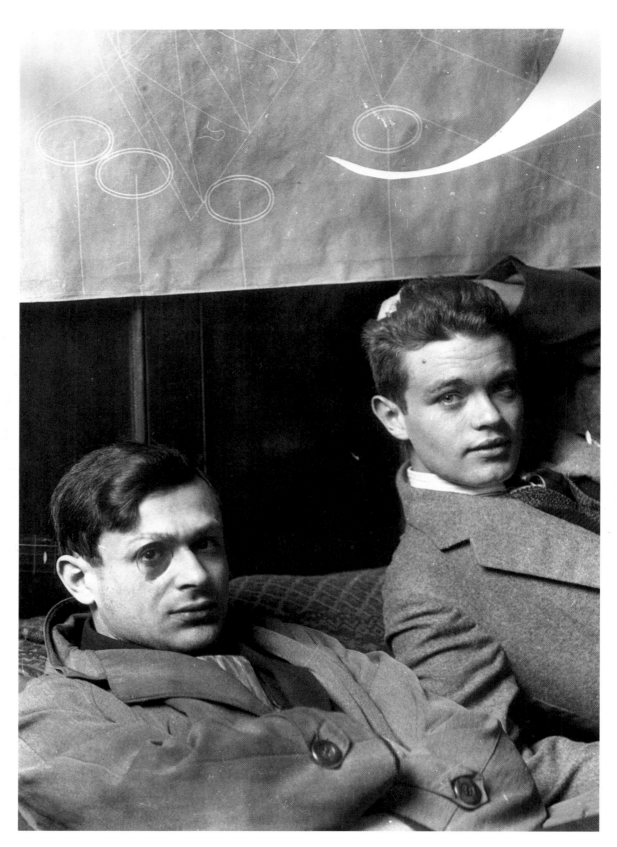

161 *Philippe Soupault*, 1921, silver print

162 *Tristan Tzara and René Crevel beneath Silk Painting*, 1928, silver print

from the waist up, sports a hat and cane (fig. 161). Picabia is seated at the wheel of his elaborate car, his arm leaning against the bulbous horn (fig. 88). The portrait of Tzara, who sits nonchalantly at the top of a ladder, with an axe and an alarm clock strung up over his head with the image of a giant nude bleeding into a plaster wall beside him, has a sense of casually impending disaster that the young dadaists found attractive (fig. 83). In another image, Tzara and René Crevel, friends of Man Ray's, sit beneath his large painting on silk (fig. 162). Its geometric shapes float in an atmosphere of their own, and the men below lean nonchalantly against the wall in positions that recall Man Ray's portrait of Duchamp and Stella, in which the upturned head of a woman smoking a cigarette floated above them (fig. 15). Man Ray also experimented early on with color. One of his most attractive images shows a young woman seated in front of the same silk painting, with his looping *Lampshade* nearby, the same object that encloses the necks of Tzara and Cocteau in another portrait, conjoining them in an unfolding spiral.

163 *Nancy Cunard*, 1926, silver print, Collection Gilman Paper Company

All of these portraits are full of the lighthearted esprit of newly found comrades. Women, on the other hand, were usually photographed as exotic creatures, like, for instance, Nancy Cunard, wearing two armloads of African ivory bracelets (fig. 163), and Peggy Guggenheim in an oriental outfit by Poiret (fig. 98). Kiki, Man Ray's mistress of the early twenties, was by far his most photographed subject. A well-known personality in Montparnasse when Man Ray met her, Kiki was a free spirit, a true antibourgeoise who had been both mistress and model to many artists in the quarter. She brought instant celebrity to Man Ray, a new Montparnassian, and he endowed her with a certain amount of seriousness, almost respectability. He encouraged her to sing (she became a regular entertainer at the Jockey), to paint (she had at least one exhibition at the Galerie au Sacre du Printemps in 1927), and finally to write her memoirs, which were published with an introduction by Ernest Hemingway. Her simple personality, clear beauty, and statuesque figure elicited some of his most sculpturesque photographs.

The juxtaposing of Kiki's perfectly shaped white face and the dark, heavily carved African sculpture in *Noire et blanche*, for example, is haunting, not just a simple formal conceit (fig. 164). This image was an early example of his taking faces or hands—of women, in particular—out of "real" space and casting them into a more ambiguous one, rather like the dualistic space in the rayographs. This interest was evident as early as 1920, when he photographed the cigarette-smoking head from below, but in Paris he

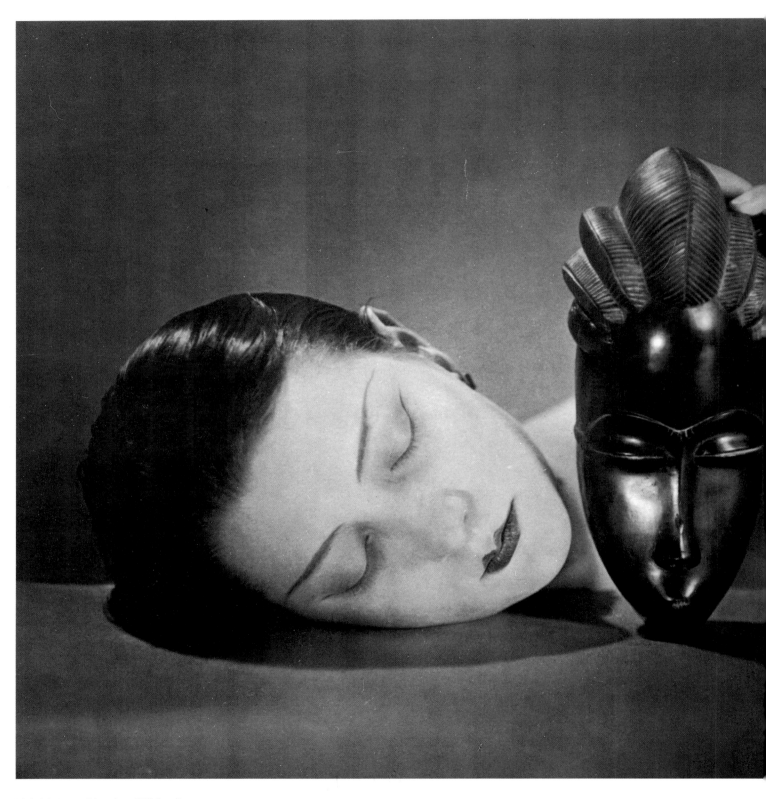

164 *Noire et blanche*, 1926, sil-
ver print

192

explored it more thoroughly. In effect, it turned the human subject into an object, as in one of his most well-known images, the punning *Violon d'Ingres* (fig. 262), inspired by Kiki's classic figure, which reminded him of Ingres's bathers the first time she posed for him.[14]

Much of Man Ray's audience was reached through the magazines—both the intellectual and popular periodicals—which were an important forum for photography and often supported experimental work. The first surrealist journal, *La Révolution surréaliste*, began publication in 1924, and Man Ray's work was prominently reproduced within its pages. In the first issue, Max Morise, in his essay "Les Yeux enchantées," raised the question of whether there could be a truly surrealist painting. While he felt that the painter's personality imposed itself on a work, preventing free association of ideas, he considered Man Ray's photographs sufficiently automatic to be surreal. By their very banality, such images as *Cours d'auto*, the double-breasted woman, and the line of laundry flying in the wind are not only unpretentious, but deliberately anti-aesthetic (fig. 165).

N° 6 — Deuxième année 1er Mars 1926

LA RÉVOLUTION SURRÉALISTE

LA FRANCE

SOMMAIRE

La dame de carreau : Paul Eluard.
FATRASIES :
Philippe de Beaumanoir, etc.
TEXTES SURRÉALISTES :
André Breton.
La fuite : Philippe Soupault.
Entrée des succubes : Louis Aragon.
Ces animaux de la famille : Benjamin Péret.
LES BUVARDS DU CONSEIL DES MINISTRES
Confession d'un enfant du siècle :
Robert Desnos.
Glossaire : Michel Leiris.
POÈMES
Benjamin Péret, Jacques Viot, Jacques Baron.

Vive la mariée : Pierre Unik.
CHRONIQUES :
Le cas Lautréamont : Paul Eluard.
Revue de la Presse : P. Éluard et B. Péret.
Le bien du siècle : René Crevel.
Europe. — Invention de Dieu : Victor Crastre.
De l'usage des guerriers morts : Paul Éluard.
Tyrannie du temps : André Masson.
Le surréalisme et la peinture : André Breton.
ILLUSTRATIONS :
Arp, Georges Braque, Giorgio de Chirico,
Max Ernst, André Masson, Picasso, Man Ray, etc.

ADMINISTRATION : 42, *Rue Fontaine,* PARIS (IXᵉ)

ABONNEMENT,
les 12 Numéros :
France : 45 francs
Étranger : 55 francs

Dépositaire général : Librairie GALLIMARD
15, Boulevard Raspail, 15
PARIS (VIIᵉ)

LE NUMÉRO :
France : 4 francs
Étranger : 5 francs

165 *La France* (formerly *Moving Sculpture*), 1919, published on the cover of *La Révolution surréaliste*, 1 March 1926

Their ambiguity is provocative and cerebral: like the rayographs, they force us to consider the immaterial aspect of wholly tangible, commonplace things, and their strangeness as well. The draped manikins he used in his fashion work also appeared on a cover of *La Révolution surréaliste* (fig. 166). Sometimes these illustrations are given humorous titles, like the rest of his work (the flying laundry was called *La France*), but in any case they are not illustrative in the usual sense but visual analogies to the text. Man Ray was instrumental in publishing Atget's work, which he had discovered in 1927. As seen in Man Ray's selections (published in *La Révolution surréaliste*), Atget's imagery shared the same ostensible ordinariness and directness, which was precisely what made it all the more provocatively mysterious and surreal (fig. 167).[15]

In the later and more doctrinaire surrealist magazines, especially *Le Surréalisme au service de la révolution*, which began in 1930, Man Ray's photographs became more overtly disturbing, their spirit more politicized (fig. 168). *Transition*, published in Paris by the Americans Eugene and Maria Jolas, was a more elegant avant-garde organ that featured surrealist work as well as other experimental things; it reproduced Man Ray's work extensively, especially his portraits of artists and writers. In 1928 the Belgian magazine *Variétés*, modeled on *Der Querschnitt* but more visually acute, also included many of his photographs of personalities, such as the flamenco dancer Vincente Escudero and the adventuress Tityana, as well as a still from his movie *L'Etoile de mer*. This journal was particularly sympathetic to surrealism and treasured mordant or mysterious images, ones closely related to the snapshots or documentary photographs in *La Révolution surréaliste*. *Variétés*, like *Der Querschnitt*, treated popular arts seriously and tried to integrate the aesthetic experience into everyday life, finding fantasy in the mundane and commonplace.

The French publication *Jazz*, which also featured Man Ray's work, was similar but more deliberately "artful": a review of entertainment, of the pleasures of strolling the streets or attending avant-garde films. Gus Bofa, the anarchist caricaturist who was a frequent contributor to *Jazz*, was an early supporter of photography as a serious aesthetic medium. He wrote in one issue:

> Photography has become what a whole generation of artists worthy of the name think it is, namely another, singularly potent, expressive medium which can create inexistent forms, put together unconnected spatial ideas, and combine abstract, subjective notions endlessly. In other

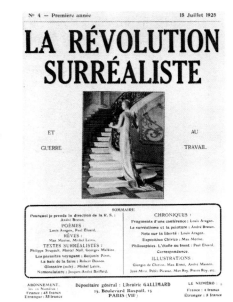

166 Untitled, published on the cover of *La Révolution surréaliste*, 15 July 1925

167 Atget, *Boulevard de Stras-bourg, Corsets*, 1912, silver print, published in *La Révolution surréaliste*, 15 June 1926

168 *Hommage à D. A. F. de Sade*, ca. 1929, published in *Le Surréalisme au service de la révolution*, no. 2, 1930

words, it can do artistic work, not just help fathers collect holiday souvenirs to be savored in the post-prandial leisure of a winter afternoon.[16]

Certainly in the twenties, Man Ray was the master of exploring photography as an agent of aesthetic communication, provocation, and documentation. No one else took the medium as seriously, or tried to integrate it as fully into the pursuit of art and daily life. The interplay of his more self-enclosed, poetic work with the more public and popular photography he made to earn his

living actually proved stimulating and expanded his aesthetic horizon.

In 1925 the poet Réne Crevel published a short article in *L'Art vivant*, illustrated by Man Ray's photographs in a range of styles: classical, romantic, "New Spirit" (the French version of Neue Sachlichkeit), impressionist, naturalist, and what Crevel termed "Man Rayist." He considered photography a medium capable of organizing the chaos of experience. Despite the diversity of Man Ray's work, the same mysterious shadows, the same ambiguous space, even a sense of fascinated detachment unites all of the images under one artistic personality. As Crevel wrote, in Man Ray's mirror common objects are imbued with a vaporous, imponderable mystery that is his own.[17]

L'Art vivant, like Man Ray himself, seriously examined a strange mixture of subjects for artistic delectation: billboards, cacti, interior decor, gypsy camps on the outskirts of Paris—all came under the editors' scrutiny. Since it was so open to diversity, the magazine became one of the major forums for discussion of photography, and by 1928 Jean Gallotti was writing a regular column entitled "Is Photography an Art?" The question was addressed in each issue through an interview with a photographer. Man Ray was not only one of the first interviewed, he was also the first painter-photographer. In this column and subsequent ones, he spoke about photography as an extension of his painting: he suppressed the lens just as artists of the time suppressed the eye.[18]

In 1928 the first popular pictorial weekly that was dedicated to photography began publication. *Vu*, one of the prototypes for *Life*, was a major source of income for photographers living in France at the time; André Kertész, Maurice Tabard, Brassaï, Germaine Krull—all appeared within its pages. Most of Man Ray's contributions were studio pieces, portraits of famous contemporaries, although occasionally his serious art was covered as "news" or published in decorative ways. Tityana, who successfully lifted the head of the stone Buddha at Angkor Wat, was immortalized by Man Ray on one of the magazine's covers (fig. 169); another showed an exotic beauty with a snake wrapped around her neck, and on yet another, Vincente Escudero's vivid dancing shadow is matched by the jazzy shapes cast by the enormous wine press in Man Ray's studio (fig. 170).

In *Vu* Man Ray's work most closely resembled that of Tabard, a friend who made elegant portraits, experimented in solarization, rayographs, and double printings, and photographed theatrical subjects such as a black American dance troupe (rivals of Josephine

169 *Tityana*, published on the cover of *Vu*, 18 April 1928

170 *Vincente Escudero*, published on the cover of *Vu*, 23 May 1928

Baker). Tabard, who became an important fashion photographer in the thirties, had a similar sense of the exotic and a facility for using artificial studio lighting decoratively and ambiguously. Brassaï's fascination with strange personalities—such as a hairdresser who liked to sleep in a coffin—was also not too distant from Man Ray's taste for the outlandish.

But Man Ray also continued to work in fashion photography. In the twenties his images appeared in *Vogue,* and by 1930 he was working regularly with both *Vogue* and *Harper's Bazaar.* As mentioned, some of his early fashion images had appeared in art publications like *La Révolution surréaliste;* in the thirties, he incorporated works of art (usually by his friends), as well as the ubiquitous wine press, into his fashion shots (fig. 171). He became expert at using studio lights to create fanciful, mysterious shadows, and he frequently employed solarization and even negative printing (as his admirers and imitators did later; fig. 172). No doubt the convergence of reality and unreality inherent in the fashion industry fascinated Man Ray, who was both an elegant, albeit sometimes star-struck, participant, yet also very much an outsider.

In 1928 Paris held the first invitational exhibition of contemporary modernist photography, the so-called Salon de l'Escalier at the Théâtre des Champs-Elysées. Man Ray was equally represented by portraiture and rayographs, as well as some flower pieces. The exhibit featured the work of Berenice Abbott, George Hoynigen Huene, Krull, Kertész, Madame d'Ora, and Atget, but it was very apparent that, unlike Germany, France had only one artist who experimented deeply with and had a constant interest in photography—and that was Man Ray. The rest were modernist workers (Krull called herself an "artisan," and this probably expressed the attitude of most of the others). Since they were either portrait photographers of celebrities and the intellectual elite or worked primarily in fashion and reportage, Man Ray stood out for straddling both the commercial and artistic domains.

The Salon de l'Escalier marked the first time Atget's work was seen publicly, as well as the beginning of a wider, less exclusively surreal interest in documentary photography as an art form. The novelist Pierre Mac Orlan wrote intensively on photography at the time; for him, the so-called documentary image was the most haunting because it contained an element of what he called "social fantasy"—it underscored a disturbing side of ordinary, overlooked things. This new appreciation of the real world, and Atget as well, may account for some investigations into street photography by Man Ray at this time, a very uncharacteristic move on his part (fig.

171 *Model with Wine Press,* published in *Harper's Bazaar,* November 1935

172 *Model in Taffeta,* ca. 1935–36, undated tear sheet from *Harper's Bazaar*

197

173). Indeed, he was so interested in controlling photographic images, such a confirmed studio dweller, that this new direction was short-lived.[19]

The contradistinction of public work—portraits of the beau monde, fashion photography, and even photojournalism—and private work, which included some objects as well as rayographs, was further heightened in the late twenties by new interests in film and painting. Man Ray's first major experimental film, *Retour à la raison*, was a primitive effort, but in it he set sequences of recognizable images against abstractions—actually cinematic extensions of his rayographs made by throwing thumbtacks, pins, salt, and other ordinary objects on the film strip, exposing, and then developing it. As in the early rayographs, he stressed the materiality of the film by writing on it—even though the writing cannot be seen when the film is projected. Kiki's nude torso, fitted with lacy shadows, is immediately, and absurdly, followed by an egg carton turning on a string—just as the abstract, cinematic rayograph sequences are followed by the moving lights on a marquee in his next film, *Emak Bakia* (1926), which was a much richer and more sustained production. In it Man Ray explored montage, beginning with the opening sequence in which his own eye is superimposed on a reflector, and later when eyes stare out from the headlights of a car. These two startling images underscore the personal and experimental character of the film.

Like the rayographs he was making around this time, *Emak Bakia* was much more abstract than the earlier *Retour à la raison*. In both he used crystals and lenses to paint, cinematically, with light; and he consistently moved from the objective to the nonobjective, the long view to the close-up, making deliberate associations between dream and realness. After the caption "The Reason for This Extravagance" appears, Man Ray begins juxtaposing boy-meets-girl sequences, like those found in sentimental movies, with funny and nonsensical scenes such as wildly dancing collars. Any hint of story is constantly undermined. Instead, there are repeated assertions of the specifically filmic qualities, such as excessive repetition, which stress that *Emak Bakia* is theater rather than document. The film seems to be a series of visual associations—sequences of running sheep, many too many legs stepping out of a car, legs dancing the Charleston—rather than thematic ones. Man Ray turns the camera upside down, shoots extreme and private close-ups as well as scenes from normal perspectives. He films objects rotating and even puts the camera under water. The closing sequence of Kiki's eyes opening to reveal that her original waking eyes were painted is a

173 Untitled, ca. 1926–27, silver print

174 Film still from *Emak Bakia*, 1926

175 *Boule de neige*, 1927, glass, paper, and crayons, present whereabouts unknown (replica, Collection Juliet Man Ray, Paris)

198

startling confrontation of real and imagined. The motif of the eye, which opens and closes the film (fig. 174), recurs in Man Ray's other works—*Boule de neige* (fig. 175), for instance—and is in direct line of descent from *The Object to Be Destroyed* (fig. 212).

Two years later Man Ray made *L'Etoile de mer*, inspired by a poem by his friend Desnos, and the following year he filmed *Le Mystère du château de dés* at the request of the Vicomte de Noailles. Both films relate to his work in other media, and both allude to a graver disquiet than anything produced before. They also, interestingly, refer to vacation time near the sea, a special, charmed existence on the beach—perhaps inspired by the seaside life on the Riviera, which Man Ray shared with Picasso, Hemingway, the Murphys, and his surrealist friends. In *L'Etoile de mer*, the boy-meets-girl scenario is consistently demoralized by erratic intersper-

sions—sensuous moments juxtaposed with images of a deserted street or flying newspapers. Some of the scenes were shot behind a gelatinous screen, which softens them; but there are ambiguous and disturbing moments, as when the woman climbs a flight of stairs with a knife in her hands. Sexual anxiety and violence flow beneath the surface of the starfish, a strange animal, at once beautiful and monstrous, its single opening surrounded by prickly, leglike protrusions (fig. 176).

The Mallarméan title of Man Ray's last film is both a pun on the cubic building of the viscount's château—Man Ray said it resembled enormous dice—and a reference to the theme of chance. *Le Mystère du château de dés* is one of the most beautiful and most approachable of Man Ray's films. It is essentially about a vacation, but a mysterious, disquieting vacation indeed, for the villa's rooms are ominously empty, and the bathers in the swimming pool are masked and manikinlike. It was a foretaste of things to come in his art.

In 1929 Man Ray also enjoyed a burst of creative energy in his painting. He hired a craftsman meticulously to prepare a series of

176 Film still from *Etoile de mer*, 1928

silvered panels and then painted on them recklessly, spontaneously, just as he must have made his rayographs on sensitized paper (fig. 177). These paintings are actually large colored drawings, abstract but hinting at recognizable subjects: masks, guitars, male and female figures, the theme of transparency common to the rayographs and to his early *Revolving Doors*. The crosshatching in his shapes also recalls the chessboard-style arrangement of colors in earlier works. Male and female figures wear hats and canes and merge with one another against an infinitude of space. There is another, darker painting of this same year, however, *Une nuit à Saint-Jean-de-Luz* (fig. 219), inspired one night in southern France when the headlights of a car produced his dramatic shadow, like a long, man-shaped exoskeleton, stretching to a black horizon, exposing its primal inner workings.

The twenties were essentially a period of exploration for Man Ray, of testing the limits. In the thirties, his work became more sophisticated, more secure, but often had a cutting edge, a hardness not seen before. Photography in the interim had gained aesthetic seriousness in France. As the critic Jacques Mauny wrote:

> The International exhibition Film und Foto, held last year in Stuttgart, has been called "the most important event since the war." Paris has suddenly become deeply interested in photography. *Foto Auge* by Dr. Franz Roh, panegyrist of the "neue Sachlichkeit," with French and English translations, and another serious book on the same subject by Waldemar George have recently appeared. Exhibitions of amazing photographs are being held everywhere. Fine photographs contribute to the decoration of ultra modern interiors. Even de luxe editions are now illustrated by surrealistic photos.[20]

Photography's artistic eminence in 1930 was in no small part due to the accomplishments of Man Ray, and his developments in the medium were by no means over—indeed, he was entering an especially fertile period in photography as well as painting and object making. He continued to test himself, to interrelate one art form with another. This need to grow, which for him also meant to contradict what he had achieved, would make the thirties one of his richest decades artistically, and his most unsettling.

As Mauny indicated, photography was receiving serious aesthetic attention in France. Much of this new interest stemmed from the modernist renaissance the medium was undergoing in Germany,

177 *Gens du monde*, 1929, oil on silver leaf and copper, Collection Marion Meyer, Paris

a renaissance that would last until Hitler declared modernism suspect. In 1922 Moholy-Nagy wrote, "To be a user of machines is to be of the spirit of this century. . . . Everyone is equal before the machine."[21] For Germany, newly democratic and rebuilding itself after the war, photography was idealized as a machine-made creation. Both its detached quality and the new technological materials like glass and chrome, so often used in its machinery and represented in its imagery, were seen as part of the new ideal order of things.

In 1929 a combination of interests and events had conspired to produce the first major photography exhibition in Germany, which shaped the appearance of both future exhibitions and photographic books. This was the *Film und Foto* show in Stuttgart, or "*Fifo*." László Moholy-Nagy was the important force: as a counter to the old ideals of pictorialism, which exhibited self-expressive photographs by artist-photographers artfully, Moholy-Nagy arranged the famous "Room 1" of the exhibition to include all kinds of photography: x-rays, press photos, scientific pictures, images made for advertising, and experimental work. It amounted to a catalogue of the diversity of photographic possibilities, stressing the inherent objective qualities of the medium. As Moholy-Nagy himself stated: "In the photographic camera we have the most reliable aid to a beginning of objective vision. Everyone will be compelled to see that which is optically true, is explicable in its own terms, is objective, before he can arrive at a possible subjective position."[22] For Moholy-Nagy, the camera's "new vision" was a corrective to the "conceptual image" of the ordinary eye, and it offered tremendous creative—and idealistic—potential.

Moholy-Nagy shared with his contemporaries a collective— and therefore anti-individualist—idealism. Like Franz Roh in *Foto Auge*, on the pages of his publications, Moholy-Nagy constantly juxtaposed one disparate object with another, revealing a formal similarity, what he called "new relationships," but at the same time undermining the wholeness and personality of each object. Another major German photographer of the period, Albert Renger-Patzsch, used a related method in his book *Die Welt ist schön* (1928). In it, the forests, seaside rocks, profile of an ostrich, and industrial landscapes are all parts of a grand world picture, all legitimately beautiful. It is no coincidence that the last photograph in the book is of a pair of praying hands. Thus, both Moholy-Nagy and Renger-Patzsch were involved in a constant dialectic between the objective fact and the unseen, higher ideal. Understandably, in Germany's postwar state, the new vision in photography—like the new archi-

tecture and design—possessed utopian implications. But also, ironically, because of its fascination with fact, German photography of the twenties was best suited to documentation and advertising.

Geometric shapes were stressed for their implications of absolutes. Two of the most reproduced images of the *Film und Foto* show were Max Burchartz's *Lotte's Eye* and El Lissitzky's *Self-Portrait* (fig. 178). In both there is a dominating geometry—either in the broad, even, interconnected forms in the girl's face, or in the superimposing of a compass and graph paper over the hand/eye double image—a perfect metaphor for the artist as grand planner of an ideal figure.

178 El Lissitzky, *Self-Portrait: The Constructor*, 1924, photomontage, Collection Lydia Winston Malbin

203

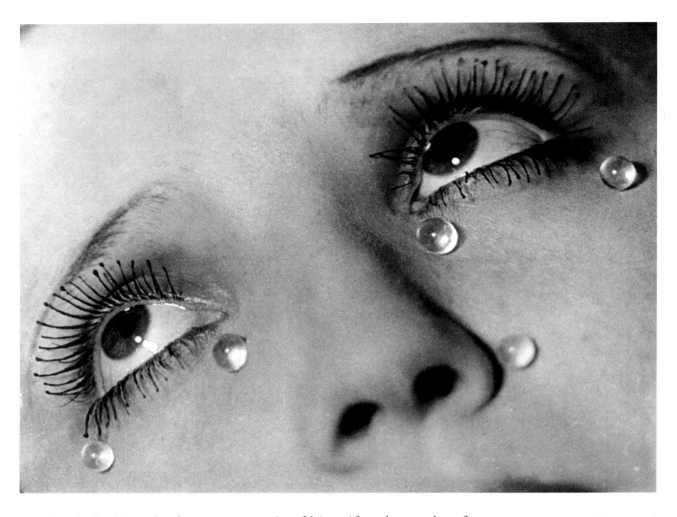

Moholy-Nagy's close-up portrait of his wife subverts her fa-
cial characteristics to experiments with focus and contrasts in light
and shadow; he also showed this image as a negative print, indicat-
ing he was chiefly interested in what photography as a medium
could do, or reveal. In contrast, Man Ray's *Glass Tears*, while
another close-up portrait, is clearly more concerned with the subject
itself (fig. 179). The almost plastic eyelashes are strange, and
stranger still are the artificial tears that decorate the woman's cheek.
For Man Ray, photography was self-directed. Even though he was
clearly fond of juxtaposing one element with another, neither the
woman's face nor the weirdly gleaming glass beads lose their indi-
viduality, aspiring toward a higher ideal; instead, they fascinate and
even disturb. Moholy-Nagy himself said of Man Ray's "Foto-
gramms" that, unlike his own, they seek "to probe the enigmatic,
uncanny, and unusual in the ordinary."[23]

Man Ray's photography of the thirties was probably affected
by the French translation of German modernism, which was a

179 *Larmes (Glass Tears)*, ca.
1930–33, silver print

204

decorative adaptation of this idealistic vision and derived from the evolution of the movement in Germany. The *Film und Foto* exhibition, sponsored by the Deutscher Werkbund, was a component of a larger German phenomenon: a growing interest in craft and in bringing good design to the middle class. At the Bauhaus, for instance, the teaching of art and architecture through design workshops was the principle on which the school was based. German art was first exhibited in France after the war in 1930, when the Werkbund was given a show in the Grand Palais, the Salon des Artistes Décorateurs. There, photographs were presented as an important aspect of modern design, and the images of Herbert Bayer, Lux Feininger, Moholy-Nagy, Walter Peterhans, and Renger-Patzsch, among others, were hung alongside Bauhaus-designed chairs and light fixtures. It was enormously popular with the French, who transformed features of Bauhaus design into luxurious decorative arts. One important French publication that owed a debt to *Foto Auge* and was in concordance with the Deutscher Werkbund show was the special issue of *Arts et métiers graphiques* dedicated to photography (March 1930). This was the first of a series of deluxe annuals devoted to photography in France.[24]

In light of the recent elevation of photography in France, it was entirely in character for Man Ray to want to contradict the notions of "good" photography. Ironically, instead of feeling in command of his career and sure of his creative instincts and contributions, by the end of the twenties Man Ray described himself as sidetracked and outcast:

> My reaction to the hectic Twenties began in 1929. My excursions into the film world had done me more harm than good. People were saying I had given up photography for the movies, few sitters presented themselves for portraits. The magazines shunned me. I decided to start all over again. . . . Having terminated a love affair, I felt ready for new adventures. I also had to get rid of the things that had taken up too much of my time and energy, especially mechanical things. . . . I no longer tried out new cameras, but did go into the darkroom now and then to make *solarizations*, since it was a deviation from the principles of good photography: to work in the dark. *Solarizations* were made comfortably with the bright lights turned on.[25]

Photographs such as *Terrain vague* expressed a deeper concern

180 *Terrain vague*, 1929, silver print

(fig. 180). One of his rare views outside the studio, in the real world, it shows a desolate corner of Montparnasse, mirroring his personal disquiet. If the level of anxiety and the degree of shock in Man Ray's work intensified in the early thirties, it was no doubt a reflection of larger issues, not the least of which was the stock market crash and the political climate. Close to home, the old surrealist group, rancorous but nevertheless cohesive, had finally

split. When he wrote the *Second Surrealist Manifesto* in 1929, Breton purged "false witnesses and money makers" from the group, namely Soupault, Desnos, Masson, Ribemont-Dessaignes, and Artaud—almost all of them friends of Man Ray's. His sense of separateness, which pervades his autobiography, no doubt seemed all the more justified. It was also the year of Dali's first show—representing a departure in style as well as in spirit—and the first year of *Documents*, a magazine of surrealist persuasion with a taste for the macabre initiated by Georges Bataille.

The rift between the surrealists continued to deepen as Europe's political temperature rose. Lotar's views of the Paris *abbatoir*, the slaughterhouse district, published in *Documents* seemed appropriate to the grimness of the times. Originally Man Ray had been drawn to Montparnasse because of its lively, cosmopolitan character. The French, however—previously so hospitable to foreigners—were becoming wary of the large international population that had taken up residence in Paris. A new anti-American feeling on the part of the intellectuals emerged. The increasing political tensions in the surrounding countries only accelerated the rate of immigration, thus exacerbating French nationalism. In the respected and widely read newspaper *Le Figaro*, the number of anti-Semitic articles directed against the Jewish artists (and their supporters) increased dramatically from 1928 to 1929. At a 1930 showing of the Dali-Buñuel film *L'Age d'or*, a protofascist youth group screaming "Death to the Jews" threw ink on the screen and then tore apart an adjoining surrealist exhibition, which included work by Man Ray. It marked the beginning of a racial slandering of surrealism as both a Jewish and a foreign perversion. Waldemar George, a Jew himself, became a vocal supporter of French painting, making clear his distaste for the foreign—and Jewish—School of Paris based in Montparnasse.[26]

The new review that began in 1930 and superseded the "surrealist revolution" put "surrealism at the service of the revolution." That same year, Louis Aragon wrote his essay "La Peinture au défi," a defense of collage as anti-art and anti-individualism. His final expulsion from the surrealist group in 1932 was precipitated by his poem "Front Rouge," which railed against the bourgeois political system and totally embraced Stalinist communism. Although new members would be admitted into Breton's group of rank-and-file surrealists—including Dali, Magritte, and Giacometti—and Breton would continue to support the left, he was denounced by the communists in 1933 and 1935 at the Writers' Congress for the Defense of Culture in Paris. His defense of the

rights of the individual was read by Eluard (Breton was not allowed to deliver it himself) at midnight to an almost empty hall.[27]

For all of Man Ray's protests of distance from political issues, he had to have been sensitive to the changing climate. As an American, he would in some way—psychologically, financially—have been affected by the stock market crash and the rapid depletion of the expatriate population in Montparnasse, as well as by the chauvinistic criticisms of America. Indeed, even before the effects of the crash were felt in France in the early 1930s, Americans were treated with suspicion and hostility; Man Ray was one of the few Americans who remained in Paris. Sympathetic to anarchism as a young man, he must have had definite feelings about his friends' interest in communism, though he made a point of steering clear of any active involvement; "aware but not indifferent," he told a friend.[28] The only political figure he photographed was Léon Blum, the hero of the Front Populaire, a leftist and fellow Jew. Later, in 1935, he created *L'Orateur* (fig. 222), comprising a vacant open mouth (it looks like Lee Miller's lips turned upside down) and a glassy, reflective object—a cogent comment on the self-absorption and emptiness of the political situation.

181 *Pablo Picasso*, 1934, published in *Cahiers d'art*, 1935

Despite his despondency, Man Ray reasserted his position in the art world during the thirties. He rephotographed many of his old friends and earlier subjects—Duchamp, Picasso, Braque, Brancusi, Tanguy, Breton, Dali, Eluard—and these portraits frequently appeared in such lush and established reviews as *Cahiers d'art* (fig. 181). In these he shows the artists as having lost their earlier tenuousness; they were more sober and confident. Man Ray's photographs of them were no longer casual and documentary but finely crafted in the studio and sometimes solarized. Like the French response to German modernism, they were often deluxe objects. The new series of artistic personalities did not delineate his friendships, as the early portraits had; instead, they are accomplished and a little impersonal, with the air of a professional making his contacts.

Photographically, his greatest innovation in the thirties was solarization. Most accounts of its discovery associate it with Man Ray's new mistress, Lee Miller, an American beauty who, determined to become his student, had come to him in 1929 with a letter of introduction from Steichen.[29] The process, which was kept secret until 1933, produced a sense of disembodiment in images by introducing light during the developing period. Man Ray's fascination with artificial light and with isolating objects to enhance their mystery intensified with solarization. His earlier fashion-related im-

ages that focussed on the heads of women—Kiki or Tityana for the cover of *Vu*—evolved into a varied assortment of disembodied anatomical parts. Floating faces, hands, masklike heads, etherealized torsos with an unhealthy glow—all beautifully printed—were the products of this invention (fig. 182). The strange new aura that

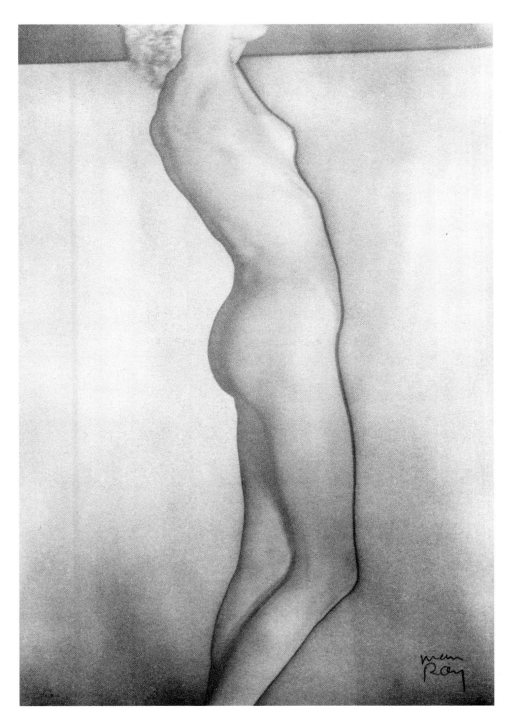

182 Untitled, 1936, solarized silver print

solarization gave to fashion and celebrity portraits was also very appealing—even more so because Man Ray refused to overindulge in the technique. Solarization became a very imitable kind of photography, though—particularly after Tabard published the secret process, thereby abruptly ending his friendship with Man Ray.[30]

With Lee as his model and fellow photographer, Man Ray made *Electricité*, an imaginative, deluxe portfolio advertisement for the Paris electric company, featuring such images as Lee's classical nude torso superimposed with lines suggesting electric current (fig. 183). At Peignot's request, Man Ray and his assistant Boiffard also went out in the streets to photograph Paris for a projected book on

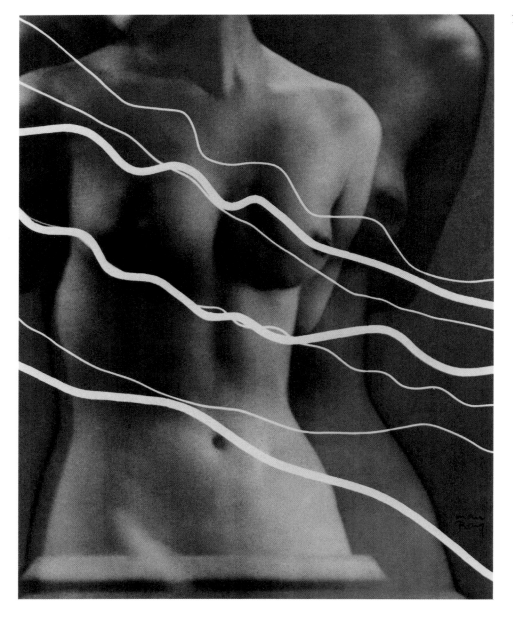

183 *Torso*, 1931, from the portfolio *Electricité*

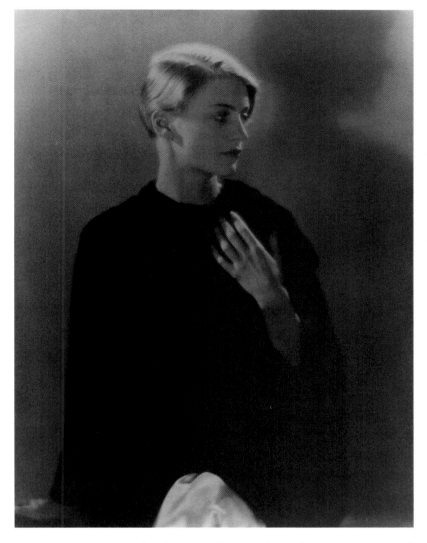

184 *Lee Miller*, ca. 1930, silver print

the city.[31] In 1932 he had no fewer than three one-man shows, and he continued to exhibit frequently—photography as well as work in other media. By 1934 a major book of his photographs was published, with appreciative, evocative texts by Breton, Eluard, Duchamp, and Tzara. Thus, after a photographic lull and sense of discouragement, Man Ray took up the medium with renewed intensity, endowed it with magic, and reasserted his status as the acknowledged master.[32]

But Lee Miller's presence must have disturbed him enormously. She was intelligent, supremely independent, and creative in her own right. She was a challenge to him, and her sexual freedom deeply hurt him. Also intimately tied to fashion, both as a photographer and a model, she must have reinforced the strange relationship between reality and fantasy, the metaphors of fashion, that Man Ray had developed (fig. 184). The fragmented or disembodied

female figure that had interested him sporadically as a theme now almost obsessed him. Lee's eye was planted on the new *Object to Be Destroyed*, her lips floated over the horizon in *A l'heure de l'observatoire—Les Amoureux*. Her participation in Cocteau's film *Blood of a Poet* may have inspired many of Man Ray's photographs in which casts of ancient sculpture seem alive—the Venus de Milo and classical heads, which, as in the movie, were deliberately punned with the heads of living persons. The comparison of Lee to classical sculpture—a flawless, timeless beauty, but emotionally cold—no doubt compelled him. Throughout the thirties, women's figures and faces, made of stone and often paired with a living model, would be a prominent motif. But Lee must also have inspired the many lilies (*lys* in French): calla lilies and madonna lilies, painted white or reversed to black. All the flowers, like his fashion models, were isolated in the studio, seen under electric light, and frequently solarized. The callas especially, with their connotations of death, have an odor of poisonous perfume, true *fleurs du mal* (fig. 185).[33]

The many studies he made for the cover of his book *Photographs by Man Ray 1920 Paris 1934* include images of a woman looking remarkably like Lee posed in the midst of a selection of objects, one of them a metronome with Lee's eye on it (fig. 208). In the center of his painting of artists' objects made at the same time, *Le Logis de l'artiste*, a plaster-looking head, made after a photograph of Lee, appears with its throat cut. In the book's cover illustration, there is an unsettling tension between the girl and her sour observer, the plaster cast of Man Ray's head—Man turned to stone. The objects themselves, disparate and strangely vivid, add to the tension: a hand shoots out of a geometric shape, another cradles a fragile light bulb. The final version is even more anxiety provoking (fig. 186). To the left, a wooden hand shoots out of a geometric object, while Man Ray's bust stares down at a plaster hand holding a light bulb, mirrored by a catching toy—a ball on peg. With its close-up views juxtaposed against a vast space in the background and its magical, fetishistic objects in disquieting relationships, the image is a monument of surrealism.

In *Moi, elle* Man Ray juxtaposed a Queen of Hearts, selected by the false hand of a wooden manikin, with a primitive female fetish (fig. 187). He had made women into objects before, as for instance in *Violon d'Ingres* (fig. 262), not only a reference to the classical purity of Kiki's torso and to the hobby of the famous painter, but also to putting woman in her place, as a thing of pleasure. Man Ray sometimes enjoyed putting her in her place forcibly, and more than once he proudly commented on violently

185 *Calla Lilies*, ca. 1930, solarized silver print

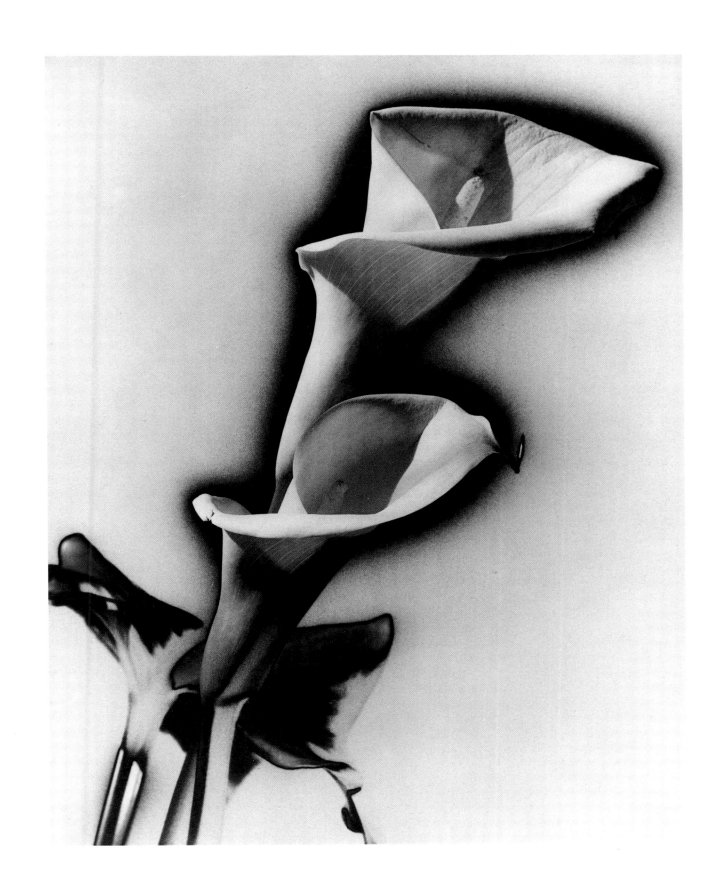

man Ray

186 Cover of the album
*Photographs by Man Ray
1920 Paris 1934*

187 *Moi, elle*, 1934, silver
print

188 *Lee Miller Wearing Collar
with Seabrook*, ca. 1928–
29, photograph

189 Untitled, ca. 1928–29,
photograph

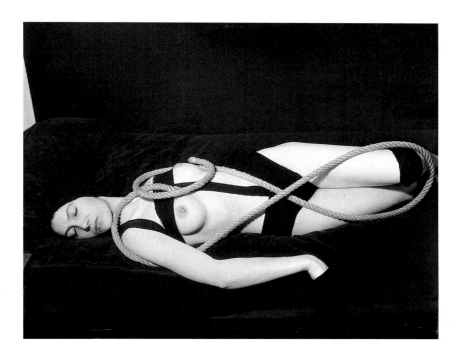

abusing women. He helped the explorer William Seabrook, for
example, fashion a necklace that would be deliberately painful to
Seabrook's wife, and he documented Seabrook's continuing fascina-
tion with algolagnia (figs. 188, 189). Man Ray always stressed his
admiration for the writings of the Marquis de Sade; Sade, though
obsessed with sexual cruelty and using women as objects of plea-
sure, was the great ideal of freedom to Man Ray, as to all the
surrealists. There are photographs in which he directly alluded to
Sade, like the explicitly titled *Hommage à D. A. F. de Sade* (fig.
168), a portrait of Lee Miller with a wire cage thrown over her
head, and later *Aline et Valcour* (fig. 268), which like the photo-

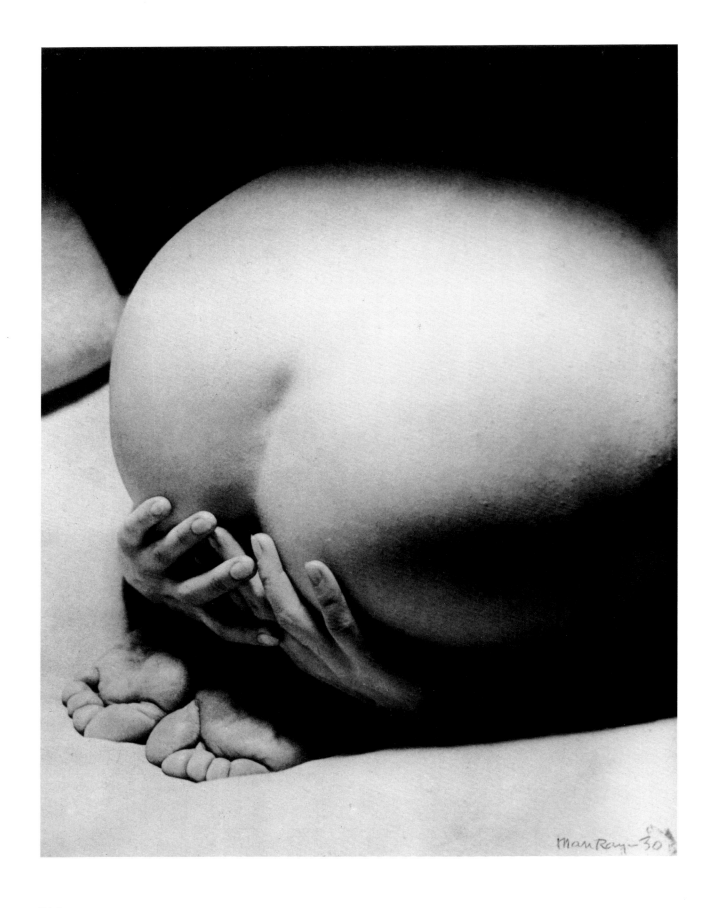

216

graph from *Le Surréalisme au service de la révolution*, depicts a woman's head trapped in a bell jar—both symbolic decapitations. *La Prière* also alludes to Sade's angry anticlericism and fondness for sodomy (fig. 190). Like the other images, it is made all the more shocking by the studio lighting and direct posing of the subject. There are other images with Sadean overtones: peaches, pears, an apple with a screw in place of its stem, all stand-ins for the female body—luscious, edible, depersonalized (fig. 191). While sex might be a saving grace, as in *La Prière*, it could also be a deadly trap (fig. 192).[34]

In the world of fashion, Horst, Hoynigen Huene, Blumenfeld, and Lee Miller all treated the beautiful woman as an object. Women were set against mirrors—with the mirror view often appearing more real—or juxtaposed with classical statuary. Even Steichen experimented with masks, a tribute to the surrealist spirit, if not to Man Ray directly. The fetishistic appreciation of gloves and hands, the personal character of objects such as jewelry, and the treatment

190 *La Prière*, 1930, silver print

191 Untitled, 1931, silver print

192 Untitled, ca. 1929, silver print

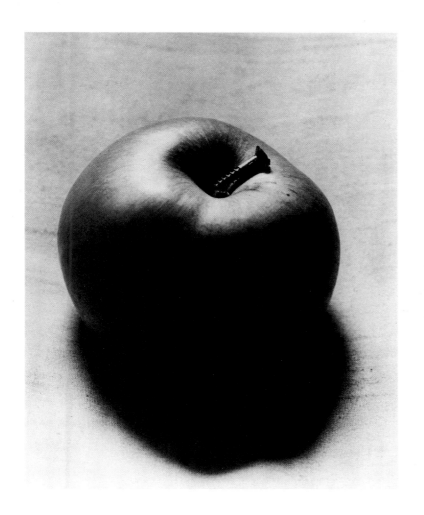

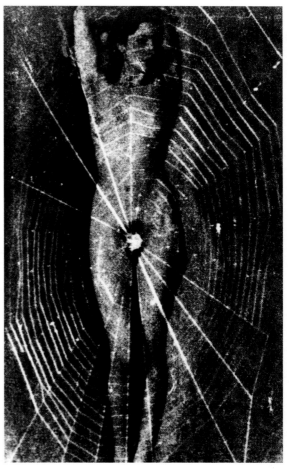

of woman as a cold, distant, mechanical being were constants in the pages of *Vogue* and *Harper's Bazaar* (fig. 193). In the mid thirties Man Ray was a prominent contributor to both magazines; although much of his work was banal, to be sure, there were moments of great invention and beauty. By the late thirties most of the contemporary fashion photographers were following his stylistic lead, just as they also drew upon Ernst's collages and Tanguy's deep spaces.

After his successful campaign to reestablish his presence as a photographer in the early years of the decade, Man Ray's interest in the medium waned. He earned his livelihood as a celebrity portraitist and fashion photographer, working intensively for *Harper's Bazaar*. His work was accomplished but held few surprises. It was also antithetical to a new and vital form of photography appearing in France: photojournalism. The young photographers Robert Capa, "Chim," and Henri Cartier-Bresson took up such leftist causes as the Spanish Civil War with visceral intensity. Their work was frequently reproduced in *Regards*, the communist weekly, and *Vu*, which by then only occasionally published Man Ray's work. By 1936 *Vu* had become a vivid, engrossing magazine, featuring the photojournalists, as well as the street photographs of Brassaï and Isaac Kitrosser and the Bauhaus-inspired cityscapes from the Studio Schall—all enlivened by Alexander Liberman's forceful layouts and his collages. The latter often dramatically focused on the German menace or the social experiments in Soviet Russia. Such a forceful presentation of the medium, as directly engaged not only by broad political movements but also by daily events at home, seemed more relevant and challenging than the work Man Ray was producing.

Man Ray and the former surrealist Louis Aragon did grasp this changed attitude to photography. In 1933 Man Ray wrote an essay "On Photographic Realism," in which he compared the timelessness of painting with photography's need for social contact and its reliance on actuality.[35] At a symposium in 1936 at the Maison de la Culture, Aragon opened the discussions by stating that "in art and in literature, the cardinal problem—the open wound—that which stirs the tempest on all sides, in short, the only issue over which, in these days of the Popular Front, one can bring the artists of the period ardently to grips . . . is the question of realism." Aragon clearly enunciated a need for social realism, for politically committed works of art, and he examined photography as well as painting—or to put it more accurately, he examined the interrelationship of the two and discerned an important bifurcation, between Man Ray's work and that of the young Cartier-Bresson:

193 Untitled, 1936, silver print

From 1920 to 1934, from photos which might be simple magazine illustrations to these black and white rayograms taken by direct impression on the plate without a camera, Man Ray embodies to perfection the classical in photography. It is now no longer in the pose or composition of photography that he imitates the picture or painting: Man Ray is not a contemporary of Ingres, but of Picasso. His photography, with striking virtuosity, succeeds in reproducing the very *manner* of modern painters, that element, in them, which more than any other, it seems, should challenge the objective and mechanical. Even the impasto—even the very touch of the painter—we find it all here. . . . More than ever photography, in the case of Man Ray, its master in the post-war period, is a studio art, with all the term applies: the eminently static character of the photograph. An art which corresponds fully to the social balance of the period, when the Treaty of Versailles was not yet entirely shattered and when "prosperity" allowed the experimenter a relative tranquillity, reflected in beautiful human faces that are without defect and without misery.

Aragon then compared Man Ray's "classicism" to the new current in photography, which had begun with snapshots and continued with film and technological developments in cameras (undoubtedly the compact 35-mm Leica):

Today the crowds are returning to art through the photograph—with the excited gestures of children at play, with the attitudes of a man surprised in his sleep, with the unconscious habit gestures of the *flaneur*, with the heteroclite diversities of human beings as they follow one another along the streets of our modern cities. And here I have especially in mind the photographs of my friend Cartier. . . . [T]his art, which is opposed to that of the relatively peaceful after-war period, truly belongs to this period of wars and revolutions we are in now, by the fact of its accelerated rhythm. I find it extremely symptomatic that the photographic anthology of Man Ray bears the date of 1934. It would lose its significance had it been extended beyond the sixth of February of that year. The advances in photographic technique are parallel to the social events which condition them, and render them necessary.[36]

Under the extreme political conditions, it is hardly surprising that Man Ray increasingly withdrew from reality and turned to fantasy. Not only did nonreal imagery become his principal approach to fashion work, he also turned away from photography and toward painting. He was delighted with the positive response *A l'heure de l'observatoire—Les Amoureux* received at the large retrospective of surrealist art at the Museum of Modern Art in New York. So important was this painting to him that he made a series of photographs in which it hovers over a nude, a self-portrait, a fashion model from *Harper's*, a recumbent classical torso, and a chessboard (fig. 194). Clearly these works are descendants of the earlier studio photos of Stella and Duchamp in New York, of Tzara and Crevel in Paris—and yet they are totally different. The ideal art object still floats above, in its own atmosphere, yet the real world beneath it has become self-enclosed and contrived.

194 Untitled, 1936, silver print

In this vein, Man Ray created two of his most interesting photographic works of his later period in Paris: the books *Facile* (1935) and *La Photographie n'est pas l'art* (1937). *Facile* was made with his old friend Paul Eluard and consisted of photographs of Eluard's wife, Nusch. Man Ray had previously used photographs of Nusch in his fashion work, to which the book is directly related. Lithe and elegant, Nusch's nude body decorates the pages in innovative layouts: it is solarized, made negative, and double-exposed, and it floats on each page like a drawing in an undetermined space (fig. 195). The only other subject in the book is a pair of gloves.

La Photographie n'est pas l'art, a portfolio that he made with Breton, is an antisocial counterpart to the fun and challenge of his photographs of the twenties. It seems a litany of what photography is, a medium that can describe real things and also transform them into appealing or appalling objects, yet which cannot be "art." Many of the images are hard, even brutal: photographs of insects, mating frogs, a detail of a notebook that looks rotten or moldy, a simpering "pictorial" portrait, fashion pictures entitled *Sex-appeal* and *New Winter Fashions*—the latter depicting fruits bundled on a tree to protect them from insects and harsh weather. The titles are often laden with sarcasm, as with the picture of a New York skyscraper called *Utilitarian Air-Emptier*, or the close-up of an ant colony entitled *Cerveau bien ordonné* (*Well-ordered Brain*). The whole book seems a despairing counterpoint to Franz Roh's idealism, a

195 Spread from *Facile*, 1935

surrealist taint on the utopian Bauhaus faith in photography's liberating versatility.

By 1938, the city Man Ray had arrived at seventeen years earlier had changed dramatically. As a result of *Kristallnacht* in Germany, demonstrations were staged against Jews in Paris and foreigners were attacked in the streets. Quotas, in effect since 1932, were now more rigidly adhered to, producing a large number of illegal residents and workers. By 1938 French citizenship could be stripped from a naturalized citizen for modest infringements, and the situation was even more precarious for noncitizens. The playwright Jean Giraudoux asserted in 1939: "Our land has become a land of invasion. The invasion is carried out just as it was in the Roman Empire, not by armies but by a continual infiltration of barbarians."[37] With such sentiments publicly expressed by influential Frenchmen and supported by the ministry, Vichy was not far behind. Clearly, Man Ray's studied independence, lack of political affiliation, and commitment to artistic objectivity was a very real posture of self-preservation.

Toward the end of his stay in Paris, his vision became progressively grimmer throughout all his work except fashion. While the theme of suicide had interested him in his New York period and intermittently in Paris, it was replaced by themes of rottenness and dissolution. The strange object *Les Ponts brulés* (*Burnt Bridges*) looks like a primitive totem, and his photographs of it form a record of a flaming horsehair object, as it is deliberately pushed into fire and destroyed (fig. 217). While classical art appearing in the works of his contemporaries often had a sentimental, even escapist, element, Man Ray employed it to suggest threat or lethargy; likewise, new negative meanings were attached to geometry. Like classical sculpture bound and mutilated (fig. 196), the logic and harmony that geometry implied went awry, became dangerous and susceptible to misuse. *Non-Euclidean Object I*, with its tightly, wildly knotted rubber tubing pressed close against a geometric shape, expresses a disquieting tension (fig. 214). In *Mire universelle*, a fragment of the Three Graces stands perilously between targets and a menacing-looking hexagon, pyramid, and cone (fig. 218).

In 1934 Man Ray made a series of photographs of mathematical objects that had been discovered at the Poincaré Institute by Max Ernst. "The fact that they were man-made was of added importance to me," he wrote, "and they could not be considered abstract as Breton feared when I first showed them to him—all abstract art appeared to me as fragments: enlargements of details in nature and art, whereas these objects were complete microcosms."[38]

 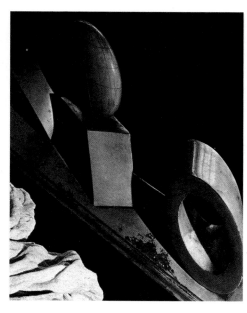

In other words, they had a strange self-sufficiency. Published in
Cahiers d'art in 1936, they resembled dessicated, yet living, land-
scapes. In *Perspective for a Cube, a Cone and a Cylinder* (fig. 197),
geometry, usually representing reason or logic, is suddenly de-
formed. It is these forms—and their landscape—that appear in his
later paintings.

Many of the most powerful and frightening works of the mid
and late 1930s show a charged sensitivity to shadow. The beastly,
terrifying head of the Minotaur emerges from the torso of a woman
distorted by shadow (fig. 199); in *Eteignez tout*, a shadow decapi-
tates a woman (fig. 198). At the same time, Man Ray reintroduced
the automaton. *Collage, ou l'âge de la colle*, is an assemblage of
drafting materials, with a picture of Mr. and Mrs. Woodman en-
gaged in sex in one corner and a dark photograph of a decapitated
female torso (a plaster cast) in the other, the whole smeared with
glue. The mechanical human reappears elsewhere, as in *La Femme
portative* (fig. 200), a woman who can be assembled in a moment,
like a toy, or *La Jumelle*, with shiny metallic thighs and a torso
sliced in two by a pane of glass. Shadow and automaton become
one in the sticklike figures of *The Wall, Swiftly Walk over the
Western Wave*, and *Rebus* (figs. 230–232). Elusive and transient as
shadows, many are set in a strange landscape derived from Mou-
gins: long expanses of deserted, uninhabitable space—the same
landscape in which he positioned the stony Sade (fig. 224). In some
of these paintings, there are truncated realistic hands, holding the
sun or the world (in which continents are metamorphosed into

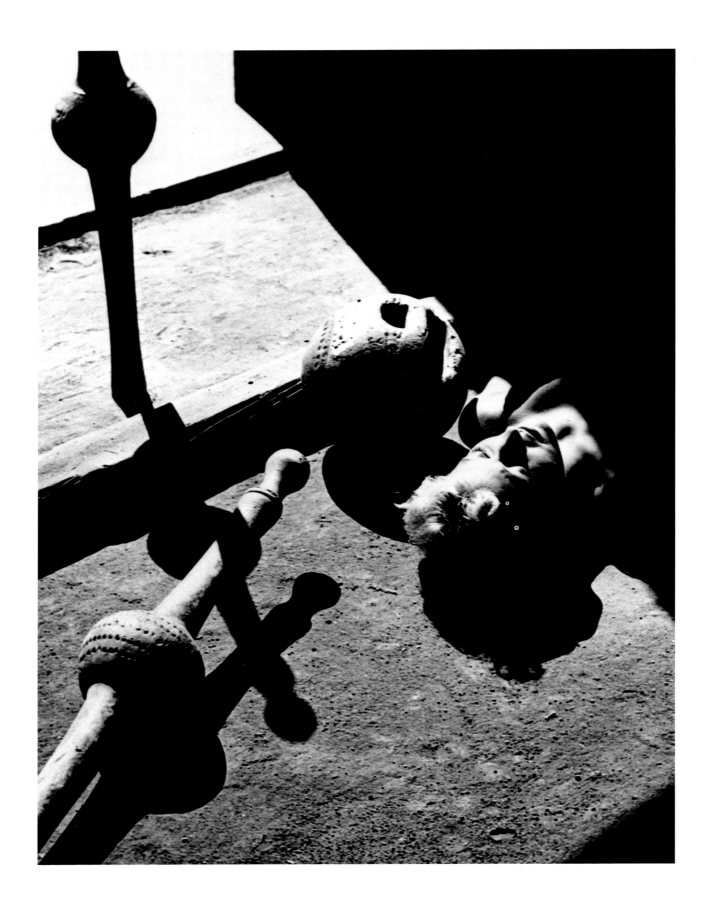

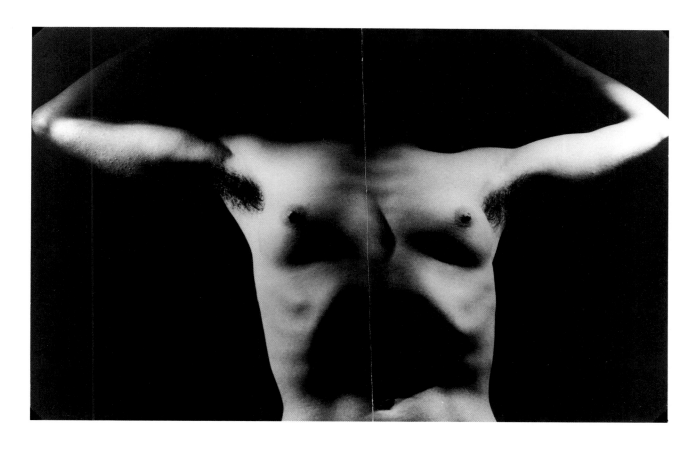

198 *Eteignez tout*, ca. 1936–37, silver print

199 *Minotaur*, 1936, silver print

200 *La Femme portative*, 1936, pen and ink on paper, from the series *Les Mains libres*, The Art Museum, Princeton University, museum purchase, The Laura P. Hall Memorial Fund

fighting figures) or directing a ship. They seem to represent a strange, fateful, willful power.

Man Ray's photographic career had begun from a need for reproductions of his art. His fascination with replication lasted throughout his career, intensified by his commitment to the medium of photography. More than any other artist of his generation, he moved easily from making an object, to making a photograph of it, to reproducing his own work repeatedly—as he did, for example, with his sighted metronome, first called *The Object to Be Destroyed*, later *Indestructible Object*, and finally *Perpetual Motif.* His careless attitude regarding the uniqueness of each object was probably (at least originally) motivated less by political or theoretical concerns than by prosaic ones, such as limited storage space for the three-dimensional works or the ability to disperse his objects far afield. In the late thirties, however, his replication of images from one medium to another accelerated and expanded. *Venus restaurée* was an object and a photograph, while photographs served as models or inspirations for paintings like *Le Beau Temps.* The Picasso-inspired drawings in *Les Mains libres* were in many cases made directly after photographs, some ten years old. The threatening events on his doorstep could not have but encouraged the intense focus in his studio, this strange aesthetic inbreeding he now developed. It was a time of self-examination for other artists, too. Marcel Duchamp was carefully, photographically, reproducing his work in a *boîte en valise*, before he packed his bags and left Europe. Although Man Ray avoided mentioning the political anguish he must have felt in the thirties, he wrote extensively on his adventures during and after the fall of France in 1940—as though the strain had been relieved and he was happily experiencing freedom at last.[39]

Man Ray's most complex painting of the late thirties is *Le Beau Temps* (fig. 226), with its appropriately acidic colors for an acid title. Many of its themes and some of its elements are borrowed from earlier photographs. Two robotic figures—one male, one female—stand in a bizarre, semicivilized setting. The male's body is pierced through by a bullet-shaped object, and his head is a lampshade with a candle inside and a propeller on the back. He stands in front of two spear-shaped espaliered trees with no fruit or leaves, set against a decaying wall. At his feet lie a book of strange geometrical writings and two little stones that Man Ray had earlier photographed in close-up. Between the two figures is a door with two feet, which prevents it from moving, and a spherical shape at the top. Delicately painted on its panels are four nudes in vulnerable positions. As if to underscore the human nature of the door, a

stream of blood runs down the keyhole to the floor as the male robot turns the knob. The other figure has a cone head, arms like propellers, a sleek mechanical torso supporting a skirt like a circus tent. In the background is *La Fortune* (fig. 225)—an object and painting both—and a view of Man Ray's country home, where he grew espaliered fruit trees. The lights are on, showing a canvas poised on an easel and a couple embracing. On the roof, however, are two mythological-looking beasts: a bull-like creature with its teeth firmly planted in a reptile's throat. The bull seems engaged in not only devouring its victim, but also copulating with it.[40]

Le Beau Temps was a remarkable and complex visual summary of Man Ray's artistic state on the eve of war and his departure for America. The work contains a number of autobiographical elements: his country house, his fruit trees, his easel and model, his own objects and photographs, and his anxiety. Just as fascinating is its allusion to Picasso. The empty, beachlike space of the painting; the harlequin configuration and two-dimensionality of the male figure; the conjunction of large abstract shapes with realistic details, often cruel; the deformed womanlike figure; even the Ingresque drawing of the realistic details—all related stylistically to the work of Picasso. There are other grounds for comparison, as well. Both Picasso and Man Ray were foreigners, thus outsiders. They both used iconography to elucidate autobiography. And Picasso's great versatility, his ability to draw Ingresque portraits and paint abstract compositions, his constant interfacing of the classical past with objects of the present, were characteristics shared by Man Ray.

Even the title, "Sunny Weather," may refer obliquely to what were the real *beau temps*, the years immediately preceding this painting, when Man Ray and his friend Ady spent their summer vacation on the beach in the south of France in the company of Nusch and Paul Eluard, Lee Miller and Roland Penrose (soon to marry), Picasso and Dora Maar. Both Man Ray and Picasso shared a strong interest in bullfights, which they attended in the south. As a demonstration of friendship, Picasso drew Man Ray's portrait for the latter's 1934 volume of photographs; and Man Ray wrote an introduction to Picasso's photographs when they were published in *Cahiers d'art*.[41] At the time, Man Ray was also experimenting in film again. A newly discovered sequence shows his friends on the beach, with brilliant distortions of color; another unedited segment presents bullfighting as both gory and mythic. Even Man Ray's experiments in still color photography—linear, strangely classical, and occupying a wonderfully ambiguous position between photography and painting—recall the works of the Spanish artist. Antibes

and Mougins, where they all vacationed, was in fact where Man Ray seriously started painting again. When he left for his house in the suburbs of Paris, Man Ray actually turned his little Antibes studio over to Picasso.[42]

The fighting mythological animals, making love and war, in *Le Beau Temps* point to another correspondence between Man Ray and Picasso: themes of beauty and sexual pleasure conjoined with the monstrous or bestial were also a preoccupation of Picasso's in the late thirties. Both artists used the Minotaur as a symbol of reason and irrationality combined. In his short poem "Dictionnaire panoramique de Pablo Picasso"—published by their mutual friend from the south, Christian Zervos—Man Ray enumerated colors, objects, and the concept of violence wedded to love as distinguishing traits of his friend's art.[43]

In his last years in Paris, Man Ray worked either strictly for commerce (mainly photographs for *Harper's Bazaar*) or for himself, through his strange, distraught, inward-turning paintings. It was a profound change in direction that would affect his work in the United States. The fertile playfulness of the twenties, of comingling fashion with surrealist photography, "art" with "life" in all kinds of variations, had hardened into photography as a livelihood and painting as personal expression. The man-made mathematical objects—complete "microcosms," not abstract but real—were no longer amusing but disturbing. The objective, intellectual view that had informed his work, especially his photographs, had become nightmarish. No wonder Max Ernst's shoe-figure is poised to kick the geometric object to smithereens.

NOTES

1. Quoted in Janus, *Man Ray: The Photographic Image*, p. 9.

2. Man Ray, *Self Portrait*, p. 384.

3. Although Duchamp and Man Ray were staying in Chastel's apartment at the time, Chastel was in London setting up a shop for Poiret when Man Ray met the designer. So the introduction was probably through Gabrielle Buffet.

4. Man Ray's belief in replication may be viewed as a counter to Stieglitz, who insisted, especially later in his career, that photographs were not replicable, that each print was unique. See Man Ray, *Self Portrait*, pp. 56, 96–97; and Phillips, "Man Ray and Moholy-Nagy: Rayographs and Photograms," pp. 48–63.

5. Man Ray, *Self Portrait*, 128–29. Ribemont-Dessaignes said of Man Ray's rayographs: "[He] is the subtle chemist of the mysterious who sleeps with the metrical fairies of spirals and steel wool. He invents a new world and photographs it to prove that it exists. But as the camera also has an eye, although without a heart, he suppresses it" ("Dada Painting or the Oil-Eye," p. ll).

6. Tzara had a collection of "Schadographs" at the time (presently at the Museum of Modern Art, New York); only one bore any relation to Man Ray's work. I am indebted to Peter Galassi for this information.

7. Tzara also supported the rayographs above "painting with a ponytail, in a gilded frame. That is their monument, which we piss on" ("Photographie en revers," in Man Ray, *Les Champs délicieux*, n.p.).

8. Jean Vidal, "En photographiant les photographes: Kertész, Man Ray," *L'Intransigeant*, 1 April 1930.

9. "Experiments in Modernistic Photography," *Vanity Fair*, July 1921, p. 60.

10. Man Ray states in *Self Portrait* that Duchamp later titled the photograph "*Elevage de poussière*—Bringing up Dust or Dust Raising." He also noted that "this . . . was indeed the domain of Duchamp" (p. 91). When it was published in the 1 October 1922 issue of *Littérature*, it was titled *Vue prise en aéroplane* with a caption that read: "Voici le Domaine de Rrose Sélavy/Comme il est aride—comme il est fertile/comme il est joyeux—comme il est triste!"

11. Kiki used to call him "mon petit Man," and he was in fact only about 5 feet 7 inches tall.

12. In her essay for the catalogue *Objects of My Affection* (New York: Virginia Zabriskie Gallery, 1985), Rosalind Krauss misquotes the popular song "The Object of My Affection," and in so doing fails to appreciate the erotic nature of the object for Man Ray. The song should read: "The object of my affection/ Can change my complexion/ From white to rosy red." However, Krauss proves the theoretical importance of photography to surrealism, and Man Ray in particular, in her essays for *L'Amour fou: Photography and Surrealism*.

13. Man Ray, *Self Portrait*, p. 203. For Man Ray's own comments on the special status portraiture afforded him, ibid., pp. 118, 196. *Hands off Love* appeared in *La Révolution surréaliste,* nos. 9/10 (1 October 1927), and *Du temps que les surréalistes avaient raison* was published by the group in Paris in 1935. Lucien Treillard believes that Man Ray did not sign other manifestos because of his noncitizen status and the risk of deportation from France.

14. *Noire et blanche* was originally made for *Vogue* (Migennes, "Les Photographies de Man Ray," p. 154). By hobby, Ingres was a passionate amateur violinist. In fact, *violon d'Ingres* is a French term for hobby, as is *dada*. See Man Ray, *Self Portrait*, p. 144.

15. Thomas Michael Gunther discovered and published many of the Atget photographs in Man Ray's collection (now at the George Eastman House). See Gunther, "Man Ray and Co.: La Fabrication d'un buste," *Colloque Atget: Actes du colloque*, 14–15 June 1985, pp. 66–73. Man Ray considered Atget a naïve—but then he cultivated this impression about himself as well. See Paul Hill and Thomas Cooper, *Dialogue with Photography* (New York: Farrar, Straus & Giroux, 1979), pp. 17–18.

16. Bofa, "Magie noire," *Jazz*, no. 3 (February 1929): 108 (translation by Maria Morris Hambourg).

17. Crevel, "Le Miroir aux objets."

18. Gallotti, "La Photographie est-elle un art?"

19. Mac Orlan, "L'Art littéraire et d'imagination," *Les Nouvelles Littéraires*, 22 September 1928, p. 1. Man Ray's street photography was probably due to the influence of Atget. According to Lucien Treillard, Man Ray, who did not collect, nevertheless collected Atget. For examples of Man Ray photographs in the style of Atget, see J. H. Martin, *Man Ray Photographs*, illus. 231–35, 246–47.

20. *New York Times*, 11 May 1930, p. 18.

21. As quoted in Sybil Moholy-Nagy, *Moholy-Nagy: Experiment in Totality* (Cambridge, Mass.: MIT Press, 1969), p.19.

22. Moholy-Nagy, *Painting, Photography, Film*, trans. Janet Seligmen (Cambridge, Mass.: MIT Press, 1973), p. 28.

23. Quoted in Moholy-Nagy, "Fotoplastische Reklame," *Offset-buch-und-werbekunst* 3, no. 7 (1926): 388.

24. For the impact of German art on French, see Michel Hoog, "Le Bauhaus et la France," *Cimaise*, nos. 16–17 (December 1969–January 1970): 52.

25. Man Ray, *Self Portrait*, pp. 291–92. This same year he also produced *Suicidal Self Portrait*; see Lucien Treillard, *Man Ray* (Tokyo: Gallery Odakyu, 1984), no. 5.

26. For information on the increasing separation of French painting from the School of Paris, and the attendant anti-Semitism, see Kenneth E. Silver and Romy Golan, *The Circle of Montparnasse: Jewish Artists in Paris, 1905–1945* (New York: Jewish Museum, 1985). For information on the political situation of Jews before Vichy, see Michael R. Marrus and Robert O. Paxton, *Vichy France and the Jews* (New York: Basic Books, 1981).

27. Roger Shattuck, *The Innocent Eye: On Modern Literature and the Arts* (New York: Washington Square Press, 1986), p. 21.

28. Lucien Treillard, interview with author, Paris, summer 1986. For the rise of anti-Americanism, see David Strauss, *Menace in the West: The Rise of French Anti-Americanism in Modern Times* (Westport, Conn.: Greenwood Press, 1978).

29. See A. Penrose, *The Lives of Lee Miller*, p. 30, and Amaya, "My Man Ray: Interview with Lee Miller," p. 57. Although Amaya implies that Miller was in Paris in 1928 making solarizations, this does not appear to have been the case. See also Man Ray, "A l'heure de l'observatoire . . . les amoureux," *Cahiers d'art* 10, nos. 5–6 (1935): 127. An interesting variant on the story of solarization can be found in Miller, "I Worked with Man Ray," p. 315. For this information I am indebted to Mr. Penrose.

30. See Tabard, "Notes sur la solarisation."

31. Boiffard was a big man and could carry Man Ray's heavy equipment around Paris for him. When Boiffard left, Man Ray stopped the project (Treillard, interview with author, Paris, summer 1986).

32. Art exhibitions of photography were regularly held in Paris by 1930. Man Ray's work was shown in Europe and the United States at the Galerie d'Art Contemporain (Paris, 1930–31), the Harvard Society for Contemporary Art (1930), the Albright-Knox Art Gallery (Buffalo, N.Y., 1931–32), L'Exposition internationale de la photographie (Brussels, 1932), the Julien Levy Gallery (New York, 1932), the Royal Photographic Society (London, 1933), the Galerie de la Pléiade (Paris, 1933–35), and L'Exposition internationale de la photographie contemporaine (Paris, 1936). Cartier-Bresson recalled that when he was entering photography, Man Ray was the artistic photographer, as Kertész and Germaine Krull were the master photojournalists. For this information I thank Peter Galassi.

33. See A. Penrose, *The Lives of Lee Miller*, p. 41.

34. There are frequent references in *Self Portrait* to Man Ray beating women. Timothy Baum contends that this was Man Ray's way of showing off, or compensating for being a small man (Baum, interview with author, 1986). For information on the Marquis de Sade, see *The Marquis de Sade: An Essay by Simone de Beauvoir*, trans. Annette Michelson (London: John Calder, 1962), p. 31: "The fact is that the original intuition which lies at the basis of Sade's entire sexuality, and hence its ethic, is the fundamental identity of coition and cruelty."

35. Man Ray, "Sur le réalisme photographique," *Cahiers d'art* 5–6 (1933): 120–21.

36. Quotations from Aragon, "Painting and Reality: A Discussion," *transition* 25 (1936): 93, 96–97, 99.

37. As quoted in Marrus and Paxton, *Vichy France and the Jews*, p. 53.

38. Man Ray, *Self Portrait*, p.368.

39. Ibid., pp. 298–324.

40. Although these animals resemble animal depictions in the archaic style, they are more imaginary. Man Ray called them "gargoyles," but they seem to have no medieval prototypes. Most likely, they were his own invention, a bestial commentary on the condition of mankind in 1939. The closest correspondence in the art of his contemporaries is seen in André Masson's painting *Cheval attaqué par un poisson* (1939), reproduced in José Pierre, *L'Aventure surréaliste autour d'André Breton* (Paris: Artcurial, 1986), p. 74.

41. Man Ray, "Picasso, Photographe," *Cahiers d'art* 6–7 (1937): n.p.

42. Man Ray "acquired a permanent apartment" in Antibes in 1937 explicitly to paint undisturbed, a place to go "whenever I could get away from my photographic work in Paris" (*Self Portrait*, p. 227). In 1939 he gave it up; when Picasso took it over, he saw the collage *Trompe l'oeil*, which he asked to have. Man Ray then made an exact painted copy of the work for himself.

43. "Dictionnaire" was published in *Cahiers d'art* 10 (1935): 205. For Picasso's art of this period, see Lydia Gasman, "Mystery, Magic and Love in Picasso, 1925–1938: Picasso and the Surrealist Poets" (Ph.D. diss., Columbia University, 1981).

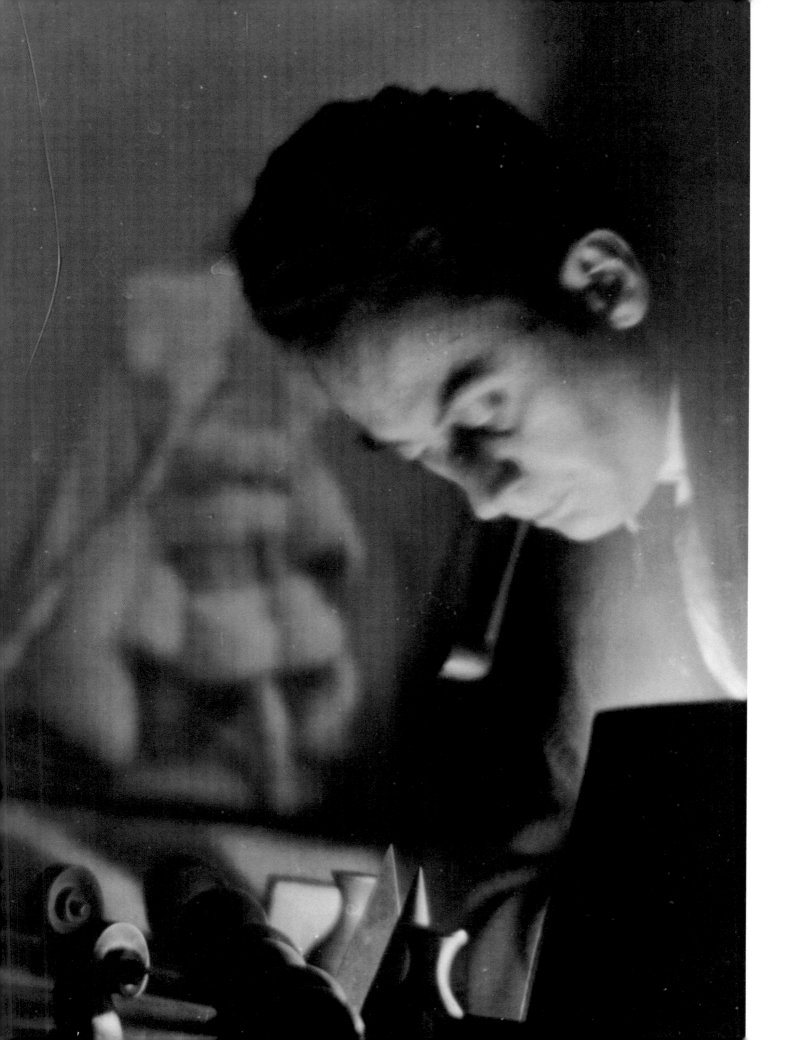

CHAPTER FIVE

CONFIGURATIONS OF FREEDOM

Stephen C. Foster

The Europeans' initial acceptance and endorsement of Man Ray was based more on a set of expectations than on any knowledge of his work. The expectations, for the most part, involved his Americanism and all that it historically—or potentially—represented. Only tenuously tied to mainstream traditions, bearer of an uncompromising individualism, and in possession of a much envied frontier "metaphysic," Man Ray promised to embody perfectly the principles and goals of the Paris group. Adopted as a "primitive," if only in a very limited sense, Man Ray provided a culturally fresh, unimpeded, unideological outlet for the natural or spiritual side of dada—the uninstitutionalized aspect to which dada as a movement aspired. The American effectively embodied the myth, so important for the dadaists and later the surrealists, of "beginning anew."[1]

For Man Ray, it was a different matter altogether. Unlike Europe, with its time-honored sanction of the artist as adversary, in America the alienation of the artist was oppressive, for there was as little resistance as there was support. Working in America also entailed working in a country where modernism had little place. Paris promised to lift the pall of aesthetic demoralization Man Ray suffered in America and to provide the potential for freedom and invention he so needed. Dada, especially, seemed to offer a permissivity in art and life that Man Ray found bracing and liberating.[2]

Although the dadaists' and Man Ray's surface expectations were fairly clear, the realities were not. Paris dada was a complex situation, both in terms of its history and its own perception of its future. Although predisposed to dada by 1918, somewhat preceding Tristan Tzara's and Francis Picabia's Zurich collaboration on the *Anthologie Dada* (a double issue of their series of publications collectively called *Dada*), the French were hesitant to invest wholeheart-

Self-Portrait with Chess Set, 1921, silver print

233

edly in the movement until Tzara's arrival in Paris on 17 January 1920, by which time he was "awaited like a sort of Anti-Messiah" (fig. 201).[3] As Breton later saw it, Paris, seeking direction after the war, perceived dada as a temporary maneuver until the right development revealed itself.

Working together for only a brief period of time, Tzara and Picabia had brought dada as close as it ever came to a coherent set of principles, and it was this dada that migrated to Paris. There, however, its original purposes, defined in the aesthetic isolation of Zurich, had to be integrated with the reawakening of French mainstream modernism. The reshaping of dada toward these ends was undertaken largely by André Breton, already committed to the rebuilding of modernism as the nominal leader of the *Littérature* group that had received dada in Paris and hosted Man Ray the night of his arrival. Tzara sought to entrench dada in France, and his continued publication of *Dada* in Paris attests to his determination.[4]

201 *Tristan Tzara*, ca. 1921–22, silver print

While Tzara viewed dada as an end unto itself, a permanent denial of any possibility of resolving world conflict, Breton endorsed dada to clear the air, to provide a clean slate upon which new chapters of modernism would be written (fig. 202). He saw little use in pursuing dada for its own sake. Picabia, initially more in tune with Tzara, had by mid 1921 become critical of both points of view and was well on his way to complete independence. Already at odds, Tzara and Breton would openly split over these issues soon thereafter. The end of Paris dada was, in a sense, factored into its anarchistic charter. Thus, by the time Man Ray arrived in July of 1921, dada "was no longer anything but a four-franc cocktail that the Café Certà . . . offered along with a 'Pick me Hup' or a 'Kiss me Quick' at three francs and fifty centimes."[5]

Man Ray, then, stepped into the crisis of dada rather than into its program and became part of the internal struggle of a group to which he never really belonged. Although aware of Zurich dada while still in New York and responsible, with Marcel Duchamp, for the publication of *New York Dada* in 1921, his early concept of the movement did little to prepare him for Paris. For Man Ray and Americans in general, dada was perceived and assimilated as a new chapter of modernism, replete with its futuristic orientation, utopian outlook, and conviction that the problems of the world could be stylistically formulated and resolved. He would have had little notion at that point of dada's—and especially Tzara's—antimodernist bias.[6]

Nevertheless, Man Ray did show affinities with a dada "spirit"

202 *André Breton*, ca. 1921–22, silver print

that the Parisians greatly appreciated. Most obvious was his commitment to objects, as shown in *The Enigma of Isidore Ducasse* (fig. 74), a work rooted in the same soil from which dada sustained itself. It is worth noting, however, that *The Enigma* was sufficiently unspecific to dada to permit its publication in the December 1924 issue of *La Révolution surréaliste*. It was precisely this lack of obligation or commitment to dada's politics and future that freed Man Ray to pursue its principles and ideals; for him, dada was not a movement but an intrinsic part of his work and life. The fact goes far in accounting for the high esteem in which he was held among the ranks of the dadaists-surrealists, and why he was respectfully exempted from their internal problems. It may also explain why he never completely entrusted his faith in art to dada. He took what he considered valuable, as he was later to do with surrealism. By his own admission, Man Ray's interest in the dadaists had as much to do with their personae as their ideas and creations: "I had always wanted to know the human side of creators whose work had interested me, and their biographies were as fascinating for me as their works."[7]

What was at stake, what constituted the issues over which dada either failed or transformed itself into surrealism, could essentially be reduced to a disagreement over the value of "purposive action" in a reconstruction-minded postwar society. The position of each party in this dispute had clear ramifications for art and literature. Tzara's fundamentally nonpurposive dada, whose basis was antiwar sentiment, was bent on the destruction of all conventions and norms. It sought not merely to subvert, but rather to invert the value systems that had permitted the "War of Wars." For reason, dada substituted the irrational; for faith, skepticism; for purpose, chance. Conventional systems of morality and ethics were held in contempt. Art, which had shown itself incapable of significant reform, had to be rejected along with other aspects of prewar culture. A profound sense of disgust lay behind expressions of this disillusionment. Radical techniques of public manifestation, provocation, insult, and ridicule became the dadaists' stock in trade as they sought to raise public consciousness of Europe's tragic situation. The Zurich *Dada Manifesto of 1918* made Tzara's position perfectly clear:

> Every man must shout: there is great destructive, negative work to be done. To sweep, to clean. The cleanliness of the individual materializes after we've gone through folly, the aggressive, complete folly of a world left in the hands

of bandits who have demolished and destroyed the centuries. . . . Every product of disgust that is capable of becoming a negation of the family is *dada*; protest with the fists of one's whole being in destructive action.[8]

Tzara's subsequent Paris manifestos essentially maintained this point of view. The *Manifesto of Monsieur Aa the Antiphilosopher, Tristan Tzara Manifesto, Monsieur Aa the Antiphilosopher Sends Us This Manifesto*, and the *Dada Manifesto of Feeble Love and Bitter Love* all promoted Tzara's conviction that to take any other line would represent a regression into the very prewar state of mind that dada was trying so hard to erase. For Tzara, the end of the war did not mean the end of the protest.

Picabia's position was somewhat more complex. An early acquaintance of Duchamp, he responded to the art world in much the same way. Following brief and rather superficial involvements with cubism, both became disillusioned with modernism, particularly the sensual, as opposed to critical, basis of its self-styled historical mission. Partly due to his exhilarating experience of America when he exhibited in the New York Armory Show in 1913, Picabia moved into a mechanomorphic imagery that evolved during his work with Alfred Stieglitz and the latter's publication *291*. Picabia's own periodical, *391*, reflecting the influence of New York, was first published in Barcelona in 1917 and subsequently in New York, Lausanne, Zurich, and Paris (through October 1924). It was in Lausanne that Picabia was first contacted by the Zurich dadaists and brought for a short, but important, period of time into their orbit and into collaboration with Tzara on *Anthologie Dada*.

Picabia's resumption of activities in Paris was very different from Tzara's first-time experiences there. In returning home, Picabia had to contend with his background in French modernism. He also did not accept Tzara's belief that further protest was necessary or useful. Nor, however, did he accept Breton's reinstatement of modernism. Consequently, his involvement with Paris dada was brief and somewhat half-hearted. Convinced of the bankruptcy of dada as a movement (though he never relinquished some of its most cherished ideals and, in that respect, was similar to Man Ray), he withdrew in 1921, the year of Man Ray's arrival in Paris. Duchamp's position was similar, with one major difference: since he had never stepped into the movement, he never had to step out.

Breton saw it very differently. *Littérature* had already begun publication in 1919, advancing the cause of a number of wartime periodicals such as *SIC* (1916–19) and *Nord-Sud* (1917–18). Assisted

by Louis Aragon, Philippe Soupault, and Georges Ribemont-Dessaignes, Breton saw beyond dada to the beginnings of a new French modernism. With its strongly literary thrust, Paris dada was changed little by the arrival of Hans Arp in 1920, Man Ray in 1921, and Max Ernst in 1922. Indeed, the visual arts never occupied a prominent place in the movement, as it would in the later stages of surrealism. Man Ray himself noted, "Curiously enough, at the time of my first encounter there were no painters in the group." The first—and one of the few—"group" exhibitions, held at the Galerie Montaigne in June 1922, was relatively small and symbolized a reservation about the visual arts that was not to change officially for several years, until Breton's publication of *Le Surréalisme et la peinture* in 1928.[9]

Almost in anticipation of surrealism, Breton had stated in 1922 that "Dadaism cannot be said to have served any other purpose than to keep us in the perfect state of availability in which we are at present, and from which we shall now in all lucidity depart towards that which calls us."[10] This lack of commitment to dada principles is best illustrated by his ill-conceived plans for a "Congrès de Paris" that same year. Designed to give direction to the different forms of modern art, the Congrès was to be held under police protection and follow parliamentary procedures. It was an unthinkable turn of events from Tzara's point of view, and the Romanian politely declined to participate. Infuriated, Breton publicly denounced him as a fraud and an *arriviste*, claiming that "Tzara had no hand in the invention of Dada." In defense of the excommunication, Breton added, "It's been said that I change people the way you change boots. Please be charitable and grant me this luxury. I can't always wear the same pair. When they don't fit me anymore I give them to my domestics." In what amounted to a showdown among members of the group, the event was finally aborted, Man Ray among those entering a "no confidence" vote.[11] For all practical purposes, the incident spelled the end of the movement.

The uproar created by Breton and Aragon at Tzara's "Soirée du coeur à barbe" was the last straw:

> The death rattle of dada was heard on a July night in 1923 at the Théâtre Michel in Paris, although it must be admitted that since the Congrès de Paris, dada had been more or less moribund. On this occasion, Tzara's third play, *Le Coeur à Gaz*, was to be presented. When Tzara's former friends, Louis Aragon, Benjamin Péret, and André Breton, came to sabotage the play, a furious fight broke out.

Leaping up on the stage, Breton began to attack the actors, who were unable to fight back because they were rigidly encased in cardboard boxes designed by Sonia Delaunay.[12]

Man Ray himself had become a more-or-less willing collaborator that evening with his three-minute film *Retour à la raison*. In response to Tzara's request, he had literally patched together a sequence of images, many of them based on the same principle as his rayographs. The film broke twice in the course of its projection and was never seen that evening in its entirety. According to Man Ray, "The Dadaists were joyful—as for me, I knew it was near the end of my reel, so did not regret the interruption, on the contrary, it may have induced the public to imagine that there was much more to the film, and that they had missed the import of the *Return to Reason*."[13]

Despite surrealism's deep debts to dada—the improbable marriage of objects and words, the folding of art into life, the submission of process to chance, and the elevation of the ordinary into renewing aesthetic contexts—dada's principles were all reconsidered in light of their value for restoring humanity to its preconscious roots. For Breton, surrealism was a cultural blueprint for all walks of life: moral, ethical, political, and economic as well as aesthetic. It was no less a reconstruction philosophy than De Stijl or constructivism. Influenced primarily by his experience as a psychiatric aid during service in the war and his studies of Freud, Breton stressed revealing the subconscious. The *First Manifesto of Surrealism*, published in 1924, set the tone (minor alterations were introduced in the second surrealist manifesto in 1929) for the duration of the movement:

> SURREALISM, n. Psychic automatism in its pure state, by which one proposes to express—verbally, by means of the written word, or in any other manner—the actual functioning of thought. Dictated by thought, in the absence of any control exercised by reason, exempt from any aesthetic or moral concern.

> ENCYCLOPEDIA. *Philosophy*. Surrealism is based on the belief in the superior reality of certain forms of previously neglected associations, in the omnipotence of dream, in the disinterested play of thought. It tends to ruin once and for all all other psychic mechanisms and to substitute itself for them in solving all the principal problems of life.[14]

Until 1928, neglect of the visual artist was as much or more the rule than it had been with Paris dada. Not a single painter or sculptor was mentioned in the main body of the text, although a few, including Man Ray, were mentioned in the following footnote:

> I could say the same of a number of philosophers and painters, including, among these latter, Uccello, from painters of the past, and, in the modern era, Seurat, Gustave Moreau, Matisse (in "La Musique," for example), Derain, Picasso (by far the most pure), Braque, Duchamp, Picabia, Chirico (so admirable for so long), Klee, Man Ray, Max Ernst, and, one so close to us, André Masson.[15]

Man Ray was represented in the first surrealist exhibition at the Galerie Pierre in November 1925, but a mere nineteen items were included, and the show "represented more a community of interest among former Dadas and their sympathizers than an original stylistic or technical point of departure."[16] While the March 1926 exhibition of Man Ray's work, inaugurating the opening of the Galerie Surréaliste, may well have reflected a growing concern to bring painters into the movement, it scarcely indicated a basic reorientation. Although the pictorial arts entered surrealism by the mid to late twenties, they were essential to neither its conception nor its perpetuation.

Man Ray was not unaware of his relationship to dada and surrealism. He well recognized the dadaists' use of him, as is clear from his statement regarding his exhibition at Librairie Six, that it served as an "occasion and pretext for the group to manifest their antagonism to the established order and to make sly digs at those who had seceded from their movement."[17] The latter reference is surely to Picabia, who, according to Man Ray, was feuding with the dadaists but whose concept of dada he may have prized above all others. Although Man Ray claimed to have seen little of Picabia in New York, and although Picabia was not part of the social scene into which Man Ray was introduced upon his arrival in Paris, Picabia's aloofness from the movement's dogmas must have appealed to Man Ray's innate independence and his remoteness, as an American, from the political debates. Picabia, who by this time enjoyed a major reputation, took notable and highly visible exception to the "new rules" of Breton and Tzara. Indeed, Picabia rejected the very concept of rules. Like him, Man Ray refused to make choices. That Man Ray could dispassionately play Picabia's

game is revealed by his comment to a friend, "Today it is more interesting to baffle the Surrealists than to startle the old fogeys."[18] To a degree, Man Ray became a weapon in the struggle between the dadaists and the future surrealists. It was vastly to his credit that he was assimilated by neither.

Both dada and surrealism made their greatest contributions in articulating the so-called crisis of reality. In *Le Surréalisme et la peinture*, Breton explained it in a way that brought literature and the visual arts much closer together:

> But beyond this aspect of emotion for emotion's sake, let us not forget that for us, in this era, it is reality itself that is involved. How can anyone expect us to be satisfied with the fleeting sense of uneasiness that some particular work of art may bring us? There is not a single work of art that can hold its own before . . . our integral *primitivism*. When I know what will be the outcome of the terrible struggle within me between actual experience and possible experience, when I have finally lost all hope of enlarging to huge proportions the hitherto strictly limited field of action of the campaigns I have initiated, when my imagination recoils upon itself and serves only to coincide with my memory, then I will willingly imitate the others and grant myself a few relative satisfactions. I shall then join the ranks of the embroiderers. I shall have forgiven them. But not before![19]

Dada had been disenchanted with the limitations imposed by reigning culture on art and life. Surrealism was enchanted by the possibilities of the extraordinary. The one attitude was never present at the complete expense of the other. For the artists involved, including Man Ray, what was at stake was nothing less than freedom, the ability to respond to and create one's own environment. Rebuking cultural limitations was essential not only to the free and creative behavior of individuals but to the very possibility of human individuation.

Man Ray's objects, photographs, and paintings attempted to undo the ordinary antecedents and consequences of human action. Rejecting the notion that mere things were a source of meaning, Man Ray concentrated on their interrelationships and on ideas. As Man Ray's colleague Patrick Waldberg explained: "The *creations* he gives us to contemplate are put before us in their concrete reality,

but prolonged *ad infinitum* by the impalpable enigma of the *idea* and multiplied in their power by the oneiric suspense of *chance*."[20]

Man Ray's works are not so much expressive objects as they are instruments of insight into the possibilities of reality. Reality is here understood as a field of *potential* knowledge. It is not conventional knowledge, defined as the limitations by which things and ideas are operative within a culture. Nor is it that by which individuals, ideas, and things acquire their orthodox social meaning or relevance.

Trompe l'oeuf addresses the questions of reality directly (fig. 203). A pun on *trompe l'oeil*, the work is a photograph of an ostrich egg nested in a toilet seat. The object constitutes its own reality in

203 *Tromp l'oeuf*, 1930, mixed media, present whereabouts unknown (1963 replica, Collection Juliet Man Ray, Paris)

spite of the realism inherent in the photograph and the literalness of the toilet seat. Indeed, it is the tension between the two different means of presenting orthodox reality into which Man Ray slips his new reality: the beginning of the world, the creation, hatched from an egg. As Picasso had done much earlier with works such as *Still-Life with Chair Caning*, Man Ray frames the work in a way that subverts the traditional function of the frame, which was to isolate the aesthetic experience. Instead, his frame makes it contiguous with everyday life.

The surrealist painter Salvador Dali declared:

> It is at least possible that the poet's creations are destined very soon to assume such tangibility and so most queerly to displace the limits of the so-called real. I certainly think that one must no longer underrate the hallucinatory power of some images or the imaginative gift some men possess independently of their ability to recollect.[21]

The gratuitous act, the unexpected situation, and the shocking juxtaposition all place reality beyond the constraints of the social and the conventional.[22] Dada stated the problem; surrealism provided it with rich poetic content. Man Ray straddled that pivotal point between the two, the given and the possible. He was both, and he was neither. He recognized that a "spirit exists which seeks neither the authority of consecrated art, nor the justification in any effort in work or play of a cooperative nature. It is sort of a gratuitous invention."[23]

In this respect, Man Ray concurred with his friend Duchamp. He veered close to what might be characterized as an anti-avant-garde position. He insisted, ad nauseam, that his concern was for the experience, not the experiment. He had little faith in the over-arching social utopianism implied by the most positive aspects of surrealism (to say nothing of De Stijl, international constructivism, purism) and not much more in the "cleansing" actions of dada. Man Ray's revolution was an individual's affair. This is not to say that he was without social purpose in his work. Art did have a mission for him. His uncharacteristically careful text "The Age of Light" gives the lie to the common impression of Man Ray as asocial or acultural:

> In this age, like all ages, when the problem of the perpet-
> uation of a race or class and the destruction of its enemies,
> is the all-absorbing motive of civilized society, it seems

irrelevant and wasteful still to create works whose only inspirations are individual human emotion and desire. The attitude seems to be that one may . . . return to the idyllic occupations only after . . . solving the more vital problems of existence. Still, we know that the incapacity of race or class to improve itself is as great as its incapacity to learn from previous errors in history. All progress results from an intense individual desire to improve the immediate present, from an all-conscious sense of material insufficiency. In this exalted state, material action imposes itself and takes the form of revolution in one form or another. . . . For what can be more binding amongst beings than the discovery of a common desire? And what can be more inspiring to action than the confidence aroused by a lyric expression of this desire? . . . [T]he awakening of desire is the first step to participation and experience.[24]

His position is compelling. He expresses the highest regard for the individual while he resists positioning the individual within culture, committing him to politics, or advancing him into a historical future. There is no "historical mission"; progress results from the individual's desire to improve the present. Although consistent with surrealism's content, Man Ray's stance breaks with the movement's socially derived intuition and cultural strategy.

This intimate, but nonpartisan alignment with both dada and surrealism strongly underscores that he was part of what each was *about* but not part of what each of them *was*, as "movements." He therefore could move freely between the two, avoiding both their factionalisms and their orthodoxies. In this respect, he won the same privileged place as Duchamp, from whom he learned so much so well.

Conventions, the prime cultural targets of the dadaists–surrealists, were not deplored because they were wrong or lacked reality, but because they allowed no options, no questions asked. In his best work, Man Ray challenged not just conventional realities but the nature and structure of expectations from which conventional realities are composed. He addressed the fact that the realities revealed by his art were dependent upon the individual spectator's mental or emotional domains.

His early Paris objects, constituting a veritable summa of object history, manifest this point of view. They belong, however, as

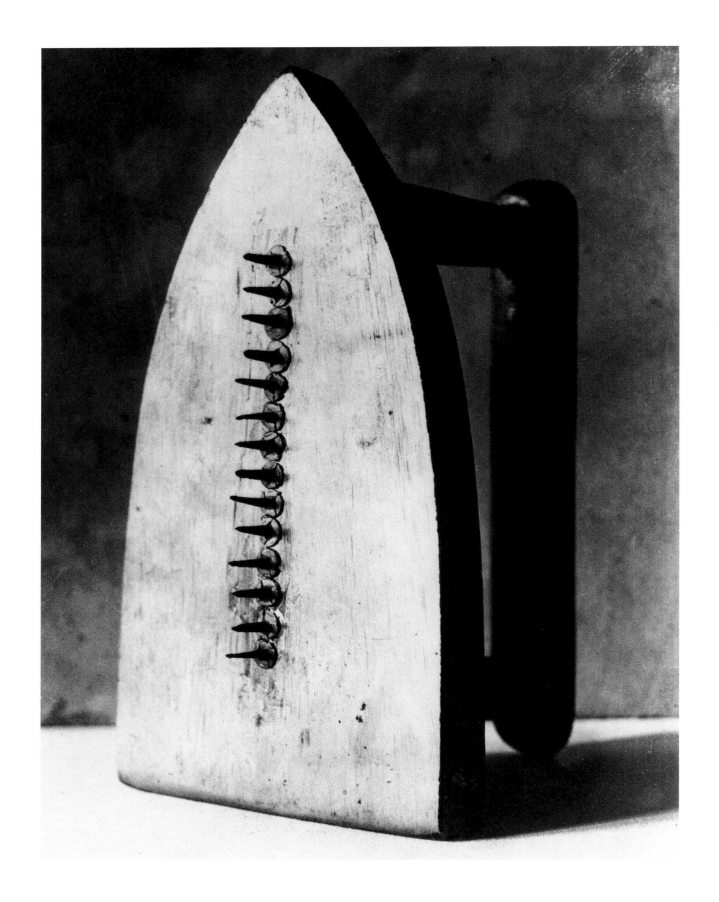

244

his later objects do not, to identifiable traditions of object making. A consummate work of its kind, *Cadeau* is irrefutably Duchampian, both in its conceptualization and presentation (fig. 204). A perfect reiteration of Louise Norton's comic parody and refutation of the "monogamous object," written in defense of Duchamp's submission of a urinal (*Fountain*) to the 1917 exhibition of the Society of Independent Artists, *Cadeau* is a case of displacement, aesthetic transactionalism, and black humor.[25] The object is removed from its familiar context—connections between it and other aspects of material culture are obliterated—and represented to the spectator in a position normally reserved for works of art. As if to fight any laziness in the spectator's critical perception of the object, Man Ray attaches fourteen tacks to the functional surface to underscore its decontextualization. Conceptually, the work is "one shot": it surprises, delights, and shocks. More important, it involves the spectator in an active rather than a passive capacity. In the process, its former reality, cloaked in the conventions of its utility, is stripped away to reveal the "object" itself.

While the concept of *Cadeau* derived from Man Ray's New York experiences with Duchamp, his vocabulary extended well beyond that of the French artist. His wood relief *L'Hôtel meublé* (fig. 205), for example, reflects sources ranging from Picasso to Kurt Schwitters, whom he knew through his association with Katherine Dreier's Société Anonyme. Picasso had approached the readymade in 1917 with his assemblage *Compote*, had experimented with relief constructions from 1913 on, and had, in fact, provided most of the important early twentieth-century artists with the seeds of their radical vocabularies. Schwitters and a number of other dadaists (Arp, Raoul Hausmann, Johannes Baader, Ernst), although varying radically in their sociopolitical stances, all shared the concern of liberating objects from their stereotypical place, or obsolescence, in culture. Once freed and in possession of their own identities as "things," the objects would transmute into fresh, expressive entities. The importance of *Cadeau*, however, is that it does not simply take one thing and make it another, with a new, fixed definition. In a way that anticipates Man Ray's later objects, *Cadeau* becomes the center of an idea, where, as Breton so beautifully put it in *Surréalisme et la peinture*, "[T]he mind on finding itself ideally withdrawn from everything, can begin to occupy itself with its own life, in which the attained and the desired no longer exclude one another."[26]

Further influences were exerted by the surrealist objects of Breton, Soupault, Aragon, and others, works whose marriage of

204 *Cadeau*, 1921, mixed media: iron and tacks (original lost; photograph by the artist)

205 *L'Hôtel meublé*, 1921 (1969 replica illustrated), wood collage, Enrico Baj Collection

language and object were to surface in Man Ray's *De Quoi écrire un poème* (fig. 206). Produced in 1923, just preceding the publication of the *First Manifesto of Surrealism*, it anticipates the latter's injunction that "the creation of 'surrealist objects' responds to the necessity of establishing, in Paul Eluard's decisive phrase, a veritable 'physics of poetry.' "[27] Illustrated in *La Révolution surréaliste* two years later, the work visually answers its own question: "From what to write a poem?" Sewn-together things present a poetic idea whose structure resides in language. The quill, paper, and cardboard, as well as the nameplate and frame, belong to the tradition of Apollinaire's street poetry (the nameplate was purchased at a flea market), the same Apollinaire who proposed the term *surrealism* as early as 1917. In his transposition of poetry into the world of things, Man Ray frees the "poetic" from imprisonment in the written word. He finds precisely the point—the idea—at which words and things coincide.

Largely the works of poets and frequently of little formal value, the surrealists' object-poems nevertheless do illustrate, as Tzara maintained, that it was not the reality or "objectness" of matter that was at stake but the meanings that matter assumed in our minds. It was from the surrealists that Man Ray derived the perception of his objects as ideas.

Yet the influence of neither Duchamp nor the surrealists accounts for Man Ray's uniqueness. For this we must look to the relationship between his objects and photographs. While a full account of his career as a Paris photographer is rendered elsewhere in this book, it is essential to note his success photographing the works of others and in portraiture and fashion. Man Ray became, in his own words, "an official recorder of events and personalities." More important, his work involved the manipulation of objects, which was essential to the discovery, development, and execution of the rayographs. His account of this discovery conveys his zeal for handling objects and materials:

> I mechanically placed a small glass funnel, the graduate and the thermometer in the tray on the wetted paper. I turned on the light; before my eyes an image began to form, . . . distorted and refracted by the glass more or less in contact with the paper and standing out against a black background, . . . I made a few more prints, setting aside the more serious work for Poiret, using up my precious paper. Taking whatever objects came to hand; my hotel-room key, a handkerchief, some pencils, a brush, a candle, a piece of twine.[28]

206 *De Quoi écrire un poème*, 1923, mixed media, Musée National d'Art Moderne, Centre National d'Art et de Culture Georges Pompidou, Paris

While it has been asserted that Man Ray's focus was on photography and only indirectly "on objects that he assembled chiefly for use as models and pretexts for unconventional photographs," it would be a mistake not to view the objects and their manipulation as significant in their own right.[29]

In the rayograph "Gun with Alphabet Squares," his positioning and choice of objects provides syntactical cues that allude to some alternative reality (fig. 207). The most obvious, the alphabet squares, are particles of language that imply communication. The gun is both a means of deconstruction—it sits in the center of the blown-apart language—and an instrument of chance, the negation of "rational" construction. These specific elements are the coordinates with which the spectator must operate. They may not provide "content," but they do provide a conceptual and associational grid for working through possibilities.

Much later in his career, Man Ray revealed his private world of objects in his cover studies for his book *Photographs by Man Ray 1920 Paris 1934* (fig. 208). His *Object to Be Destroyed* sits next to the

207 Untitled ("Gun with Alphabet Squares"), 1924, rayograph

208 Trial cover of *Photographs by Man Ray 1920 Paris 1934*, 1933, three-color carbon transfer print

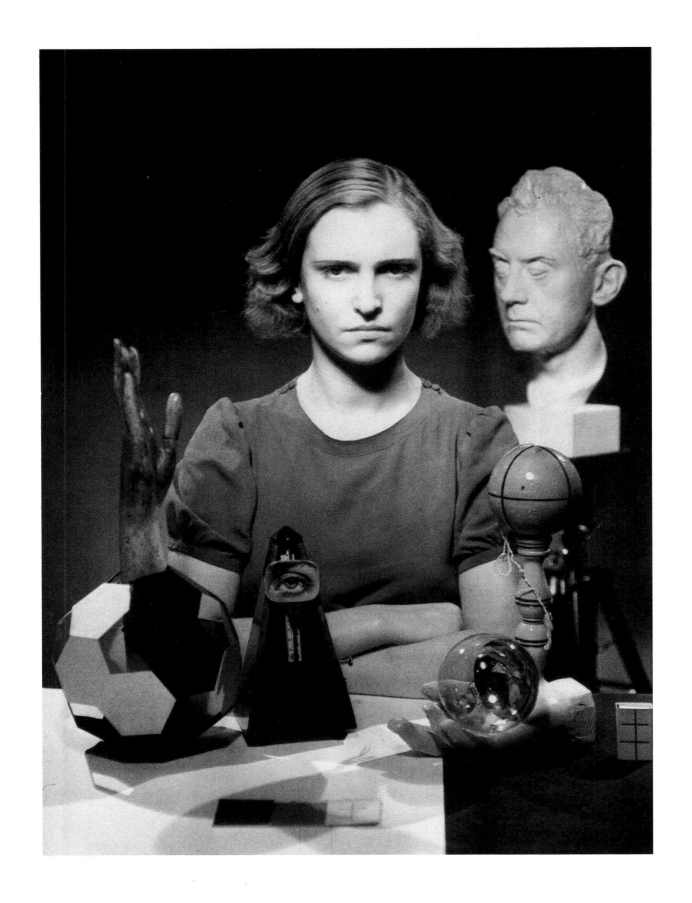

top of *Non-Euclidean Object I*. The entire array, including the spectator and a number of the artist's other works—for example, *Main Ray* (fig. 209), late cousin of the 1920 *Puericulture* (fig. 210)—is presided over by Man Ray. That his portrait bust is dumb and cold as stone is significant: his role as configurer of the assemblage is over. He now defers to the transactions of the spectator. What these things mean to Man Ray is present only in their potential; what they mean to the woman is only just evolving. Man Ray's disposition of the objects is a provisional beginning point, in no way

209 *Main Ray*, 1935–36, mixed media, private collection

210 *Puericulture*, 1920, painted metal and plaster, Art Institute of Chicago, Bequest of Florence S. McCormick

211 *Still Life with Violin and Dice* (film still from *Emak Bakia*), 1926

meant to be final. *Still Life with Violin and Dice*, a frame from the film *Emak Bakia*, discloses the same point of view (fig. 211). The dice, geometrical objects, sit on other geometrical forms, but as instruments of chance, they free themselves and their companions from any "necessary conditions." They become an individual's poetic material, with any one of their numerical combinations offering insight into the realm of possibility.

In one of Breton's most eloquent remarks on the visual arts, he perfectly encapsulated Man Ray's accomplishment throughout the twenties and thirties: "Objects thus reassembled have in common the fact that they derive from, and succeed in differing from the objects which surround us, by simple *change of role*."[30] Man Ray himself never hesitated to commit his objects to situations. Indeed, it is impossible to account for their creation without their "situation." An object's meaning may derive from its relationship to other things, or it may serve as a catalyst in the creation of new relationships and configurations. Man Ray's chess pieces illustrate the latter role. The objects make no sense independent of the game; their significance resides in the movement, the progress of the play. Either or both of these roles may reveal themselves in the course of objects assuming their meaning. They constitute the creative center of Man Ray's and his spectator's activity. The process, in either case, is inherently aesthetic.

The motion of *The Object to Be Destroyed*, real or imagined, provides a temporal geometry, a perfect sequence of intervals within which one performs a piece (fig. 212). Equipped with the eye of God—who is created in the image of man—the object becomes a brilliant parody of terminism, a concept that establishes a set interval—of grace—in which man is allowed to "perform" and win approbation. In *Emak Bakia*, the scroll, pegbox, neck, and fingerboard of a stringed instrument function in a like manner: determining the intervals through which play—or music—is processed (fig. 213). The strings, however, are frayed, unraveled, resembling the hair of a worn-out bow. Man Ray reminds us here of the dependent relationships between the things played and the instrument that plays upon them, an eloquent metaphor for the constraints on creative freedom in the impoverished context of orthodox culture.

Both objects imply set limits; at worst, both tyrannize the

212 *The Object to Be Destroyed*, 1923, mixed media: metronome with photograph (original object destroyed; photograph by the artist)

213 *Emak Bakia*, 1926, wood and horsehair (original object lost)

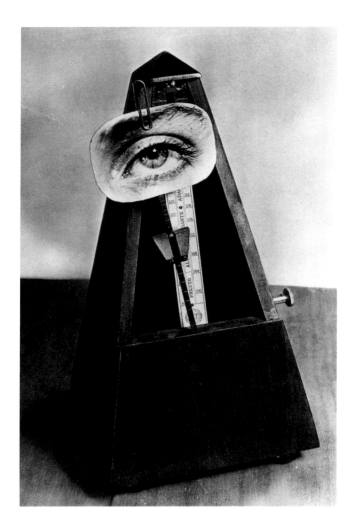

252

214 *Non-Euclidian Object I*, 1932, mixed media (original object lost; photograph by the artist)

215 *Manikin with Sphere and Cone*, ca. 1926, silver print

possible. And both are endowed with human features—the eye and the hair—which equate the strictures implied with the very condition of being human. We understand ourselves to the extent that we consent to such points of reference. But by calling attention to these things, the objects are ultimately freed to respond to new situations—are permitted, even forced, to find new conditions for their reality. Corrupted conventions seek their validation in the process of establishing a new reality. This is the case with even the highest-level abstractions. *Non-Euclidean Object I* both invokes and defies our culture's most revered scheme for making order of things (fig. 214). Its rational structures undermine themselves in such a way that their poetic associations supersede their scientific ones. Like *The Object to Be Destroyed* and *Emak Bakia*, it has attributes of the human condition, which is both dependent on rational conventions and yet also seeks liberation from them. True to his dada heritage, Man Ray makes this eloquently clear in his *Manikin with Sphere and Cone* (fig. 215), in which the featureless manikin only promises to find its humanity through the subversion of geometry.

Although always incipiently critical, Man Ray's objects are,

more important, liberating. It is in their freedom that we perceive the conventions as conventions. In a letter to André Breton published as a catalogue introduction for a 1948 exhibition of Man Ray's work, the latter discussed his views on science, geometry, and, in particular, the mathematical objects that served as a source for his *Shakespearean Equations*. He wrote:

> "Oh austere mathematics! I have not forgotten you . . ." sings Lautréamont in his second Canto in which there is very little mathematics and one of the most powerful indictments of man's follies and obsessions ever recorded. "Your modest pyramids will endure longer than the pyramids of Egypt, those ant-hills erected by stupidity and slavery."

Man Ray explained that the text's "employment of an irrelevant subject for the declaration of a conviction and for a denunciation" had always been a model for him.[31] This is a central issue—perhaps the central issue—of his work.

Responding to Breton's admonishment that he might be "falling into the trap of closed rationalism [in] opposing mathematical objects with their arid formulas to poetical objects," Man Ray claimed that he valued them precisely for their potential for perversion. "Let me reassure you, I have always been in accord with you in the necessity of perverting the legitimate legends of the mathematical objects." The "legitimate legends" are, of course, the paradigms, the equations governing rationalism—myths, of sorts, that have so suffused Western consciousness as to win almost universal consent and, hence, "legitimacy." It was Man Ray's avowed purpose as an artist to undermine these myths. At the same time, he disavowed any attempt to make the objects "serve as a projection of or a justification for abstract art." As Patrick Waldberg asserted, "On the contrary, each one has almost always been conceived from an extra-aesthetic point of departure and in such a way that our minds are dragged away from all formal notions of art."[32] They are, nevertheless, man-made objects with which the artist took liberties, mathematically and formally. It is through their authoritarianism, their "legitimate legends," that one most clearly perceives the possibility of freedom. They, as do all men's works, become part of Man Ray's "pattern for a more generous world." Man Ray's point of view here is as refreshing as Breton's is doctrinaire. Man Ray has, to paraphrase Ribemont-Dessaignes, committed murder for love, has destroyed form in order to provide it with a virgin existence.[33]

For Man Ray, each object has a destiny—no necessary destiny, but a destiny nonetheless. It is implied for the artist, in the process of conceiving of the object, and it is there for the spectator who is willing to play. One person's perception of that destiny does not necessarily coincide with another's. What, then, can we say of the meaning of such works as *The Object to Be Destroyed* or *Emak Bakia*? Man Ray stated that

> in assembling *Objects of My Affection*, the author indulged in an activity parallel to his painting and photography, an activity which he hopes will elude criticism and evaluation. These objects are a mystery to himself as much as they might be to others, and he hopes they will always remain so. That is their justification, if any is needed.[34]

Yet he clearly does not perceive them as meaningless. "What are they about?" or "What do they mean?" are simply the wrong questions. Saying that a work means X, Y, or Z defeats much of the point of Man Ray's art. "What meaning have they?" is better, because it implies that meaning has accrued to the object. And this is, in fact, the case. The objects are meaningful to the degree that each acquires meaning in transaction with an individual—either the artist in terms of whatever processes and circumstances surrounded the creation or presentation of the object in the first place, or the spectator, of whom Man Ray demands nothing short of "creation."

> The experiment lies with the spectator in his willingness to accept what his eye conveys to him. The success of the experiment is in proportion to the desire to discover and enjoy, and this desire alone can be the only measure of the painter's value to the rest of society. Why should not the public and the critic share the burden of responsibility now and then?[35]

We are asked to shape our own experience of a work of art—of life itself. The world is the responsibility of each individual. *Main Ray*, nominally the artist's self-portrait, encapsulates the act of creation, apotheosizes the making of a reality, and offers a universalized gesture of the artist (fig. 209). What Man Ray gives is what humanity most needs: he restores life to living. *Ce qui manque à nous tous* breathes life into creation, and the bubble (glass), the "orb" of the individual, mirrors, in its tenuousness and delicacy, the world

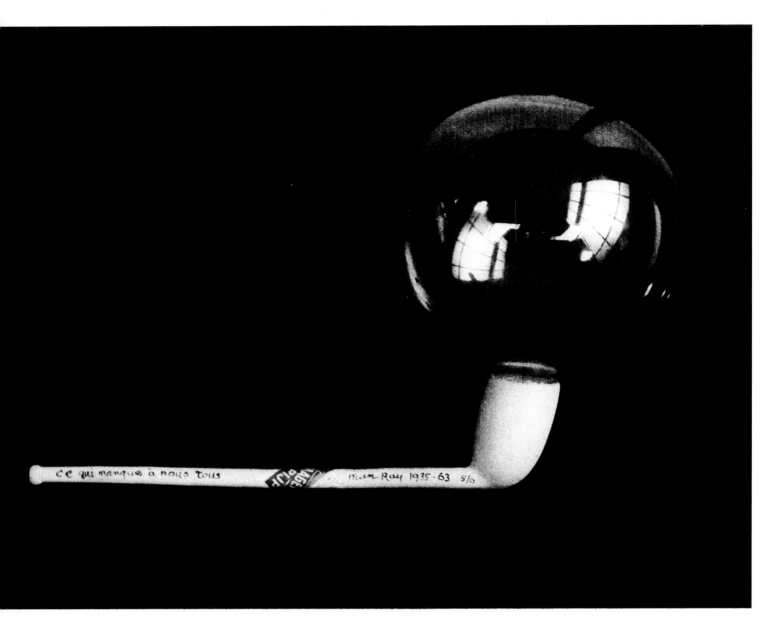

from which it is composed and within which it finds its context (fig. 216).

For André Breton and Man Ray, life was energy—the energy created by the improbable marriage of things conventionally designated to different worlds. The results could be reassuring or disturbing, calming or explosive. As it is for the amateur in the chemistry laboratory, so it was for Breton and Man Ray: the exact nature of the results were never quite predictable. As Man Ray stated:

The reserves of this energy within us are limitless if we

216 *Ce qui manque à nous tous*, 1936, mixed media (original object destroyed; photograph by the artist)

256

will draw on them without a sense of shame or of propriety. Like the scientist who is merely a prestidigitator manipulating the abundant phenomena of nature and profiting by every so called hazard or law, the creator dealing in human values allows the subconscious forces to filter through him, colored by his own selectivity, which is universal human desire, and exposes to the light motives and instincts long repressed, which should form the basis of a confident fraternity. The intensity of this message can be disturbing only in proportion to freedom that has been given to automatism or the subconscious self.[36]

The intensity of Man Ray's disturbance of norms is clear from *Les Ponts brulés* (*Burnt Bridges*, fig. 217), a sinister object-event that consumed itself in fire, forcibly reminding us that the role assumed by any object is subject to change. It is unique in Man Ray's oeuvre, for it comprises a series of events over a period of time. Made, photographed, and destroyed expressly for the 1936 *Exhibition of Surrealist Objects*, the completed work is unretrievable, short

217 *Les Ponts brulés*, 1935, mixed media

257

of its total re-creation and reenactment.

In fact, such threatening possibilities never lie far below the surface in any of Man Ray's works. *Mire universelle* may, depending on one's frame of mind, indicate a universal end goal or thing aspired to, like a classical ideal (fig. 218). It could as easily refer to a target. Man Ray reinforces the militaristic, violent associations of the term by juxtaposing the Three Graces with geometry that as much simulates artillery and weaponry as it suggests classical order and classical sources of inspiration.

Man Ray's works, then, become events in the consciousness of the spectator, and Man Ray, the maker of events. *Les Ponts brulés* is

218 *Mire universelle*, 1933, mixed media, private collection

thus representative of all his works to a degree. His congruence with the avant-garde abided in his conviction that it is through the event that one is transported from one position to another. He differed from the avant-garde in his refusal to launch his journey from a point in conventional social or political domains. From the perspective of the "politicized movement," Man Ray's art operated through fantasy; from Man Ray's viewpoint, it was the avant-garde that, bordering on the comic, fantasized about significantly shaping or altering social institutions. Man Ray's events were instruments of access to new domains of experience; they had no historical momentum and implied no teleology. He was serious when he said that he did not know what his works meant. Man Ray was a maker (of events), not the event (maker). We have to consider his role independent of his work. He is the involver, the stager of situations, the configurer of relationships between desire and action, the initiator. On the other side stands the spectator, the initiated, no less important than the artist, and in the middle is the object, the initiation. Man Ray's objects permit initiation into the possible.

Throughout his career as an object maker, Man Ray persisted in painting—sporadically in the twenties and more sustainedly in the thirties, when financial success with his photography permitted more free time. Although frequently related to his photographs and objects, his canvases represent a fundamentally different side of his character.

Paintings fix images in a way that objects, or the manipulation of objects, cannot. It was inevitable, based on the nature of the medium, that Man Ray would reach conclusions in his paintings and state positions about himself, thus making the role of the spectator significantly more passive. Man Ray's remark "I paint what I cannot photograph; I photograph what I cannot paint" is crucial.[37] He meant the comment literally. It was also a matter of intention: objects, photographs, paintings—each provides a different mode of "framing the experience," of setting the degree of openness or closure of the work, of identifying the role of the artist. For Man Ray, each medium served a different function, while conceptually complementing the others.

It is in his paintings that Man Ray most became an "artist," that he most consistently relinquished his positions or ideas to visual form. With a few exceptions, his paintings fall into a category close to criticism—that is, they bring things together with some kind of conclusiveness and provide clues to the rest of his work. At the same time, painting constituted a dialogue essential to

his approach to other media. It represented Man Ray's home base, from which he derived and measured his other achievements. The act that *sets free* is different from *freedom*, and it was as a means of achieving freedom that painting figured most prominently in his career. It was only by maintaining his role as an "artist" that Man Ray could sufficiently liberate himself to do his other work. You can only give away something you already have. No artist, no a-artist. Painting for Man Ray was essential as a means of self-criticism.[38]

Une nuit à Saint-Jean-de-Luz is a perfect example of Man Ray painting what he could not photograph (fig. 219). When the headlights of a car threw an enormous shadow of the artist one night, it was not unlike the process and the imagery of his rayographs. There was no way of holding the image, however, short of painting it. Rooted in real experience, the work is both a document of the event and a strong evocation of the sensation it induced. Man Ray presents himself as an "object" and defines his role in the world as a thing among other things. Painting, object, and rayograph are all melded into one consummate work.

More direct references to objects occur in *Retour à la raison III* (fig. 220), a painting of earlier works, including *Lampshade* and a variety of chess pieces. As centered in the imagination as *Une nuit*, the painting juxtaposes elements with an expressiveness that would be impossible to realize in a photograph or in a collation of objects. The relative scale of actual objects, for example, would have been determined by the selections Man Ray made from what was available in his studio. In the painting, the objects are imaginative, merely an allusion to the real world. Although based on an earlier drawing for the cover of *Broom* and his film of the same title, the painting permits a far greater degree of manipulation in the size, shape, and, consequently, meaning of material things.

Perhaps the best example of Man Ray's search for the perfect union of image and medium—and the importance of painting in his oeuvre—is *A l'heure de l'observatoire—Les Amoureux*, which he worked on from 1932 to 1934 (fig. 221). Inspired by the lipstick impression of Kiki's lips on his shirt collar, the image was translated into a photograph of her lips, then into the painting. Man Ray himself explained: "If there had been a color process enabling me to make a photograph of such dimensions [39⅜ × 98½ in.] and showing the lips floating over a landscape, I would certainly have preferred to do it that way."[39]

In terms of its subject, *A l'heure de l'observatoire* beautifully spans his life, his art, and what he perceived as their purpose. His

219 *Une nuit à Saint-Jean-de-Luz*, 1929, silver leaf and oil on canvas, Musée National d'Art Moderne, Centre National d'Art et de Culture Georges Pompidou, Paris

220 *Retour à la raison III*, 1939, oil on canvas, Modern Kunsthandels, Anstalt Collection

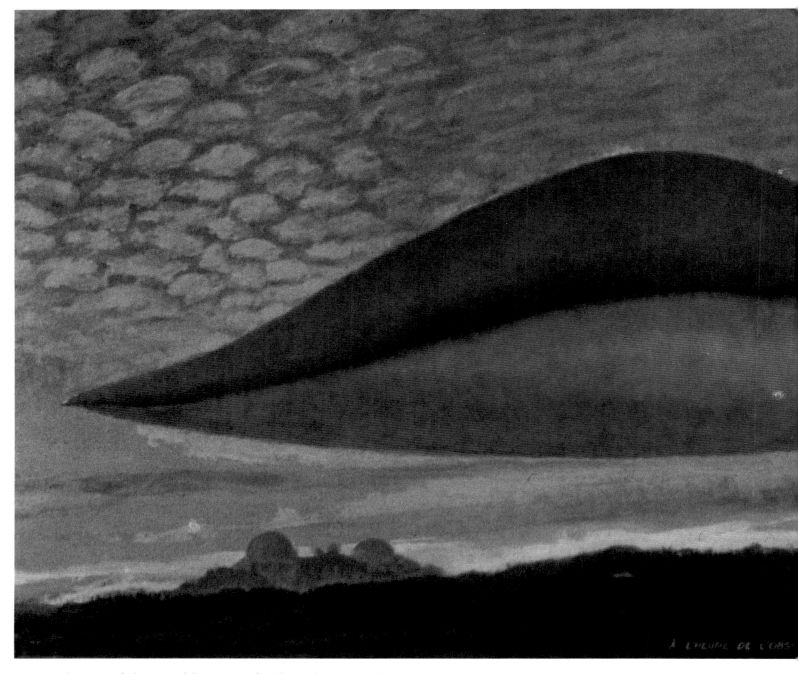

embrace of the world was as frank and outsized as the "lovers'" embrace in the painting:

> The red lips floated in a bluish gray sky over a twilit landscape with an observatory and its two domes like breasts dimly indicated on the horizon—an impression of my daily walks through the Luxembourg Gardens. The lips because of their scale, no doubt, suggested two closely

221 *A l'heure de l'observatoire— Les Amoureux*, 1932–34, oil on canvas, Nyarkos Collection

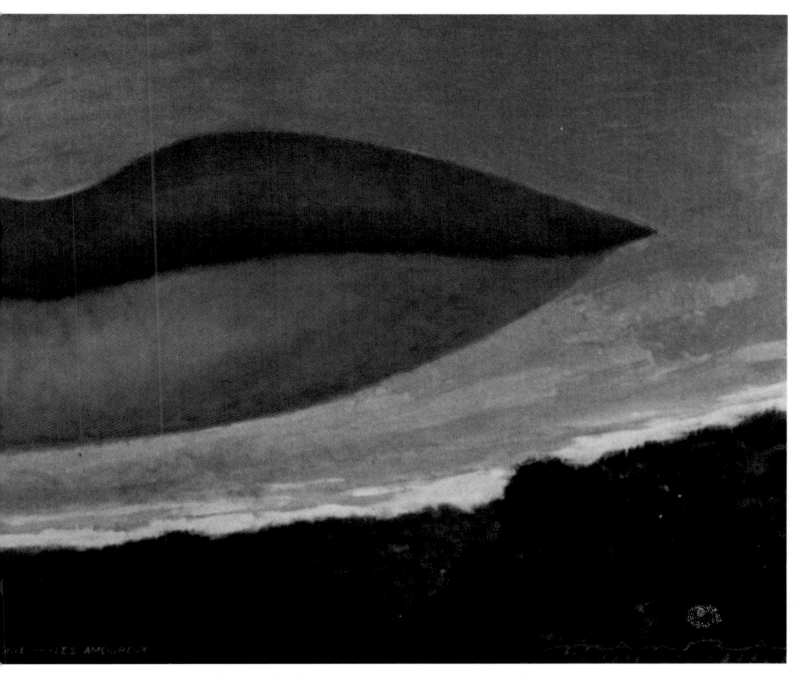

joined bodies. Quite Freudian. I wrote the legend at the
bottom of the canvas to anticipate subsequent interpreta-
tions: Observatory Time—The Lovers.[40]

Or, more to the point:

"Your mouth itself becomes two bodies separated by a
long, undulating horizon. Like the earth and the sky, like
you and me."[41]

Yet the motif of the lips is not exonerated from the dark side
of human nature. *L'Orateur* (fig. 222) presents an image as ominous
as *A l'heure de l'observatoire* is jubilant. The intimacy and shared
desire of the latter work surrenders to the gaping mouth of a speech
giver; the observatory and gardens are replaced with a distorted,
less private space. The picture is filled with the emptiness of rheto-
ric—of the orator, the politician, the critic.

As for all those associated with surrealism, dreams were fre-
quently a source of Man Ray's images. *Les Mains libres* (1937), a
book of drawings "illustrated" with texts by Paul Eluard, indicates
in its punning title the freedom of the artist. "Freedom from
what?" becomes the inevitable question. The lack of restraint in the
relationships between the things depicted indicates that they were
retrieved from the deep reaches of the subconscious: "At night
before falling asleep, if an idea occurs to me I immediately make a
drawing. And in the morning when I wake up, if I have dreamed I
sketch my dream immediately. Many of the *Mains Libre* drawings
are drawings of dreams."[42] When objects are drawn into the works,
they serve symbolic purposes. The pencil as cathedral spire, for
example, is the instrument through which the artist creates the
aesthetic experience—an expression of the spiritually infinite—as
well as his phallic ego (fig. 223). Responding to Freud, Sade, and
Breton, among others, Man Ray defeats the rational conventions of
culture by psychologically preceding them. The position latent in
these works was given a definitive statement one year later.

222 *L'Orateur*, 1935, mixed
media, Hamburger
Kunsthalle

264

223 *Où se fabriquent les crayons*
(*Where Pencils Are Made*),
1936, ink on paper, pres-
ent whereabouts un-
known, published in *Les
Mains libres*, 1937

224 *Imaginary Portrait of
D. A. F. de Sade*, 1938,
oil on canvas and wood,
The Menil Collection,
Houston

265

Of all Man Ray's works, the *Imaginary Portrait of D. A. F. de Sade* is probably the most frankly ideological and symbolic (fig. 224). The individual revolution in consciousness is embodied in what for Man Ray was an unprecedented identification of himself with a historical figure. It is a unique reflection of near perfect parity between himself and another individual (could he have but photographed Sade!). The defeat of reason is rendered by a landscape of the subconscious, the internal regions of Sade's mind. The latter was the very symbol of artistic freedom, of which Breton proclaimed: "The mere word 'freedom' is the only one that still excites me. I deem it capable of indefinitely sustaining the old human fanaticism."[43] Sade breaks through centuries of institutional bondage and witnesses the burning of the Bastille, symbolizing the destruction of all that is responsible for the imprisonment of the spirit. It is also a clear victory of subconscious over conscious, passion over reason. All the conventions of morality and ethics crumble in the face of the imagination. The "revolution" that Man Ray had begun with anarchistic activities like the "Ridgefield Gazook" was consummated here.

Man Ray's intent all along was "to avoid the danger of using the image to communicate some point. The image must not be useful; it must be innocent. Surrealist art must be stripped of rhetoric; it must never seek to prove anything."[44] With the best of Man Ray's creations, then, we are faced with what might better be termed *positions* than *works of art*. One of his finest paintings, *La Fortune* (fig. 225), is explicit in its reference to position play; its very title invokes a wealth of attendant concepts, such as chance, risk, hazard, and luck—all of them essential to his role as an artist.

The corridor of vision in the painting is a billiard table set in an environment employing standard artistic conventions. The possibilities of the world are given a succinct metaphor in the concept of the game. But there is more at stake than meets the eye. Alexander Cockburn defined the situation perfectly:

> I think one can argue that games, with their own laws and their own time frames, represent an expectancy on the part of the contenders and of the audience; that games direct a question at the very heart of society and of culture as to what it could be and what it could become in terms of freedom and realized human potential.[45]

Man Ray's work becomes the individual's domain, a place where he contends with society for freedom.

225 *La Fortune*, 1938, oil on canvas, Whitney Museum of American Art, New York

One year later, the optimism so characteristic of Man Ray's earlier work gave way to a deep pessimism: *Le Beau Temps* looks conventional war straight in the eye (fig. 226). No longer willing to leave conclusions to the spectator, Man Ray spelled out the ramifications of society's perversion of science, the crimes and follies of the impending conflict, and what he perceived as the inevitable loss of an already precarious freedom. The painting is the sad account of the errors he saw man committing; the message was that society and culture were imperiled.

Le Beau Temps throws in doubt everything Man Ray had so confidently asserted only a few years before. In the background, a couple embraces in a colonnade, near a painting on an easel, a reflection of the artist's former point of view. They are seemingly unaware of the destruction of the dream that occurs immediately above them: two beasts, pressed together like the lovers in the background and in *A l'heure de l'observatoire*, engage in mortal combat. In the foreground, the male and female constructions are

267

separated by a door, which, about to open on a new reality, spills blood (an ironic reference to Breton's earlier "doors" to reality?). The male, built from the same material as the wall, is also fragmented and at the point of breaking apart. The pair of lips at the midsection makes us suddenly realize that the personage is none other than Man Ray. It was his last ambitious painting before he left war-torn Europe in 1940.

Before Man Ray left for America, however, he was involved in what he himself perceived as the climax of surrealist activity, the

226 *Le Beau Temps*, 1939, oil on canvas, Collection Juliet Man Ray, Paris

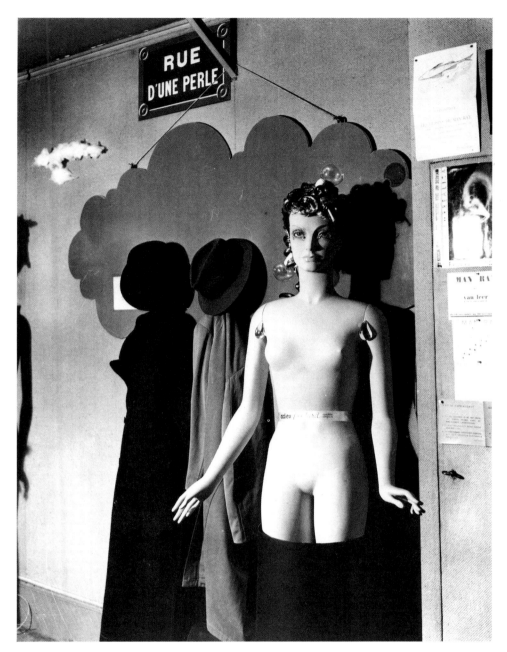

227 Manikin designed by Man Ray for *Exposition-ale du Surréalisme* at the Galerie des Beaux-Arts, Paris, 1938 (photograph by the artist)

International Surrealist Exhibition of 1938. Ending his collaboration with the movement much as he had begun it—as the "master of lighting"—Man Ray was responsible for designing the illumination of the show, consisting of daylight bulbs hidden behind ramps. On opening night, however, the lights were not turned on. Those attending were merely given flashlights, which were both a means of viewing the show and who else was there as well as a comment on the limitations of conventional ways of seeing. Besides the lighting, Man Ray was responsible for one of a series of female

dummies that lined the hall—a surrealist street—leading to the main exhibition space (fig. 227). Each manikin—by Arp, Dali, Duchamp, Ernst, Miró, Tanguy, and others—presented something of an introduction to the show as well as the artist's self-portrait. Together, they created a bizarre reception line. Man Ray's dummy was secondary to his total involvement in the art of the occasion, and his involvement in the occasion as a work of art. It serves as one more reminder that all of his works related to each other and to the works of others. It is difficult, if not impossible, to separate his works from some order of events.

Man Ray's art, determined in its disregard of conventional society, resists at all costs the commonplace idea that the individual should understand himself in terms of his place in society. Man Ray's contribution can best be defined in terms of what he rejected: culture as perceived from a place "inside" it. Such a vantage point was what the dadaists found most objectionable and tyrannous. What was required, and what Man Ray provided, was an asocial, acultural domain, as well as a means—his art—of both integrating and individuating experience in its most basic and essential forms.

What Man Ray's works mean requires an answer as unconventional as the works themselves. The best of his works are more than encoded messages, revealed secrets or mysteries, or objects expressing sentiments—all of them limited conventions for meaning that flows *from* art *to* the spectator. Meaning in Man Ray's art is something that evolves, that is unimaginable independent of the unfolding of the creative experience. Man Ray's objects are indestructible because they are composite, more or less resolved, but never firmly fixed. They are about time and the reconciliation of things, about the motion of reality, about the configurations of freedom.

NOTES

1. See Estera Milman, "Dada New York: An Historiographic Analysis," in Foster, *Dada/Dimensions*, pp. 165–86, for a discussion of New York's perception of dada and for a description of Katherine Dreier's concept of "natural-born American Dadaism" (p. 181).

2. For an evaluation of modernism in early twentieth-century America, see Meyer Schapiro, "Rebellion in Art," in Daniel Aaron, ed., *America in Crisis* (New York: Alfred A. Knopf, 1952), pp. 203–42.

3. Hans Richter, *Dada Art and Anti-Art* (London: Thames and Hudson, 1965; reprint ed., New York: Oxford University Press, 1978), p.168.

4. See Michel Sanouillet, ed., *Dada Reimpression integrale et dossier critique de la revue publiée de 1916 à 1922 par Tristan Tzara* (Nice: Centre du XXième Siècle, 1976), for facsimile reproductions of

the Zurich and Paris issues.

5. Elmer Peterson, *Tristan Tzara: Dada and Surrational Theorist* (New Brunswick, N.J.: Rutgers University Press, 1971), p. 77.

6. See Milman, "Dada New York," pp. 165–86.

7. Man Ray, *Self Portrait*, p. 196. He signed neither of the movement's manifestos, partly due to the risk of expulsion from France for political activity (ibid., p. 264).

8. Tzara, "Dada Manifesto 1918"; reprinted in Barbara Wright, trans., *Seven Dada Manifestos and Lampisteries* (New York: Riverrun Press, 1981), pp. 12–13.

9. Man Ray quotation from *Self Portrait*, p. 108. *Le Surréalisme et la peinture* (Paris: Gallimard, 1928) was actually conceived in 1925, the date of the first surrealist group exhibition.

10. Quoted in George H. Hamilton, *Painting and Sculpture in Europe: 1880–1940* (1967; Baltimore: Penguin Books, 1972), p. 388.

11. Breton quoted in Peterson, *Tristan Tzara*, p. 78; Man Ray's vote in Billy Klüver, "Man Ray Chronology," typescript.

12. Peterson, *Tristan Tzara*, pp. 77–79.

13. Man Ray, *Self Portrait*, pp. 260–62.

14. Breton, "The First Surrealist Manifesto," excerpts in Lippard, *Surrealists on Art*, p. 20.

15. Ibid., p. 21.

16. Hamilton, *Painting and Sculpture in Europe*, p. 391.

17. Man Ray, *Self Portrait*, pp. 112–13.

18. Quoted in Schwarz, *Rigour of Imagination*, p. 58.

19. Breton, *Surrealism and Painting*, pp. 3–4.

20. Waldberg, "The Objects of Man Ray," in Schwarz, *Man Ray: 60 anni di liberta*, p. 124.

21. Dali, "The Object as Revealed in Surrealist Experiment," as translated in *This Quarter* 5 (September 1932): 200.

22. For a discussion of these points, see Foster, *Dada Artifacts*, pp. 7–25.

23. Man Ray, "Preface" for a proposed book, *One Hundred Objects of My Affection*; reprinted in Seitz, *Assemblage*, p. 49.

24. Man Ray, "The Age of Light"; reprinted in Langsner, *Man Ray*, pp. 20–21.

25. Norton, "The R. Mutt Case," *Blind Man*, vol. 2 (New York: privately published, 1917).

26. Breton, *Surrealism and Painting*, p. 4.

27. Breton, "Crisis of the Object," as quoted in Lippard, *Surrealists on Art*, p. 53.

28. Quotations from Man Ray, *Self Portrait*, pp. 118, 128–29.

29. Schwarz, *Rigour of Imagination*, p. 57.

30. Breton, "Crisis of the Object," as quoted in Lippard, *Surrealists on Art*, p. 55.

31. Quotations from Man Ray, "A Note on the Shakespearean Equations," in Langsner, *Man Ray*, p. 22.

32. First three quotations by Man Ray, ibid.; Waldberg, "The Objects of Man Ray," p. 124.

33. Man Ray, "A Note on the Shakespearean Equations," in Langsner, *Man Ray*, p. 22; Ribemont-Dessaignes, *Man Ray*, p. 90.

34. Man Ray, "Preface," in Seitz, *Assemblage*, p. 48.

35. Man Ray, "It Has Never Been My Object," as quoted in Schwarz, *Man Ray: 60 anni di liberta*, p. 48.

36. Man Ray, "The Age of Light," in Langsner, *Man Ray*, p. 21.

37. Quoted in A. D. Coleman, "Introduction," in *Man Ray: Photographs, 1920–1934* (New York: East River Press, 1975), n.p.

38. As discussed by Estera Milman, who has been most helpful in her comments on this manuscript.

39. Man Ray, *Self Portrait*, p. 255.

40. Ibid.

41. Man Ray, "A l'heure de l'observatoire . . . les amoureux," *Cahiers d'art* 10, nos. 5–6 (1935): 127.

42. Quoted in Bourgeade, *Bonsoir, Man Ray*, p. 115.

43. Breton, "The First Surrealist Manifesto," in Lippard, *Surrealists on Art*, p. 11.

44. Wallace Fowlie, *Age of Surrealism* (Bloomington: Indiana University Press, 1960), p. 142.

45. Cockburn, *Idle Passion: Chess and the Dance of Death* (New York: New American Library, 1974), p. 214.

CHAPTER SIX

EXILE IN PARADISE: MAN RAY IN HOLLYWOOD, 1940–1951

Merry Foresta

[T]here was more Surrealism rampant in Hollywood
than all the Surrealists could invent in a lifetime.
Man Ray, quoted by William Copley in
"Portrait of the Artist as a Young Art Dealer"

When the boat that had carried him away from warring Europe docked in the Port of Newark in late summer of 1940, Man Ray was an artist without a country.[1] Although still a citizen of the United States, he had been a resident of Paris since 1921, an American well known to European audiences but virtually a stranger in his native land. Not only had he left behind the familiar territory of Montparnasse cafés, he had also been forced to abandon his most important works of the last twenty years: photographs, negatives, objects, and many of his paintings, including his master-piece from the early 1930s, *A l'heure de l'observatoire—Les Amoureux* (fig. 221). Unstretched and rolled, his canvases were buried beneath the floors of generous friends; in their attics fragile objects and glass negatives were boxed and stored.[2] With everything else, Man Ray had left behind his acclaim as an artist. No wonder that as the boat docked in safe harbor he was "overcome with a feeling of intense depression." As he explained, "Leaving twenty years of progressive effort behind me, I felt it was a return to the days of my early struggles, when I had left the country under a cloud of misunder-standing and distrust." Indeed, it was not the returning American, but his fellow traveler and friend, the exotic Spanish artist Salvador Dali (fig. 228), who attracted the attention of the swarm of report-ers and photographers who "had come aboard seeking out celebri-ties."[3]

Photograph of a collage by Man Ray. Detail of fig. 253.

Man Ray had garnered fame as a member of the avant-garde circles of Europe during the 1920s and 1930s, yet few in the United States knew about his work. Whereas Dali had always cultivated publicity during his trips to New York for exhibition openings, Man Ray had traveled home too rarely and too unobtrusively—to photograph for fashion magazines such as *Harper's Bazaar* and *Vogue*—to secure a similar reputation. His only significant appearance in New York during those years was at the 1936 opening of *Fantastic Art, Dada, Surrealism* at the Museum of Modern Art. Several of his paintings were included, among them *A l'heure de l'observatoire*, which was ultimately hung in an out-of-the-way spot to accommodate the trustees, who felt it was too sexually provocative. Unknowledgeable about his artwork, reporters were interested only in the famous people Man Ray had photographed. It was small consolation that modern-thinking Helena Rubenstein begged him to lend her the controversial "Lips" painting for her Fifth Avenue window display of lipsticks.[4]

228 Virgil Thomson and Salvador Dali on board the *Excalibur,* Lisbon to New York, August 1940 (photograph by Man Ray)

When Man Ray arrived in New York in 1940, the attention he received was predominantly from advertising agencies, which were eager to reemploy the photographer who had produced such fine and innovative work during the last decade.[5] But if as a commercial photographer Man Ray had a firm future in New York, his standing as a fine-arts photographer was less secure. The inaugural exhibition of the new Department of Photography at the Museum of Modern Art in December 1940 included a photograph and two rayographs by him, all work from the early 1920s; but there were four recent photographs by Edward Weston and more than twice as many prints by Alfred Stieglitz. Although Stieglitz had once lamented from New York that he did not enjoy the success of a "Man Ray in Paris," glory at the Museum of Modern Art in 1940 was clearly his.

Not only did Man Ray have to contend with a sense of alienation as the prodigal son, but he also had to face his frustration with an American audience who misunderstood his multidefinition of an artist. Questions like "Who?" and "What?" were problems for painter/photographer/filmmaker/object-maker/designer Man Ray. It is, he said, the "statisticians and bureaucrats who have always had trouble with my name, not knowing whether to list it under *M* or *R*. The French had no trouble, treating it simply as one word. . . . [A]s with many who would not accept me both as a photographer and a painter[,] I had to be one or the other, to the detriment of one of the forms of expression."[6] It was the struggle to receive his full due as an artist in America—from the "statisti-

274

cians and bureaucrats" who insisted on categorizing him—that occupied Man Ray for the next eleven years of "exile"—indeed, for the rest of his life.

For the most part, New York in the 1940s embraced the refugee artists, especially the surrealists. Social columns in newspapers often mentioned the comings and goings of such personalities as Salvador and Gala Dali, the André Bretons, and Marcel Duchamp. Activity among the artists, both European and American, was high. The first issues of *View* magazine, founded and edited by the poet Charles Henri Ford during the initial flurry of émigré activity, were devoted to articles about the newly arrived artists, as well as reports about those still in Europe. In November 1940, for example, *View* reported that artists Matta and Gordon Onslow-Ford planned to publish an art review in New York, tentatively titled *Gold*, that would continue along the line of the Paris review *Minotaure*. It also mentioned plans for a bilingual, French-American literary magazine to be edited in Brooklyn by Ivan Goll. In that month's column "To and from America," it was predicted that Marcel Duchamp, who had not yet arrived, "may see his many friends on these shores soon," and that artists Max Ernst, Leonid, and Raoul Ubac were also expected. Mention that "Man Ray in New York dreams of going to New Orleans, to live and paint pictures" indicated that Man Ray had already made two key decisions: to seek his audience elsewhere and to concentrate on the medium of paint.

Being an "American in New York" had none of the cachet Man Ray's nationality had offered him in Paris. While he had achieved a certain stature in Parisian circles, in America such "foreign" popularity was now the privilege of artists such as Matta, Yves Tanguy, Ernst, and, above all, Duchamp. Without a gallery affiliation, steady patron, or his work to serve as credentials, Man Ray had little to hold him in New York. Under the circumstances he might have chosen New Orleans as a logical alternative. A city of French culture, it would have provided him with a familiar environment. Other artists, including in the teens Jules Pascin, had previously chosen it for that very reason. But in 1940 there was no international art community in New Orleans, and certainly it was not a center of avant-garde activity; Man Ray must ultimately have decided it was no place to live *and* paint.

In his autobiography, Man Ray suggests that he "discovered" Hollywood on his way to retire in Tahiti.[7] In fact, he followed a migration of European artists to Hollywood that had begun in the 1930s. Predominantly filmmakers, writers, and musicians who saw

themselves as vanguardists, the artists had emigrated to America with a very particular knowledge about the country. From sources as varied as children's books, silent films, and political propaganda, they had acquired an image of the United States as, alternately, a visionary landscape and a technological nightmare, populated by cowboys and Indians, gangsters and beauty queens. Above all else, they were entranced by America's movies.

Americans in Paris had also championed Hollywood. Asked by the Ballet Suédois to create an "American ballet" for a November 1923 prèmiere in Paris, artist and entrepreneur Gerald Murphy composed *Within the Quota*, about a Swedish emigrant in New York. In his attempt to succeed, the man falls victim to characters such as the "jazz baby" and a cowboy and loses everything, only to go to Hollywood and reap fame and fortune as a movie star. Predictably, in the finale the once-poor emigrant is wooed and won by "America's Sweetheart."[8]

During the war Los Angeles provided more support for artists than any other American city, hoping at the same time to quell the puritanical notion that a comfortable environment fosters hedonism at the expense of creativity. Hollywood not only engaged the American and European literary elite, but also directors, designers, and cinema technicians. Although Hollywood would later gain the reputation as a spoiler of artistic integrity, initially it was a nurturing, appreciative place where the film industry provided shelter to artists who could not survive elsewhere. For Europeans, the haven from Nazi persecution meant physical survival as well as artistic possibilities; for some American artists, such as writer William Faulkner, who was employed by Hollywood at a time when East Coast publishers were not receptive to his work, the city offered creative sustainment.

To many, Los Angeles was the prototypical modern city. Developed by wealthy real-estate investors from the East, rather than as a result of frontier conquests and settlements, Los Angeles was a unique achievement. Artificially planned, the city was laid out before people arrived. With the completion of the first freeway in 1940, it gained the mobility that implied modernity; and as one of its chief industries, it could boast the most modern art form, film. On 10 January 1941, under the headline "Expert Declares Paris Art Gone," the *Los Angeles Times* quoted no less an East Coast authority than Professor Theodore Sizer, director of the Yale Art Gallery, as saying: "Art, the old art of Paris is gone, finished. . . . The greatest art done today is moving pictures." Seeking a place of greater opportunity, dealer Julien Levy temporarily abandoned New

York in 1941 and established a "traveling gallery, a caravan of modern art," in California. Not surprisingly, the adventurous Levy showed not only the work of such modern masters as Joseph Cornell, Tanguy, and Dali, but also the sketches for Milt Caniff's cartoon strip *Terry and the Pirates*, the Walt Disney Studio water-colors for *Snow White* (he tried and failed to get those for *Fantasia*), and, "just for fun," the paintings of comedienne Gracie Allen.[9]

If modernity required letting go of one's roots, Hollywood was a perfect place for the European artists, already cut off from their native culture, to do so. The freshness of Los Angeles and the chance to create anew inspired them in a way the mature culture of Europe could not. Many of those who came to Hollywood in the 1940s had actually experienced a similar artistic migration before, notably the Berlin émigrés, uprooted exiles from the Russian Revolution who had found artistic fulfillment and employment in Berlin during the 1920s. A decade later, it was Hollywood that promised them activity and an opportunity to practice their art. Bertolt Brecht, for example, was assured by his friend Lion Feuchtwanger that it was best to go to California because "it was a better place for refugees, cheaper, with more opportunities for employment."[10]

While it shared such practical advantages with Berlin, however, Southern California offered far more: in the 1940s it was the embodiment of fantasy and myth, the place to make dreams come true. The October 1940 issue of *View* featured a keynote article entitled "Hollywood in Disguise: Gods and Goddesses Paid to Be Alive." Although the "gods and goddesses" mentioned were film stars such as Garbo and Gable, the questions posed and answered by the author also could have been addressed to artists, writers, and the filmmakers themselves: "Where did the gods go? . . . The Gods are glad, paying rent in Hollywood." "Fugitives in Dreamland" was how French refugee editor Pierre Lazareff described the community of Europeans in Hollywood at the time. "To all the best-informed Frenchmen, as well as to all Europeans," he declared, "Hollywood seemed more than a *mirage* city, a city of legends. Hollywood was the *creating* place for *all* the mirages and for *all* the legends of the world."[11]

After a cross-country journey by car, Man Ray arrived in Hollywood in early November 1940. A hopeful stop was made in Chicago, where he tried to rekindle the interest of the Arts Club, which had exhibited his work between the wars. With no recent work to show, however, Man Ray could only strengthen his resolve to "settle down and paint."[12] Surely his choice of California as the place to reestablish his reputation as a painter was based on

the successful 1935 show of his work at the Los Angeles Art Center. Without doubt his resolution to paint was a reaction to the popular categorization of him as "only" a photographer, while his choice of Hollywood was perhaps motivated by the allure of a community that comfortably, at times handsomely, rewarded its artists.

The creator of only four short films in the 1920s, Man Ray nevertheless enjoyed a considerable reputation as a surrealist filmmaker. Along with other artists, such as Fernand Léger and Dudley Murphy, authors of *Ballet mécanique* (1924), and Luis Buñuel and Dali, producers of several films, including *Un Chien andalou* (1928), Man Ray had made significant contributions to experimental film. Twenty years after their production, his *Retour à la raison*, *Emak Bakia*, *L'Etoile de mer*, and *Le Mystère du château de dés* were well known and appreciated by the film community.

Since Hollywood then hosted some of the best European filmmakers—and one-time colleagues of Man Ray's—such as Buñuel and Fritz Lang, he could not have resisted thinking that there might also be opportunities for him. If he did, he met the same frustration as the others, who, once lured to Hollywood, found it difficult to make films there. Some succeeded—Fritz Lang among them—but others, like Max Ophuls, languished in Hollywood for as long as six years without a single assignment. William Copley, director of Copley Galleries in Hollywood during the late 1940s and a longtime friend of Man Ray's, acknowledged the latter may have expected to work in the movies. "What he didn't know was that 'avant-garde' were dirty words in Hollywood. They wined and dined and flattered him and listened to his excitingly outrageous ideas with carefully deaf ears. They had no intention of letting him near a camera."[13] To the inquiries of an interested producer, Man Ray described his requirements for movie-making: "optical changes on the cameras, different arrangement of the lighting, slight modifications of the developing and printing of the negatives and finally, the makeup and costumes of the actors would require special attention. As for myself, I'd be in front of the camera, not behind it, playing the principal part." Unfortunately for Man Ray and his colleagues, "Art" was too impractical for commercial Hollywood. Later, perhaps as a result of his disappointment, Man Ray would write in his autobiography that he had little interest in films, that he "put [his] camera aside knowing that [his] approach to the movies was entirely at odds with what the industry and the public would expect of [him]."[14]

Although Man Ray turned his back on a career in film, he did

not totally ignore the industry. Throughout the eleven years he spent in Hollywood, he enjoyed the company of sympathetic actors and directors who often engaged him in projects as an unofficial consultant or, as Albert Lewin did, used his objects or paintings as props in films. Man Ray's only significant contribution, though, was "Ruth, Roses and Revolvers," a script for an episode in Hans Richter's 1946 film *Dreams That Money Can't Buy*, which also included segments by Alexander Calder, Ernst, Duchamp, and Léger.[15]

Illustrated with a photograph of a wilting rose and a revolver and portraits of the main characters (fig. 229)—friend and actress

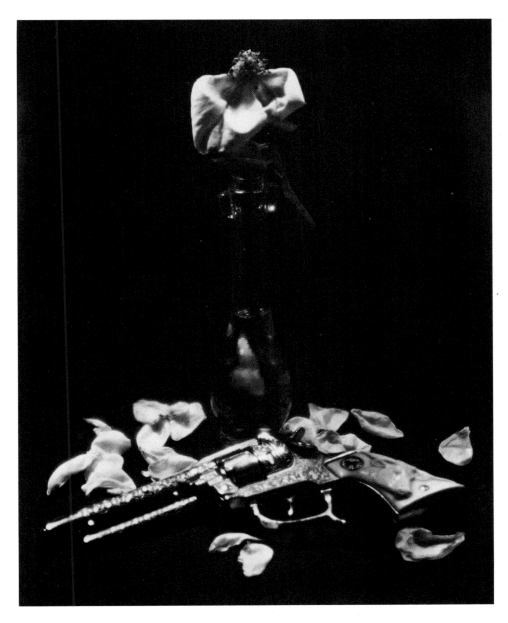

229 *Ruth, Roses, and Revolvers*, 1945, silver print

Ruth (of the title) Ford and Man Ray's wife Juliet—the script was published in the December 1944 issue of *View*. As though describing a dream, it recounts the mimetic reactions of an audience viewing a film. Completely controlled by the images and actions of the well-known, but uninspired, actor on the screen, the passive assembly neither understands nor appreciates their situation. In the text, Man Ray disgustedly notes their powerlessness, their inability to see beyond the obvious. "[I]t is like this coin," he concludes, "People look only at one side of this for the more prosaic details of value, country of origin, motto, but look carefully at the other side and you will see the real decorative value." As if describing a personal currency, he used the film to note again the theme of misunderstanding that permeated his American career.

Man Ray's decision to move to Hollywood might also have been influenced by the presence of collector Walter Arensberg, who had moved to Los Angeles in 1924. Since the twenties, his acquisition of pre-Columbian and Oceanic art had surpassed his collection of avant-garde painting. Both of these passions, though, had been eclipsed by Arensberg's writing and research, particularly his study of Baconian theory.[16] Throughout the 1940s, he opened his home and his collection to curious art enthusiasts and to friends such as Marcel Duchamp and Man Ray, but he had little interest or time to re-create the salon that had earlier in the century provided a forum for artists in New York. While Arensberg may have reminded Man Ray of productive years before he left for Paris in 1921, the now-elusive collector was of little encouragement or support in Hollywood.

Although Man Ray had left his major paintings and objects behind in Paris, he had been able to carry with him enough work to arrange an exhibition at the Frank Perls Gallery in March of 1941. To those drawings, watercolors, and rayographs he added a number of early paintings that had been in storage in New York. An announcement of the show in *Art Digest* enthusiastically reported that Man Ray, "labeled by his friend Pablo Picasso 'enfant terrible of Montparnasse,' had returned to America." The notice also mentioned that the exhibition would include "recent paintings, watercolors, drawings and photographic compositions," but it is unlikely that Man Ray could have painted more than a few new pictures by the time of the opening.[17] Like the luggage he carried to France in 1921, however, Man Ray's 1940 valise had also held a portfolio of photographs documenting his work; with these images, he "reconstructed"—his word—a number of his most successful paintings.

In spite of the auspicious announcement, the exhibition was reviewed in April's *Art Digest* as "Man Ray's Remote Art." Henry Millier, critic of the *Los Angeles Times*, described the artist as "one of the leaders of the surrealist movement," but concluded that "Man Ray's aesthetic psychological exercises, while done with evident artistry, seem products of a period which was more exciting than substantial; a period, to us, remote in feeling and in time." The show was to him "like a trip through all the curious isms which fascinated many of the brightest brains in Europe twisted and decimated by war." While Millier acknowledged that "in Paris Man Ray very much 'belonged'" and that "he was in the movement, wherever it turned," the critic also declared that "America is on a different track."[18]

Most distant of all were Man Ray's latest works, which Millier described as "melancholy 'romantic' subjects in which a continent is shown cracking apart." Based on earlier watercolors and a group of 1938 paintings such as *The Wall* (fig. 230), which featured fleeing figures against bleak and disintegrating landscapes, Man Ray's *Swiftly Walk over the Western Wave* was particularly poignant (fig. 231). Measuring only eight inches square and featuring a single fleeing figure poised like a statue on a gridded block, the painting serves as Man Ray's crest. Like the figure of his earlier *Rebus* (fig. 232), or the manikins depicted in the equally disheartening drawings, such as *Le Dernier Homme sur terre* (fig. 233), the "man" of this small, but powerful, painting represents a personal reference— to Man Ray's flight from East to West, Europe to California, and his existence in the empty, ambiguous landscape of universal dilemma.

Another work reconstructed from photographs of earlier paintings produced a strange landscape and subject for an American audience. Although he substantially changed *Imaginary Portrait of D. A. F. de Sade* (fig. 224)—first painted in Paris in 1936—by replacing the burning towers with a scene of reconstruction and the fiery-red palette of the original with a cooler one of blue and green, it was not enough to dissuade Millier from equating the subject with "crime and torture magazines." Essentially, Man Ray's paintings were too full of despair to be popular in California before Pearl Harbor, where the horrors of war and displacement were indeed remote.[19]

Although misunderstood by critics and the public—who abstained from purchasing any of his works in the Perls Gallery show—Man Ray was welcomed by museums in California. In the first years after his arrival, he was invited to exhibit at the M. H.

230 *The Wall*, 1938, oil on canvas, private collection

231 *Swiftly Walk over the Western Wave*, 1940, oil on canvas, Collection Suzanne Vanderwoude, New York

232 *Le Rebus*, 1938, oil on canvas, Musée National d'Art Moderne, Centre National d'Art et de Culture Georges Pompidou, Paris

233 *Le Dernier Homme sur terre*, 1940, watercolor and ink on paper, present whereabouts unknown

de Young Museum in San Francisco (1941), the Art Museum in Santa Barbara (1943), the Pasadena Art Institute (1944), and the Mills College Art Gallery (1945). The Los Angeles County Museum of History and Art gave Man Ray two exhibitions: the first in 1943 showed his paintings; the second in 1945 was a fuller retrospective that included photography and drawings.

Throughout the United States, there was a small professional and educated audience who could place Man Ray in the context of European surrealism and appreciate his innovative approach to making art. Indeed, in the history of modernism—European and American—by 1940 Man Ray had made his mark. In retrospectives covering the first half of the twentieth century, works by him were always prominent. As one of the original members of Katherine Dreier's Société Anonyme, Man Ray was included in the exhibition of the collection organized at Yale University in 1942. His rayographs and paintings were shown in *Abstract and Surrealist American Art* at the Chicago Art Institute in 1945; and four works were included in the Whitney Museum's 1946 *Pioneers of Modern Art*, the catalogue listing him as the "principal American member of the Dada and Surrealist movements."[20]

During the early 1940s, Man Ray continued to execute new versions of earlier works. By the time of his 1944 exhibition at the Pasadena Art Institute, he could add to original paintings from the teens and twenties a number of works that "reconstructed" more recent work from Europe. Besides the *Imaginary Portrait of D. A. F. de Sade*, Man Ray improvised on *The Poet* (1936), *La Fortune* (1938), and *Le Beau Temps* (1939), as well as other important paintings from earlier in his career. Perhaps because he was no longer able to locate or obtain a fresh selection of important early paintings for his exhibitions, new versions of *Promenade* (1915) and *Legend* (1916) were also made. All of these adaptations vary in size, scale, and medium from their predecessors. His most famous painting, *A l'heure de l'observatoire—Les Amoureux*, was redone in smaller scale; and to *La Fortune* he added a mysterious tower in the distance, referring as much to his favorite landscapes of Leonardo as to the castle of the Marquis de Sade, or even to traditional fairy tales and imprisoned beauties—perhaps implying his own exile in a "foreign" country. *La Femme et son poisson II*—originally a 1936 drawing published in *Les Mains libres* and a 1938 oil—became more colorful when reconstructed in 1941. A year later Man Ray recreated ten paintings based on his 1916 collage series *The Revolving Doors*. The artist resisted the notion that these new versions were copies, explaining that they were "variations of the same subject."

234 *Night Sun—Abandoned Playground*, 1943, oil on canvas, private collection, Paris

In Hollywood Man Ray painted narrative pictures. Some, such as *Night Sun—Abandoned Playground* (fig. 234), are like stage sets that use pieces of Man Ray's own drama. Indeed, an earlier study for this work depicted figures moving about the space like actors in a theater. Although evocative of his bleak landscapes from the late 1930s, *Night Sun* is filled with colorful details. A setting sun over blue ocean, white beach, and uprooted cypress tree describes Man Ray's California. The mood is still somber, but the chessboardlike ground is now steady and even, the geometric drawing inscribed on the beach reinforcing the security of perspective. Once again Man Ray featured the brightly colored clouds of his 1938 and 1941 *La Fortune* to suggest his fantastic situation. The house is similar to that first painted in *Le Beau Temps* (1939), but in 1943 the rooms are full of active molecular configurations, the designs of a new age. Similarly, *Optical Longings and Illusions* (fig. 235), a 1944 collage, uses the atomic arrangements as a kind of happy background.

Later, Man Ray used *Night Sun* and other paintings as sources for a novel that he began (though never completed) in the late 1940s. Possibly intended for film but more likely a literary experiment, the manuscript described a futuristic place of sensual delights. Although it takes place in the nonspecific setting of a dream, the

$= s$

man Ray-1943

Optical Longings and illusions

235 *Optical Longings and Illusions*, 1943, collage, Ruth Ford Collection, New York

story of Roger the painter is, not surprisingly, similar to Man Ray's. The cityscape of two-story skyscrapers, which had "the illusion of buildings that had been laid on their side," was like watercolor drawings Man Ray had made of Los Angeles (fig. 236); and, as in the two *La Fortune*s and *Night Sun*, the "artificial sky" contained clouds, each, as in the landscape described in the novel, a

286

"different tint of one of the colors of the rainbow, creating an effect of permanent festivity."[21]

Literature often offered Man Ray models for his paintings during this time. In *Aline et Valcour* (fig. 268), after a novel by the Marquis de Sade, he used old photographs from Paris to create a scene suggestive of an entire script. The work depicts the decapitated head of a blindfolded girl lying on a book and under a glass bell. Beside the still life, a wooden manikin lies exhausted between the geometric shapes of a sphere and a cone. Justice, Man Ray says, has been contained, the hero vanquished, ideals compromised. *Infinite Man* (fig. 238) depicted his by-then familiar manikin flailing at colorful forces of abstraction in an architectural space borrowed from one of his photographs of the Los Angeles Coliseum. More heroic than *Aline et Valcour*, it is no less tragic: to Man Ray's mind, the struggle of the individual was the story of the modern world. That the "Last Man on Earth" had become "Infinite" indicated not only Man Ray's continued hope for success in California, but also his all-encompassing method of achieving it.

Working from photographic copies, or from sketches and notes for paintings that he had not had time to realize before his flight from Paris, Man Ray thus reconstituted his career in an attempt to

236 *Problem of the Skyscrapers—and Solution*, 1940, ink and pencil on paper, Indiana University Art Museum, Bloomington

237 *Henry Miller and Masked Nude* (two versions), 1945, silver prints

238 *Infinite Man*, 1942, oil on canvas, private collection, Milan

reach his new audience. But his works were to remain forever "remote" to American viewers, because they were in fact conceived in another time. Mindful of what he had lost, nostalgic for his unquestioned acceptance by the European avant-garde, Man Ray in Hollywood was, for the most part, not working in the present.

If the paintings were misunderstood by an audience that lacked the context of their initial creation, increasingly Man Ray was willing, if not eager, to explain his personal aesthetics in writing. In one of his most straightforward interpretations of this period, he commented in his 1962 autobiography: "I felt an increasing urge to state my ideas in words. . . . The statements of Delacroix and of Cézanne have more significance than the words of any of their critics, have finally obliterated the latter. A phrase dropped casually by Picasso could silence any argument. Such statements are not merely attempts at justification; they are reserve arrows for the same target. They crystallize and confirm the painter's intentions; incidentally are aid to those who cannot see and understand at once."[22] Self-flattering, even presumptuous in connecting himself to masters of French art, Man Ray's comments reveal his interest in using writing as a medium of explanation and revelation.

The 1941 exhibition at the M. H. de Young Museum in San Francisco included work from every medium in which Man Ray had worked except film. Not well received—Man Ray was seen by the San Francisco critics as an imitator of surrealism, not one of its participants—the exhibition nevertheless provided him with an occasion to lecture and write about his work and art in general. Perhaps in response to his reception in San Francisco, Man Ray published an article in the January 1941 issue of *California Arts and Architecture*. Punningly titled "Art in Sanity," it was both a jab at the Society for Sanity in Art, a conservative San Francisco group whose yearly shows featured the best in popular representative painting, and a treatise on the reception of art in America. The title was also a pun on a radio lecture, "Art in Society," that Man Ray had delivered almost immediately after his arrival in California.[23] In fact, the texts were the same. "How much of an artist's work is experiment?" "Does he present problems?" Addressing the critics, Man Ray responded to his questions by declaring that the work of an artist "offers a solution." It is the critic, he said, who should experiment with his own reactions to the work of art, who should admit that the "problem is for himself to solve: a problem of acceptance."

Other texts by Man Ray from the period echo similar thoughts. For the catalogue of his 1944 exhibition at the Pasadena

Institute of Art, he wrote a brief preface. The short, disconnected statements that make up the text all share the by-then-familiar defensive tone. Whereas "I do not believe in progress in art" and "The real experiment is whether the spectator is willing to accept what his eye conveys to him" defend the paintings, the statement he makes about his photographs sounds once again his frustration at their being held in higher esteem than his canvases: "I may have made some experiments in the newer art of photography, but I have never shown them, or they have been destroyed in the process. Every work of art is final in itself and not a promise of something better to come."

For the most part, May Ray still resisted the advances of fashion magazines that continued to offer him work; but he did briefly photograph movie stars in their homes and on the sets, probably in the hope of making connections that would prove as helpful as those made through his photographing of celebrities in Paris. Artistically, however, Hollywood offered little stimulus to Man Ray's work in the medium. Although he did make portraits of friends and acquaintances such as Henry Miller (fig. 237), and published images in *California Arts and Architecture* and *View* (figs. 239, 240) that were reminiscent of his 1930s work for *Minotaure* and *La Révolution surréaliste*, his commitment was minimal. Lauded for his past experiments in the medium, he preferred to spend his creative efforts elsewhere.

Published in two issues of *View* magazine, "Photography Is Not Art" responded even more forcefully to those who preferred to discuss his photographs to the exclusion of his work in other media (fig. 241).[24] It is the verbal equivalent of his 1936 photographic book of the same title. The book, with annotations by Breton, included ten photographs with descriptive titles such as "An accidental snap-shot of a shadow between two other carefully posed pictures of a girl in a bathing suit," or "A dying leaf, its curled ends desperately clawing the air."

As if summoning strength from enigmatic references to the past, Man Ray began his article with a quote from Breton—"I wish I could change my sex as I change my shirt"—and a list of the 1936 titles, which he slyly declared belonged to the ten best photographs he had produced. As always, the essay was an attack on the art critic, who Man Ray cunningly typed as the "artificial florist"; but it was also a defense of photography, which he claimed was a victim of those who confused it with painting or drawing. According to Man Ray, in the rush to imitate nature an individual can imagine "that he is making a good drawing, when he is simply

239 Untitled, ca. 1945, silver print, published in *California Arts and Architecture*, March 1942

making a poor photograph, or that he is making a work of art with the camera when he makes a good automatic drawing with it.'' He also cautioned the photographer whose ''concern with *how* the thing is to be done, instead of *what* is to be done, is a repetition of the spirit that held in the early days of painting when painters went about smelling each other's oils.'' This advice no doubt applied to those who would rather concentrate on Man Ray's method for his

240 Untitled, ca. 1943, silver print, published as the cover of *View*, April 1943

241 "Photography Is Not Art," by Man Ray, *View*, October 1943

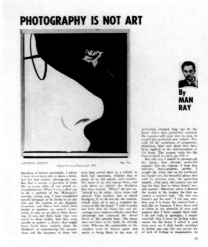

unique rayographs or solarizations rather than the visual effects such darkroom techniques produced. Artists are not technicians was his message; for Man Ray the medium was only a tool with which to realize the artist's ideas.

More lyrical than his essays, Man Ray's conclusion to his unpublished 1944 poem "Diatribe" also makes his point about the value of artistic concept over method:

The manipulation of man-made engines
Require a steady hand for their smooth working
Ever since our love for these engines
Has replaced our love for more human attributes
Disaster is on the increase
The consolation however still remains
The pen is mightier than the sword
Ink is more indelible than blood
And now the blackening by light
Of a silver sheet
Confounds our most precious proverbs.

The exception to Man Ray's abstinence from the art of photography was a series, which continued until his death, of portraits

242 *Juliet*, ca. 1943, silver print

243 *Juliet*, ca. 1943, silver print with colored pencil, Studio Marconi, Milan

of his wife, Juliet. They met in Hollywood in 1940, and she soon proved a rejuvenating influence. Young and vivacious, she was the model-inspiration, a role that previously had been held by, among others, his first wife, Adon Lacroix, then Kiki and Lee Miller in the twenties and thirties.

The portraits of Juliet are, for the most part, informal, often simply the face of a pretty girl (fig. 242). Some, however, are elegant figure studies that echo the work of painters such as Ingres or Vermeer. Otherwise nude, a turbaned Juliet is reminiscent of Ingres's bathers (fig. 243), a more serious tribute by Man Ray to one of his favorite artists than was his earlier photograph of Kiki, *Violon d'Ingres* (fig. 262). Shown leaning against a simple stand, Juliet is posed much as a model would be in preparation for a drawing class. In fact, Man Ray often worked on his photographic prints with colored pencils or ink in order to enhance the images, to make them appear more like drawings.

In the mid forties Man Ray once again faced a New York audience. In January 1945, at the invitation of Julien Levy, he participated in an exhibition devoted to chess. For the occasion, he designed a new set, an update of his 1920 creation, and had it turned in wood by a local California craftsman (fig. 244). Along with chess sets by his old Paris colleagues—among others, Ernst, Duchamp, Tanguy, and Calder—the small sculptures on Man Ray's board in *The Imagery of Chess* exhibition honored a game and theme that, following Duchamp's preoccupation, had claimed the attention of many of the surrealists. Perhaps prompted by the Levy show, Man Ray created a number of works inspired by the intellectual board game. *Endgame*, a 1942 photograph, initiated a sequence that included drawings and a painting. The chaotic image of manikins arranging the chessboard was Man Ray's statement on the war's desperate finale.

On 10 April the Julien Levy Gallery opened a solo exhibition of Man Ray's work. Although Levy was most interested in what Man Ray called *Objects of My Affection*, the show also contained paintings, drawings, and rayographs. As usual, the critics found it easiest to write about the photographs, or about the "distinguished photographer" Man Ray, the "American influence in the Surrealist group."[25] Anticipating such comments, the artist had already printed his counter on the cover of the exhibition catalogue (fig. 245). Designed by Duchamp in collaboration with Man Ray, the cover featured *The Kiss*, a 36-mm frame from a movie, reported to be the first kiss in the history of cinema. Duchamp had directed the printer to blow up the photograph, reproduce it, reduce it, and

244 *Man Ray and Chessboard*, ca. 1945, silver print

EXHIBITION · MAN RAY

APRIL · 1945

JULIEN LEVY GALLERY · 42 EAST 57 N.Y.

245 Cover design by Duchamp in collaboration with Man Ray for the catalogue of the 1945 Julien Levy Gallery exhibition. *The Kiss* was a reproduction of a frame from a movie, reportedly the first kiss in the history of the cinema.

reenlarge it several times. The result was an image, in Levy's words, "so enlarged, bendayed, processed, polkapatterned, that the original image was all but impossible to identify. To most it looks at first sight like a splash of water in a sieve or a splash of snow on a window screen."[26] This manipulation of photographic reproduction techniques for the purpose of obfuscation echoed the thrust of Man Ray's art. In the catalogue Man Ray explained: "In whatever form it is finally presented; by a drawing, by a painting, by a

photograph or by the object itself in its original material and dimensions, it is designed to amuse, bewilder, annoy or to inspire reflection, but not to arouse admiration for any technical excellence usually sought for in works of art."

Although in later exhibitions pre-1940 objects would also be gathered under the title *Objects of My Affection*, the ten works in the New York show were all done during his Hollywood residence. Some of the objects were dryly described by the artist in the catalogue, including *Domesticated Egg* (fig. 246), which was "no more improbable than preserved egg, though admittedly less edible," and *Silent Harp* (fig. 247), the "Violon d'Ingres of a frustrated musician. He can hear color as easily as he can see sound."

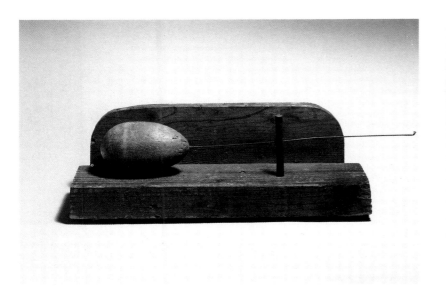

246 *Domesticated Egg*, 1944, wood and wire construction, Collection Mrs. Jean Farley Levy, Bridgewater, Connecticut

247 *Silent Harp*, 1944, violin neck, mirror, and lattice board, Collection C. C. Pei, New York

248 *Self-Portrait*, 1944, aluminum mirror framed in wood, The Morton Neumann Family Collection, Chicago

249 *Optical Hopes and Illusions*, 1945, wooden banjo frame, wooden ball, and mirror, Collection P. Matisse, New York

250 *Table for Two*, 1944, wood, Collection Timothy Baum, New York

Others, though, carried more sincere messages, like the description of *Self-Portrait* (fig. 248): "reflected in a flexible mirror, is capable of infinite variations simply by the pressure of a finger to the surface of the mirror, permitting as many modifications as does the application of a brush to canvas, with the advantage of attaining that instantaneous quality felt in a work realized by more laborious means." If Man Ray often created his art with a practiced eye on the audience for which it was intended, then *Self-Portrait* recognized the viewer in a special way. Concerned as he was in the 1940s with rebuilding his reputation, and often calling on the audience or critic to experiment in order to gain the insight necessary for understanding, Man Ray concocted a mirror that first, and only briefly, provided an image of the artist; more often, it revealed the face of the viewer. The work, which also allowed each "self-portraitist" further control through manipulation of the mirror, was a stroke of brilliance.

In part visual one-liners, the objects of Man Ray's affection also were personal anecdotes from various aspects of his life. *Palettable*, made shortly after Man Ray's return in 1940, is a comment on the painter's accessories, made more useful as furniture for practical-minded America. *Optical Hopes and Illusions* (fig. 249), despite its tuneful title and banjo shape, is an ominous toy that makes no sound but rather, like a deceitful pendulum, entertains through distortion. It as likely refers to Man Ray's artistic aspirations as to the fantasyland of Hollywood, or in 1944, the ever-expected, never-arrived end of the war. *Domesticated Egg, Table for Two* (fig. 250), and *Mr. Knife and Miss Fork* (fig. 251), referred to his new relationship with Juliet Browner; *Life Saver* (fig. 252), made for friend and sometime-patron Mary Wescher, was a thank you for her support.

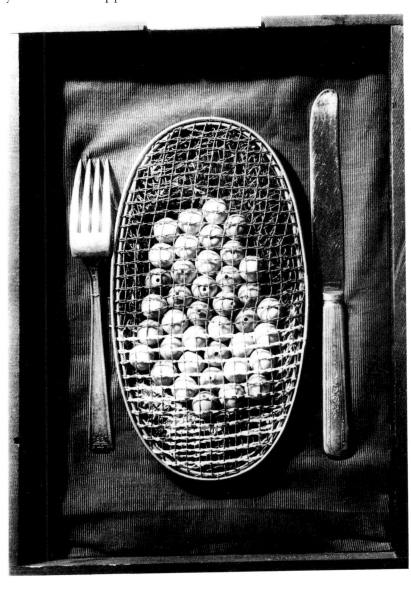

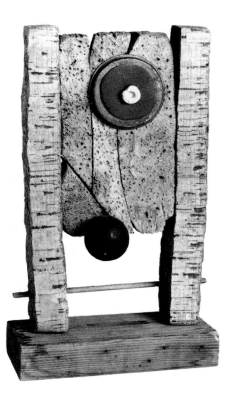

251 *Mr. Knife and Miss Fork*, 1944, fork, knife, wooden beads, string, wire, and fabric, framed in wood, private collection, Princeton, New Jersey

252 *Life Saver*, 1944, cork, wood, metal, and rubber, The High Museum of Art, Atlanta

The *Objects of My Affection* were examples of the crossover between high art and popular culture that was notable in Los Angeles during the 1940s. While Hollywood's "film noir," for example, drew on the contributions of German expressionism of the 1920s, it also used the popular pulp magazines of the 1930s for its stories of corruption. Rooting culture in a medium like film that could be mass-produced created a distinctive aesthetic middle ground. Man Ray's 1940s objects, made of commonplace or household items such as wooden darning eggs or bowls, extended the dada tradition of the found or modified object, a tradition that challenged the inaccessibility of art. As was true of many of his earliest objects, some pieces existed only in the form of photographs. With titles that echoed popular songs of the day—"The Object of My Affection"—or colloquial phrases—"Table for Two," "Enough Rope," "Abracadabra"—he further invited a wider audience to participate in his personal poetry.

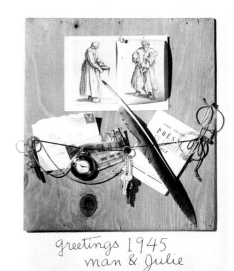

253 Photograph of a collage by Man Ray with New Year's salutation

There is no better example of Man Ray's ready ability to fashion an image from a selection of aesthetic and prosaic references than a collage he made as the model for a photograph (fig. 253). Eventually duplicated and sent to friends, each copy signed "Greetings 1945 Man and Julie," the card, like any end-of-year letter, makes a number of references to the artist's life, past and present. The small photograph is a postcard picture of Man Ray's house in France; the letter underneath reveals his Hollywood address of 1245 Vine Street. The title page to a 1942 book by Man Ray's friend and one-time collaborator Paul Eluard is included, bearing the inspirational message "Poésie et Vérité." Also depicted are Man Ray's glasses, the scissors used for the collage, his watch, and, appropriate for a resident of the newly freewayed Los Angeles, the keys to his blue Graham Page, a supercharged car of which he was very proud. Most important, a quill pen points out two figures at the top of the collage. The etchings of beggars are by Callot, a reference to the French artist's most famous series, *Les Misères et les mal-heurs de la guerre* (*The Miseries and Unhappiness of War*), and Man Ray's own wry comment on his current situation. Despite such European references, overall the image celebrates the nineteenth-century American tromp l'oeil tradition of John Peto and William Harnett; the simple New Year's card was Man Ray's modern version, with his camera supplying the magically believable conversion from three to two dimensions.

Hoping for a response to his Levy Gallery show, Man Ray traveled east in early May. Passing through Chicago where he "talked with everybody including Catherine [*sic*] Kuh" (then cura-

tor of the Art Institute), he arrived in New York "dead-tired" after an all-night train ride in the same pullman with Fernand Léger and another French painter. While letters home to Juliet were enthusiastically descriptive of family gatherings and meetings with old friends such as Duchamp ("he is the same as ever") and Breton ("he was very sweet and conciliatory"), they were also frank assessments of his critical reception. "My show is not a sensation in N.Y. With shows opening every day, sometimes 2 or 3, it can't be." Though he thought his show was intelligently hung, Man Ray rightly assumed that Levy could do nothing with his pictures and objects, for his gallery's atmosphere, in Man Ray's words, was "calculated for the school of decomposition of [Eugene] Berman and Max Ernst." His things, he continued, "looked too brilliant and white on the dead grey walls."[27]

Indeed, in the midst of ecstatic V-E Day celebrations, Man Ray was personally, and his work stylistically, out of place. Although he wrote that "I'm really looking over the land, to see what sort of places people live in, what they pay, and how they make their living," it was no doubt disappointing that invitations to collaborate on films about housing projects were more plentiful than gallery shows or museum purchases. If he had thought that he might be ready for New York, after a few days he wrote that "he had done well to move to Hollywood." Included in parties, in New York, he felt himself the knowledgeable outsider: "Went to a party at David Hare's. Imagine a loft in the slums in back of Wanamaker's on 12th St. The disemboweled works of a piano in the middle of the floor, a cage in the corner for a kinkajew, tools and objects all around, like my studio. . . . A swing in the middle of the studio with Peggy Guggenheim in it holding a glass. David Hare looks like my idea of Rimbaud. . . . All these people seem to have so much energy. As if nothing had been done before."[28] His account read like a description of dada activities twenty-five years earlier; Man Ray surely knew that such lively gatherings *had* been done before, himself a central participant instead of merely a commentator.

Though he did not lack for attention, he was cast in the past tense rather than the present. Katherine Dreier arrived at his show with a Yale professor in tow; he didn't purchase any work but instead asked Man Ray for his autograph. "I am very much entertained by it all," he wrote, but he added emphatically, "I must get down to serious and continued work, produce a lot, that is the secret of being important."[29] His goals included a renewed effort at self-description and interpretation, in the form of his autobiographi-

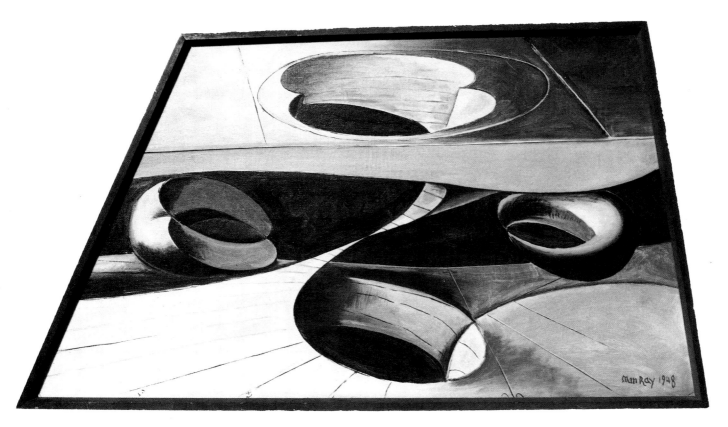

cal *Self Portrait*. Abandoning thoughts of a move to New York or an immediate trip to Paris, Man Ray returned to Hollywood with a full agenda.

Having heard from newly liberated Paris that his small house in Saint Germain-en-Laye had survived the war, he was even more pleased to find that much of his art, through the efforts of friends, had survived as well. Perhaps inspired by a few works that were sent to Hollywood, he went to Paris in 1947. Sifting through piles of negatives, gathering prints that had been scattered across attic floors, and dusting off canvases that he had once thought lost, Man Ray was like an artist reborn. Save for the large painting *Le Beau Temps* (fig. 226), which was left in Paris for exhibition in the Salon d'Automne, Man Ray had all of his work shipped to Hollywood.

In 1948 his *Paintings Repatriated from Paris* joined a new series of paintings, *Equations for Shakespeare*, in an exhibition at the Copley Gallery. In fact, the new works completed a project begun in Paris over ten years earlier when Man Ray photographed displays of mathematical objects at the Poincaré Institute. The prints of wood, wire, and plaster models were the centerpiece of a 1936 issue of *Cahiers d'art* devoted to the surrealist object. In 1948, Man Ray used the images to confront issues of painting.

On their most elemental level, his paintings from photographs

254 *Shakespearean Equation: Measure for Measure*, 1948, oil on canvas, Hirshhorn Museum and Sculpture Garden, Smithsonian Institution, Washington, D.C.

point out the relationship possible between the two media. Each of the works in *Shakespearean Equations,* as the series is also called, is linked to a specific object in the photographs; in some respects they are a continuation of Man Ray's earlier abstract, though object-derived, rayographs. In some cases Man Ray copied a single mathematical object faithfully and titled it appropriately, such as *Measure for Measure* (fig. 254), based on the image *Un plan bitangent à un tore le coupe suivant deux cercles* (fig. 255). Similarly *Merry Wives of Windsor* is based on a photograph of *Allure de la fonction elliptique p' (U) pour G2 = 0 et G3 = 4.* Some paintings from the series combine natural objects, such as a peach and butterfly wing in *The Merchant of Venice*, with the man-made mathematical representations. Others, like *Macbeth* (fig. 256), are more expressive interpretations of objects, compositions that suggest human, not algebraic, figures and relationships.

In addition to its references to representation and photographic

255 *Un plan bitangent à un tore le coupe suivant deux cercles,* ca. 1933, silver print

301

256 *Macbeth*, 1948, oil on canvas, Middendorf Gallery, Washington, D.C.

reality, imagination and science, *Shakespearean Equations* also confronted contemporary issues of abstraction. It was a popular, albeit difficult, topic. As the war effort wound down, in the major art journals less attention was paid to the subject of camouflage and more to nonrepresentational art. Critics like Grace Clements of *California Arts and Architecture* grappled with not only the validity of abstraction for a modern society, but also the need for reality in art. "Reality," she wrote, "is revealed through relationships—relationships which include man's moral nature as well as his physical and psychological nature, his relationship to environment, society, and of course the physical world."[30] Man Ray had argued the question

302

similarly in a small catalogue for a 1944 exhibition organized by the Open Circle, an association that declared itself the "Formative Group of Abstract Painters in California." In his entry, Man Ray stated that "abstract art . . . is no cold, mechanical conception born of the machine age, but an adaptation of contemporary materials to serve the human equation. The abstract artist is intent on creating a work, isolated from its casual, immediate surroundings, but confirming the most universal human experience."[31]

An impressive catalogue was published for the Copley Gallery exhibition. *To Be Continued Unnoticed*, an unbound folio of essays and reproductions of drawings, objects, and photographs was a calculated document. The inclusion of a page devoted to reviews of earlier exhibitions, in which critics had resorted to nonsensical language to express the effect of Man Ray's art, lent the publication the flavor of his 1921 dada catalogue at Librairie Six, while simultaneously turning the sting of sarcastic critics into entertainment. Another page featured a portrait of Juliet, an exact version in paint of the photograph that illustrated "Photography Is Not Art"—thus another equation of the two media. A statement by Man Ray—a synthesis of earlier writings that defended his stance as a multimedia artist—was followed by "A Note on the Shakespearean Equations." In this text Man Ray related a discussion with Breton, who had earlier misunderstood the use of the Poincaré models for creative purposes. Mistrusting the easy poetry of the objects taken out of context, Breton had urged substituting "intentionally more elementary . . . but humanly more evocative" titles for the "closed rationalism of the objects." As for the "sure" procedure from the "abstract toward the concrete," that gave them creative life, Breton approved.[32]

In the conclusion of the essay, which was in the form of a letter to Breton, Man Ray assured him that he had always agreed on the "necessity of perverting the legitimate legends of the mathematical objects, if we are to consider these as a valid source of inspiration." They were never intended as a justification of abstract art, but rather for the "discomfiture and impotence they worked on the exponents of nonobjective art with whom my principal quarrel is the poverty of inventiveness and imagination." Although Man Ray declined to use the titles first suggested by Breton, such as *Pursued by Her Hoop*, *Ring of the Rose Bush*, or *The Abandoned Novel*, and instead used titles of Shakespearean plays (perhaps a snide comment on Walter Arensberg's preoccupation with Francis Bacon), his goal of provocation was still clear.

Although the colorful *Shakespearean Equations* were stylistically

out of place in 1940s Hollywood, in concept they had much to do with the ongoing aesthetic dialogue taking place there. Although few were ready to cope with the questions raised by the "human equations" of paintings derived from photographs representing abstract mathematical formulas, for Man Ray they were solutions to an ideological puzzle he, far more than his American compatriots, had been committed to solving in Paris before the interruption of war.

The Copley Gallery exhibition marked the high point of Man Ray's experience in Los Angeles. Copley was an enthusiastic young admirer and created the kind of energy for projects that recalled earlier adventures with the surrealists. Besides the unbound portfolio, his gallery also published a limited-edition book entitled *Alphabet for Adults*. This, too, was the realization of a project that had begun many years earlier. The first alphabet was to be made from rayographs, but editorial interference from an overly critical publisher had led Man Ray to abandon the series.[33] The finished alphabet was made up of drawings, the letters illustrated by words and pictures recognizable as the artist's lexicon. The images are personal, the drawings as humble as the materials he used to make his *Objects of My Affection*. *B* is "bother," its picture a maze (fig. 257); *P* is "prepare," its picture the cracking ground of earlier paintings; *C* is "common," more amusingly a picture of bedded domestic bliss.

Although no match for Man Ray's first Paris exhibition, hosted by the dadaists, his opening at the Copley Gallery was a special event. In addition to the art and the two publications, the occasion introduced a significant Parisian institution to Los Angeles: the café (fig. 258). "Café Man Ray" featured tables with red-and-white checkered tablecloths set in front of the gallery, and in place of the traditional awning, Man Ray's coathanger object, *Obstruction* (fig. 72), hung "like a floating pyramid." Wine was served, along with onion soup made by the gallery's secretary, Igor Stravinsky's daughter-in-law Françoise.[34]

In all, it was quite an attraction for Hollywood's diverse community, which included Josef von Sternberg (whose impressive collection of German expressionist painting had accompanied him to Hollywood), Fanny Brice, Ruth Ford, Harpo Marx, and Edward G. Robinson. Among the others attending were California artists Lorser Feitelson, Helen Lundeburg, Henry Lee McFee, and Peter Krasnow; East Coast and international artists George Biddle, Hans Hofmann, Isamu Noguchi, Eugene Berman, Matta, Knud Merrild, Max Ernst, and Dorothea Tanning; composers George Antheil and

257 *Bother*, from the series *Alphabet for Adults*, 1948, ink on paper, Collection Juliet Man Ray, Paris

Visit Café Man Ray
ONE NITE *ONLY* Dec. 13, 1948
FRENcH CUisiNe
AMeriCan CockTails

Observatory Time—the Lovers 1934

258 Invitation to Man Ray's
exhibition opening, 13
December 1948, Copley
Galleries, Beverly Hills

Stravinsky; conductor Leopold Stowkowski; writers Bertolt Brecht, Aldous Huxley, Thomas Mann, and Henry Miller; and filmmakers Luis Buñuel, Jean Renoir, Otto Preminger, and René Clair, who, along with his wife, had waited for a boat to America with Man Ray and Dali in Lisbon.

Few other galleries besides the Copley entertained enthusiasts of modern art. And few of those were willing to depart from the more accepted modes of modernism. Dali—who had established a California audience based on the virtuoso, Renaissance-style execu-

tion of his small paintings—exhibited several times at the posh Dalzell Hatfield Galleries in the Ambassador Hotel.[35] A gallery at the J. W. Robinson Company department store showed contemporary work, along with Van Goghs and Picassos. The Stendahl Art Gallery, which originally operated out of the home of ex–candy manufacturer Earl Stendahl, dealt in pre-Columbian art (which was convenient for next-door neighbor Walter Arensberg), impressionism, and the recent work of Rufino Tamayo, David Siqueiros, and Diego Rivera. The Frank Perls Gallery, having exhibited Man Ray and Hilaire Hiler, preferred to focus on the work of Paul Klee. Although conservative, these galleries offered the West Coast rare opportunities to see original work by modern masters.[36]

One of the most important galleries to show contemporary art was the American Contemporary Gallery, owned and directed by Clara Grossman. Along with the Copley Gallery, the Stanley Rose Bookstore (which was a gathering place for writers as well as artists), and briefly in 1948 Vincent Price's Institute of Modern Art, "Clara's" provided a forum for the exchange of ideas about art. Inspired by the intellectual ACA Gallery in New York, the gallery sponsored lecture and film series, often hosting evenings to highlight the work of a particular individual. In the summer of 1943 a succession of Friday nights were devoted to historical films obtained from the Museum of Modern Art Film Library. Many of their makers were present in Hollywood and were invited to speak: René Clair, Jean Renoir, Dudley Murphy, John Howard Lawson, James Wong Howe, and Man Ray. Although few of the young filmmakers who heard the latter could expect to use the medium as independently as he had, Man Ray's thoughts centered on the themes of technology, the pure work of the artist's hand, and art in general.

Another forum for the discussion of such topics was offered by Antonin Heythum, director of the new Art and Technology program at the California Institute of the Arts. Heythum, a Czechoslovakian stage designer, had known Man Ray in Paris, and in Hollywood the two men spent time together, often in the company of Heythum's students. John Whitney, who with his brother James was part of a considerable group of young abstract filmmakers in Hollywood during the forties, remembers that Man Ray would converse for hours about ideas ranging from "Jung, to a concern for the soul . . . the necessity for finding techniques to sharpen the irrational, inspiration after technique."[37] From fine artists to animators from the Disney studio, a number of people were inspired by Man Ray's experience and willingness to share his ideas.

Along with many of the other European émigrés to Hollywood, Man Ray recognized and impressed on younger artists that art must work as a critical phenomenon. Throughout his career, he had understood the need for an audience, and in his work he continually provoked a response from his public. In America, however, his audience was too small, its response too limited. Having experienced success in Europe, never in America, Man Ray not surprisingly chose to return to Paris in 1951.

In her review of Man Ray's 1944 exhibition at the Los Angeles Museum, Grace Clements commented that it was difficult in a time of war to answer the sailor who might exclaim upon seeing the show, "Don't tell me *this* is what I'm fighting for!" Five years later, in its review of Man Ray's Copley Gallery show, the *Art Digest* made this summary comment about his works: "They are interesting to those who care." Man Ray's painted melodramas and statements of extrapictorial surrealist aesthetics were never favored by a public that felt more comfortable with him as a historical figure than with his interruptive presence.

In Hollywood Man Ray was both a conduit of historical surrealism and a synthesizer of his own past. If his paintings were never a dominant influence on the Los Angeles art scene, however, his presence was. Although painter George Biddle, who visited Man Ray shortly after his arrival in Hollywood, found the older artist to be "terribly conceited, full of whimsies and rather sweet," he also declared that Man Ray represented the "essence of the current 'Ecole de Paris.' Talent, sophistication, decadence, some undeniable artistry and a great deal of showmanship."[38] Ultimately, Man Ray's Hollywood years proved that it was not a question of whether his purposefully remote art was understood or not understood, liked or disliked. What was important was that the impulse that engendered his activity was recognized by many of his peers—both European and American, in Hollywood and New York, as a creative and therefore constructive process.

NOTES

1. Man Ray's steamer, the *Excambion*, departed Lisbon 8 August 1940. In his escape from Europe, Man Ray followed a path used by many of the artists and intellectuals fleeing the terror of Nazi occupation. After a harrowing, unsuccessful flight from Paris before the occupation, Man Ray eventually made his way by train to Spain, and from there to Lisbon, Portugal, where he joined other passengers waiting for boats to New York. In *Self Portrait*, he devotes an entire chapter, "Occupations and Evasions" (pp. 291–324), to his last year in Europe and a full account of his escape from Paris.

2. Although many of Man Ray's things were stolen or destroyed (especially the paintings by other artists that he owned), Lefebvre-Foinet, his framer, and his friend Ady were especially helpful in saving a great deal of his work.

3. Quotations from Man Ray, *Self Portrait*, pp. 323–24.

4. Ibid., p. 257.

5. Ibid., p. 324.

6. Ibid.

7. Ibid.

8. Interestingly, in Paris the ballet was a hit; in New York, where it premiered in April 1924, it was panned.

9. Levy, *Memoir of an Art Gallery*, pp. 254–55.

10. Anthony Heilbut, *Exiled in Paradise: German Refugee Artists and Intellectuals in America, from the 1930s to the Present* (New York: Viking Press, 1983), p. 182.

11. Pierre Lazareff, "Fugitives into Dreamland," *California Arts and Architecture*, September 1941, p. 17. Lazareff, head of the editorial department of *Paris soir*, opened his article with an anecdote about three French reporters. One tells a story about the fantastic occurrences he has witnessed, such as the eruption of Mount Vesuvius. The next reporter, unimpressed, tells a story about the important people he has interviewed, such as Clemenceau and Einstein. Still unimpressed, the third reporter says he returned from Hollywood, "And the two others put their elbows on the table and silently listened to him with their mouths wide open."

12. Man Ray, *Self Portrait*, p. 328. The 1929 exhibition at the Arts Club had included mostly photographs and rayographs, but only one of his aerograph paintings and a chess set.

13. Copley, "Portrait of the Artist as a Young Art Dealer," manuscript in Archives of American Art.

14. Quotations from Man Ray, *Self Portrait*, pp. 345, 262.

15. Lewin commissioned Man Ray to paint a portrait of Ava Gardner for the film *Pandora's Box* and used a Man Ray–designed chessboard in that film and several others. An art collector, Lewin also used the work of other artists in his films, most notably a painting by Ivan Le Lorraine Albright for *The Picture of Dorian Grey*.
 Scenarios for *Dreams That Money Can't Buy* were adapted by Richter and shown in the form of dreams. Besides "Ruth, Roses and Revolvers," the dreams included Calder's "Ballet" (music by Edgard Varèse), Duchamp's "Rotoreliefs" and "Nude Descending a Staircase" (music by John Cage), Ernst's "Desire" (music by Paul Bowles), Léger's "La Fille au coeur préfabriqué" (lyrics by John Latouche), and Richter's own "Narcissus." The music for Man Ray's dream was by Darius Milhaud.

16. From as early as 1915 Arensberg devoted much of his energies to a study of the cryptic messages he believed were hidden in the poetry and plays of Dante and Shakespeare. In the Shakespearean plays, he hoped to prove through hidden signatures that Francis Bacon was in fact the author of those works.

17. "Man Ray in Hollywood," p. 14.

18. Millier quotations in this and next paragraph, "Man Ray's Remote Art," p. 40.

19. Such criticism was leveled not only at Man Ray. Fellow expatriate artist Hilaire Hiler, best known for his exploits at the Paris Jockey Club in the 1920s, also faced critics in Hollywood who preferred his paintings of Paris snowscapes to others such as *Iceberg*, which depicted real threats like German U-boats on Atlantic crossings from Europe—and which, according to one writer, were "no better than a highschool stu-

dent's dabble into abstraction" ("Art: Los Angeles," *California Arts and Architecture*, February 1942, p. 11). Hiler's exhibition was at the Frank Perls Gallery, 1–16 February 1942.

20. Lloyd Goodrich, *Pioneers of Modern Art* (New York: Whitney Museum of American Art, l946), p. 26.

21. Quoted from Man Ray's untitled manuscript, Man Ray Archives, Paris.

22. Man Ray, *Self Portrait*, p. 338.

23. In *California Arts and Architecture*'s monthly column about art events, the reviewer described the Society for Sanity in Art show. The idea, he said, "must consist in overlaying the attempt to paint, photographically the more superficial aspects of things seen, with a rosy veil of sentimentality; and in avoiding like the plague any hint of structure, either artistic or physical, beyond the rather hazily seen surface of things. This aim, apparently shared by almost the entire membership of the Society, makes of art as innocent and harmless an occupation as the painting of forgetmenots on teacups, with about the same significance to the main stream of living art" (December 1941). Man Ray's lecture was broadcast over Radio Santa Barbara, 10 December 1940.

24. *View*, April 1943, p. 23; October 1943, pp. 77–78, 97. The cover of the April issue also featured a photograph by Man Ray.

25. Maude Riley, "The Camera Does Lie—Via Man Ray," *Art Digest*, 15 April 1945, p. 8. The Levy exhibition was first shown in Hollywood at the Circle Gallery in 1944.

26. Levy, *Memoir of an Art Gallery*, p. 28.

27. Man Ray quotations from his letter to Juliet Man Ray, 2 and 7 May 1945.

28. Man Ray quotations, ibid., 3 May 1945.

29. Ibid., 7 May 1945.

30. Clements, "Why Abstract?" *California Arts and Architecture*, no. 6, October 1945, p. 21.

31. Manuscript for "The Open Circle: Formative Group of Abstract Painters in California," Man Ray Archives, Paris.

32. Man Ray, *Self Portrait*, p. 368.

33. Bourgeade, *Bonsoir, Man Ray*, pp. 87–88.

34. Copley, "Portrait of the Artist as a Young Art Dealer," p. 46.

35. "Everyone has agreed that the execution of the paintings is nothing short of incredible, that Dali is a first-rate draftsman, and a brilliant entertainer" (*California Arts and Architecture*, October 1941, p. 39).

36. Other galleries include En's Gallery, 2521 West Seventh Street; the Raymond and Raymond Galleries, 8652 Sunset Boulevard; James Vigeveno Galleries, 160 Bronwood Avenue, Westwood Hills; Frederick Kahn Gallery and Katzenellenbogen Gallery, Sunset Strip.

37. John Whitney, interview with author, Los Angeles, California, August 1986.

38. George Biddle Diary, 14 December 1940, Archives of American Art.

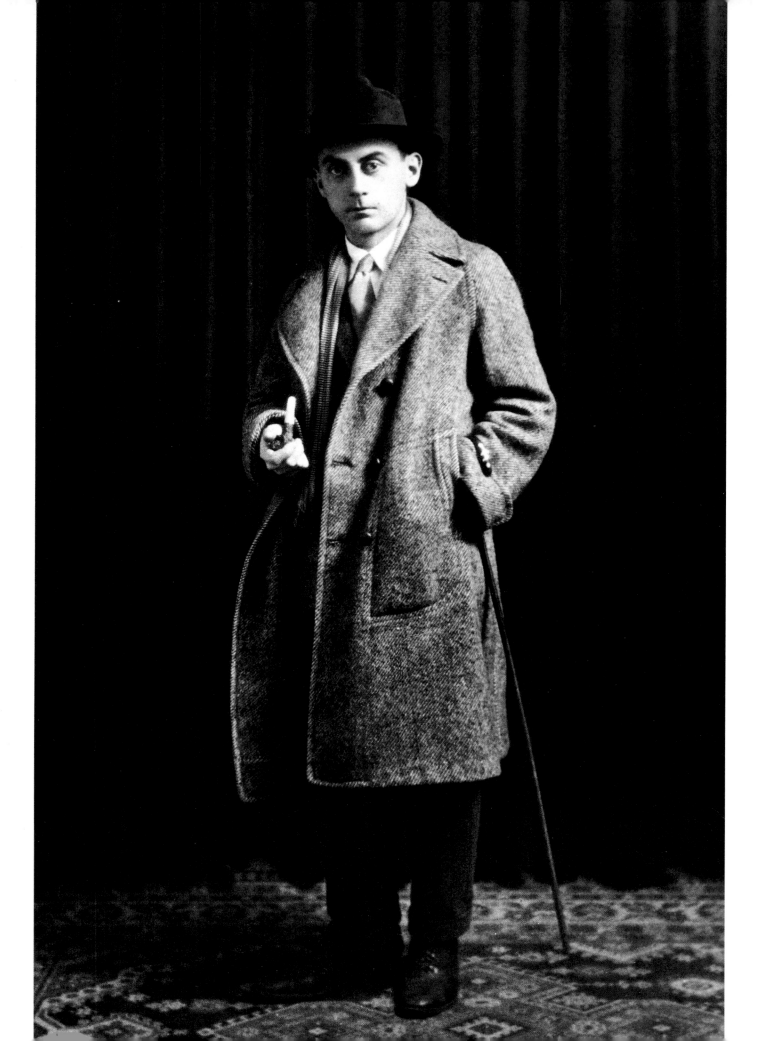

CHAPTER SEVEN
CANDOR AND PERVERSION IN NO-MAN'S LAND

Roger Shattuck

Man Ray had connections. He moved as easily from one social group to another as from one country to another. He seemed to be always on familiar ground. When this short, determined American arrived in Paris in 1921 at the age of thirty, he brought with him an old theatrical trunk full of works of art. He also had with him a few hundred borrowed dollars, no knowledge of the language, and hopes that a French friend he had known for five years in New York would meet the boat train. The friend, Marcel Duchamp, was waiting on the platform at the Gare Saint-Lazare and took him that afternoon to the café Certà in a dusky glassed-in *galerie* near L'Otéra. The dada group of moonlighting medical students and writers met there every afternoon dressed like Man Ray himself in suit, tie, and fedora (fig. 259). It was 22 July, a date he later changed to Bastille Day. At the Certà, André Breton, Louis Aragon, Philippe Soupault, Paul and Gala Eluard, Jacques Rigaut, and Theodore Fraenkel welcomed Duchamp's friend more with gestures than with words. Age meant a great deal to this exuberant band. Breton, the oldest at twenty-five, was ten years younger than Duchamp and five years younger than Man Ray. The dadaists were eager to add to their number an experienced American who had found his way in New York to an artistic dissidence and extremism close to their own. Always independent, more protected than hindered by being an outsider, Man Ray stayed with the French group through the next twenty years of unruliness and adventure.

To the young men in the café Certà, the summer of 1921 was the doldrums. In 1919 Breton, Soupault, and Aragon had launched

259 *Self-Portrait*, 1920, photograph

an anti-art review, ironically named *Littérature*, and devoted themselves to automatic writing and discovering the secret street life of Paris. In January 1920 they invited to Paris from Zurich the Romanian dada poet and notorious public agitator Tristan Tzara. For two seasons the self-constituted demolition squad outraged or entertained the art world and themselves with a series of manifestos, public meetings, and violent demonstrations. In May 1921 they threw their full support behind Max Ernst's first Paris exhibit of collages; to much of the French press, a German artist was still *un sale boche*. Ten days later in a crowded concert hall and with full judicial robes and procedures, Breton staged a mock trial of the eminent author Maurice Barrès.

But such a trial raised awkward problems. If dada stood for the flaunting of all constraints and for total freedom, in the name of what law could anyone accuse anyone of an infraction? By the autumn that followed Man Ray's arrival, the raucous, yet fragile, dada movement had fallen apart into three clusters around Tzara, Breton, and Francis Picabia. Breton was himself virtually put on trial for proposing a plan as serious as a huge international congress to consider the state of European culture. It took three years to construct out of the ruins of dada a new enterprise that would be called surrealism.

During the interval, which was both slack and tense for the dadaist-surrealist group, Man Ray simply followed the connnections he found within his reach. Before he had unpacked the works in his trunk, his new friends proposed that he provide the first exhibit at the Soupaults' Librairie Six gallery. Through Picabia's first wife, Man Ray met the fashion designer Paul Poiret and began taking commercial photographs for him. By the time of his December opening, May Ray had started the portrait photography that brought him growing celebrity and a stream of famous sitters—French, American, English, and Irish. He had also begun learning French from Kiki, the popular artists' model and Montparnasse figure who became his mistress for nine years.

In the catalogue of the Librairie Six show, the dadaists rivaled one another in their fabulous descriptions of Man Ray as a chewing-gum millionaire turned artist and come to Paris to bring a new poetic springtime. Among the densely packed balloons at the opening, Man Ray met the fifty-five-year-old composer Erik Satie. They went out to warm up with a grog in a café. Coming back, Satie helped Man Ray buy a flatiron and tacks for the self-defeating *Cadeau* he constructed on the spot and added to the items on exhibit (fig. 204). Also at that opening, Man Ray's guest Matthew

Josephson met Louis Aragon and through him the rest of the dadaists. Because he could speak reasonably fluent French, Josephson became the only American who participated in the group's discussions and celebrations. Also at this time, Tzara became enthusiastic about Man Ray's cameraless rayographs. The Romanian contributed the influential preface to the album in which the first rayographs were published, *Les Champs délicieux* (1922). (Two years earlier, Breton and Soupault had called their automatic writings *Les Champs magnétiques*.) When Breton gave a talk in November 1922 at the Atheneum in Barcelona on the state of the arts in France, he devoted as much time to Man Ray as to Duchamp and Picasso. Within a short while, living what he called a double life between commercial photography and art, Man Ray had arrived. His sense of humor and his genius inspired André Thirion to write the most succinct of all biographies: "Man Ray had an important position in Montparnasse because of his inexhaustible inventiveness, his friendliness, and the new use he made of the camera. He dazzled us all with his cars. And the girls he went out with were beautiful."[1]

Neither wealth nor social standing gave Man Ray the connections that opened his way to success in Paris. He had earned them during twelve hard years as a fledgling artist in New York. While he was steadily employed as a draftsman for a map publisher, his own work recapitulated the stages of Western art up to the 1913 Armory Show. That huge display of the latest European work seemed made to order for this young American who had chosen art as his calling. At twenty-two, already a habitué of Stieglitz's Gallery 291 of photography and painting, he left his Jewish family and moved to a house in rural New Jersey. He took a new name, married a young Belgian woman with a child by a previous husband, and found a set of new friends among writers, artists, and anarchists.

Everything pointed to Man Ray's independence and resolute purpose. Through Stieglitz, through his well-read wife, Adon, and through his new friend Marcel Duchamp, Man Ray educated himself spottily in literature, art history, and philosophy. In *Self Portrait*, he states that in 1913 or 1914 Adon produced out of a crate of books works by Baudelaire, Mallarmé, Rimbaud, Lautréamont, and Apollinaire and translated them for him. His chronology may waver a bit, but there is no denying that he picked up an impressive French background without the language. The three single-issue avant-garde reviews he published, the "Ridgefield Gazook" (1915), *TNT* (1919), and *New York Dada* (1921, with Duchamp), display his own spirited originality and anarchist humor more than

they reveal the influence of reviews from Zurich and Paris. Appropriately, Duchamp took the ferry from Manhattan to look up Man Ray in New Jersey, not vice versa. By the time Man Ray finished *The Revolving Doors* in 1917 (figs. 55–64), he had assimilated the formal innovations of cubism and futurism, of machine art, abstraction, and collage. He was working on his own. "I couldn't go back; I was finding myself."[2]

Displayed with all their provoking titles as the centerpiece of his third one-man show at the Daniel Gallery in 1919, *Revolving Doors* remained renderings on paper and were never translated into the series of paintings he had once planned. But they represented Man Ray's state of mind at that time better than the large-scale painting *Rope Dancer* (fig. 52). The colored cutouts of *Revolving Doors* developed a brand of geometric-anthropomorphic fantasy that we can associate either with nineteenth-century caricaturists like John Tenniel and Grandville or with modern makers of the whimsical grotesque like Paul Klee and Max Ernst. Aerographs and photographs, which he conceived of not as mere records but as independent works, would soon give him further opportunities to distance himself from traditional easel painting.

Two photographs of 1920 have particular significance. One shows a large lumpy object covered with a rug or heavy matting and firmly tied with rope (fig. 74). Its title, *The Enigma of Isidore Ducasse*, underlines the uncertain identity of the shape, which could be vaguely human, or animal, or mechanical. The famous simile from Lautréamont's *Les Chants de Maldoror*, "lovely as the fortuitous encounter on a dissecting table of a sewing machine and an umbrella" (*chant sixième*), has led many observers to see in the round projections the form of a sewing machine. In any case, Man Ray assembled the amorphous object in his New York studio, photographed it, disassembled it, and kept only the print for exhibition. The cropping and title of another photograph, *Dust Raising* (fig. 148), exploit ambiguity in a different fashion. En route to identifying the dust-covered shape as Duchamp's *Large Glass* (*The Bride Stripped Bare by Her Bachelors, Even*), we respond to various cues that suggest both landscape (oblique perspective, straight lines like roads) and cloudscape (clumps of dust in the foreground). The photograph masks its subject more than it displays it. In both cases, since the original assemblage or object has ceded its existence to the photographic image, we adopt an aesthetic attitude toward the photograph. These are not identification pictures but works of art in themselves.

Because of the presence of these two photographs in his lug-

gage, along with several paintings, Man Ray arrived in Paris as an involuntary smuggler. He relates in some detail the misleading explanations he gave the customs inspector about the strange objects in his trunk. The works, however, cleared the severe inspection of not only the French customs service, but also Breton and the dadaists. They had strict regulations, based in part on the attitudes of Rimbaud and Lautréamont and more recently Jacques Vaché, who "kicked any work of art away from him with his foot." The dadaists excluded from their universe art for art's sake. According to Breton, dada works had to "lead somewhere"—to a revision of moral and aesthetic values, to a new spark of lucidity, even to a nihilistic "nothing."[3] Max Ernst's collages passed inspection as antipainting, and in the catalogue preface to Ernst's first Paris show in 1921, Breton referred in his first sentence to the moral blow administered to painting and literature respectively by photography and automatic writing. Man Ray's collection passed dada muster for similar reasons. Objects and photographs figured prominently among his works; few were easel paintings. He often chose enigmatic and humorous titles. These factors prompted the dadaists to accept Man Ray as a fellow anti-artist who had liberated himself from traditional art.

Despite appearances, Man Ray introduced into the dada movement works that obliquely or covertly incorporated principles of design and form, color and line long associated with Western art. The sackcloth texture, diagonal trussing, and looming relation between figure and ground in *The Enigma of Isidore Ducasse* are carefully arranged within a conventional frame to suggest, precisely, the fetishism of an undivulged work of art. *Dust Raising* does not mock the category of "art"; rather it suggests the build-up on Duchamp's work-in-progress of a special kind of reverse patina or aura, not a rich layer of color but a sedimentation that evokes burial and archaeological rediscovery. Furthermore, Man Ray's prints seem to have convinced the dada group almost overnight that the unpredictable results he obtained from a partially mechanical process were particularly appropriate to their anti-art stance in *Littérature* and later in *La Révolution surréaliste*.

Late in life Man Ray made a statement that applies to his whole career: "Everything is art. I don't discuss these things anymore. All this anti-art business is nonsense. They're all doing it. If we must have a word for it, let's call it Art."[4]

The quiet, contraband artist who supplied dada and surrealism with art in the form of photography and displaced objects like *Cadeau*

had three interchangeable garments in his wardrobe: the garments of mystery, humor, and the erotic. He sometimes wore all three at once. "Mystery—this was the key word close to my heart and mind," he said.[5] His objects were "designed to amuse, bewilder, annoy." Many of his self-portraits served a similar function of mocking provocation. One of them shows the artist, with only a bathrobe to cover his nakedness, standing next to a bed and close to a nude photograph (could it be a mirror?) of Lee Miller the beautiful on the door beside him (fig. 260). Sensuous floral wallpaper fills the rest of the composition. In another self-portrait, he lounges in double-breasted suit and tie, smoking a cigarette, in what is obviously a lighting setup for dress models. He called it *Fashion Photograph* (fig. 261).

This tendency toward spoof declared itself very early in Man Ray's free-wheeling use of language. The one irrepressible number

260 *Self-Portrait*, ca. 1929, silver print

261 *Fashion Photograph*, ca. 1930, silver print

262 *Le Violon d'Ingres*, 1924, silver print

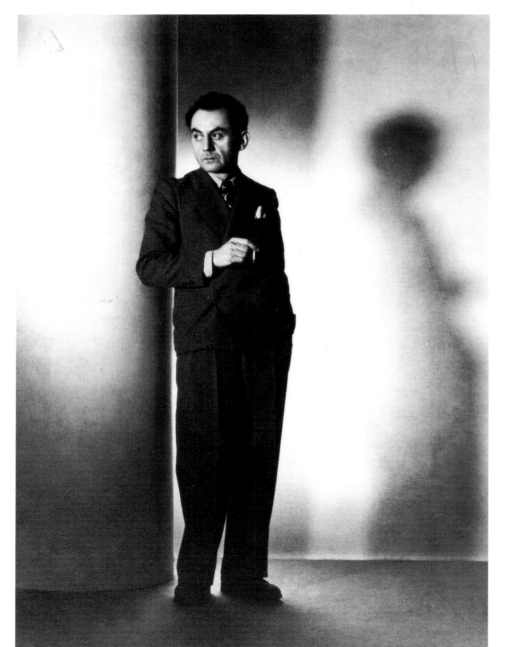

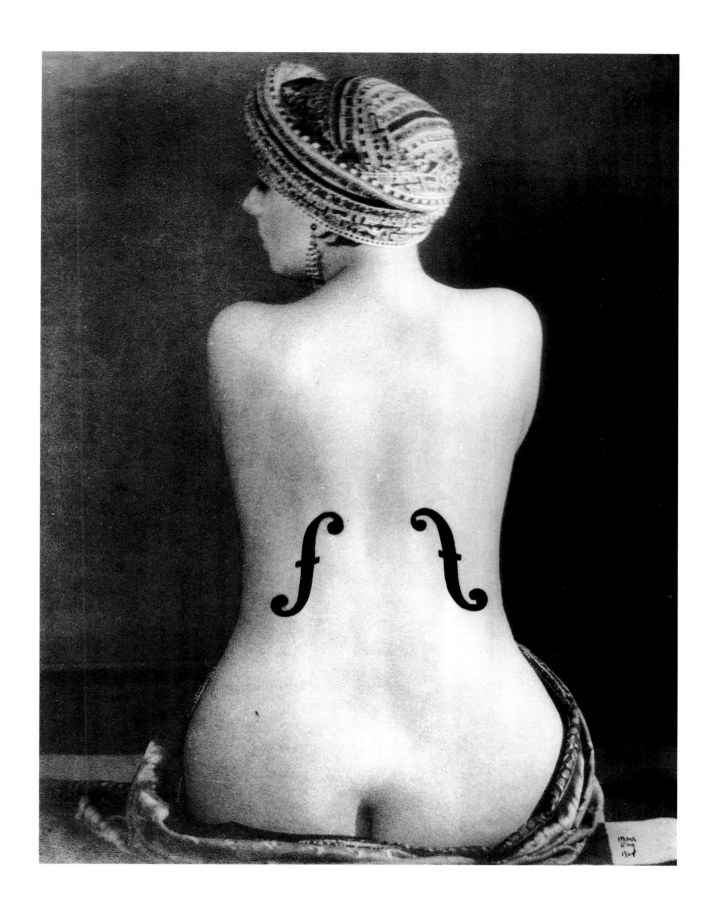

of the "Ridgefield Gazook" in 1915 reveled in puerile puns and portmanteau formations. "How to make tender buttons itch." "Soshall science." "Art Motes." This low level of wordplay became somewhat more subtle after he met Picabia and especially Duchamp, whose style of sophisticated verbal invention increasingly displaced the plastic components of his anti-art objects. Man Ray's titles, however, do not reliably endow his works with undertones of mystery, as Magritte's and De Chirico's titles do, or with innuendos of eroticism and humor, as Duchamp's do. Only *Violon d'Ingres* (fig. 262) sets off an inexhaustible series of associations that combines mystery, humor, and the erotic. I cannot help wondering which (presumably French) collaborator helped him find the multiple visual-aural pun that rhymes violin shape with woman's torso, with the French expression for hobby, with a famous composition by Ingres—and more. Does the title of this photograph that apes a painted nude tell us that photography was only Man Ray's hobby? In any case, Man Ray never gave up on words. At the end of *Self Portrait*, he twice refers to reversing the Chinese proverb to produce the notion that one word is worth a thousand images. "In a life devoted to the graphic arts, I have felt more and more a desire to supplement my work with words."[6] He wrote those words in the book that represented that very supplement.

263 Man Ray's studio, rue Ferou, 1987

Man Ray's wardrobe was not his only resource. Another reason why he won a place for himself as an artist in several media is that he was handy—handy not so much with brushes and words as with things and devices (fig. 263). As a young boy he built a soapbox cart that looked like a locomotive and devised a sheet-brass lampshade with decorative perforations made on his mother's sewing machine. He excelled more in mechanical than in artistic drawing. Throughout his life he never stopped selecting objects from his environment and displaying them with titles intended to generate a steady cultural-aesthetic current of the unexpected. One of his first creations in Paris was *L'Hôtel meublé* (fig. 205). The small wooden assemblage (a combination bookshelf/floor plan/cabinet) crosses the seamy connotations of life in furnished rooms with a neat structure suggesting the niches and categories of the mind. One of his last objects, *Etoile de verre*, is a fragment of glass glued onto painted sandpaper (*papier de verre*) to make a dim pun and a striking facsimile of a seascape (fig. 264). This handyman worked steadily at his chosen tasks and achieved the rewards he deeply desired. The most ingenuous and unpretentious sentence he ever uttered describes his carving out a new life for himself in Hollywood during World War II: "Well, now I had everything again, a woman, a studio, a car"—

318

264 *Etoile de verre*, 1965, sandpaper, glass, and chalk, Collection Juliet Man Ray, Paris

a down-to-earth version of "A loaf of bread, a jug of wine, and Thou," without the sentimentality.[7]

By the time Man Ray walked into the café Certà in Paris, he had also found his pace. Here more than anywhere he revealed himself as a cultural and artistic crossbreed. His formative years in and around New York City gave him many of the characteristics of a young man in a hurry. Most of the early incidents in *Self Portrait* illustrate the rapidity with which Man Ray wanted to work through the stages of art-school training and reach the contemporary scene. By the end of his life, he perceived that swiftness arose out of long years of discipline, as in the case of the Chinese artist who spoke of the lifetime of practice required to draw one adequate dragon. "In painting, with skill and new techniques," he said, "I sought to keep up with the rapidity of thought, but the execution still lags behind the mind as it does behind perception."[8] To a large extent, Man Ray learned such patience and wisdom from his French friend in New York, the artist who retired from active painting before he was thirty. Duchamp's coolness and detachment left a deep mark on Man Ray. The word *leisure* keeps recurring in *Self Portrait* in an unselfconscious fashion. One of the few significant reasons he gives us for not devoting himself more to film had to do with the tension generated by its limited period of screening: "I prefer the permanent immobility of a static work which allows me to make my deductions at my leisure, without being distracted by attending circumstances."[9] Not unexpectedly, he projected this pace, this sense of being a spectator of life and art, even a certain laziness, onto the ethos of Paris:

I'd go into hiding [during World War II], I thought, until I could return to my accustomed haunts: to the easy, leisurely life of Paris, where one could accomplish just as much and of a more satisfying nature—where individuality was still appreciated and work of a permanent quality gave the creator increasing prestige.[10]

He preferred to take his time. But he could also respond swiftly to commissions like Tzara's urgent request in July 1923 for a film to be used during "Soirée du coeur à barbe," or to unexpected situations like forgetting the lens when he went to photograph Matisse in the painter's studio. (He substituted a pair of eyeglasses.)

Man Ray worked at a steady, leisurely, almost lazy pace of invention that arose both from a certain detachment from his surroundings—always the American in a foreign culture—and from confidence in his materials—always the handyman and jack-of-all-trades.

Man Ray chose to live peacefully with two anomalies. He was an American living and pursuing a prominent career in a foreign country, and he was an artist who practiced two creative careers that were widely considered incompatible. The parallels between his situation and that of other historical figures apparently never occurred to him and have rarely occurred to his critics.

After becoming one of the most celebrated and enthusiastic supporters of the American Revolution through his pamphlets *Common Sense* and *The Crisis*, Thomas Paine carried his revolutionary zeal back to England. Two years later, his stinging reply in *Rights of Man* to Burke's *Reflections on the Revolution in France* (1790) was condemned as seditious libel. Paine had already escaped to Paris. There he participated in the French Revolution as an elected delegate to the National Convention and later to the Assembly, and as an appointed member of the Committee of Nine to frame a new constitution. Unable to speak French, imprisoned for ten months as an enemy alien (i.e., of English birth) until James Monroe obtained his release as an American citizen, aging and sick with a malignant fever contracted in prison, Paine remained one of the few international figures who played a significant role in French revolutionary history. He had the courage to oppose on humanitarian grounds the death penalty for Louis XVI. In prison he wrote the first part of *The Age of Reason*, a powerful deistic pamphlet that attacked the superstition and repression of revealed religion. Later, Paine wrote two more books of political criticism and theory. When he returned

to the United States in 1802, he did not fare as well as Man Ray in 1940 in California. His religious and economic iconoclasm exceeded the limits of the new democracy.

We tend to forget that during the crucial decade of the French Revolution, Paine was welcomed into the official assemblies of the new government seething with radical ideas about the transformation of society and everyday life. These bodies contained the intellectual ancestors of the young men who welcomed Man Ray to the café Certà in 1921. Amid the excitement, both men protected their special status by remaining *bricoleurs* and inventors. Paine's schemes to design and promote iron bridges resemble Man Ray's discoveries in photography. Their lack of linguistic fluency as well as an incorrigibly independent, even "American" strain in their characters kept them—for a time at least—at a safe distance from the Parisian battles. It seems inevitable that, at the end of their careers, both men would fall from notoriety into comparative obscurity.

James McNeill Whistler provides a counter example. His early drawing skills earned him a job in cartography, as later did Man Ray's. But having learned fluent French in Russia as a boy, the dandified and witty Whistler was at home immediately in France and in England. Working first in Paris, he made a name for himself at the Salon des Refusés in 1863 and appeared in a group portrait with Delacroix, Fantin-Latour, Baudelaire, and Manet—all before he was thirty. In London he particpated in the pre-Raphaelite movement as independently as Man Ray collaborated with the dadaists and surrealists. But in almost every respect, Whistler's and Man Ray's approaches to their artistic calling differed. Whistler sought every opportunity for outrage, publicity, conflict. His fierce gregariousness and taste for adventure inevitably led him to courtroom disputes, scandal, and debts. Man Ray apparently got along with everyone—except a few envious Americans in Paris who thought he must be a fraud or a snob to know so many French artists. He systematically avoided politics, crowds, demonstrations, arguments. He was responsible with money, whereas Whistler was a spendthrift. They practiced two different ways of succeeding as an American abroad.

The revolutionary journalist John Reed represents a third way, based on near total identification with a foreign cause. Three years older than Man Ray, he reached Russia at age thirty in 1917 and immediately wrote *Ten Days That Shook the World*. He approached closer to revolution than Paine, worked for the Soviet propaganda bureau, and welcomed appointment as Soviet consul in New York. (The United States turned down the arrangement.) Reed was buried

in 1920 in the Kremlin. In his case the man, in both his professional and personal life, was devoured by conversion to a virtually religious cause. Man Ray loved Paris deeply but kept his feet firmly planted on the ground of his career as an artist and photographer, serving no cause more limited or limiting than individual freedom. He was admitted directly into high-party councils of dada and surrealism, as Reed was welcomed by Soviet leaders. But Man Ray refused to be an ideologue and maintained a special status in which he was not subject to party discipline and politics. Partly through his own temperament and his experience in New York, benefiting from the example of Duchamp as independent senior partner to everyone, Man Ray succeeded better than Paine, Whistler, and Reed in remaining patiently himself, an uninsistent American. He sustained the role through two of the most turbulent decades of artistic activity in the history of Paris. The fact that he was neither an intellectual nor middle class probably protected him against the temptations of ideology and snobbery.

Near the end of his life, in a series of interviews with Pierre Bourgeade, Man Ray pointed out in passing: "In my first film, *Etoile de mer* (*Star Fish*, 1928) there are no doors. Doors have disappeared. People disappear without going through doors because there aren't any."[11] Man Ray's memory failed him about the film, two scenes of which prominently feature a door. Yet the motif of a universe without boundaries, without compartments, remains significant. Duchamp, by building a mock-up of a two-way door in a tight corner of his Paris studio, proved that a door can be simultaneously open and shut. In his early writings especially, Breton speaks of leaving doors open so that people can come freely in and out of his life. Through out-of-focus shots and unfettered editing, Man Ray went a long way in *Etoile de mer* toward eliminating barriers. Nonalignment functioned from the beginning as a principle of his artistic conduct. He moved unrestrained among nationalities, social classes, artistic genres, and rival schools.

One aspect of this openness was his willingness to collaborate. A lot could be said about his prolonged collaboration with Duchamp, and about the works he produced with Tzara and Eluard. Reversing the usual order of events surrounding the French *livre d'art*, poets set down words to "illustrate" images that Man Ray had already created. Breton relied on him as house photographer for *La Révolution surréaliste* and used him to illustrate his most important literary works, principally his novel *L'Amour fou* (1937). Man Ray's relations with Kiki, Lee Miller, Adrienne, and Juliet add

colorful chapters to the history of the manifold form of collaboration known as "the artist and his model."

Yet his principal collaborations may have been with artists he never met in the flesh. In 1925 Breton had the aging poet Saint-Pol-Roux "Le Magnifique" visit Man Ray's studio for a portrait photograph. Some twenty-five years before, the poet, in his flamboyant early days, had been photographed in the Nadar studio. Man Ray cannot have lived very long as a photographer in Paris without coming up against the figure of Félix Tournachon. Under the name of Nadar, he drew caricatures, wrote journalistic pieces, developed the photographic portrait into a stunningly successful and subtle art form, and constructed his own balloon for aerial photography and publicity. Man Ray and his biographers never mention Nadar, but it is hard to believe that his blend of art, technology, and self-promotion did not play a role in Man Ray's career decision six months after he arrived in Paris: "I now turned all my attention to getting myself organized as a professional photographer."[12] His portrait photographs of famous persons, particularly in the twenties and thirties, practiced a combination of straightforwardness and sensitivity to the sitter's personality and vocation that lies close to Nadar's work. The miniature shots of the surrealists pasted up as a chessboard refer obliquely to Nadar's Rogues' Gallery displays of painters and fashion models (fig. 265). The blurred nude photograph (probably of Kiki) that appears in the second issue of *La Révolution surréaliste* (1925) occupies an artistic space close to that of one of Nadar's rare nudes (figs. 266, 267).[13] Nadar's model is traditionally identified as Christine Roux, the inspiration for Musette in Henri Murger's *Scènes de la vie de bohéme* (1851). In both photographs, the model holds her arms over her head and reveals her shapely body in a pose reminiscent of Ingres's *La Source*.

Much more has been made of Man Ray's collaboration with Lautréamont. On several occasions, Man Ray stated that his first wife, Adon Lacroix, introduced him to *Les Chants de Maldoror* in 1914. Unless she had among her books a very rare early edition, it seems more likely that he encountered the tortured imagination of Lautréamont in 1919 in the pages of *Littérature* or in the following year in the edition published by La Siréne. In fact, 1920 is the date assigned to the unidentified wrapped object now known as *The Enigma of Isidore Ducasse*; Man Ray was still in New York.[14]

Man Ray's claims to have been marked by Lautréamont several years before the dadaist-surrealist group discovered him ring less true than his statements about the importance of his discovery of the Marquis de Sade. In his conversations with Bourgeade, Man

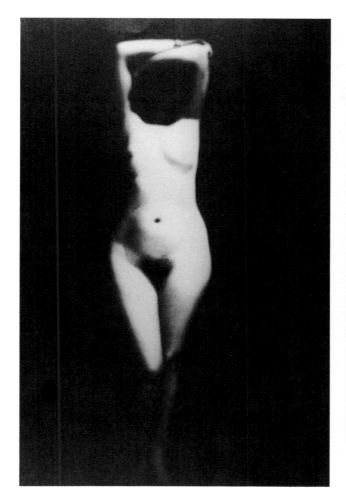

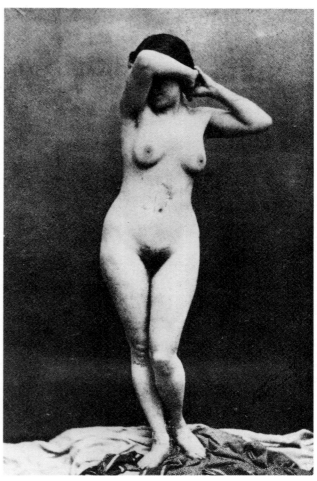

Ray told how one of his neighbors in the Montparnasse building where he had his first studio, barely a year after his arrival in Paris, was the devoted Sade editor and expert Maurice Heine. Heine asked Man Ray to photograph the fragile fifty-foot roll of paper on both sides of which Sade had written *The One Hundred Twenty Days of Sodom* in prison. Intrigued, Man Ray investigated Sade's career more thoroughly than he had that of any other historical person. And he went on to read all of Sade's novels:

> above all *Aline and Valcour* which is in my opinion the most important because all political questions are treated in it with very little pornography. It's a bit boring to read, that's true, but I read it from beginning to end. In this book Sade talks already of a United States of Europe! He solved all the problems![15]

265 *L'Echiquier surréaliste* (*Surrealist Chessboard*), 1934, photomontage, Vera and Arturo Schwarz Collection, Milan

266 *Kiki*, ca. 1923, silver print

267 Nadar, *Christine Roux*, ca. 1855, Bibliothèque Nationale, Paris

In 1940 Man Ray "waxed fervid and eloquent" about "his hero" to Henry Miller in Hollywood: "Sade represented complete and absolute liberty."[16]

Man Ray's respectful opinion of Sade's imaginary African country of Butua makes one wonder if he understood the language of *Aline and Valcour*. Butua's "incredible liberty" consists of the total, institutionalized subjugation of women to men's pleasure (female orgasm, considered dereliction of duty in servicing a man, merits the death penalty), absolute tyranny of the sultan, human sacrifice, and cannibalism. "Sade showed what you could do if you had power."[17]

Man Ray's blind enthusiasm when he talked about Sade disappears in the images he devoted to the writer-philosopher. Their subtlety points to a whole different circuit through which he could channel human fantasies about power and pleasure. The series of photographs and paintings, executed over a twenty-five-year period, turns on three primal scenes. In the earliest scene, later restated in the oil painting *Aline et Valcour* (fig. 268), an artist's articulated manikin reclines in the foreground between a cone and a sphere. Out of the background looms a lovely (severed?) head of a blindfolded woman, her chin resting on a green book, the whole encased under a gleaming glass bell that stands on a bureau. From

268 *Aline et Valcour*, 1950, oil on canvas, present whereabouts unknown

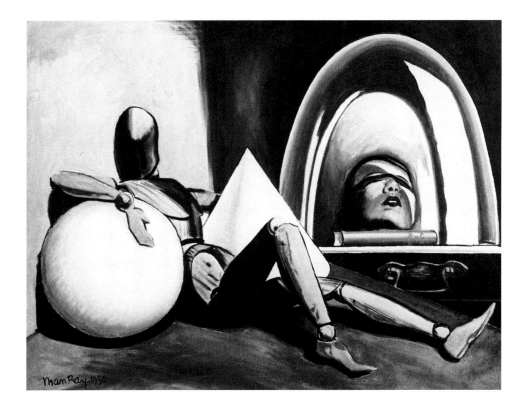

Sade's novel of systematic repression of everything except male pleasure, Man Ray distills a cryptic, almost lyric dream image. Only the faint decapitation motif suggests the carnage and algolagnia of Sade's narrative. The painting conveys the impression of a code, a rebus. The book is closed, as is the drawer. The woman's eyes cannot see. The wooden manikin is only a replica of a human being. All communication seems blocked.

One assembles the cues of *Monument à D. A. F. de Sade* (fig. 269) with greater reward. The folds of naked flesh are framed by the cutout of an inverted cross. It takes a moment to recognize that the soft folds belong to the buttocks of a person seen close-up from behind, with his or her left leg raised as if on tiptoe. The superimposition of a rigidly ruled cross over delicate asymmetrical shadings from a particularly private part of the human body shouts with connotations: beauty, excrement, vulnerability, asininity, intimacy, sodomy, black magic, incongruity, blasphemy, and more. Here the simplicity and familiarity of the elements combined suggest that Man Ray was spoofing the myth of Sade as an author who attracts by corrupting and whose perversion some would equate with innocence. *Monument* remains one of Man Ray's most successful and witty compositions.

In 1938 he painted another striking work that identifies the marquis as its inspiration: *Imaginary Portrait of D. A. F. de Sade* (fig. 224). A massive masonry head (with red lips and one blue eye) bursts out of the semblance of a masonry body in the foreground and looks toward the Bastille, in flames in the background. In the middle ground, small figures lit by the fire enact scenes of struggle and defiance—or perhaps celebration. The great stone face missing one eye and labeled below in large capitals "S A D E" conveys a menacing authority as it contemplates the holocaust. The composition—a humanoid figure on the left imagining or witnessing a possibly frightful and enigmatic scene in the right background—recurs in *Aline et Valcour*. Paradoxically, the seemingly indestructible figure of stone decrees in the subscription painted on the canvas below that the "traces of my tomb shall disappear from off the face of the earth, as I hope my memory shall be wiped out in the minds of men"—the last sentence of Sade's will. Those words deeply impressed Man Ray, who seems to be implying the opposite result. As the stones of the Bastille were looted and reused in hundreds of other structures, Sade's teachings will "disappear" into the subconscious musings of mankind. Man Ray's response to Sade is troubling and more ambiguous in his images than in his words.

Man Ray described Maurice Heine, who devoted most of his

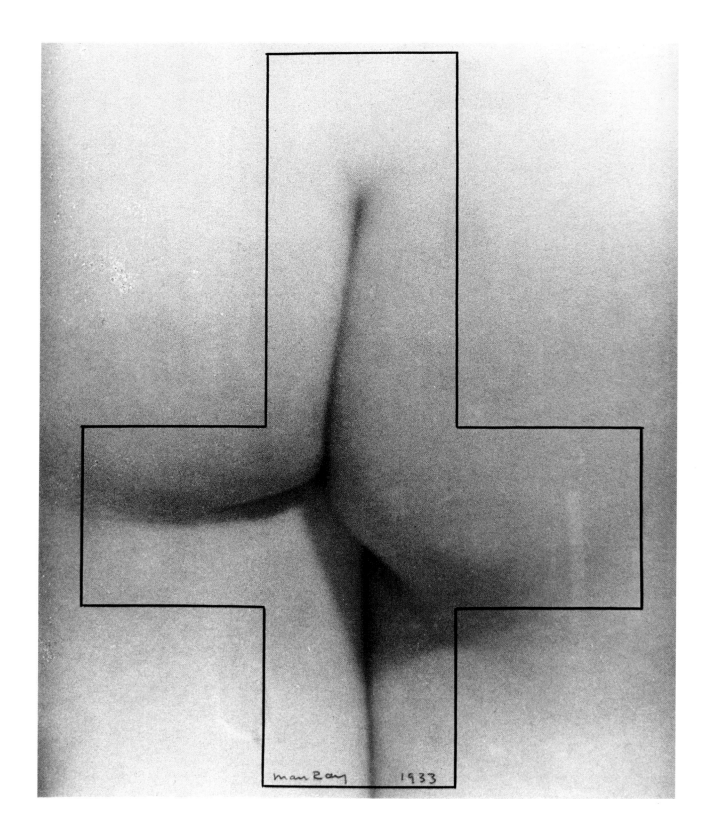

life to rescuing and publishing Sade's work, as a sweet and gentle man. I read this description as an involuntary anti-Sadean self-portrait, another of his major genres. For Man Ray's favorite collaborator was himself. Among his self-portraits, there is a brief series worth lingering over. In 1937 Man Ray experimented with a variation on the rayograph, this time using a camera with the shutter open in the semidark. Sitting in front of it with a small flashlight, Man Ray "drew" in the air and thus onto the film (fig. 270). The white arabesques of movement between blobs of rest have a physical scale that corresponds to the reach of the arm of the blurred, yet recognizable, artist whose body fills the frame. We discern in the background works by Man Ray and other artists. In *Space Writings*, the photographer has recorded himself as an easel

269 *Monument à D. A. F. de Sade*, 1933, silver print

270 *Space Writings*, 1937, photograph

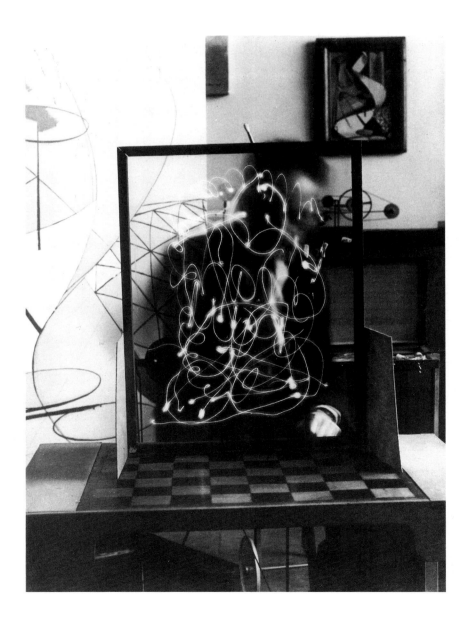

artist painting in framed space, a proper tribute of the photographer to the painter. It is almost a spectral portrait.

The rapid ten-year evolution of Man Ray's art in New York records his discovery of flatness, of the picture plane as reaffirmed by at least a half-century of European painting culminating in cubism. What happens in *Space Writings* replicates a tendency visible in many of his early works like *Dance*, *Rope Dancer*, and *Revolving Doors*. By inscribing movement through an overlay of images, as suggested by cubism, futurism, and Duchamp's famous *Nude* in particular, Man Ray began to flatten out not only space but time as well. The long exposure time that remains undeclared and unfelt in *Dust Raising* cannot be overlooked in *Space Writings*. A major segment of Man Ray's best work, encompassing both machine motifs and the human figure, studies movement or narrative crossed with a static freeze-frame image. He apparently never reproduced Etienne Marey's and Eadweard Muybridge's experiments with multiple cameras and motion study. But in works like *Revolving Doors* and *Space Writings* he expressed a desire to test Lessing's law: the image describes; the word narrates. The format of *Revolving Doors*—images hinged to a vertical stand, permitting the viewer to flip through the plates easily and rapidly—suggests a narrative sequence. At the same time, each separate colored plate in the group forms a free-standing multiple overlay of elements that projects the tracery of their possible permutations. A single well-chosen image encroaches on narrative time. As a photographer, Man Ray never lost a powerful sense of the *instantané*, or snapshot that both arrests and affirms motion. Some of this quality was evident early on in the plates of *Revolving Doors*. The precisely drawn spiral that forms the vertical armature of *The Meeting* lays out around itself the space and time for the two caricatured male and female cutouts to turn and maneuver as on a carousel (fig. 58). Thirty years later, Man Ray followed similar principles in painting his other important series, *Shakespearean Equations* (figs. 254–56). Photographs taken in the Poincaré Institute of artificial objects constructed to illustrate mathematical formulas provided him with templates, which he varied and combined freely. By letting the "abstraction" reside in the mathematically generated models, Man Ray could first photograph and then paint their convenient concreteness. A mixture of playfulness and formalism propels *Shakespearean Equations* and—more successfully—*Revolving Doors*. Those images iron time flat and present it as a laminated series of stencils.

Man Ray remained a studio artist. Except for a few commis-

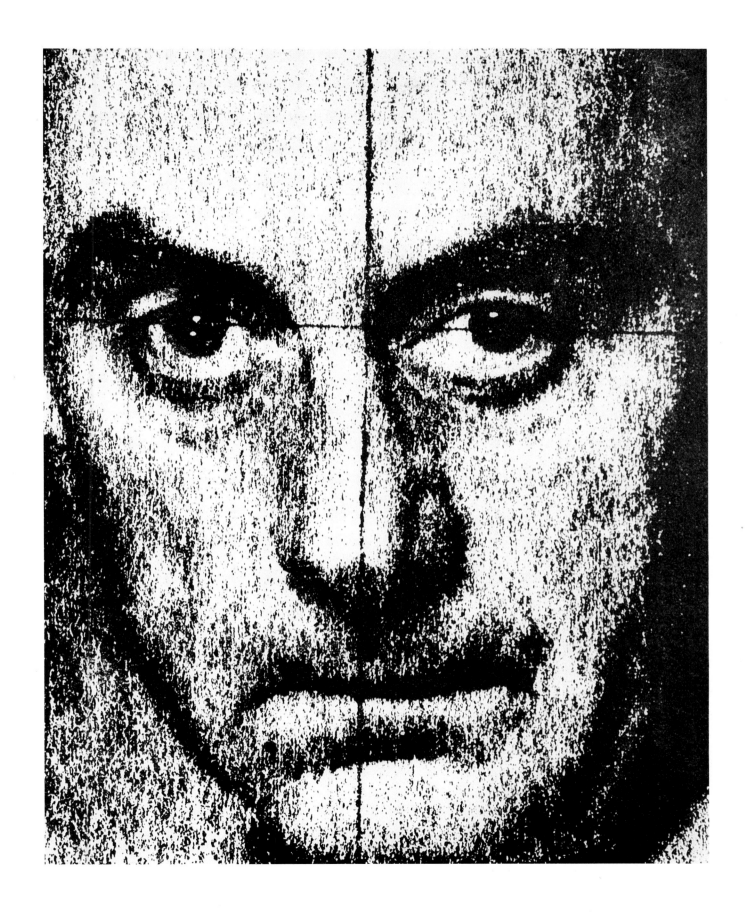

sions (it was Tzara who dragged him to photograph Proust on his deathbed), he did not work as a journalistic or candid photographer. His late statement about his hybrid vocation rings true: "I paint what I cannot photograph, something from the imagination, or a dream, or a subconscious impulse. I photograph the things that I don't want to paint, things that are already in existence."[18] He never confined himself to bed like Proust with his manuscripts banked around him. But his life and work centered in the restricted city spaces he designed for himself in New York, Paris, and Los Angeles. After two years in rural New Jersey, he never again aspired to work *en plein air*. His location of choice was a personal downtown quarterdeck or headquarters where his handiness, his freedom, and his penchant for collaborations could find their mutual compatibility. Apparently, he never developed studio fever; his photography, his painting, and his three-dimensional constructions fed and foiled one another in ways that kept Man Ray constantly on the move artistically. He may have been right in considering himself lazy. But his laziness was shot through with an insatiable restlessness. "Man Ray has one fault. He never does the same thing twice."[19] No, Bourgeade was wrong. That's a description of Duchamp, the cat that walked alone. Man Ray repeated himself often, always with enough variation in medium and approach to produce a new work. For instance, the self-portrait he offered as a frontispiece to his autobiography is a modified and reversed replica of *Monument à D. A. F. de Sade*. Instead of a backside seen through an inverted cross, he presented his own full face with cross hairs running through his pupils and aimed to catch him precisely between the eyes (fig. 271). I am, the image says, a camera-rifle-captive-model-eye-target-prey-witness-hunter-artist come out of America to explore the no-man's land between art and photography. Nothing could be more candid than my self-portrait. Nothing could be more perverse than some of my works.

NOTES

1. Thirion, *Revolutionaries without Revolution*, trans. Joachim Neugroschel (New York: Macmillan, 1972), p. 134.
2. Man Ray, *Self Portrait*, p. 71.
3. Vaché quoted in Breton, *Les Pas perdus* (Paris: Gallimard, Idées, 1969), p. 75; for dada artistic principles, see Breton, "Maldoror" in *Les Pas perdus*, p. 69.
4. As quoted in "Interview with Man Ray," in Martin et al., *Man Ray Photographs*, p. 36.
5. Man Ray, *Self Portrait*, p. 76.
6. Ibid., p. 395.
7. Ibid., p. 335.
8. Ibid., p. 397.
9. Ibid., p. 287.
10. Ibid., p. 323. Merry Foresta commented on this quotation: "What do you think was the source of Man Ray's laziness—courage or fear? Was the camera the tool of a lazy painter? The quote is a 1962 Man Ray writing about his thoughts in 1940s California about the Man Ray that had existed in 1930s France. The 1930s Man Ray—well known, fashionable, traveler to the South of France—was a different Man Ray from the defiant experimental artist of the 1920s."
11. Bourgeade, *Bonsoir, Man Ray*, p. 52.
12. Man Ray, *Self Portrait*, p. 119.
13. See Nigel Gossling, *Nadar* (New York: Alfred A. Knopf, 1976), p. 69.
14. The photograph carried no title when published on the first page of the first issue of *La Révolution surréaliste* (1924).
15. Quoted in Bourgeade, *Bonsoir, Man Ray*, p. 76.
16. Miller quoted in Schwarz, *Rigour of Imagination*, p. 322.
17. Quoted in Bourgeade, *Bonsoir, Man Ray*, p. 78.
18. Quoted in Martin, *Man Ray Photographs*, p. 35.
19. Bourgeade, *Bonsoir, Man Ray*, p. 5.

SELECTED BIBLIOGRAPHY

This bibliography represents a selection of the more important published and unpublished resources used by the authors during the preparation of this book. It is divided into "Books and Articles," "Archival Papers," and "Writings by Man Ray."

Books and Articles

A.v.C. "Man Ray's Paint Problems." *American Art News* 14, no. 6 (13 November 1915): 5.

Amaya, Mario. "My Man Ray: Interview with Lee Miller." *Art in America* 63, no. 3 (May–June 1975): 57.

Aragon, Louis. "Painting and Reality." In *Collections Commune*. Paris: Editions Sociétiés Internationales, 1937.

"Arts." *California Arts and Architecture* 60, no. 8 (November 1943): 8, 10.

Barr, Alfred H., Jr., ed. *Fantastic Art, Dada, Surrealism*. Essays by Georges Hugnet. New York: Museum of Modern Art, 1936.

Beach, Sylvia. *Shakespeare and Company*. New York: Harcourt and Brace, 1980.

Belz, Carl. "The Role of Man Ray in the Dada and Surrealist Movements." Ph.D. diss., Princeton University, 1963.

———. "Man Ray and New York Dada." *Art Journal* 33, no. 3 (Spring 1964): 207–13.

Bourgeade, Pierre. *Bonsoir, Man Ray*. Paris: Pierre Belfond, 1972.

Breton, André. "First Surrealist Manifesto." In *Manifestos of Surrealism*. Translated by Richard Seaver and Helen R. Lane. Ann Arbor: University of Michigan Press, 1969.

———. *Surrealism and Painting*. 1924. Reprint. Translated by Simon Watson Taylor. New York: Icon Editions, Harper and Row, 1972.

Camen, Roland. "Man Ray/Hans Arp, Expositions et galeries." *Paris-Montparnasse*, 15 November 1929, pp. 15–17.

———. "Photographie d'aujourd'hui." *Paris-Montparnasse*, 15 March 1930, pp. 15–16.

"Can a Photograph Have the Significance of Art?" *MSS*, no. 4 (December 1922): entire issue.

Clements, Grace. "Art: Los Angeles." *California Arts and Architecture* 61, no. 10 (October 1944): 10, 37.

Cocteau, Jean. "Lettre ouverte à Man Ray, photographe américain." In *Les Feuilles libres*, no. 26 (April–May 1922): n.p.

Coleman, A. D. *Man Ray*. Millerton, N.Y.: Aperture, 1979.

———. "The Practical Dreams of Man Ray (1890–1976)." *Art News* 76 (January 1977): 52.

———. "Returning to Man Ray." *New York Times*, 12 August 1973, pp. 16, 24.

Cowley, Malcolm. "Parnassus-on-the-Seine." *Charm* 1, no. 6 (July 1924): 19–80, 83.

Crevel, René. "Le Miroir aux objets." *L'Art vivant*, July 1925, pp. 23–24.

"Dadaism Yields to Art Machine." *New York Herald* (Paris edition), 18 July 1922, p. 2.

Desnos, Robert. "Man Ray." In *Photographic Compositions by Man Ray*. Chicago: Arts Club of Chicago, 1929.

———. "The Art of Man Ray." *transition*, no. 15 (February 1929): 264. (First published in *Le Journal*, December 1923.)

Dictionnaire abrégé du surréalisme. Paris: Galerie Beaux-Arts, 1938.

Duchamp, Marcel. "Man Ray." In *Collection of the Société Anonyme: Museum of Modern Art 1920*. New Haven: Yale University Art Gallery, 1950.

Eluard, Paul. "Notes on the Drawings of Man Ray." In *Man Ray Drawings*. New York: Valentine Gallery, 1936.

" 'Emak Bakia' by the Noted Modernist Artist Man Ray." Program for Film Arts Guild, 6 March 1927, Société Anonyme Collection.

Foster, Stephen C., ed. *Dada Artifacts*. Iowa City: University of Iowa Museum of Art, 1978.

———, ed. *Dada/Dimensions*. Ann Arbor, Mich.: UMI Research Press, 1985.

Gallotti, Jean. "La Photographie est-elle un art?" *L'Art vivant*, 1928, p. 282.

Herbert, Robert L., et al. *The Société Anonyme and the Dreier Bequest at Yale University: A Catalogue Raisonné*. New Haven: Yale University Press, 1984.

Janus. *Man Ray: The Photographic Image*. Translated by Murtha Baca. Woodbury, N.Y.: Barron's, 1980.

Josephson, Matthew. *Life among the Surrealists*. New York: Holt, Rinehart and Winston, 1962.

Jouffroy, Alain. "Man Ray devant les femmes." *XXe Siècle* 35 (December 1970): 49–57.

———. "Introduction au génie

de Man Ray." In *Man Ray*. Paris: Musée National d'Art Moderne, 1972.

Kiki (Alice Prin). *Kiki's Memoirs*. Translated by Samuel Putnam. Paris: Black Mannikin Press, 1930.

Klein, Jerome. "Art Goes GaGa as Surrealists Return in Force." *New York Post*, 12 December 1936.

Kovacs, Steven. "Man Ray as Film Maker." *Artforum* 11, no. 4 (December 1972): 62–66.

Krauss, Rosalind, and Jane Livingston. *L'Amour fou: Photography and Surrealism*. New York: Abbeville Press, 1985.

Langsner, Jules, ed. *Man Ray*. Los Angeles: Los Angeles County Museum of Art, 1966.

Lebel, Robert. "Man Ray et Duchamp avant et après." *Journal Artcurial*, no. 16 (May 1980): n.p.

Levy, Julien. *Memoir of an Art Gallery*. New York: Putnam, 1977.

Lippard, Lucy, ed. *Surrealists on Art*. Translated by Richard Seaver and Helen R. Lane. Englewood Cliffs, N.J.: Prentice-Hall, 1970.

McAlmon, Robert, and Kay Boyle. *Being Geniuses Together, 1920–1930*. Rev. ed. San Francisco: North Point Press, 1984.

McBride, Henry. "Farewell to Art's Greatness." *New York Sun*, 12 December 1936. (Conger Goodyear Papers.)

"Man Ray Finds Surrealism in Roosevelt Boat." *New York Herald Tribune*, 2 January 1937.

"Man Ray in Hollywood." *Art Digest* 15, no. 11 (1 March 1941): 14.

"Man Ray Issue," *London Bulletin*, no. 10 (February 1937).

"Man Ray: Precursor of Avant Garde Filmmakers." *Washing-ton Post*, 3 October 1970. (Library files, National Museum of American Art, Smithsonian Institution, Washington, D.C.)

"Man Ray's Remote Art." *Art Digest* 15, no. 12 (March 15, 1941): 14.

Mandiargues, André Pieyre de. "Objets surréalistes." *XXe Siècle* 36, no. 42 (June 1974): 121–30.

Martin, Henry. "Man Ray: Spirals and Indications." *Art International* 15, no. 5 (May 1971): 60–65.

Martin, Jean-Hubert, et al. *Man Ray Photographs*. New York: Thames and Hudson, 1982.

Martin, Jean-Hubert, Rosalind Krauss, and Brigitte Hermann. *Man Ray: Objets de mon affection*. Paris: Philippe Sers, 1983.

"Le Masque de verre" [pseud.]. "Les Echos." *Comoedia*, 3 December 1921, n.p.

Matthews, J. H. *Surrealism and Film*. Ann Arbor: University of Michigan Press, 1971.

Mellow, James R. *Charmed Circle: Gertrude Stein and Company*. New York: Holt, Rinehart and Winston, 1974.

Melville, Robert. "Man Ray in London." *Arts* 33, no. 9 (June 1959): 45–47.

Migennes, Pierre. "Les Photographies de Man Ray." *Art et décoration* 54 (November 1928): 154–60.

Miller, Lee. "I Worked with Man Ray." *Lilliput* 9 (October 1941): 315.

Mumford, Lewis. "The Art Galleries: Critics and Cameras." *The New Yorker* 10, no. 33 (29 September 1934): 33–35.

Naumann, Francis M. "The Early Works of Man Ray, 1908–1921." Ph.D. diss., City University of New York, 1986.

———. "Man Ray and the Ferrer Center: Art and Anarchy in the Pre-Dada Period." *Dada/Surrealism*, no. 14 (1985): 10–30. (Reprinted in *New York Dada*. Edited by Rudolf E. Kuenzli. New York: Willis Locker and Owens, 1986.)

———. "Man Ray, Early Paintings 1913–1916: Theory and Practice in the Art of Two Dimensions." *Artforum* 20, no. 9 (May 1982): 37–46.

———. "The New York Dada Movement: Better Late than Never." *Arts* 54, no. 6 (February 1980): 143–49.

"A New Method of Realizing the Artistic Possibilities of Photography." *Vanity Fair* 19 (November 1922): 50.

"New Photography Employs No Lens." *New York Times*, 6 January 1923, p. 13.

Padgett, Ron. "Artist Accompanies Himself with His Rays." *Art News* 65 (November 1966): 79–80.

Penrose, Anthony. *The Lives of Lee Miller*. New York: Holt, Rinehart and Winston, 1985.

Penrose, Roland. *Man Ray*. London: Thames and Hudson Ltd., 1975.

Phillips, Sandra. "Man Ray and Moholy-Nagy: Rayographs and Photograms." *Arts in Virginia* 25, nos. 2–3 (1985): 48–63.

Piene, Nan R. "Light Art." *Art in America* 55, no. 3 (May–June 1967): 26–35.

Pincus-Witten, Robert. "Man Ray: The Homonymic Pun and American Vernacular." *Artforum* 13 (April 1975): 54–58.

Rabbito, Karin Anhold. "Man Ray in Quest of Modernism." *Rutgers Art Review* 2 (January 1981): 59–69.

Ribemont-Dessaignes, Georges. "Dada Painting or the Oil-

Eye." *Little Review* 9, no. 4 (Autumn–Winter 1923–24): 10–12.

———. *Man Ray*. Paris: Gallimard, 1924.

———. "Man Ray." *transition*, no. 15 (1929): 264–66.

Richter, Hans. *Dada: Art and Anti-Art*. New York: Oxford University Press, 1978.

Rose, Barbara. "Kinetic Solutions to Pictorial Problems: The Films of Man Ray and Moholy-Nagy." *Artforum* 10 (September 1971): 68–73.

Rubin, William. *Dada, Surrealism and Their Heritage*. New York: Museum of Modern Art, 1968.

Sanouillet, Michel, ed. *Dada à Paris*. 2 vols. Nice: Centre du XXième Siècle, 1965.

Schwarz, Arturo, ed. *Man Ray, Carte varie e variabili*. Milan: Gruppo Editoriale Fabbri-Bompani, 1983.

———. *Man Ray: 60 anni di liberta*. Paris: Eric Losfeld, 1971.

———. *Man Ray: The Rigour of Imagination*. New York: Rizzoli International, 1977.

———. *New York Dada: Duchamp, Man Ray, Picabia*. Munich: Prestel-Verlag, 1973.

Schwarz, Arturo, Howard Risatti, and Norman Gambill. *Man Ray: Photographs and Objects*. Birmingham, Ala.: Birmingham Museum of Art, 1980.

Seitz, William, ed. *Assemblage*. New York: Museum of Modern Art, 1961.

Seldis, Henry J. "Life with Dada Casts Magic Spell." *Los Angeles Times*, 27 October 1966, pt. 4, pp. 1, 10.

"Studio Gossip." *New York Herald* (Paris edition), 4 February 1923, p. 2.

Tabard, Maurice. "Notes sur la solarisation." *Arts et métiers graphiques*, no. 38 (November 1933): 30–33.

Turner, Elizabeth. "The American Artistic Migration to Paris between the Great War and the Great Depression." Ph.D. diss., University of Virginia, 1985.

Waldberg, Patrick. "The Objects of Man Ray." *XXe Siècle*, n.s. 31 (December 1968): 65–79.

Watt, Alexander. "Dadadate with Man Ray." *Art and Artists* 1, no. 4 (July 1966): 33.

Watts, Harriet Ann. *Chance: A Perspective on Dada*. Ann Arbor, Mich.: UMI Research Press, 1980.

Wescher, Paul. "Man Ray as Painter." *Magazine of Art* 46 (January 1953): 31–37.

"With the Artists." *New York Herald*, 28 January 1922, p. 2.

Zerbib, Marcel. *Objets de mon affection*. Paris: N.p., 1968.

Zervos, Christian. "Mathématiques de l'art abstrait." *Cahiers d'art* 11, nos. 1–2 (1936): 4–20.

Archival Papers

The Archibald S. Alexander Library, Rutgers, The State University of New Jersey, New Brunswick. Periodicals and small magazines, 1920–39.

Archives of American Art, Smithsonian Institution, Washington, D.C. Diary, George Biddle Archives, 1940; exhibition catalogues, Daniel Gallery Papers; Man Ray correspondence, Paul and Mary Wescher Archives; Man Ray correspondence, catalogues, and original photographs, Edith Halpert and Downtown Gallery Archives.

Collection Timothy Baum, New York. Marcel Duchamp–Man Ray correspondence.

Sylvia Beach Collection, Princeton (New Jersey) University Library. Man Ray–Sylvia Beach correspondence and photographs by Man Ray.

Bibliothèque Littéraire Jacques Doucet, in the Bibliothèque Sainte Genèvieve, Paris. Published and unpublished material, including the archives of Tzara, Georges Ribemont-Dessaignes, André Breton, and Robert Desnos.

Nancy Cunard Collection, Delyte W. Morris Library, Southern Illinois University, Carbondale. Letters, unpublished and published manuscripts related to expatriate activities.

Galerie Aronowitsch, Stockholm. Complete album of Man Ray's *Objects of My Affection*, 1944.

Conger Goodyear Papers, Museum of Modern Art Archive, New York. Scrapbook of newspaper and magazine clippings and letters concerning 1936 exhibition *Fantastic Art, Dada, Surrealism*; Alfred Barr–Man Ray correspondence.

H. D. Collection, Yale University Library, New Haven, Conn. H. D.–Bryher correspondence concerning Man Ray, Paris, and photography.

Ferdinand Howald Collection, Department of Photography and Cinema/Library for Communication and Graphic Arts, The Ohio State University, Columbus. Man Ray–Ferdinand Howald correspondence.

André Kertész Archives, Association pour la diffusion du patrimonie photographique, Paris. Exhibition catalogues pertaining to 1920s Paris photography events.

The Carleton Lake Collection, Harry Ransom Humanities Research Center, The University of Texas at Austin. Diaries of Henri-Pierre Roché; Marcel Duchamp–Man Ray correspondence.

Henry McBride Papers, New York Public Library. Man Ray–Henry McBride correspondence.

Collection Juliet Man Ray, Paris. Letters and manuscripts by Man Ray and associates Marcel Duchamp, Katherine Dreier, Ezra Pound, Gertrude Stein, Kiki (Alice Prin), Pascin, Carl Van Vechten, Julien Levy, Virgil Thomson, Sylvia Beach, George Anthiel, Alfred Barr, Lee Miller, Berenice Abbott, E. L. T. Mesens, Georges Ribemont-Dessaignes, and Roland Penrose.

The Penrose Foundation, London. Collections of Roland Penrose and Lee Miller.

Société Anonyme Collection, Beinecke Rare Book and Manuscript Library, Yale University, New Haven, Conn. Letters, catalogues, original photographs, scrapbooks, and Man Ray–Katherine Dreier correspondence.

Gertrude Stein Collection, Collection of American Literature, Beinecke Rare Book and Manuscript Library, Yale University, New Haven, Conn. Man Ray–Gertrude Stein correspondence.

Stieglitz Collection, Collection of American Literature, Yale University Library, New Haven, Conn. Letters and manuscripts related to the reception of photography and art in Paris and New York.

Collection Lucien Treillard, Paris. Exhibition catalogues; Man Ray publications; unpublished material, including unfinished novel by Man Ray.

William Carlos Williams Collection, Beinecke Rare Book and Manuscript Library, Yale University, New Haven, Conn.

Writings by Man Ray

"Age de la lumière." *Minotaure* 1, nos. 3/4 (October–December 1933): 1–5.

Alphabet for Adults. Beverly Hills, Calif.: Copley Galleries, 1948.

Analphabet. New York: Nadada Editions, 1974.

A Book of Diverse Writings. Ridgefield, N.J.: N.p., 1915. Edition of 20.

Les Champs délicieux. Paris: Société Generale d'Imprimerie, 1922.

Les Mains libres. Paris: Editions Jeanne Bucher, 1937.

New York Dada. Single issue. New York: Published in cooperation with Marcel Duchamp, 1921.

"A Note on the Shakespearean Equations." In *To Be Continued Unnoticed*. Beverly Hills, Calif.: Copley Galleries, 1948.

Oggetti d'affezione. Turin: Giulio Einaudi, 1970.

La Photographie n'est pas l'art. Preface by André Breton. Paris: GLM, 1937.

Photographs by Man Ray 1920 Paris 1934. 1934. Reprint. New York: Dover Publications, 1979.

"Photography Is Not Art." *View*, no. 1, ser. 3 (April 1943): 23; no. 2, ser. 3 (October 1943): 77–78, 97.

A Primer of the New Art of Two Dimensions. New York: privately published, 1916.

"The Ridgefield Gazook." In maquette form only. Ridgefield, N.J., 31 March 1915.

Self Portrait. Boston: Little, Brown and Company, 1963.

"What I Am." In *An Exhibition Retrospective and Prospective of the Work of Man Ray*. London: Institute of Contemporary Arts, 1959.

ACKNOWLEDGMENTS

Although acknowledged and admired, Man Ray's virtuosity in a range of media remains startling, his longevity and traveled life awesome. Personal freedom and artistic independence were his perpetual battle cries. Such diversity may be the stuff of which art-historical myths are made, yet the pace of Man Ray's popularity has baffled scholars, who, in their rush to analyze divergent styles and attitudes, have often lost sight of the originality that spurred his career. Because of the artist's own attempts to confound scholars—thereby avoiding the usual art-historical categorizations—the search for Man Ray has been difficult. He is widely known as a photographer; however, this does scant justice to the breadth of his creativity. A comprehensive treatment of Man Ray's work in all media is long overdue.

The seven scholars who have contributed to this volume have brought both new information and new insights to the study of Man Ray. To my fellow contributors Stephen Foster, Billy Klüver, Julie Martin, Francis Naumann, Sandra Phillips, Roger Shattuck, and Elizabeth Turner, I owe thanks for their participation as well as their patience with the unruly subject of Man Ray. Beyond her contribution as author, Elizabeth Turner, who was a curatorial consultant for the project, deserves special thanks for advice and support.

This book could not have been even imagined without the support of Juliet Man Ray, the artist's widow. It was she who first suggested to me the need and importance of undertaking such a project. The insights, documents, introductions, and general entrée into Man Ray's world that she provided were indispensable.

Vital to the entire project were those individuals who knew the artist well. I wish to underscore the cooperation of Man Ray's friends and colleagues, who granted interviews, time, photographs, letters, manuscripts, and advice. In Paris, Lucien Treillard especially deserves thanks for the tremendous effort he made toward the success of this project. As friend and assistant to Man Ray, he not only provided access to Man Ray archives but also acted as guide to them. In New York, Timothy Baum was of equal assistance. Beyond providing photographs and documents, his introduction to dada and its spirit was unparalleled. Naomi Savage,

Man Ray's niece, generously provided family papers and personal reminiscences of her uncle.

Those who had worked with Man Ray, or those who had simply, because of their admiration, made it their business to study Man Ray and his art, were generous with thoughts and ideas. Many went beyond the simple call of duty in terms of time, photographs, documents, and introductions to other Man Ray enthusiasts. Special thanks are extended to: S. J. Staniski, Marion Meyer, Neil Baldwin, Arnold Crane, Virginia Zabriskie, Aleta Wallach, Patti Cadby Birch, Claude Hersaint, Elisa Breton, Jean-Paul Kahn, Anthony Penrose, Jean Farley Levy, Herbert Lust, Sylvio Perlstein, Mina Sarofim, Maurice Weinberg, Sylvia Sator, Ninette and Peter Lyons, Anne and Van Reeves, Ruth Ford, Gérard Lévy, James and Barbara Byrnes, James Whitney, Jacqueline Goddard, Arturo Schwarz, Georgio Marconi, Janus, Nikki Diana Marquardt, Philippe Rein, Agnes Rein, Dennis Powers, Maria Alvarez, Dominique Willoughby, Patrick de Haas, Robert Ballard, Carla Verri, Lydia Gasman, Dorothea Tanning, Martica Sawin, Alan Tarica, Mary Jane Laurent, George Dalsheimer, Howard Read, Gerd Sander, Daniel Filipacchi, Lucien Scheler, Jean-Hubert Martin, William N. Copley, Enrico Baj, Gertrude Neier, Maria Hambourg, David Travis, Frank Kolodny, Mr. and Mrs. Melvin Jacobs, Mr. and Mrs. Morton Neumann, Herbert Neumann, Patrick Waldberg, Jacques Foujour, Bruce Davidson, Andy Warhol, Irving Penn, Robert Mann, Harry Lunn, Elizabeth Phillips, and Richard Sandor.

Several libraries and their staffs merit special gratitude: the Archives of American Art, Washington, D.C. (Senior Curator Garnett McCoy and Archives Technician Colleen Hennessey); the Bibliothèque Littéraire Jacques Doucet, Paris (Conservator François Chapon); the Beinecke Rare Book and Manuscript Library, Yale University (Director Ralph W. Franklin); the Firestone Library Rare Book Room, Princeton University (Curator of Manuscripts Jean F. Preston); the Harry Ransom Humanities Research Center, the University of Texas at Austin (Director Decherd Turner, Librarian John P. Chalmers, Curator Carlton Lake); the Houghton Library, Harvard University (Emily Wal-

hout); the Van Pelt Library, University of Pennsylvania; the University of Delaware Library; the Delyte W. Morris Library, Southern Illinois University at Carbondale (Expatriate Literature Collection, David Koch); the New York State Library, Cultural Education Center, Albany (James Corsaro); and the Library of the National Museum of American Art and the National Portrait Gallery, Washington, D.C. (Librarian Cecilia Chin, Library Technician Martin Kalfatovic, Assistant Librarian Patricia Lynagh, and Technical Information Specialist Roberta Geier).

Among the museums and archival collections that have responded to endless requests for information and photographs with extraordinary patience and professional skill, I count: the J. Paul Getty Museum, especially Curator of Photography Weston Naef, Louise Stover, and Joan Gallant; at the Museum of Modern Art, the Department of Photography, especially Sarah McNear (now associate curator of the Allentown Art Museum), the Film Stills Archives, and the Library; the Philadelphia Museum of Art, especially Director Anne D'Harnoncourt; Condé Nast Publications, Curator Diana Edkins; the Museum of Fine Arts, Houston; the Metropolitan Museum of Art; the Art Institute of Chicago, especially Curatorial Assistant in the Department of Photography Sylvia Woolf; the Menil Collection, Houston, especially Director Walter Hopps and Chief Curator Neil Printz; the Yale University Art Gallery and the Collection of the Société Anonyme, New Haven; the National Portrait Gallery, especially Curator of Photography Will Stapp; the Gillman Paper Company; the Roland Penrose Foundation and the Lee Miller Archives; the Hamburger Kunsthall, especially Werner Hoftmann; the Musée National d'Art Moderne, Paris; Bibliothèque Nationale, Paris; Moderna Museet, Stockholm; Westfalisches Landesmuseum fur Kunst und Kulturgeschichte, Münster; Kunsthaus, Zurich; Museum Ludwig, Cologne; the Whitney Museum of American Art; the André Bloc Foundation, Meudon; the Tate Gallery, London; the Museum of Fine Arts, Boston; and the High Museum of Art, Atlanta.

I wish to thank personnel with the following galleries and auction houses for their help, without which many of Man Ray's most important works would still be unavailable: the Zabriskie Gallery, especially James Reinish (now director of twentieth-century painting, Hirschl and Adler Galleries, New York); Beth Urdang (now of Beth Urdang Fine Arts, Brookline, Mass.), Anne Lapidus, and Deborah Eigen; Robert Miller Gallery, New York; Middendorf Gallery, Washington, D.C., especially Chris Middendorf; Harcourt Contemporary Gallery, San Francisco; Fraenkel Gallery, San Francisco, especially Jeffrey Fraenkel; Meredith Long and Company, especially Jenny Long; Edwynn Houk Gallery, Chicago; George Dalsheimer Gallery, Baltimore; Studio Marconi, Milan, especially Gio Marconi; Galerie Françoise Tournie, Paris; Galerie Marion Meyer, Paris; Galerie Aronowitsch, Stockholm; Galerie 1900/2000, Paris, especially Marcel Fleiss; Artcurial, Paris, especially Thessa Herold; Galerie Octant, Paris, especially Alain Paviot; G. Ray Hawkins Gallery, Los Angeles; Cordier and Ekstrom, New York; Sotheby Parke Bernet, New York and London, especially Beth Warren, curator of photography in New York; and Christie's, New York.

To Jerome Gold, administrative curator of the Man Ray Trust, goes a special note of appreciation. His commitment to the publication was without parallel. His assistance in searching out photographs and facts was unfailing.

Strong support at home came from editor Gaye Brown and her assistants Carole Broadus and Jeannie Kiernan; staff photographers Margaret Harman and Mildred Baldwin and the Office of Research Support, especially Mary Kaye Freedman. The Department of Graphic Arts patiently cooperated with a project that became increasingly demanding. In addition, I would especially like to thank Chief Curator Elizabeth Broun and Curator-in-Charge of Painting and Sculpture Virginia Mecklenburg for good advice and needed encouragement over several years.

I am particularly grateful for two Smithsonian Scholarly Studies Program grants as well as a Research Opportunities Fund grant that provided the funds for research and travel. The endorsement of Dr. Charles C. Eldredge, director of the National Museum of American Art, is also greatly appreciated.

—MERRY FORESTA

INDEX

Page numbers in italics refer to illustrations.

342

345

COLLECTION AND PHOTO CREDITS

All material for reproduction was obtained from the collections indicated in the captions, except for those in the list that follows. In the case of Man Ray's photographs, the captions do not cite owners and locations, since the images may be found in a number of collections.

Art Institute of Chicago: figs. 99, 123 (Julien Levy Collection), 168 (Mary Reynolds Collection); Archives Photographiques, Caisse Nationale des Monuments Historique et des Sites, Paris: fig. 267; Timothy Baum: figs. 18, 199 (photos by Nathan Rabin); Timothy Baum Archives: figs. 33, 44, 176 (photos by Nathan Rabin); Bibliothèque Littéraire Jacques Doucet, Bibliothèque Sainte-Geneviève: figs. 9, 84; Christie's, New York: fig. 47; George Dalsheimer, Baltimore: fig. 22 (photo by Geoffrey Clements); Mr. and Mrs. William Donnelly, East Hampton, New York: fig. 133; Photography by Jacques Faujour: figs. 141, 177; Danielle Filipachi, Paris: fig. 234; Ruth Ford, New York: fig. 229 (photo by Otto Nelson); Photography by Roger Gass: fig. 117; J. Paul Getty Museum, Malibu, California: frontispiece, figs. 7, 11, 15, 16, 65, 92, 104, 128, 138, 151, 179, 182, 185, 190, 196, 207, 208, 238; Gilman Paper Company, New York: figs. 70, 150; Peggy Guggenheim Collection, Venice: fig. 54; Hirshhorn Museum and Sculpture Garden, Smithsonian Institution, Washington, D.C.: fig. 111 (photo by Lee Stalsworth); Houghton Library, Harvard University, Cambridge, Massachusetts: figs. 126, 195; Billy Klüver and Julie Martin Archives, Berkeley Heights, New Jersey: figs. 77, 78; Kunsthaus Zurich: fig. 83; Museum Ludwig, Cologne, West Germany: fig. 105; Library of Congress, Washington, D.C.: fig. 129; Man Ray Trust ADAGP: figs. 153, 175, 218 (photos by G. Chapelle), 31, 90, 91, 107, 108, 122, 127, 134, 141, 152, 158, 171, 172, 192, 203, 245, 253, 257, 259, 263 (photos by Jacques Faujour), 8, 25, 72, 74, 81, 82, 89, 96, 101, 106, 109, 110, 113, 116, 144, 145, 148, 153, 156, 161–163, 181, 193, 201, 209, 211, 213, 215, 217, 223, 258, 261, 262, 270 (photos by Guerin), 112 (photo by Jacqueline Hyde), 271 (photo by Stanley Stansky), 14, 26, 29, 38, 39, 95, 102, 114, 124, 125, 173, 184, 188, 189, 191, 198, 202, 212, 216, 220, 221, 226–228, 234, 249, 251, 264, 268; Menil Collection, Houston: figs. 73, 190, 224 (photo by Hickey Robertson); Photography by Claude Mercier: fig. 4; Collection, The Museum of Modern Art, New York: figs. 23, 27, 28, 157, 164, 180 (all Gift of James Thrall Soby), 99, 149 (both Purchase), 135–138, 174 (all Film Stills Archive), 167 (The Abbott-Levy Collection. Partial gift of Shirley C. Burden), 194; Musée National d'Art Moderne, Centre Georges Pompidou, Paris: figs. 10, 131, 132, 197, 242, 260; National Museum of American Art, Smithsonian Institution, Washington, D.C.: figs. 30 (Gift of Juliet Man Ray), 55–64, 183 (Juley Photo Archive); National Portrait Gallery, Smithsonian Institution, Washington, D.C.: figs. 98, 130; National Museum of American Art/National Portrait Gallery Library, Smithsonian Institution, Washington, D.C.: figs. 125, 239–241; Philadelphia Museum of Art: figs. 1 (Gift of Friends of Philadelphia Museum of Art), 94 (Gift of Carl Van Vechten, photo by Jose Broderick); Rutgers University Library: fig. 97 (photo by Sara Krauskopf); Richard Sandor, Chicago: fig. 115 (photo by Michael Tropea); Arturo Schwartz, Milan: fig. 269; Roger Therond, Paris: fig. 266; David Travis: figs. 169, 170; Photography by Michael Tropea: figs. 51, 248; Van Pelt Library, University of Pennsylvania, Philadelphia: figs. 165, 166; Courtesy *Vanity Fair*: figs. 100 (© 1922 [renewed 1949, 1950] by Condé Nast Publications, Inc.), 146 (© 1921 [renewed 1949, 1950] by Condé Nast Publications, 159 (© 1922 [renewed 1950, 1978] by Condé Nast Publications, Inc.); H. Roger Viollet, Paris: figs. 36, 75, 76; Aleta Wallach, Beverly Hills, California: fig. 255; Whitney Museum of American Art, New York: figs. 225 (photo by Geoffrey Clements), 228; Yale University Art Gallery, New Haven, Connecticut: figs. 1, 142 (Gift of Collection Société Anonyme), 71 (Bequest of Katherine Dreier); Zabriskie Gallery, New York: fig. 244.